CYPRIOT CERAMICS: READING THE PREHISTORIC RECORD

The publication of these symposium papers was
supported by generous grants from the
A.G. Leventis Foundation, the
Institute for Aegean Prehistory,
and the Archaeological Institute of America

The symposium was sponsored by
The University Museum of Archaeology and Anthropology
and funded with the assistance of grants from
the National Endowment for the Humanities,
the Samuel H. Kress Foundation,
the University of Pennsylvania,
and the Archaeological Institute of America

University Museum Monograph 74

UNIVERSITY MUSEUM SYMPOSIUM SERIES
VOLUME II

Published by

The A.G. Leventis Foundation

and

The University Museum
of Archaeology and Anthropology
University of Pennsylvania

CYPRIOT CERAMICS: READING THE PREHISTORIC RECORD

Jane A. Barlow
Diane L. Bolger
Barbara Kling
Editors

1991

Design, editing, typesetting, production
Publications, The University Museum

Printing
Science Press
Ephrata, Pennsylvania

Library of Congress Cataloging-in-Publication Data
Cypriot ceramics: reading the prehistoric record / Jane A. Barlow,
Diane L. Bolger, Barbara Kling, editors.
 p. cm. -- (University Museum monograph ; 74) (University
Museum symposium series ; v. 2)
 Proceedings of an international conference held at the University
Museum of Archaeology and Anthropology in October 1989.
 Includes bibliographical references and index.
 ISBN 0-924171-10-3
 1. Pottery--Cyprus--Congresses. 2. Pottery, Prehistoric--Cyprus-
-Congresses. 3. Cyprus--Antiquities--Congresses. I. Barlow, Jane
Atwood. 1928- . II. Bolger, Diane R. III. Kling, Barbara.
IV. University of Pennsylvania. Museum of Archaeology and
Anthropology. V. Series. VI. Series: University Museum symposium
series ; v. 2.
DS54.3.C9 1991
939'.37--dc20 91-26521
 CIP

Colophon drawn by Georgianna Grentzenberg

Endpapers designed by Carole Bolger

TABLE OF CONTENTS

LIST OF FIGURES

LIST OF TABLES

ACKNOWLEDGMENTS

It is with great pleasure that we take this opportunity to thank the institutions and individuals who contributed their time, effort and assistance toward the organization of the October 1989 colloquium *Cypriot Ceramics: Reading the Prehistoric Record*, as well as those who have helped make possible the publication of this book.

Generous grants from the National Endowment for the Humanities, the Samuel H. Kress Foundation, the Archaeological Institute of America and the University of Pennsylvania supported conference and travel expenses and made possible the participation of a large international group of scholars. Without this fundamental assistance the colloquium could not have taken place.

We would especially like to thank Professor James D. Muhly of the Department of Oriental Studies at the University of Pennsylvania, who in addition to representing the University during the planning and fundraising stages became an active member of the organizing committee. We and the conference benefitted greatly from his time and experience. In addition, we owe a great debt of gratitude to Ms. Jean Donohoe, who managed countless details of planning during a period when none of the organizers was able to be in Philadelphia, and who enlisted a team of student volunteers to assist with arrangements during the conference. We also appreciate the support and good will received from the Department of Antiquities, Cyprus, and particularly from the Acting Director, Mr. A. Papageorghiou, who unfortunately was unable to attend.

A great number of the people at The University Museum deserve recognition for their efforts in organizing the colloquium, and for its subsequent publication. We are grateful to Dr. Robert H. Dyson, Jr., Director of The University Museum, for securing the use of many museum facilities and for accepting the publication of the conference proceedings in The University Museum Symposium Series. Dr. David G.

Romano, Keeper of the Collections of the Mediterranean Section, kindly arranged for the use of a large number of ceramics from the Museum collections for study and discussion during the conference. Dr. Greg Possehl, Assistant Director of The University Museum, and Ms. Pat Goodwin and the staff of the Special Events Office were instrumental in making arrangements with various Museum departments and with hotels and transportation facilities in Philadelphia. Mr. Von Bair and Mr. Alan Waldt of the Museum Business Office provided considerable assistance with financial planning and the preparation of grant proposals, and Ms. Suzanne Clappier and Ms. Lisa Prettyman helped with the administration of funds.

The publication of the present volume would not have been so readily achieved without the encouragement and active support of Dr. Vassos Karageorghis, through whose good offices funding in generous measure was obtained from the A.G. Leventis Foundation. Financial support for the publication was also generously granted by the Institute for Aegean Prehistory and the Archaeological Institute of America. We extend our sincere gratitude to these institutions for their support. Thanks are also due to Ms. Karen Vellucci, Managing Editor of the Museum Publications Office, for seeing this volume through all the stages of production, to Ms. ZoAnna Carrol for editorial assistance, and to Ms. Carole Bolger for help with artistic design.

Last, but certainly not least, we would like to thank the contributors to this volume, many of whom travelled great distances to participate in the colloquium. It is, above all, their scholarly contributions and lively discussions that made the conference a success.

Jane A. Barlow
Diane Bolger
Barbara Kling

PREFACE

During the last thirty years of intensive archaeological activity in Cyprus, American participation has been both active and significant. Apart from the missions from various American universities and other learned institutions which excavate on the island every year, a large number of students have been researching on topics of Cypriot archaeology. There is now an impressive number of young American scholars who specialize in various aspects of ancient Cypriot studies, from the Palaeolithic period to the folk art of present day Cyprus. There is in America a revival of interest in ancient Cyprus, and a tangible proof of this interest is the organization of conferences on specific aspects of Cypriot archaeology which have been or will be organized soon. The University Museum of Archaeology and Anthropology at the University of Pennsylvania, with a long tradition of active participation in ancient Cypriot studies, has manifested in various ways its renewed interest in the island's past.

The organization at The University Museum in October 1989 of an international conference for the study of prehistoric Cypriot ceramics satisfied a demand not only on the part of Cypriot specialists but also of all those scholars who work in the Eastern Mediterranean and the Near East. Prehistoric Cypriot ceramics, either because of their peculiarity and I daresay beauty, were widely traded, especially during the late part of the Bronze Age, and constitute an important source of information for archaeologists about 'international' trade and cultural relations.

Several decades have elapsed since the gigantic efforts of the Swedish Cyprus Expedition to establish a detailed classification of the prehistoric pottery of Cyprus. New discoveries resulting from stratified excavations and the current application on a wide scale of modern technological and scientific methods have contributed considerably to the study of ceramics, such as provenience,

chronology and stylistic evolution. It has been realized by various scholars that the classification which has been in use up to now and which offered in the past an excellent tool for research had to be reconsidered in the light of new data and possibilities for further refinement.

Specialists from many countries currently active in Cypriot prehistory discussed for three days in Philadelphia numerous aspects concerning the infinite variety of Cypriot ceramics, in a spirit of cordial collaboration and with a genuine desire to advance knowledge, without polemics, ill feelings or preconceived ideas. While acknowledging the need to proceed cautiously, it was felt that several novelties should be introduced in ceramological studies, namely with regard to the various names which have hitherto been used for identification of prehistoric Cypriot pottery. Names, for example, which arbitrarily determined chronological limits should be reconsidered in the light of more accurate chronological data. It was an exciting experience for all participants to be able to see and handle the objects of their discussions by having vases or potsherds in front of their eyes for clearer definition.

The organizers of this conference, particularly Professor James Muhly, Dr. Jane Barlow, Dr. Diane Bolger, and Dr. Barbara Kling, deserve to be congratulated for their initiative.

The published proceedings of the conference will constitute the permanent contribution to be used by all archaeologists, but it should be stressed that we are far from pronouncing a 'final verdict.' As was stressed at the end of the conference, the exchange of ideas should continue until we reach a wide consensus for the establishment of chronologies, classifications and labels which will make our studies more accurate without creating further confusion.

Vassos Karageorghis

FOREWORD

Some might ask what a scholar like me, associated with drilling holes in metal artifacts, is doing at a gathering of pottery people. I can say only that, in representing the University of Pennsylvania, I have tried to be of some help to the organizers of this conference. I believe that Jane Barlow, Diane Bolger and Barbara Kling have done a great service in bringing together specialists in Cypriot pottery to spend three days talking about current problems. Arrangements in the University Museum were ably assisted by Jean Donohoe, and access to the Museum's collections, a vital factor in the decision to hold this conference here, was facilitated by David Romano, Keeper of the Mediterranean Section of the Museum. The Conference itself was made possible by grants from the National Endowment for the Humanities, the Samuel H. Kress Foundation, the Archaeological Institute of America and the University of Pennsylvania. We are grateful to all these organizations for their generous support; without it this conference would never have taken place.

The major question that many will ask is, "why all the fuss?" Why the interest now in a topic that has been studied in great detail over the past one hundred years? The reason for this, as I understand it, is a growing feeling that changes are necessary in the ways in which we study Cypriot pottery. The detailed classifications proposed over the years, based upon factors of shape and decoration, work well when one is dealing with whole pots from tombs, but are difficult to use when an archaeologist is faced with the task of organizing and classifying the scrappy sherd material that represents the bulk of the ceramic finds from any settlement excavation. Scholars faced with the responsibility of publishing such material, and it is such scholars who gathered for this conference, have come to believe that they must work out new ways of extracting information from their material. Hence this workshop.

As Vassos Karageorghis pointed out in his opening night address at the conference, the chronological classification of pottery should represent only the beginning of our pottery studies. A ceramic chronological sequence must not represent the final goal of our endeavors but only their necessary starting point. Without a reasonable and workable ceramic sequence, however, subsequent archaeological research cannot have much meaning. For most scholars working in the field of Cypriot archaeology in all periods down to the beginning of the Iron Age, the present ceramic classification system has come to be regarded as increasingly cumbersome as new excavations and new kinds of technical analyses have yielded new information. Classification systems must adjust to new evidence or fall into disuse.

The pioneers of Cypriot archaeology who devised the fundamental typologies, especially the members of the Swedish Cyprus Expedition, created systems that have served students of Cypriot archaeology very well over a period of half a century. They would, I am sure, also be the first to take advantage of the vastly greater body of evidence we are fortunate enough to have at our disposal today. It is within this spirit of constructive criticism and reasoned argumentation, based upon new evidence, that revision can best be carried out.

James D. Muhly

BIBLIOGRAPHIC ABBREVIATIONS

Acts 1973 Department of Antiquities, Cyprus. *Acts of the international archaeological symposium "The Mycenaeans in the Eastern Mediterranean."* Nicosia, 1973.

Acts 1979 Department of Antiquities, Cyprus. *Acts of the international archaeological symposium "The relations between Cyprus and Crete, ca. 2000-500 B.C."* Nicosia, 1979.

Acts 1985 Papadopoulos, T., Ed. *Acts of the second international congess of Cypriot studies. A. Ancient Section.* Nicosia, 1985.

Acts 1986 Karageorghis, V., Ed. *Acts of the international archaeological symposium "Cyprus between the Orient and the Occident."* Nicosia, 1986.

Enkomi Dikaios, P. *Enkomi Excavations 1948-1958.* Mainz am Rhein, 1969-71.

HST 1 Åström, P., D.M. Bailey and Vassos Karageorghis. *Hala Sultan Tekke 1. Excavations 1897-1971. SIMA* XLV: 1. Göteborg, 1976.

HST 3 Åström, P., G. Hult and M.S. Olofsson. *Hala Sultan Tekke 3. Excavations 1972. SIMA* XLV: 3. Göteborg, 1977.

HST 4 Hult, G. *Hala Sultan Tekke 4. Excavations in Area 8 in 1974 and 1975. SIMA* XLV: 4. Göteborg, 1978.

HST 5 Öbrink, U. *Hala Sultan Tekke 5. Excavations in Area 22. 1971-1973 and 1975-1978. SIMA* XLV: 5. Göteborg, 1979.

HST 6 Öbrink, U. *Hala Sultan Tekke 6. A Sherd Deposit in Area 22. SIMA* XLV: 6. Göteborg, 1979.

HST 7 Hult, G. *Hala Sultan Tekke 7. Excavations in Area 8 in 1977. SIMA* XLV: 7. Göteborg, 1981.

HST 8 Åström, P., E. Åström, A. Hatziantoniou, K. Niklasson, and U. Öbrink. *Hala Sultan Tekke 8. Excavations 1971-1979. SIMA* XLV: 8. Göteborg, 1983.

Kition I Karageorghis, V. *Excavations at Kition I. The Tombs.* Nicosia, 1974.

Kition IV Karageorghis, V., J.N. Coldstream, P.M. Bikai, A.W. Johnston, M. Robertson, and L. Jehasse. *Excavations at Kition IV. The Non-Cypriote Pottery.* Nicosia, 1981.

Kition V Karageorghis, V. and M. Demas. *Excavations at Kition V. The Pre-Phoenician Levels.* Nicosia, 1985.

SCE I Gjerstad, E., J. Lindros, E. Sjöqvist, A. Westholm. *The Swedish Cyprus Expedition: Finds and Results of the Excavations in Cyprus 1927-1931.* Vol. I Text; Vol. I Plates. Stockholm, 1934.

SCE II Gjerstad, E., J. Lindros, E. Sjöqvist, A. Westholm. *The Swedish Cyprus Expedition: Finds and Results of the Excavations in Cyprus 1927-1931.* Vol. II Text; Vol. II Plates. Stockholm, 1935.

SCE III Gjerstad, E., J. Lindros, E. Sjöqvist. A. Westholm. *The Swedish Cyprus Expedition: Finds and Results of the Excavations in Cyprus 1927-1931.* Vol. III Text; Vol. III Plates. Stockholm, 1937.

SCE IV Pt.1A Dikaios, P. and J.R. Stewart. *The Swedish Cyprus Expedition: The Stone Age and The Early Bronze Age in Cyprus.* Lund, 1972.

SCE IV Pt.1B Åström, P. *The Swedish Cyprus Expedition: The Middle Cypriote Bronze Age.* Lund, 1972.

SCE IV Pt.1C Åström, P., with a contribution by M.R. Popham. *The Swedish Cyprus Expedition: The Late Cypriote Bronze Age: Architecture and Pottery.* Lund, 1972.

SCE IV Pt.1D *The Swedish Cyprus Expedition: The Late Cypriote Bronze Age: Other Arts and Crafts by Lena Åström; Relative and Absolute Chronology, Foreign Relations, Historical Conclusions by Paul Åström with contributions by V.E.G. Kenna and M.R. Popham.* Lund, 1972.

A note on the names of archaeological sites in Cyprus

Many archaeological places in Cyprus are designated by a general site name and a more specific locality, of which there may be several for any general site. Within the text of this volume, such names appear in the format site-locality, e.g., Sotira-Kaminoudhia, at least the first time they appear within individual papers; thereafter, they are sometimes abbreviated to locality alone. This map includes only general site names.

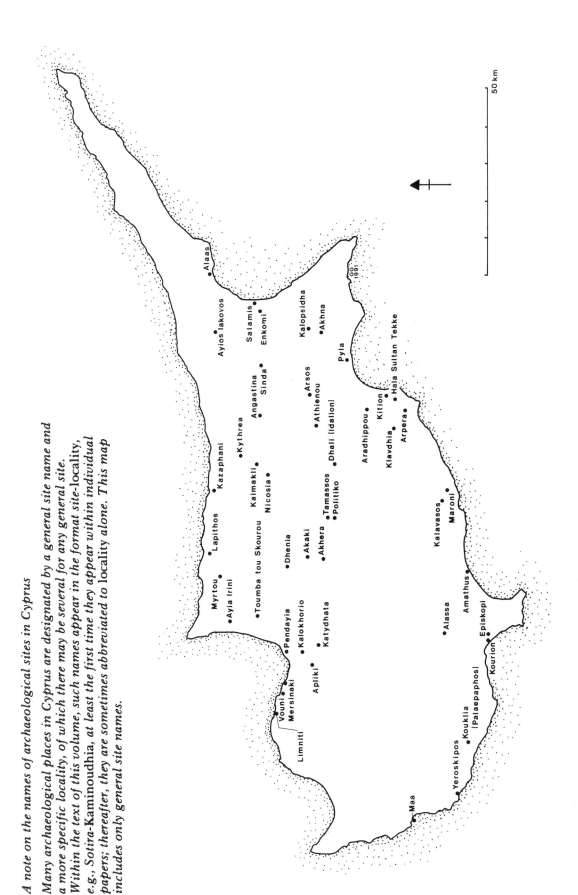

Major Late Bronze through Archaic sites in Cyprus mentioned in text. See also Figures 10.1, 11.11, 15.6.

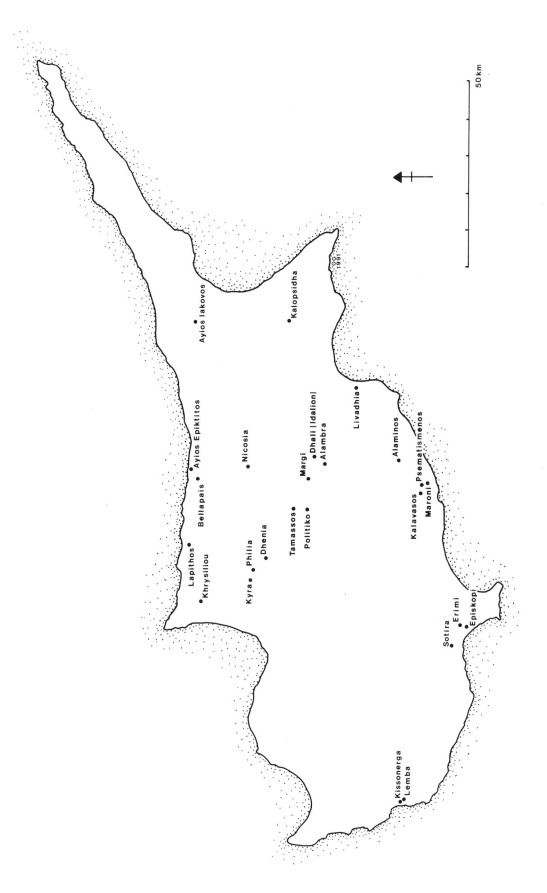

Neolithic, Chalcolithic, Early and Middle Bronze Age Cyprus. Major sites mentioned in text. See also Figures 3.1 and 7.6.

Introduction

From earliest times, the island of Cyprus has been a crossroads for many different cultures at the eastern end of the Mediterranean. And yet Cypriot art, with an exuberant spirit all its own, maintained an independent identity in the face of influences from the Levant, the Aegean, Anatolia and Egypt. Nowhere is this more evident than in its ancient pottery, which has, accordingly, become the most important tool of archaeologists for understanding the development of Cypriot culture and the relations of Cyprus with its overseas neighbors. The detailed technical studies of prehistoric Cypriot ceramics published in this volume were presented at the colloquium, *Cypriot Ceramics: Reading the Prehistoric Record*, at The University Museum of Archaeology and Anthropology at the University of Pennsylvania in October, 1989. Together they demonstrate the current state of research and the new directions in which Cypriot pottery specialists are moving in studying this essential archaeological material.

OVERVIEW OF CYPRIOT POTTERY STUDIES AND CURRENT PERSPECTIVES

Archaeological activities began on a large scale in Cyprus shortly after the middle of the nineteenth century when diplomats from various foreign governments profited from a weakening Ottoman government to conduct virtually uncontrolled excavations and to export large quantities of antiquities. Among these was the American, General Luigi Palma di Cesnola, joint consul for the United States and Russia, who amassed a private collection of sculpture and pottery which he ultimately offered to the fledgling New York Metropolitan Museum of Art. The museum accepted the collection and Cesnola became the museum's first director (Cesnola 1877; 1885-1903).

Although unauthorized digging was prohibited under the British administration which began in 1878, excavation procedures of the time were casual by modern standards. Finds were routinely divided among the various parties involved in an excavation, and many artifacts fell into private hands or were sold in the commercial art market. At the end of the century, a basic typology for early Cypriot pottery was proposed by John L. Myres and Max Ohnefalsch-Richter for the large quantity of material, much of it unprovenanced, that had accumulated in the Cyprus Museum (Myres & Ohnefalsch-Richter 1899; see also Sandwith 1877). The refinement of this typology and the establishment of a chronological framework based on well documented excavated remains would not be undertaken until the second quarter of the twentieth century, with the work of J.L. Myres (1914) and of the Swedish Cyprus Expedition, under the direction of Einar Gjerstad.

In 1926 Gjerstad published a dissertation which, among other contributions, further refined Cypriot pottery classification (Gjerstad 1926). Gjerstad went on to lead the Swedish Cyprus Expedition, directing excavations in the 1920s and 1930s at numerous sites primarily in the north of the island. These excavations resulted in four volumes, written by several distinguished scholars, published between 1934 and 1972 (*The Swedish Cyprus Expedition*, Volumes I-IV), which collectively formed the basis for a modern scientific understanding of Cypriot prehistory.

The typology that emerged from these early studies identified a series of wares that were distinguished and named according to physical attributes or technical features intrinsic to them, such as Red Polished, White Painted, White Slip and Base Ring. Unlike pottery classes designated by period (e.g., Late Minoan IA), by site of first identification (e.g., Khirbet Kerak ware) or by presumed ethnic users (e.g., Philistine), nearly all Cypriot wares have been named after an easily visible trait of the pottery itself. As Merrillees has observed, this system has the advantage of identifying a ware by an obvious physical characteristic while leaving its chronological and geographical boundaries free-floating and therefore adjustable as new evidence appears (Merrillees 1978).

Despite the flexibility inherent in the system as it was initially conceived, many problems of classification and terminology of Cypriot pottery from the Late Neolithic through the Early Iron Age periods have arisen in recent years. In part this can be attributed to the small material base and the limited geographical range on which the early systems were based. Problems also exist because, for reasons still not understood, archaeological sites in Cyprus do not contain the substantial layers of mounded habitation debris characteristic of their Near Eastern counterparts; the lack of superimposed deposits makes the establishment of chronological links among sites difficult. An additional complication is a frequent imbalance in the archaeological record, with some periods represented primarily or exclusively either by tomb or settlement material and lacking the complementary ceramics found in other types of contexts.

Systematic excavations in many previously unexplored areas of the island over the last several decades have greatly increased the amount of ceramic material available for study and have raised questions concerning the validity of applying the early systems to the entire island. Accordingly, new pottery terminologies have proliferated in the archaeological literature, sometimes confusing our understanding of the chronological sequence, the relations between different areas of the island, and the relations between Cyprus and its neighbors in the eastern Mediterranean.

Furthermore, there have been changes in the methods and goals adopted by ceramic specialists in the analysis of Cypriot pottery. Potsherds that can be dealt with statistically or analyzed by new technologies have received much more attention in recent studies, supplementing the information that can be derived from whole vessels alone. In addition, coarse and plain wares, once virtually ignored, are now being appreciated. Understanding the methods that ancient potters used to achieve colors, finishes, fabrics and shapes provides a growing number of specialists with additional information for discerning lines of development and interrelationships among the various wares.

PURPOSE AND STRUCTURE OF THE PHILADELPHIA COLLOQUIUM

The conference at which the papers in this volume were delivered was conceived out of a general feeling among ceramic specialists working in Cyprus of dissatisfaction with the existing taxonomic systems. It was also motivated by the realization that time pressures and excavation schedules rarely allow pottery specialists to meet in Cyprus to exchange ideas and to view and handle excavated material from sites other than those at which they work. Consequently, the conference was intended to bring together scholars currently studying Cypriot pottery to address specific problems of typology and terminology and to handle and discuss samples of relevant sherd material.

Issues were addressed both at open public sessions, in the form of brief critical papers targeting specific taxonomic issues, and in workshop sessions, open to speakers only, during which problems raised in the papers were discussed in greater detail and illustrated with sherds which participants had brought with them or had arranged to borrow from the collections of The University Museum. Workshop sessions were divided into two chronologically based groups: one for wares of the Late Neolithic through the Middle Bronze Age and the other for wares of the Late Bronze and Early Iron Ages.

Ceramic specialists working in virtually all periods of Cypriot prehistory participated in the conference. The papers presented offer an overview of some of the major taxonomic problems facing pottery analysts in Cyprus today and the approaches and remedies currently being taken to solve them. All of the authors, with the exceptions of Fischer and Merrillees, were also present to discuss these issues at the workshop sessions.

NEOLITHIC AND CHALCOLITHIC PERIODS

Small-scale excavations in the 1930s by the Swedish Cyprus Expedition in the north at sites such as Kythrea and Lapithos, and by Porphyrios Dikaios of the Cyprus Department of Antiquities in the south of the island at Sotira, Erimi and Khirokitia, yielded sufficient evidence to isolate many of the major early pottery types. As several of the papers point out, however, chronological relationships among these wares were not altogether clear, due to the limited nature of these early investigations and the lack of a clear stratigraphical framework. The ceramic sequence for the end of the Chalcolithic and the transition to the Bronze Age, for example, was derived by seriation, a method not often applied with success to small, geographically scattered samples such as those in question. Moreover, the wide variations of fabric, shape and decoration among these early handmade wares led to numerous and sometimes imprecise

classification categories, some of which now appear to overlap or even duplicate one another. Indeed, as argued by **Peltenburg**, the division of the Neolithic and Chalcolithic wares into a multitude of types and subtypes has led to a proliferation of terms which effectively obscure the real similarities between them. In addition, **Baird** challenges the application of the term *ware* in its traditional sense, i.e., a distinctive fabric that occurs in association with a readily identifiable morphological and decorative range, to pottery of these early periods and instead suggests a multivariate approach such as he has employed in his analysis of ceramics from early Chalcolithic Kalavasos-*Ayious*.

Recent studies of pottery from other Chalcolithic sites have adopted a "lumping" approach in which typological analysis tends toward the division of pottery into broad ceramic classes, such as those of J.D. Stewart on Lemba-*Lakkous* (Stewart 1985, 59-69, 154-160, 249-270) and D. Bolger on Erimi-*Pamboula* (Bolger 1985 and Kissonerga-*Mosphilia* (Bolger 1986). Even so, the problems of reconciling current typologies with results of earlier publications remain and can only be solved by a detailed review of relevant collections of ceramics in the museums of Cyprus and elsewhere.

EARLY AND MIDDLE BRONZE AGES

The transition from the end of the Chalcolithic to the Early Bronze Age in Cyprus, represented in ceramic terms by new pottery types such as Black Slip and Combed, Philia Red Polished and White Painted IA, remains problematic and ill-understood. Traditionally, the changes in the archaeological record at this time have often been associated with new population influxes ("refugees") from Anatolia at the end of Anatolian EB II. (See Mellink 1991, however, on the dates of EB II.) Similar ceramic types from sites of western and southern Anatolia and sites of the so-called Philia culture in Cyprus have been cited as proof of the Anatolian origin of these radical social and political upheavals. **Bolger** argues, however, that many of the ceramic antecedents are present in Cyprus and suggests that some if not all of this pottery was produced in Cyprus in imitation of Anatolian wares. **Swiny** presents ceramic evidence from the setlement and cemetery of Sotira-*Kaminoudhia* on the south coast, some of which may be datable to this transitional period. Further investigation of the stratigraphy of the site may be necessary, in addition to the detailed analysis of the pottery that is already underway, before the picture is clear. Certainly a series of radiocarbon dates would help to narrow the possible chronological range.

Several studies addressed issues related to Red Polished and White Painted wares, the principal pottery types of the Early and Middle Bronze Ages. While **Swiny**

discusses the complexities involved in establishing parallels between the ceramics that have emerged at Sotira-*Kaminoudhia* and recognized wares, **Herscher** enumerates several Red Polished vessel types that can be connected with specific regions or sites. These vessels may help to establish chronological ties or trade patterns. **Maguire**'s study of White Painted V suggests that careful stylistic analysis may reveal centers of production and distribution; she suggests that current typologies might be modified to allow for such considerations. **Barlow**, in an analysis of fabric composition, points out some fundamental technical similarities of all the Red Polished ware. The similarities stem from the selective use of varying combinations of two different types of clay for various vessel shapes (Barlow & Idziak 1989). Exactly how this knowledge can best be used within a classification system to understand regional and chronological relationships among sites will become clearer as research continues.

LATE BRONZE AND EARLY IRON AGES

The Late Cypriot Bronze Age witnessed the appearance of numerous new types of pottery in Cyprus, some that developed from earlier ceramic traditions and others that reflect the increased foreign contacts of the island at this time. The potter's wheel gradually came into use for the first time, much later than in neighboring regions (see Gjerstad 1926; Sjöqvist 1940; *SCE* IV Pt.1C). Papers devoted to the Late Bronze and Early Iron Ages dealt with a wide range of these wares, plain and decorated, that have raised numerous questions in understanding the progress of Cypriot history both within the island and in relation to other areas.

In a detailed study of Late Cypriot Base Ring ware, **Vaughan** challenges the existing typology, arguing that some of the characteristics for distinguishing Base Ring I and II in fact often overlap and that the implied clear-cut chronological distinction of Base Ring I to Late Cypriot I and Base Ring II to Late Cypriot II is oversimplified and inaccurate. She proposes a revised typology that comprises a more detailed description of technical and physical attributes than has previously been used, one that may eventually enable certain variations to be connected with specific sites. If confirmed by further research, the revised typology will require a reassessment of Base Ring material and the date of contexts in which it occurs not only in Cyprus but also throughout the Near East, where Base Ring ware was exported in quantity during the Late Bronze Age and the stylistic and chronological distinction between Base Ring I and II has been accepted and often used for dating purposes.

Several papers were devoted to the study of two often-neglected groups of pottery, the monochrome and plain

wares. In a detailed analysis of Plain White wares which refines the types previously defined, **Keswani** examines evidence for standardization of this material as a preliminary step in consideration of the organization of the production of Late Cypriot ceramics. Discussions by **Russell** and **Pilides** of handmade monochrome wares suggest new ways of subdividing the large quantity of material of this type. **Russell**'s study, which developed from her detailed analysis of ceramics from Kalavasos-*Ayios Dhimitrios* and the identification of the peculiarities of monochrome pottery at that site, suggests that regional or even site-specific types can now be isolated. **Pilides**' analyses of a variety of handmade burnished pottery known as "Barbarian ware" identify several subgroups of this material as it has been previously defined in Cyprus. Her paper takes important steps toward clarifying which elements of Late Bronze Age monochrome pottery resulted from new or foreign influences and which elements developed out of local ceramic traditions.

The question of the origin of some of the pottery types that appear in Late Cypriot contexts was addressed in different ways by several contributions. In a detailed study of the distribution and chronology of Red Lustrous Wheelmade ware, **Eriksson** argues for an indigenous Cypriot origin for this pottery type. The complementary contributions of **Åström** and **Fischer** discuss the possibility of characterization of Canaanite ware by means of the analytical techniques MCA (Micro-Colour Analysis) and SIMS (Secondary Ion Mass Spectrometry). In a survey of the characteristics and distribution of gray burnished wheelmade wares that are found in small quantities at Eastern Mediterranean sites dating to the end of the Late Cypriot IIC and Late Cypriot IIIA periods, **Allen** argues for a northwest Anatolian origin for this material.

Pottery of Aegean type and Aegean influence in Cypriot pottery production has for many years been much discussed by ceramic specialists, and was the subject of several papers. In a survey of possible Aegean influences in local Cypriot pottery production throughout the Late Bronze Age, **Cadogan** concludes that it is only in its closing years, the late thirteenth century and twelfth century BC (the periods Late Cypriot IIC and IIIA) that such influences became significant. Much attention was paid in other papers to the wheelmade, matte-painted material from these periods which is generally considered to be produced in Cyprus itself and which has come to be referred to by a variety of terms, such as Late Mycenaean IIIB, Decorated Late Cypriot III, Rude Style and Mycenaean IIIC:1b (e.g., Gjerstad 1944; Furumark 1944; Karageorghis 1965; *Enkomi*; Kling 1986). **Kling**, in a plea for the general adoption of the term White Painted Wheelmade III for all pottery of this type, argues that the division of this

material into a series of separate wares that has evolved in the past several decades is artificial and has clouded our understanding of both the chronology and the historical interpretation of this important transitional period, in that it has implied the existence of sharp divisions and sudden changes. **Sherratt** states similar concerns and proposes the need for a new model for interpreting the period that integrates the continuity and fluidity that are increasingly appreciated to have characterized the LC IIC/IIIA transition. From the site of Alassa, **Hadjisavvas** presents new material of this type which will be an important addition to future study of both the LC IIC-IIIA ceramics and period in general.

In a contribution that deals with the ceramics of the very end of the Late Cypriot Bronze Age (Late Cypriot IIIB), **Iacovou** outlines the essential features of Proto-White Painted ware by discussing its differences from earlier (LC IIIA) and later (CG I) ceramics. She then offers an interpretation of those distinctions.

ETHNOLOGICAL AND THEORETICAL CONSIDERATIONS

In addition to studies devoted to specific ceramic types, several contributions deal with topics of a more general or theoretical nature. **Caubet and Yon** present a discussion of the application of the techniques typically used in studying ceramics for analysis and classification of terra cotta figurines. Two papers discuss the use of modern ethnographic studies for understanding ancient pottery production. **Hemsley** suggests that the selection and preparation of clays and the firing techniques used by modern potters illuminate the activities of ancient craftsmen working with essentially the same raw materials. **London**'s study argues that the degree and nature of variations seen in traditional pottery produced at various centers in Cyprus today reflect not chronological differences, as is often assumed in the interpretation of ancient ceramics, but regional and individual needs and features of the organization of the pottery industry. Her paper considers the challenge facing modern archaeologists of constructing typologies of ancient pottery that communicate these additional types of information.

Papers from the final public sessions conclude with two presentations expressing diverse viewpoints on changes in classification systems. **Merrillees** adopts a conservative approach, arguing generally for retention of the conventional taxonomic systems in their existing form. **Frankel** acknowledges the limitations of the conventional classifications while also noting the tensions and complexities of moving toward systems that may eventually yield both broader and more specific information.

WORKSHOP DISCUSSIONS AND CONSIDERATIONS FOR FUTURE STUDY

The points raised in the workshop sessions clarified some of the trends inherent in the new developments, illuminated the reactions and responses of specialists to each other's work, and proposed some directions for future work in Cypriot ceramics. All participants agreed that the existing classification system has provided helpful subdivisions in the ceramic record of prehistoric Cyprus and established a broad chronological framework that has proved useful for several decades. Recent work is showing, however, that some of the pottery classes are not as easily distinguishable from each other as is implied by the present taxonomy and that some do not fit the chronological framework as well as was once supposed. A question that appeared in many of the papers and was the focus of much of the discussion was to what extent a given taxonomy clarifies or obscures problems under consideration.

Much of the discussion for the early periods centered upon the problems of defining a ware, i.e., a distinctive fabric that occurs in association with a readily identifiable morphological and decorative range; whether we indeed have wares in this sense before the Bronze Age; and whether the present taxonomic system distinguishes wares defined in this way.

It was suggested that Philia Red Polished may be the earliest pottery type that occurs islandwide that merits the term *ware* in this sense. Baird's work with the Chalcolithic ceramics of Kalavasos-*Ayious* was seen as providing a means for characterizing the less consistent types of pottery found in earlier periods by disengaging ceramic attributes from one another, analyzing them separately, and documenting the frequencies with which they are found to be associated with other attributes. It was argued that groups identified by this multivariate type of analysis represent a smaller degree of abstraction from actual ceramic practices than does the concept of ware, and thus can potentially shed greater light on analyses of past behavior.

Along similar lines, it was noted that Peltenburg's study of Chalcolithic monochrome wares points out the danger of going too far in differentiating between pottery types that are in fact quite similar. Apart from breeding nomenclature for Chalcolithic monochromes (Red Slip, Red Lustrous, Red Monochrome, Red Monochrome Painted, Red Polished, etc.) which is no less than dizzying, taxonomic splitting has served to underscore the divisions between wares while at the same time masking the palpable similarities between them. As a solution, it was proposed that in this instance greater attention be paid to morphology. Closer analyses of

shapes, it was argued, may both help to revise what is currently seen as an overclassified typology and to synchronize assemblages from various regions of the island.

Similar concerns were raised in discussion of the pottery of Early-Middle Bronze Age. For example, it was noted that Swiny's preliminary analyses of ceramics at Sotira-*Kaminoudhia* have thus far not revealed a clear division of monochrome ware types similar to those at nearby Episkopi-*Phaneromeni*. This has led to the adoption of a typology at *Kaminoudhia* which replaces the traditional Red Polished I South Coast, Dark Red Polished, and Red Polished Mottled wares with a more broadly-based Red Polished category whose precise chronological range has yet to be determined. Although temporal factors may to some degree be at play here, the ceramic disparity between these two closely situated sites demonstrates the effects which geographical factors, even at the intraregional level, can have upon the manufacture of similar ware types, and raises questions about establishing taxonomic distinctions that will illuminate rather than blur these disparities. It was felt that Herscher's attempt to synchronize ceramic assemblages by establishing intra-island stylistic linkages is valuable within this context of pronounced regional variation. Barlow's research on Red Polished clay composition may provide an additional approach, especially when techniques of manufacture may eventually be linked to easily observable criteria of shape and surface treatment.

Discussion of the problem of the definition of wares in the Early-Middle Bronze Age raised an issue that has frequently been noted by scholars in the past, specifically, the subdivision of wares into categories designated by Roman numerals that not only identify a discrete category but also imply the chronological period to which the category belongs. In some cases the distinction between categories is unclear; in others, the chronological separation does not hold up; in still others, both of these inconsistencies are found. For example, numerical subdivisions within Red Polished ware have acquired chronological connotations which now seem misleading. Red Polished III extends both earlier and later in time than was once believed, and there is a great deal of overlapping in all Red Polished categories. The White Painted sequence displays similar inconsistencies, some of which are undoubtedly complicated by regional biases. Although the group did not feel that the current state of research was sufficiently advanced to warrant changes to the basic system, the discussion raised the

awareness of all participants of the difficulties in the existing system and suggested that greater attention needs to be paid in future studies to the discrepancies that are now recognized to exist.

Very similar issues were discussed in the workshop session devoted to Late Bronze and Early Iron Age wares. The definition of wares and the question of when and how to establish subdivisions within wares received considerable attention. For example, Russell's and Pilides' work on Late Bronze Age Monochrome pottery suggests that the subdivision of some kinds of pottery that have previously been treated as one type can provide valuable information on regional and site-specific peculiarities, and isolate the sources of influence at work in the production of ceramics. The establishment of the criteria for making such subdivisions, however, is a difficult problem. Discussants noted, for example, that criteria frequently overlap between categories or are subjectively defined. It is often difficult, especially when dealing with sherds, to distinguish not only the suggested categories of a given ware, but even to distinguish one ware from another. This potential danger in suggesting new subdivisions is already a problem in other wares that are now seen to be excessively subdivided, sometimes along inappropriate lines, and the question was raised as to whether it is really important to push a sherd into one category or another. It was generally felt that in such cases it may be more important not to force the distinction, thus emphasizing the relationship between wares and allowing uncertainties in classification to be known. This is particularly vital when chronological or historical interpretations are based on classification of pottery.

The issue of the taxonomic practice of the subdivision of wares into categories designated by chronologically suggestive Roman numerals was raised in this workshop as well. In particular, the correlation of Base Ring I and Base Ring II with successive chronological periods was seen to be so seriously misleading that agreement was reached to consider eliminating the use of the Roman numerals for this ware entirely. The need for a reassessment of the numerical subdivision of other Late Cypriot wares was also noted.

Discussion of the White Painted Wheelmade III category touched on these points and raised some of the broader issues that result from changes in pottery classifications. This category comprises several types of pottery that were in use during the last phases of the Late Cypriot Bronze Age that carried various names with implicit chronological and cultural meaning that accented division and change at the time of the Late Cypriot IIC/IIIA transition. There was a growing feeling that the incorporation of all these groups into a general category can contribute to our emerging understanding of the continuity and cultural mixing that, in

fact, was present at this time. The possibility remains that at a later date it may be desirable to subdivide this group along lines that carry fewer cultural or chronological connotations. The use of the term White Painted Wheelmade *III* for all of this material, however, was not acceptable to everyone because of the implications that the Roman numerals have come to have in Cypriot nomenclature, i.e., that this pottery should first appear in Late Cypriot IIIA. According to our present understanding, however, this pottery begins in Late Cypriot IIC. In this case, it is because the definition of these periods has moved away from the original, pottery-based conception. Late Cypriot IIC and IIIA are now viewed as historical periods, distinguished by destructions and abandonments. There was considerable discussion of whether this is a helpful direction in which to move, whether we can hope eventually to differentiate these periods by a fuller range of archaeological materials, including architectural phases, faience, metals and the like as well as pottery, or whether a return to a stricter reliance on pottery is preferable. Issues such as these will undoubtedly be discussed for decades to come, and will continue to raise new and important questions that will greatly expand our understanding of prehistoric Cyprus.

As a possible means of reducing all the taxonomic problems outlined above, there was a unanimous call in both workshop sessions for greater depth and clarity in descriptions of fabrics. A consensus began to emerge that improved knowledge of pottery technology, i.e., an understanding of materials and manufacturing methods, can provide a basis for classification that will strengthen or change existing systems. It was felt that a wide range of objective descriptive criteria should be used, including materials and firing technology as used by Vaughan in her reassessment of Base Ring ware and Barlow in her studies of Red Polished ware, as well as shape and surface treatment.

It was also suggested that, in the present state of research, the basic "umbrella" terms and their subdivisions in present use should be retained. In cases where existing subdivisions are becoming problematic, however, or overlaps with other wares are clear, it may be preferable to omit reference to the subdivisions and simply describe clearly the relationship of the material to possible subgroups or other wares. Stray finds can be classified into the large group, and associated with individual categories at specific sites if possible. Clear, detailed descriptions of the peculiarities of wares at individual sites may eventually form a basis for redefining subdivisions within some wares. Local ceramic sequences such as those now being built up in the Vasilikos Valley Project and the Lemba Archaeological Project are important reference sources. Easy access to a stratigraphical museum in Cyprus which would provide

a study collection of different types of material from different levels at a large number of sites would also be enormously helpful.

Although technical analyses of pottery are becoming an increasingly important part of ceramic studies, discussion of their uses in taxonomic problems was limited. Much of the work now being undertaken is at an experimental stage. Some studies have yielded insights that are helpful in field sorting while others may reveal or confirm connections among sites. The need for clear goals and careful sampling was stressed.

New directions such as these may refine chronologies and enhance our understanding of site-specific and regional peculiarities. Changes in classification and new directions in studying ceramics also have considerable potential for changing and broadening our understanding of other aspects of Cypriot culture and our methods of studying it.

Other substantive results of the colloquium will emerge slowly as work in Cypriot ceramics progresses. Perhaps most encouraging to the organizers was a realization that very many ceramic specialists and archaeologists in the field are seeking change and that most of the new ideas are being seriously considered or actively supported. Together with the clarification of views that the discussion allowed, we suspect that this may lead to more cooperative work in the future and more communication among specialists working at different sites.

Although we feel that these efforts toward revisions in the existing pottery classification system for prehistoric Cyprus are a step forward, we acknowledge that changes in the system might well create confusion, not only within the realm of Cypriot archaeology but also for scholars working on Cypriot material throughout the Eastern Mediterranean. As we work toward implementing revisions, frequent and open communication is essential among archaeologists working throughout the Aegean and the Near East. Changes in nomenclature in Cypriot pottery have implications beyond Cyprus. At the very least, any new suggestions must refer back to the existing system to assist scholars within Cyprus and elsewhere.

The publication of the papers and the discussion of issues that took place at the conference, therefore, serves to clarify many of the problems and points of view that are basic to the work of scholars in Cyprus and in the many areas with which Cyprus was in contact during the prehistoric periods. It also serves as a reference for the suggestions and guidelines for change proposed by the specialists who participated. Of course, this is only the first step. It is our hope that the conference will provide a stimulus for all scholars to proceed along these new lines which we believe show considerable promise for increasing our understanding of the prehistory and protohistory of Cyprus and the Eastern Mediterranean.

Jane A. Barlow
Diane L. Bolger
Barbara Kling

REFERENCES

Barlow, Jane A. and Phillip Idziak
 1989 Selective Use of Clays at a Middle Bronze
 Age Site in Cyprus. *Archaeometry* 31, 66-76.

Bolger, Diane
 1985 From Typology to Ethnology: Techniques of
 the Erimi Potters. *RDAC*, 22-36.
 1986 Pottery of the Chalcolithic/Early Bronze
 Transition. In Excavations at Kissonerga-Mos-
 philia 1985, by Edgar J. Peltenburg *et al.*
 RDAC, 37-39.

Cesnola, L.P. di
 1877 *Cyprus: Its Ancient Cities, Tombs and
 Temples.* London.
 1885-1903
 *Descriptive Atlas of the Cesnola Collection of
 Cypriote Antiquities in the Metropolitan
 Museum of Art, New York, Vols I-III.* Boston.

Furumark, Arne
 1944 The Mycenaean IIIC Pottery and its Relations
 to Cypriot Fabrics. *OpArch* 3, 232-265.

Gjerstad, Einar
 1926 *Studies on Prehistoric Cyprus.* Uppsala.
 1944 **The Initial Date of the Cypriot Iron Age.**
 OpArch **3**, 73-106.

Karageorghis, Vassos
 1965 *Nouveaux documents pour l'étude du Bronze
 Récent á Chypre.* Paris.

Kling, Barbara
 1986 Pottery Classification and Relative Chronol-
 ogy of the LC IIC-LC IIIA Periods. In *Western
 Cyprus: Connections,* edited by David W.
 Rupp, 97-113. Archaeological Symposium at
 Brock University, March 21-22, 1986. SIMA
 LXXVII. Göteborg.

Mellink, Machteld
 1991 Anatolian Contacts with Chalcolithic Cyprus.
 BASOR 282/283, 167-175.

Merrillees, Robert S.
 1978 *Introduction to the Bronze Age Archaeology of
 Cyprus.* SIMA Pocketbook IX, Göteborg.

Myres, John L. & Max Ohnefalsch-Richter
 1899 *A Catalogue of the Cyprus Museum with a
 Chronicle of Excavations Undertaken since the
 British Occupation and Introductory Notes on
 Cypriote Archaeology.* Oxford.

Sandwith, T.B.
 1877 On the Different Styles of Pottery Found in
 Ancient Tombs in the Island of Cyprus. *Ar-
 chaeologia* 45, 127-142.

Sjöqvist, Erik
 1940 *Problems of the Late Cypriot Bronze Age.*
 Stockholm.

J.D. Stewart
 1985 Ceramics. In *Lemba Archaeological Project I:
 Excavations at Lemba-Lakkous, 1976-1983,* by
 Edgar J. Peltenburg, 59-69, 154-160, and 249-
 270. Göteborg.

Toward A Definition of the Late Chalcolithic in Cyprus: The Monochrome Pottery Debate

Edgar Peltenburg

SPECIAL ABBREVIATIONS

BP	Black Polished pottery
BTW	Black Topped pottery
CPW	Coarse Painted ware
CW	Coarse ware
EChal	Early Chalcolithic period
GBW	Glossy Burnished Ware
LChal	Late Chalcolithic period
MChal	Middle Chalcolithic period
RB/B	Red and Black Stroke Burnished pottery
RBL	Red and Black Lustrous pottery
R&BP	Red and Black Polished pottery
R L	Red Lustrous pottery
RMP	Red Monochrome Painted pottery
R-on-R	Red-on-Red pottery
R P	Red Polished pottery
R S	Red Slip pottery
R W	Red-on-White pottery
SW	Spalled pottery
WP	White Painted pottery

The beginning of the Early Bronze Age is generally acknowledged to be one of the major watersheds of Cypriot history. Discussion has focused on the origins and role of the transitional Philia group in order to explain the profound changes that took place then in Cyprus. The vexed "Philia question" has been examined in terms of the group's relations with Anatolia and other Early Bronze Age assemblages, rarely in terms of preceding populations on the island. When this is attempted, firm conclusions are hard to come by.

Pottery figures prominently in these discussions. Thus Hennessy (1973, 3-4), following Stewart's references to derivation from "a common stock" (*SCE* IV Pt.1A, 296), suggests that the "disjointed" Chalcolithic record provides forerunners for Philia pottery. The parallels prove to be no more than very general morphological features and monochrome finishes. Where required, as in the case of WP pottery, painted RW forerunners are invoked with equal disregard for what we now realize is a lengthy and complex Chalcolithic record (*SCE* IV Pt.1A, 230, 269; see Bolger 1983, 71-72 for some of the problems). Dikaios on the contrary, having inferred that the native population was weakened when "the Khirbet Kerak ware movement invades Cyprus," suggested that "little of the traditional culture survived" after the start of his initial stage of the Early Cypriot (= Philia group; *SCE* IV Pt.1A, 202). He and others (e.g., Catling 1971, 812) stressed the new characteristics of the intrusive Philia pottery, calling attention to the novelty of Philia broad flat bases which are in fact neither so broad nor, as is evident in the much expanded LChal evidence now at our disposal, so novel (see also below, p. 16). Unlike Dikaios, most observers (Stanley Price 1979, 21-22; Karageorghis 1982, 41; Knapp 1990; see also p. 16), adopt a coexistence model in which the two pottery traditions overlap, and from this they infer important developments. The most explicit interpretation is that of Gjerstad who infers a population symbiosis (Gjerstad 1980). He thus designates pottery as an ethnic equivalent instead of a cultural marker or fashion. Herscher assumes that the Chalcolithic lasted to the end of the Early Cypriot II (Herscher 1980, 18).

These conclusions are based on diachronic arguments or on the argument that native (Chalcolithic) and foreign (Philia) pottery types coexisted. At Ambelikou-*Ayios Georghios* both types are monochrome, whereas at Sotira-*Kaminoudhia* Swiny reports an association of some Chalcolithic monochrome and especially RW with Bronze Age monochromes (Swiny 1986). Swiny's is perhaps the most comprehensive evaluation of relations between the Chalcolithic and the Philia phenomenon, but it is weakened by lumping together Chalcolithic

TABLE 1.1

Radiocarbon Dates for Late Chalcolithic Cyprus

Period	Code	Context	Years BP	Years BC*
LEMBA-*LAKKOUS*				
3	BM-1353	Building 2.2	3890±50	2204-2560
	BM-1354	Building 2.2 Feature 17	3970±45	2397-2588
	BM-1541	Square L34a.2 Feature 2	4000±45	2458-2854
	BM-1541A	Square L34a.2 Feature 2	4050±50	2470-2868
	BM-1542	Building 7.3 Feature 1 +14	4090±90	2460-2910
KISSONERGA-*MOSPHILIA*				
4	GU-2157	Building 3 Unit 384	3900±50	2208-2565
	BM-2279	Building 3	4030±110	2280-2900
	BM-2279R	Building 3	4180±130	2460-3094
	GU-2155	Building 3 Found Trench	4250±170	2460-3360
	BM-2529	Building 3 Unit 461	4160±50	2590-2910
	BM-2530	Building 3 Unit 384	3960±80	2208-2860
	BM-2527	Building 493 Unit 478	4130±50	2509-2889

*Calibration from Pearson & Stuiver 1986, minimum and maximum age ranges at 2 sigma

material spread over a millennium and by the use of the settlement at Sotira-*Kaminoudhia* as a Philia benchmark (see below p. 16).

As the above highly selective survey of the literature demonstrates, the relationship of Philia with existing cultures in Cyprus is riddled with methodological confusion. It is thus understandable in such a climate of uncertainty why Catling felt compelled to suggest that "it [the LChal] contains the real beginnings of the Early Bronze Age" (Catling 1971, 808). The purpose of this paper is to provide an initial assessment of ceramics that prevailed in several regions of Cyprus during the LChal prior to the advent of RP (Philia) ware in these regions and hence to establish a firmer foundation to explain the

transformations that characterize the start of the Early Bronze Age.

The term usually employed for this period, Chalcolithic II, was introduced by Dikaios in order to incorporate the evidence from Ambelikou-*Ayios Georghios* between that of Erimi and the Bronze Age proper (*SCE* IV Pt.1A, 188-189). Because so much recently discovered data cannot easily be accommodated by Dikaios' rigid I-II scheme, the term LChal is used here (see Peltenburg 1990, 16-19 for some of its features). Much of that data comes from work of the Lemba Archaeological Project in the west. Period 4 of one of its sites, Kissonerga-*Mosphilia*, immediately precedes levels with RP (Philia). It has radiocarbon dates which are statistically inseparable

from those of Lemba Period 3 (Table 1.1) and indeed the contemporary ceramic profiles from both are virtually identical. These profiles are characterized by varieties of monochrome finishes and fabrics (Peltenburg 1987, 58-59). They belong to the mid-third millennium BC, several centuries later than the pottery from the upper levels at Erimi which have high proportions of Close Line Style RW (Peltenburg 1982a, 68-69, 113). Since Kissonerga 4 and Lemba 3 are reoccupations with, apparently, fully formed new ceramic traditions, the inception of these occupation levels should lie some time in the hiatus between Erimi and Kissonerga/Lemba dates. This hiatus could even be greater than indicated since most samples from the latter sites were obtained from structural timbers. If the LChal began soon after the abandonment of Dikaios' Erimi, it is likely to have lasted from *ca.* 2800 to 2300 BC, much longer than the oft-quoted 200 years for the Chalcolithic II.

In seeking to relate this western pre-Philia evidence to other parts of the island, pottery proves to be the principal guide, as in so many other studies of regional connections. The most comparable ceramic assemblages appear to be those from sites around Kalavasos and especially at Ambelikou (areas termed *the east* here), but published descriptions and nomenclature so ill-suited our recovered sherdage that we established an independent terminology in the west. Consequently, we have a plethora of discordant terms and we urgently require a methodology that allows us to discern, characterize and interpret the similarities that may exist. In order to generate such an approach, we should first consider in more detail the basis of the classification systems currently in use.

Dikaios' Erimi excavations in 1933-1935 were conducted under the spell of the Swedes' monumental work on Cyprus. During the 1920s and 1930s, Gjerstad and his colleagues were treating masses of provenanced vessels in a Montelian system designed to order sites chronologically. Dikaios uncritically adopted the means and goals of this nineteenth-century evolutionary classification system even though his concentration on early settlements meant that he had to deal with sherds, rather than whole vessels, produced within different social and technological parameters. Thus, he divided the material into value laden "ware" categories which were ideally regarded as bounded, mutually exclusive entities comprising three parts: fabric, finish and shape (Dikaios 1936, 26-40). Such entities could be readily comprehended and they provided easily manipulated tools for ordering sites according to the relative proportion of each ware. While acknowledging occasional shape and fabric overlaps between the wares, he failed to confront the critical issue of variability in the use of local materials, local production traditions and local styles. His approach implicitly pre-empted an investigation

into the possibility that style, for example, could have been used to communicate messages (cf. Wobst 1977) and, as was subsequently shown for the late Neolithic, evinced marked regional variation (Peltenburg 1978).

Dikaios' descriptions of monochrome pottery from Erimi, Kalavasos, Ambelikou and other sites in his 1962 synthesis reveal a lack of clear breaks between wares (especially monochromes) and an inconsistent application of his own criteria. For example, bowls with fabrics identical with RL become RBL ware if they are blackened on the inside or outside (*SCE* IV Pt.1A, 143, 152-153). As most Ambelikou bowls are so fired, the distinction between RL and RBL simply refers to surface treatment. The separation of BP ware is equally misguided since its only distinguishing feature is a gray surface (*SCE* IV Pt.1A, 144). This may be due to firing conditions or even use/post-depositional agencies. Confusion between RS and RW sherds is also possible since an entirely monochrome red surface could represent the monotone part of a motif. While varying fabrics are found at these sites, present ware classes mix paste types and there seems to be no exclusive correlation between fabrics, shapes and finishes. Bolger provides other examples of the unsuitability of Dikaios' typological treatment of Chalcolithic pottery and she ascribes the resulting discrepancies to the greater latitude potters had in fashioning handmade vessels (Bolger 1985, 23).

From the outset, Dikaios himself admitted that he had difficulty in distinguishing between wares (Dikaios 1936, 38), and initially he classified many sherds at Erimi and Ambelikou as RP. Seizing upon this inconsistency, Gjerstad (1980) reclassified the same Ambelikou pottery to argue a radically different case for the beginning of the Bronze Age (but ironically one which reverted to Dikaios' 1945 contention). Among the excavated Ambelikou sherds retained in the Cyprus Museum, he identified RP (Philia) and R&BP (Philia) together with RL already in the lowest spit of the 4.60 m. sounding. In virtually each succeeding spit, RP (Philia) is recorded along with greater numbers of RL, RBL and RW. This reappraisal is important because for the first time it provides evidence for a lengthy synchronization between wares that are often treated diachronically. (Associations between these pottery classes at Kyra-*Alonia* may not be long-lived and could be spurious: *SCE* IV Pt.1A, 152-155). In terms of ceramic classification systems, these conflicting assessments by two fathers of Cypriot prehistory emphasize the inherent weaknesses of the all-embracing "wares" taxonomy for early pottery production, one that has led to several incompatible interpretations of the Ambelikou data (Table 1.2).

Before the Bronze Age, ceramic production in Cyprus is marked by a great deal of fabric diversity and to a lesser degree by morphological heterogeneity. Fabric types often cut across shape or finish typologies. Potters' some-

TABLE 1.2

Ambelikou-*Ayios Georghios* Ceramics and their Status in Cypriot Prehistory

Author	Ceramics	Interpretation
Dikaios 1953, 322-323	Red Polished Red and Black	No Anatolian connection
SCE IV, Pt. 1A, 143-149	Red Lustrous Red and Black Lustrous Red Slip Black Polished	Native Cypriot, post-Erimi
SCE IV, Pt. 1A, 230	Chalcolithic Red Polished	Continuity with Philia
Stanley Price 1979, 21	Dark monochromes	EC traits
Gjerstad 1980	Red Lustrous Black Polished Philia Red Polished Philia Red and Black Lustrous Black Slip Red Slip Philia Red Polished IC, II, III White Painted IA	Natives & Anatolian refugees
Watkins 1981	Monochrome	Regional group, contemp. Erimi
Karageorghis 1982, 41	Chalcolithic II wares Philia wares	Natives & Anatolian refugees
Peltenburg 1982b, 58	As *SCE* IV, Pt. 1A, 143-149	Late Erimi context
Peltenburg 1987, 58-60	As *SCE* IV, Pt. 1A, 143-149	LChal
Bolger 1988, 131	As *SCE* IV, Pt. 1A, 143-149	Late Erimi

what empirical attitude to materials technology (also evident in chipped stone industries) is worthy of study in itself and it is no doubt partly due to localized production (a program of thin section analysis currently under way is beginning to substantiate this). Hence we should conclude that fabric is a poor guide to inter-site correlations, except of course for intrusive vessels transported over intermediate or long distances. Decoration within the prevalent monochrome tradition is effected by paints, slips, burnishing and fire control. Within local traditions these too are likely to fluctuate according to such factors as the skill of nonspecialist potters.

A significant feature of pre-Bronze Age pottery studies is that most of the material comes from settlement sites. We are thus comparing like with like and, more significantly, the material is largely utilitarian. In the Late Neolithic, fabric and finish have been shown to vary across the island, but shapes, designed mainly as functional containers to be used in domestic contexts, were relatively standardized (Peltenburg 1978). The latter, therefore, are likely to serve as optimal indicators of the contemporaneity of assemblages, providing change took place and did so at a rate that allows us to synchronize material within a span of some 500 years. Without independent chronometric controls, these temporal relations remain major assumptions since it is quite unlikely that change occurred at comparable rates throughout the island. Given these chronological uncertainties, fine tuning within that half millennium is not attempted here. It is suggested that Clarke's definition

(1968, 189-191) of artifacts as polythetic entities is ideally suited for the assessment of pre-Bronze Age ceramics and that for our purpose of establishing a first approximation of LChal inter-site contemporaneity we take morphology as the major constituent of the monochrome typology. In so doing we can take advantage of the increase of complete vessels that have recently become available for study and we follow an approach advocated by Stewart for RP in 1962 and implemented by Mac-Laurin in 1985. As Adams (1988) and others have advocated, we need an agenda of different classifications and typologies designed to address specific issues, and it is misguided to suggest that the rich variety of ceramics, at least in the west, is over-classified at present (Knapp 1988). To argue that clearly discordant morphologies be lumped together, as Stanley Price does in the case of RL/RP (1979, 22), is to deprive scholars of the means to assess the nature of relations between distinctive ceramic traditions. Only by isolating what clearly belongs to the LChal and to possible overlaps with the start of the EC, can we hope to determine the causes of change and variation that mark the transition to the Bronze Age.

Recent examination of the Ambelikou pottery housed in the Cyprus Museum along the lines proposed above failed to isolate any RP before the mixed 0.20-0.40 m. spit (Appendix). The pottery includes sherds identified by Gjerstad as RP (Philia) or R&BP (Philia) as well as RP IC, II, III and WP IA. General and specific reasons are given in the Appendix for refuting these identifications. Since no alleged RP (Philia) withstands close scrutiny and, as Bolger notes (1988, 129-130), morphological traditions are entirely within the Chalcolithic repertoire, it is reasonable to conclude that Ambelikou-*Ayios Georghios* belongs exclusively to the Late Erimi cultural tradition.

Representative shapes of this homogeneous assemblage are shown diagrammatically in the second and third columns of Figure 1.1, together with similar monochrome shapes from other sites excavated by Dikaios. These are located in the Ovgos and Vasilikos Valleys which lie to the northeast and southeast of the Troodos Mountains respectively. Although the evidence from Erimi has been omitted from the diagram, it should be noted that some of the shapes (e.g., Fig. 1.1: 28) occur in the monochrome class at that site too.

If we now turn to a consideration of Chalcolithic monochromes in the west of the island, an equally varied range exists: Glossy Burnished, Red Monochrome Painted, Black Topped, Coarse Painted Monochrome, Spalled, Red Lustrous and Red and Black Stroke Burnished (Peltenburg *et al.* 1985, 261-262; Bolger 1986; Peltenburg 1987). Of these, only RB/B, is exclusive to the LChal and only RB/B has a broad spectrum of forms in common with eastern sites (Fig. 1.1, left column). There are analogous shapes in other western monochromes

(Fig. 1.1: 22), but the example depicted also belongs to the LChal as defined above.

According to our argument, this form sharing among wares is to be expected. While there will have been some local shape and finish preferences, Figure 1.1 demonstrates that in spite of mutually exclusive terminologies currently in use, there is an irrefutable basic morphological unity between east and west. Regionally and locally based potters created the same shapes and showed identical preferences for low relief modeling (Fig. 1.1: 14-17), deliberate interplay of red and black surface treatments and increasingly thin walls. The last quality is most evident in the large numbers of fine, small bowls (Fig. 1.1: 1-5, 28, 29; Fig. 1.2), many with slightly everted rims and convex or broad flat bases, which now characterize assemblages. Similarities extend to large scale vessels, including pithoi (Fig. 1.1: 8-13) that unlike several other forms, are mostly distinct from MChal versions. The few examples of earlier relief decoration (Peltenburg *et al.* 1985, pl. 33: 10; Bolger 1988, 68-69) now become much more popular, even if confined to linear motifs. Particularly close analogies are afforded by the pairs of bars set vertically below bowl rims at Lemba and Kalavasos B (Fig. 1.1: 15; Fig. 1.3) and by the recurrence of circular bosses in the west and on sherds from Ambelikou and Kalavasos-*Pamboules*. These bosses may prove to be a regional phenomenon since the latter consist of what macroscopically looks like RB/B, a highly distinctive fabric/finish correlation, common in the west where, according to preliminary results of thin section analyses, it is likely to have been made from Mavrokolymbos or Marathounda resources. Its rarity outside the Paphos District, at Sotira-*Kaminoudhia* (Swiny 1985, 120), Erimi-*Pamboula*(?) (Heywood *et al.* 1981, 37) and Kalavasos-*Archangelos* and *Pamboules* suggests copies or regional exports; analysis would be desirable.

The mid-third-millennium date for this monochrome family is fixed only in the west (Table 1.1). We have seen that some of the shapes occur already at Erimi which has much earlier C14 dates; hence the beginning of some shapes extends back into the fourth millennium BC. It is not possible to calculate how early specific shapes were developed since recording and retrieval methods at deeply stratified Erimi were not refined enough. A bowl similar to Figure 1.1: 28 was found in Hut IXA (Dikaios 1936, pl. XXVI: 483, R-on-R and not RS as in *SCE* IV Pt.1A, 119, fig. 58: 3). Another from Hut XIIIB (Bolger 1988, fig. 5: 191) shows the persistence of monochromes to the end of the Erimi sequence (cf. also Dikaios 1936, pl. XXVI: 16, 20 from the same late hut). Since there is no discernible sharp division between MChal and LChal, and pottery is not the only criterion by which periods are divided, unlike the case for later periods in Cyprus (see Sherratt, this

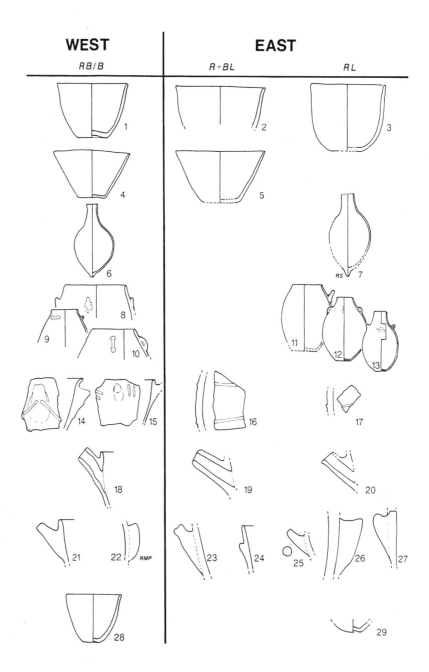

Figure 1.1 Morphological comparison of monochrome Late Chalcolithic pottery from the West (Paphos District) and the East (Nicosia, Larnaca and Limassol Districts):

1) Lemba Period 3 (Peltenburg et al. 1985, fig. 57: 1); 2-3) Ambelikou-Ayios Georghios (SCE IV Pt.1A, 145, fig. 68); 4) Lemba Period 3 (Peltenburg et al. 1985, fig. 56: 2); 5) Kyra-Alonia (SCE IV Pt.1A, 154, fig. 72: 5); 6) Lemba Period 3 (Peltenburg et al. 1985, 15, top right); 7) Kalavasos B (SCE IV Pt.1A, 137, fig. 64: 4+42); 8) Kissonerga-Mosphilia sherd no. 490; 9-10) Kissonerga-Mosphilia, nos. 1946, 2020; 11-13) Kalavasos B (SCE IV Pt.1A, 137, fig. 64: 1-3); 14) Kissonerga-Mosphilia sherd no. 211; 15) Lemba (Peltenburg et al. 1985, fig. 62: 1); 16-17) Ambelikou-Ayios Georghios (SCE IV Pt.1A, 145, fig. 68); 18) Kissonerga-Mosphilia sherd no. 113; 19-20) Ambelikou-Ayios Georghios (SCE IV Pt.1A, 145, fig. 68); 21) Kissonerga-Mosphilia sherd no. 147; 22) Lemba (Peltenburg et al. 1985, fig. 51: 2); 23-24) Ambelikou-Ayios Georghios (SCE IV Pt.1A, 145, fig. 68); 25-27) Ambelikou-Ayios Georghios and Kalavasos B (SCE IV Pt.1A, 137, fig. 64; 145, fig. 68); 28) Lemba Period 3 (Peltenburg et al. 1985, fig. 55: 2); 29) Kyra-Alonia (SCE IV Pt.1A, 154, fig. 72: 4).

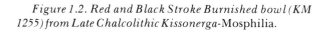

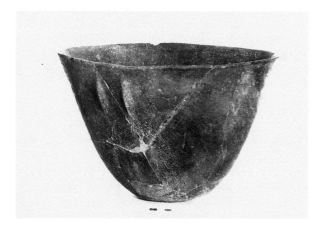

Figure 1.2. Red and Black Stroke Burnished bowl (KM 1255) from Late Chalcolithic Kissonerga-Mosphilia.

Figure 1.3. Red Lustrous bowl from Late Chalcolithic Kalavasos B. (Published by permission of the Director of the Department of Antiquities, Cyprus)

volume), the presence at Erimi of some shapes which become popular later is not surprising. They do, however, raise the important question of the degree of contemporary regional and site (Bolger 1989) variation. It is assumed here that the greater the congruence of a range of forms, the more likely assemblages are broadly contemporary. On this basis Lemba 3, Kissonerga 4, Ambelikou-*Ayios Georghios* and parts of Kalavasos B belong to the early to mid-third millennium BC. Such a chronological grouping affects existing assessments of this period.

Stanley Price was the first to suggest the evaporation of the LChal (his Chalcolithic II) because of the calibration of C14 dates and higher cross dates between Cyprus and Anatolia (1979, 21). He accepted such an inflated chronology for Philia-*Vasiliko* that it overlapped in time with part of Erimi. The implication of this reconstruction is that at least three clearly differentiated pottery traditions, painted RW, dark monochrome and RP (Philia), coexisted in Cyprus *ca.* 3000 BC. The difficulty with this is that the chronology of Philia, which lacks independent dating, is derived from crossdates with Tarsus, which also lacks C14 determinations. Since there are several schemes for dating Early Bronze II Tarsus, including its termination after 2500 BC (e.g., Yakar 1979), the case requires more supporting evidence to carry conviction. Stanley Price's correlations were made before the appearance of Lemba Archaeological Project dates. As he conceded subsequently, they render the opposing cyclical nature of the predominance of patterned/monochrome by region redundant (1979, 38, 47). But more than that, they undermine many of the argu-

ments for a *ca.* 3000 BC date for Philia and early third millennium for EC I.

Watkins (1981) hypothesizes that Ambelikou was contemporary with Erimi for two ceramic reasons (Table 1.2). First, both the evolution of pottery classes at Erimi, from monochrome toward increasing numbers of patterned, and the systematic differences between shapes at the two sites, he contends, are not to be explained diachronically. Ambelikou has mainly monochrome pottery and the evolution at Erimi should have been toward monochrome if the sites are consecutive. Second, monochrome and painted pottery sites have complementary distribution patterns in the North. These are strong arguments which, however, were also made before the publication of the dated Lemba 3 pottery.

I have attempted to deal with the second, spatial argument, by pointing to the occurrence of sites with good quality Close Line Style RW within the northern monochrome area (Peltenburg 1987, 60). These instances suggest that there is sufficient evidence available to arrange sites diachronically within that zone.

Turning to pottery evolution at Erimi, in which there is an increasing RW trajectory, and its disjunction with Ambelikou, it should be noted that clearly stratified evidence for the RW-monochrome sequence exists at Lemba and Kissonerga-*Mosphilia*. We have seen that there are limited shape parallels between later fourth-millennium Erimi and Ambelikou. This fact could be used to argue limited contact between contemporary sites, or recurrence of long-lived shapes on sites of different periods. In support of the latter is the fact that, when viewed as a whole, virtually all Ambelikou morphological attributes are consistently found in mid-

third-millennium contexts in the west, and only a few selected ones at Erimi. Sequences are also the same, in that RP appears in the terminal levels of Ambelikou and in Kissonerga Period 5. To argue otherwise is to propose that a fourth millennium style spread to the west where it is found in a barely altered state over 500 years later. If there is no gap in the later stratigraphy of Ambelikou, then that style also persisted without discernible change in the east for the same length of time. Using the congruence guideline mentioned above, detailed similarities between monochromes of east and west (Fig. 1.1) suggest a largely synchronous mid-third-millennium BC phenomenon. I use the word *largely* because of the earlier third-millennium BC chronological gap in the west. While the impressive depth of stratigraphy at Ambelikou may well fill part of this gap, it is doubtful if it extends back to the MChal.

The above assessments, as well as that of Gjerstad, assume the contemporaneity of different pottery traditions, a synchronization which Swiny also proposes for some ceramics from the Sotira-*Kaminoudhia* settlement. There, in Phase I of Area A, Chalcolithic pottery is reportedly found in association with RP types recurring in Phase II. The Chalcolithic pottery in question is apparently closest to MChal Erimi upper levels (Swiny 1986, 31), though another report mentions RB/B (Swiny 1985, 120), a later ware suggestive of occupation within the LChal. The RB/B may be early within the LChal given the high proportions of RW. Complete RW vessels are unattested in LChal deposits in the west and it is possible that RW (though not patterned: cf. CPW) ceased to be produced in the LChal. Stewart's (*SCE* IV Pt.1A, 230, 269) contention that WP IA (Philia) shows continuity with Chalcolithic RW painted traditions is unconvincing because of significant differences in motifs, compositions, absence of slip and burnish, and vessel morphology. If it does represent a resurgence, then the links with the bygone tradition were probably through other media. The Chalcolithic sherdage at Sotira-*Kaminoudhia* may thus considerably antedate the beginning of its Bronze Age occupation. The assumption that this occupation belongs to the Philia group is based more on the evidence from a nearby cemetery than any in situ RP (Philia) in the settlement, a point confirmed by Hennessy and colleagues (1988, 41) who date the latter EC IIIB-MC I. In the absence of a firm date for the settlement (see Herscher, this volume for an EC III Black Topped bottle from Area A), let alone a clear idea of the character and associations of its Chalcolithic pottery, it would be premature to accept the synchronization of the latter with RP (Philia) and other types of pottery traditions at Sotira-*Kaminoudhia*.

There is thus little evidence to support the Ambelikou/Erimi synchronism or the presence of Philia components at the Ambelikou and Sotira-*Kaminoudhia*

settlements. It is probable, however, that a distinct ceramic tradition, Philia RP, emerged in discrete areas of Cyprus during the existence of Lemba Period 3 and Kissonerga Period 4 (Table 1.1). Ceramic indicators of coexistence include Black Slip and Combed at EB II Tarsus and in Cyprus, and distinctive RB/B flat based flasks and bowls with elongated tubular spouts (e.g., Peltenburg *et al.* 1985, fig 57: 2, pl. 35: 4, 5). They are late within Lemba Period 3 and they have the same attribute, the lengthy tubular spout, as typical RP (Philia) bowls (e.g., *SCE* IV Pt.1A, fig. 80: 1-4). Since this is a new development within RB/B, it may well have been prompted by coexisting RP (Philia) (see also Bolger 1983, 60, n.7). These morphological similarities presumably motivated Karageorghis (1976, 861, fig. 41), Hadjisavvas (1977, 224) and MacLaurin (1985, 84, fig. 14: 9) to ascribe one of the Lemba spouted flasks to RP, but its fabric is consistent with homogeneous RB/B fabrics. It is precisely ambivalent shapes such as this and, as Bolger demonstrates, a tendency toward hybridization (1986, 39), by which we shall be able to gauge the nature of changes that occurred in the transition between the two eras.

On the basis of C14 dates for the western LChal and reassessment of pottery from Ambelikou, the following conclusions are proposed:

1) The lack of "fit" between fabrics, shapes and finishes suggests that there are few canonical "wares" in the LChal. So far, only RB/B has been found to approach the status of a ware, which suggests the appearance of more standardized, and perhaps more centralized, production.

2) Morphological analysis shows that potters in the LChal shared a much more homogeneous tradition than is implied by the current diversity in "wares" nomenclature. This tradition has fewer links with EC pottery than with preceding MChal ceramics. Its cohesion points to the existence of an unsuspected cultural uniformity on the island in the early to mid-third millennium BC (cf. Bolger 1988, 129-130), but such speculation needs to be substantiated by other forms of evidence from the east. The Ambelikou curvilinear structure, which appears to echo curvilinear architecture at Lemba and Kissonerga, (*SCE* IV Pt.1A, 142, fig. 66) is hardly enough for this purpose, but it does not contradict the hypothesis. If this is accepted, it remains to be explained how such uniformity emerged in an island sharply divided by topography and to what extent the pottery defined interaction between communities.

3) This uniformity, together with western C14 dates, allows us to place several assemblages in the early to mid-third millennium BC. They include discrete deposits at Dikaios' Kalavasos B. This is normally considered an earlier site (e.g., *SCE* IV Pt.1A, 198-200), but occupation here is mixed and much is LChal. The single

earlier radiocarbon date is deceptive, since it comes from Pit VIII which contains Late Neolithic pottery.

4) Shapes, especially the popular bowls, tend to much thinner walls in the LChal than in previous periods.

5) Eastern areas evince a preference for strong monotone finishes, and sharply defined blacks and reds on interiors and exteriors are particularly popular in the Morphou Bay area.

6) Western monochrome finishes often have blacks and reds mixed on the same surface, burnish marks are much in evidence (Fig. 1.2) and, in the case of RMP, brushstrokes are frequently visible. These monochromes are readily differentiated from E/MChal

GBW and BTW which emphasize the long history of monochrome traditions within the Chalcolithic.

7) Dikaios' conventional monochrome "wares" terminology essentially describes finishes, and even then it needs further refinement.

8) One can see both similarities and differences between the LChal and Philia pottery traditions. This is no longer remarkable given probable synchronisms between Lemba 3/Kissonerga 4 and Philia. The differences, however, are wide-ranging and, since in the west occurrences of RP (Philia) are accompanied by settlement destruction and abandonments, explanations for interaction between the two style zones are unlikely to come from the study of pottery alone.

APPENDIX: AMBELIKOU-*AYIOS GEORGHIOS* MONOCHROME POTTERY

A number of scholars believe that RP (Philia) pottery was recovered from Ambelikou-*Ayios Georghios* and, as stated above, this has significant implications for the start of the Bronze Age in Cyprus (Table 1.2). Gjerstad (1980), following Dikaios' (1945) initial assessment, has made the most detailed case for its identification already in the lowest spit of the 4.60 m. sounding. It is not entirely clear how he distinguished RP sherds from the other monochromes, but he did call attention to differences in shape (1980, 9) and it is noticeable that in his catalogue of selected sherds, RP (Philia) and R&BP (Philia) are largely comprised of jugs with flat bases, milk bowls with tubular spouts and bowls with plain rims. Shape may thus have been a major determining criterion, but not invariably so: he also ascribed milk bowls to RL, for example. Missing from these alleged RP Ambelikou sherds, however, are precisely those robust elements such as cut-away spouts and rod handles which are regarded as diagnostic of RP (Philia).

It should be emphasized that flat based jugs, milk bowls and plain rimmed bowls are not exclusive to RP (Philia). Flat based jugs may not be very common earlier (cf. Peltenburg *et al.* 1985, figs. 57: 2, 58: 10), but the basal sherds from which he posits jug shapes are so small that such an ascription must be regarded as tenuous. Many undoubtedly belong to popular LChal flat based bowls (Fig. 1.1: 4); it is not always self-evident from worn monochrome basal sherds if they come from open or closed shapes. When Gjerstad conceded that so-called milk bowls also occur in Chalcolithic wares, he lowered them in date to bring them into line with the appearance of RP exemplars. To achieve this he mentioned in pass-

ing that Philia ware was found at Erimi and Kalavasos B, an observation that is entirely unsubstantiated. In any case, milk bowls, that is bowls with tubular spouts, have a much longer pedigree in Cyprus and were already known in the Late Neolithic (e.g., *SCE* IV Pt.1A, 87-88, figs. 43: 1, 44: 7). There is thus no morphological reason why tubular spouts at Ambelikou have to be regarded as RP Philia. Finally, with regard to the bowls with plain rims, one need only scan the illustrations of *SCE* IV.1A or Peltenburg and colleagues (1985) to see how dominant these are within the native Chalcolithic repertoire. Again, there is no inherent reason why monochrome sherds of this type at Ambelikou should be ascribed to RP (Philia).

Gjerstad also referred to individual morphological features to identify fragments as RP (Philia). Examination of the Ambelikou material leads me to believe either that these features belong to acknowledged Chalcolithic types or that there is much room for doubt, due, for example, to the fragmentary condition of the piece. Where a decision could be made, it is listed for convenience in Table 1.3 together with proposed interpretations.

While not denying that the topmost spits contain isolated RP (Gjerstad 1980, pl. IV: 7b), the foregoing morphological considerations cast strong doubt on the existence of RP (Philia) in virtually all the Ambelikou sounding. It seems reasonable to conclude that there is little evidence to support the argument of a long-lived coexistence of radically new (his Anatolian types) and native pottery traditions at this site. The array of shapes is preferably regarded as a coherent Cypriot tradition

TABLE 1.3

Interpretation of Selected Morphological Features of Ambelikou Sherds Identified by
Gjerstad as RP or R&BP Philia

"RP" Feature Named by Gjerstad	Gjerstad 1980	Proposed Interpretation
Ear-lug	pl. II.1b	No protrusion now
Bottle mouth	pl. II.4a	cf. Peltenberg et al. 1985, fig. 45: 3 (LChal)
Flat base jug	pl. III.5c	Concave base
Tubular spout	pl. III.6c	Fig. 1.1: 18-20 (RP spouts are longer) (LChal)
Beaker	pl. III.7a	Hole mouth jar, Fig. 1.1: 8-13 (LChal)
Bottle neck	pl. III.7c	Fig. 1.1: 6-7 (LChal)
Concave base	pl. IV.1d	Fig. 1.1:28-29 (only flat bases in RP)
Horn lug	pl. IV.1c	Frag. spout edge
Amphora	pl. IV.2a	Hole mouth jar, Fig. 1.1: 8-13 (LChal)
Shaft handle	pl. IV.3d	Horn lug, Fig. 1.1: 21, 23, 25 (LChal)
Basin	pl. IV.3b	Hole mouth jar, Fig. 1.1: 8-13 (LChal)
String hole	pl. IV.5d	Boss cf. Peltenberg et al. 1985, fig. 57: 2 (LChal)

with many links to earlier styles. There is little evidence for an evolution, perhaps because of the limited sample size. Representative shapes of this homogeneous style are shown diagrammatically in the second and third columns of Figure 1.1, together with similar monochrome pottery from other sites excavated by Dikaios.

Acknowledgments

I am grateful to the Director of the Department of Antiquities, Cyprus, Mr. A. Papageorghiou and to the past Director, Dr. V. Karageorghis, for permission to study sherd material from Dikaios' excavations at Ambelikou-*Ayios Georghios* and to Dr. I.A. Todd for permission to mention here Vasilikos Valley Project material kindly made available for study by Alison South. Dr. A. Robertson carried out thin section analyses; Dr. G. Cook gave generously of his time in respect of C14 dates; and Gordon Thomas drew Figure 1.1. The British Academy assisted with a grant to enable me to attend the conference. Diane Bolger and Louise Maguire obligingly read over an earlier version of this paper, but I remain responsible for the opinions expressed here.

REFERENCES

Adams, William Y.
1988 Archaeological Classification: Theory Versus
Practice. *Antiquity* 62, 40-56.

Bolger, Diane
1983 Khrysiliou-*Ammos*, Nicosia-*Ayia Paraskevi*
and the Philia Culture of Cyprus. *RDAC*, 60-
73.

1985 From Typology to Ethnology: Techniques of
the Erimi Potters. *RDAC*, 22-36.

1986 Pottery of the Chalcolithic/Early Bronze
Transition. In Excavations at Kissonerga-*Mos-
philia* 1985, by Edgar J. Peltenburg *et al.*
RDAC, 37-39.

1988 *Erimi*-Pamboula. *A Chalcolithic Settlement in
Cyprus.* BAR International Series 443. Oxford.

1989 Regionalism, Cultural Variation and the Cul-
ture-area Concept in Later Prehistoric Cypriot
Studies. In *Early Society in Cyprus*, edited by
Edgar J. Peltenburg, pp. 142-159. Edinburgh.

Catling, Hector
1971 Cyprus in the Early Bronze Age, *CAH* Vol. I Pt.
2B, 808-823. Cambridge.

Clarke, David L.
1968 *Analytical Archaeology.* London.

Dikaios, Porphyrios
1936 The Excavations at Erimi, 1933-1935. *RDAC*,
1-81.

1945 Archaeology in Cyprus, 1939-45. *JHS* 65, 104.

1953 *Khirokitia.* Oxford.

Gjerstad, Einar
1980 The Origin and Chronology of the Early
Bronze Age in Cyprus. *RDAC*, 1-16.

Hadjisavvas, Sophocles
1977 The Archaeological Survey of Paphos. A
Preliminary Report. *RDAC*, 222-231.

Hennessy, J. Basil
1973 Cyprus in the Early Bronze Age. *Australian
Journal of Archaeology* 1, 1-9.

Hennessy, J. Basil, Kathryn O. Eriksson & Ina C.
Kehrberg
1988 *Ayia Paraskevi and Vasilia. The Excavations of
J.R.B. Stewart.* SIMA LXXXII. Göteborg.

Herscher, Ellen
1980 Southern Cyprus and the Disappearing Early
Bronze Age. *RDAC*, 7-21.

Heywood, H., Stuart Swiny, D. Whittingham & P. Croft
1981 Erimi Revisited. *RDAC*, 24-42.

Karageorghis, Vassos
1976 Chronique des fouilles et découvertes
archéologiques à Chypre en 1975. *BCH* 100,
839-906.

1982 *Cyprus from the Stone Age to the Romans.*
London.

Knapp, A. Bernard
1988 Out West in the Eastern Mediterranean
(Review) *Quarterly Review of Archaeology* 9.3,
11.

1990 Production, Location, Integration: On the
Way Up in Bronze Age Cyprus. *Current
Anthropology* 31, 147-162.

MacLaurin, Lucy
1985 Shape and Fabric in Cypriote Red Polished
Pottery. In *Acts 1985*, 73-107.

Pearson, G. & Stuiver, M.
1986 High-Precision Calibration of the Radiocar-
bon Time Scale, 500-2500 B.C. *Radiocarbon*
28.2B, 839-862.

Peltenburg, Edgar
1978 The Sotira Culture: Regional Diversity and
Cultural Unity in Late Neolithic Cyprus.
Levant X, 55-74.

1982a *Recent Developments in the Later Prehistory
of Cyprus.* SIMA Pocket-book 16. Göteborg.

1982b Early Copperwork in Cyprus and the Exploita-
tion of Picrolite: Evidence from the Lemba Ar-
chaeological Project. In *Early Metallurgy in
Cyprus, 4000-500 BC*, edited by J.D. Muhly,
Robert Maddin & Vassos Karageorghis, pp. 41-
62. Nicosia.

1987 A Late Prehistoric Pottery Sequence for
Western Cyprus. In *Western Cyprus Connec-
tions*, edited by David W. Rupp, pp. 53-67.
SIMA LXXVII. Göteborg.

1990 Chalcolithic Cyprus. In *Cyprus Before the
Bronze Age*, pp. 5-22. The J. Paul Getty
Museum, Malibu.

Peltenburg, Edgar J. *et al.*
1985 *Lemba Archaeological Project I: Excavations
at Lemba-Lakkous, 1976-1983.* SIMA LXX:1.
Göteborg.

Stanley Price, N. P.
1979 *Early Prehistoric Settlement in Cyprus 6500-
3000 B.C.* BAR International Series 65. Oxford.

Swiny, Stuart
1985 Sotira-*Kaminoudhia* and the Chal-
colithic/Early Bronze Age Transition in

Cyprus. In *Archaeology in Cyprus 1960-1985*, edited by Vassos Karageorghis, pp. 115-124. Nicosia.

1986 The Philia Culture and its Foreign Relations. In *Acts* 1986, 29-44.

Watkins, Trevor
1981 The Chalcolithic Period in Cyprus: The Background to Current Research. *British Museum Occasional Paper* 26, 9-20. London.

Wobst, M.
1977 Stylistic Behavior and Information Exchange. In *For the Director: Research Essays in Honor of J. B. Griffin*, edited by C. Cleland, pp. 317-342. Ann Arbor.

Yakar, Jak
1979 Troy and Anatolian Early Bronze Age Chronology. *AnatSt* XXIX, 51-68.

Independent Variables? A Flexible Classification of Late Neolithic and Chalcolithic Pottery

Douglas Baird

Many aspects of ceramics can be classified; in the final analysis any classification derives its value from its ability to answer questions about the relationships between separate entities, from sherds to whole assemblages. A classification can be related to a specific question, for example, the organization of decoration on vessels (Frankel 1974), or the generic sorts of clay bodies whichwere used for different vessels or assemblages (Barlow & Idziak 1989). For the Late Neolithic and Chalcolithic periods we face the problem of trying to understand and relate whole assemblages, mainly of sherds, from settlement sites. Descriptive classifications must therefore differ from the problem oriented, analytical classifications first mentioned. A descriptive classification may aim to deduce the structural order underlying an assemblage and give as clear a picture as possible of the relationships between entities making up an assemblage, in order that assessment of the nature of relationships or future analytical reclassification may be carried out to maximum effect. The end of such analysis, of course, is the clearest possible understanding of past behavior. A conventional way to carry out such descriptive analysis in the past was to determine, on the basis of preliminary analysis of material from the site (Stewart 1978) or by the use of categories from other sites, a limited number of analytical categories, to which all, or almost all, material could be assigned. Such normative categories were theoretically polythetic and thereby involved a specific combination of traits (fabric, surface finish, shape and decoration) and were thereby described as wares (Bolger 1985, 23; Dikaios 1961, 172; Stewart 1978, 9). Assemblages were then characterized quantitively by indicating the varying proportions of categories present (Peltenburg 1985, 12-14). The primary assumption underlying this system was that such normative categories existed as a function of some relationship with a prehistoric reality, and could be systematically employed. Even if such normative and exclusive categories exist in assemblages, a more empirical approach is advocated and demonstrated here, one which avoids the need for such assumptions at all.

Ceramic entities, vessels or more usually sherds, can be broken down into separate attributes such as fabric, finish, surface treatment, decoration and shape. Some of these attributes can be broken down further into separate components. For example, fabric—a macroscopically identifiable, normative and polythetic entity defined by specific, shared attributes of oxidization/reduction characteristics, color, texture and character of inclusions—can be more precisely characterized according to elemental or petrographic composition and thus be subdivided according to the clay(s) of which it is composed. A multivariate description of each ceramic entity, vessel or sherd, allows us to assess the existence of normative categories and, where these do not exist, to assess the patterns of interaction among the separate variables.

At Kalavasos-*Ayious* (Baird forthcoming a) and Kalavasos-*Tenta* (Baird forthcoming b) normative wares exist but other parts of the assemblage cannot be similarly divided. A study indicating the degrees of the concurrence of particular variables can enhance interassemblage comparisons by allowing us to isolate some of the most significant areas of interaction (e.g., differing types of combinations of fabric, finish, shape and decoration); this may be more useful than mere comparison of the proportions of different normative categories. A multivariate approach will therefore provide a better measure of the degrees of similarity or difference between whole assemblages. In the final analysis it is hoped that this approach will clarify the factors underlying the covariation of traits and will take us closer to the prehistoric potter/painter by isolating technical from cognitive associations. It is suggested that complex factors (such as the perceived needs of pot-

ters/users, access to raw material, the scheduling of procurement and production stages, and functional requirements) control the character of the relationships between fabric, finish, shape and decoration.

In the past, in the analysis of Late Neolithic and Chalcolithic assemblages, decorative modes, (that is, whether the surfaces of both open and closed vessels or sherds were completely covered in paint; completely lacked paint; had a painted pattern; or were combed, etc.) have been correlated with dominant or particular fabrics (Dikaios 1961, 172; Stanley Price 1979, 25). Thus "wares," not even in the traditional polythetic sense, have been described, (set out now in an order corresponding to that which I have just listed for decorative modes), as 1) Red Lustrous, Red Slip, Red Monochrome Painted, Glossy Burnished Ware, 2) Plain White, 3) Red-on-White, etc. At Kalavasos-*Ayious*, comparable sherds are described respectively as 1) Monochrome Red, 2) Monochrome White and 3) Red-on-White. At *Ayious* these are not, however, regarded as normative categories at the head of a hierarchy of classification as they have been elsewhere.

It seems appropriate to preface detailed discussion of variability in the *Ayious* ceramic assemblages with an outline of the circumstances of the division of this material into three stratigraphically separate groups. On the basis of an analysis by excavational context, three groups of ceramics could be isolated. These were distinguished by presence/absence of a range of ceramic traits and by variability in the character of decoration. Ayious 1a and 1b were primarily separated from each other on basis of decorative variables; Ayious 2 was differentiated from Ayious 1a and 1b by presence/absence criteria as well. Each group was found in sets of discrete pits. A large scoop or hollow containing Ayious 2 ceramics cut or overlay three pits with Ayious 1a ceramics (Baird forthcoming a). In another setting, some elements of Ayious 2 ceramics occurred in the later part of a sequence of contexts preceded by Ayious 1b ceramics. The size of the parent sample from which the percentages characterizing the presence of certain features in each group were calculated is, of course, significant. In Ayious 1a, 3128 sherds provided the parent sample, in Ayious 1b, 4596 and in Ayious 2, 13,909. These figures exclude the desurfaced sherds from each group; in the case of certain variables such as specific shape categories, only the most diagnostic proportion of this parent sample was relevant.

At *Ayious*, there are three subdivisions in the "coarse ware" component of the assemblages, which are distinguished by very specific, exclusive combinations of fabric, inclusions, surface treatment, slip and paint application and functionally oriented morphological characteristics. These three subdivisions could be described as wares in a classical sense. They separate as a

group from "fine wares" because of the quantity, variety and size of their organic and inorganic inclusions, the limited degree of finishing and decoration of the vessels, and the firing conditions which resulted in poorly oxidized or deliberately reduced surfaces and vessel walls. These features, along with the character of fabric and inclusions, resulted in relatively friable products (Baird forthcoming a). For example, *Ayious* and *Tenta* Type A vessel wall surfaces were reduced, but the underside of the base, always constructed on a mat or chopped straw, was oxidized. Such distinctions suggested that Type A, at least, was fired separately from many other vessel types (Baird forthcoming a). Significant differences in shape existed as well. Type A vessels were vertical or outward leaning concave walled trays (Baird 1986, 24). Many, if not all, of these had U-shaped openings extending the full height of the vessel wall; 20% of all Type A base sherds were fragments of such openings. Types B (Fig. 2.1: 1) and C were hole mouth trays commonly, but not always, equipped with sturdy upturned lugs (Baird 1986). Each type had its own distinctive sort of flange encircling the exterior of its base. The degree of effort expended on finishing the surface, and the type of surface finish differ dramatically between the wares. In contrast to the others, Type C was always slipped. The appearance of this last type in significant numbers is one factor which distinguishes a later phase (Ayious 2) from an earlier phase (Ayious 1).

At other Late Neolithic and Chalcolithic sites such wares are discernible. At Late Neolithic and possibly Early Chalcolithic Ayios Epiktitos-*Vrysi* (Baird forthcoming a), a range of such distinctions are replicated, albeit in distinctive local fabrics. For example, a Coarse Ware tray with U-shaped drainage holes, thin flanged straw or mat impressed bases, and heavily tempered, poorly oxidized and crumbly fabrics is reported (Peltenburg 1982, 63-66). This vessel type clearly replicates *Ayious* Type A. A Buff Coarse Ware also occurs at *Vrysi* in a distinct, usually better oxidized fabric with finer finishes; small hole mouth jars and trays are typical shapes and their bases had a more restricted flange than on the Coarse Ware (Peltenburg 1982, 63-66). Similar distinctions also occur in the Late Neolithic at Dhali-*Agridhi* (Lehavy 1974) and at Philia-*Drakos* A, at least at Philia in local fabrics (personal observations, courtesy T. Watkins). At these sites so-called Coarse Ware replicates *Ayious* Type A and some of the so-called Dark-Faced-Burnished Ware *Ayious* Type B. At Early Chalcolithic Kissonerga-*Mylouthkia*, friable Coarse Ware trays with drainage holes (Peltenburg *et al.* 1980, fig. 1: 17) and horn-lugged hole mouth trays with limited flanges and areas of burnished paint (Peltenburg *et al.* 1980, fig. 1: 15) exactly replicate *Ayious* dichotomies.

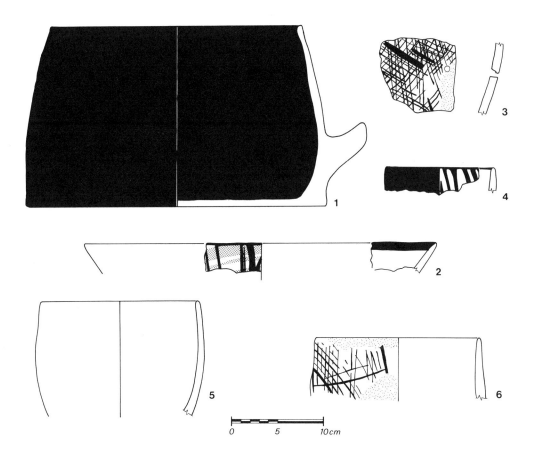

Figure 2.1: 1 Type B coarse ware (Ayious 1); 2 Open Red-On-White platter with curvilinear and bitonal exterior pattern (Ayious 2); 3 Multibrush lattice exterior, open sherd (Ayious 2); 4 Open Red-on-White hole mouth bowl (Ayious 1); 5 Open Monochrome White hole mouth bowl (Ayious 2); 6 Open Red-on-White multibrush lattice hole mouth bowl (Ayious 2).

The distinctiveness of these wares from each other and from the fine wares is probably to be attributed to the nature of their use; this is suggested because of their unique morphological characteristics. This exclusive combination of variables also marks them off from the fine wares. As I will demonstrate, the fine wares show only limited or partial relationships between fabric, finish (including slipping), shape and decoration.

Such sets of precise distinctions involving more than merely morphological or decorative parallels suggest modes of behavior relating to the production and use of vessels that were closely parallel in the north, south and west in the Late Neolithic and Early Chalcolithic. These and other ceramic features at *Ayious* suggest direct continuity between behavior in the Late Neolithic and Early Chalcolithic.

There are three fine ware fabrics at *Ayious* (Baird 1986, 20-21). Two of these receive virtually identical treatment or use. Slips hardly ever occur in earlier Ayious 1; their introduction on a wide scale in Ayious 2 is one of its distinguishing features. The same slip is applied to both fabrics only in a limited number of cases and only slightly more frequently to Fabric B, 11%, than A, 4.6% (Baird forthcoming a). We might be tempted to associate the slightly greater frequency of slips on Fabric B sherds with the fact that Fabric A is a light firing fabric, almost always oxidized, whereas Fabric B is dark firing and often poorly oxidized. The use of Fabric B with a slip for Red-on-White would thus enhance the decorative effect. That this is merely a tendency is indicated by the low proportion of Fabric B Red-on-White that is slipped. These fabrics are used for all decorative modes with and

without their occasional slips. All decorative composition types and motifs occur on both, and both occur in proportionate quantities in all open and closed shape categories. High burnishes are not more closely associated with one fabric than the other.

Only Fabric C seems to have been used as part of a set of particular associations. Thus it is almost always slipped, with slip occurring on 91.28% of Fabric C rims (Baird forthcoming a). It is used almost exclusively for open vessels, forming an average of 9.2% of Ayious 2 open sherds but an average of only 0.69% of the closed sherds. Disproportionate numbers of Fabric C occur in one specific shape category, hole mouth bowls (Fig. 2.1: 5, 6) which form only an average of 14% of the shape range in Ayious 2; in contrast, 29% of Fabric C rims fall into this shape category. As the above figures indicate, however, even these tendencies of association do not indicate an exclusive set of relationships between Fabric C and other variables.

One further constellation of attributes can be traced. This involves a lattice decoration built up of diagonally disposed, densely crisscrossed multibrush strokes (Baird 1986, 23). Sets of parallel strokes indicate a multiple tool (Fig. 2.1: 3, 6); the pigment is the same as that applied as paint on most other sherds. The swelling and thinning of individual strokes suggest the use of the brush (Fig. 2.1: 3, 6). Such a multibrush was in use elsewhere in Cyprus (Peltenburg 1982, 72) in an earlier setting. In this case, as with other Red-on-White, the paint takes a higher burnish than the adjacent slip. There is a strong correlation between motif and composition in this case, as the lattice was built up over most or all of the exterior of open vessels and was hardly ever used on interiors. This motif, like Fabric C and slips in general, occurs only in Ayious 2. It is part of a broad dichotomy between open and closed shapes (Baird forthcoming a) in that it was hardly ever employed on closed vessels. In this particular regard, the use of this motif parallels the occurrence of Fabric C which was also used only very rarely for closed vessels; it may then be especially significant that Fabric C occurs as much higher proportions of multibrush lattice sherds than of Ayious 2 sherds as a whole. Such tendencies of association do not define wares in the conventional sense. Multibrush lattice occurs on all fabrics, slipped and unslipped, with and without high burnishes. However, multibrush lattice sherds are slipped more frequently than sherds of Red-on-White in general, and indeed much higher proportions of Fabrics A and B with this motif are slipped than on average. Again we see a slight preference for slipping Fabric B over A. In addition, sherds with such compositions are highly burnished more frequently than Red-on-White, Fabric C or slipped sherds as whole. It seems likely that certain, but not necessarily all, of these correlates reflect a degree of cognitive association on the part of the pot-

ters/painters themselves. Thus, the greater frequency with which these vessels were burnished suggests pot decorators singled them out. Such factors might feed back on other correlates. For example, higher proportions of slips might relate to a greater propensity for the slips to produce high burnishes.

With the exception of the multibrush lattice, slips are not closely correlated with any level or class of decorations. There is a tendency in Ayious 2 for slips to occur somewhat more frequently in Red-on-White. On average, 25% of Ayious 2 Red-on-White open sherds are slipped, while approximately only ten percent of Monochrome Red and Monochrome White sherds are slipped. This may suggest that some vessels were completely Monochrome Red or indeed Monochrome White (Fig. 2.1: 5). One would expect the proportions of slipped Monochrome Red or Monochrome White to be closer to the proportions of slipped Red-on-White if Monochrome Red and Monochrome White sherds derived from the same vessels as Red-on-White sherds. A preference for slips on Red-on-White vessels is understandable, but here there is clearly only a slight tendency in this direction. The low proportion of slips among Red-on-White clearly indicates we cannot assume that only slipped monochrome sherds derive from Red-on-White vessels; those without slips might also. If the use of slips is chronologically varied and partially fabric-dependent, the significance of numbers of Monochrome Red sherds with slips will be different in different settings. Clearly their differing proportions will reflect both the proportions of Monochrome Red vessels and character of Red-on-White decoration. It is thus possible that similar proportions of decorative modes (formerly considered wares) at different sites or between periods may indicate quite dissimilar circumstances while similarities may be masked. Let us look at this phenomenon in relation to the development of decoration as we can document it through time at *Ayious*.

Three stratigraphically separate ceramic groups identified at *Ayious* had distinctly different proportions of Monochrome Red, Monochrome White and Red-on-White. Ayious 1a is characterized by the very high proportions of Red-on-White among open sherds, just over 70%. Among closed sherds in the same group, Red-on-White forms only 38%. It is very clear from well-preserved vessel portions and complete vessels that this latter figure merely reflects the propensity for a reserve style Red-on-White on large closed flasks and thus for extensive areas of red background field on such vessels (Fig. 2.2: 1). As a result, these two percentages may be a reflection of exactly the same proportion of Red-on-White vessels. Clearly, open and closed categories should not be treated together in this regard, as was unfortunately the case in the past (Dikaios 1961, 172-188; Peltenburg *et al.* 1985, 12-14), since averages may blur distinctions.

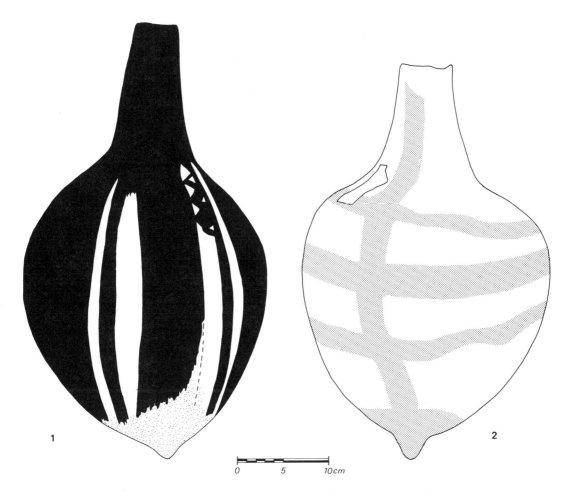

Figure 2.2: 1 Closed Red-on-White flask (Ayious 1); 2 Closed Red-on-White flask with smeary / washy paint (Ayious 2).

In Ayious 1b Monochrome Red is dominant among both open, 70%, and closed, 84%, sherds. The very high proportion of open Monochrome Red is likely to reflect the presence of some Monochrome Red vessels. Whether higher proportions of closed Monochrome Red may also reflect the presence of more Monochrome Red vessels than in Ayious 1a is questionable. Complete vessels from Ayious 1b contexts indicate very extensive red fields (Fig. 2.2: 1) and the proportions of Monochrome Red are only slightly higher than in Ayious 1a. In Ayious 2 contexts, Monochrome Red and Red-on-White open sherds vary from 20% to 60%, but Monochrome White, insignificant in Ayious 1, forms an average of 27% of open sherds. Among closed categories, Red-on-White averages 20%, Monochrome Red 65% and Monochrome White, previously insignificant, 14%. In the case of Monochrome White, well-preserved open and closed vessel portions suggest the existence of some Monochrome White vessels

(Fig. 2.1: 5), as do the similar proportions of open Monochrome White rims and body sherds. Perhaps most important though, as suggested by this and well-preserved vessel portions, is the presence of much expanded white fields on both open (Baird 1986, fig. 3: 1, 2) and closed vessels (Fig. 2.2: 2). The fact that Monochrome Red is 65% of Ayious 2 closed sherds, slightly greater proportions than for Ayious 1a, suggests that changes in the style of vessel decoration may have been much more dramatic on open shapes, further highlighting distinctions between open and closed vessels.

These figures, then, seem to reflect a generalized progression through time in attitudes to vessel decoration. Completely monochrome red exteriors were important on open vessels in Ayious 1 (Fig. 2.1: 4). There is a distinct decline in the preference for open vessel exteriors to be dominated by extensive areas of red paint from Ayious 1 into Ayious 2 (Fig. 2.1: 2). This trend must

be set beside the appearance of vessels with all over or extensive multibrush lattice covered exteriors (Fig. 2.1: 6). In Ayious 1, interiors are much more frequently decorated with fine line or complex patterns (Fig. 2.1: 4); in Ayious 2 such patterns are only slightly more frequent on interiors than on exteriors and this excludes the multibrush lattice, a composition for exteriors *par excellence*. There is a clear decline in the proportion of decorated Red-on-White interiors from Ayious 1 to 2, from 50% in the former, to 25% in the latter. Taking into account the evidence of expanded monochrome white fields on both exterior and interior, we can suggest a shift in importance of the area of active decoration of Red-on-White from the interior to the exterior of open vessels.

Moreover, in Ayious 1 reserve patterns are more prevalent than positive patterns on exteriors, but positive patterns are more important than reserve on interiors. In Ayious 2, positive patterns remain more common on interiors but there is no clear pattern of dominance on exteriors. Along with such changes as the major appearance of lattices in Ayious 2, we may observe the advent of curvilinear patterns and smeary/washy paint effects. These are often combined to produce, for the first time, bitonal effects, appropriately for Ayious 2, on exteriors (Fig. 2.1: 2).

In Ayious 1, reserve decoration and the high proportion of Monochrome Red sherds in closed vessel categories suggest that extensive, vertically arranged, dark fields were considered appropriate for vessel exteriors regardless of shape or size (Fig. 2.2: 1). In both open and closed shape categories, canons of decoration were breaking down between Ayious 1 and Ayious 2 (Fig. 2.2: 2). However, change was much less marked in closed categories in Ayious 2 from which multibrush lattices, curvilinear and bitonal effects are virtually absent. Other areas of innovation such as the use of Fabric C and white slips also failed to affect the production of closed vessels; moreover, changes in shape, well documented in open categories, cannot be attested. Part of this process of change appears to include the breaking of certain links in perception that related open and closed vessel decoration. Such differing participation of open and closed vessels in several areas of innovation must surely reflect cognitive factors.

It seems likely that the progression from reserve and contrast to free field styles plus lattices reflects the character of the development of decoration out of Late Neolithic based traditions into the direct precursor of the Erimi style, encompassed at *Ayious* alongside, but within the period of the development of the Early Chalcolithic shape repertoire.

It is clear that even when distinct wares exist as at *Ayious*, the rest of the assemblage cannot be expected to be so divided. The existence of wares is here linked specifically to the functional roles of the vessels involved. It is in the manner and development of the networking of sets of virtually independent variables that we must base our understanding of such assemblages; only upon this basis can we compare them. For example, within the fine ware category at *Ayious*, rather than distinguishing classes of ceramics relating decoration to fabric, we have a tendency to distinguish different treatments between open and closed vessels. Mere decorative categories cannot be understood as wares and thus proportions of monochrome and patterned sherds and presence and absence of slips mean different things in different settings. It is where there is paralleling of particular, partial but not exclusive combinations of variables that we might suggest the strongest relationships. At *Ayious* and Alaminos (a site to the east of *Ayious*), parallel fabrics receive identical treatment, including a distinctive multibrush lattice combination, implying close communication between communities of potters over a distance of *ca.* 10 km. (Baird forthcoming a). In order for assemblages to be compared on such bases, multivariate analyses will be required in the future. Finally, we are left with some questions: by what mode of transmission and why suddenly are technical developments like slips and multibrushes, known in earlier settings elsewhere on Cyprus, accepted in contexts like the Vasilikos Valley where they were previously unused and from where do they derive?

Acknowledgments

I would like to thank Gordon Thomas for preparing the illustrations for this paper. Dr. Jane Barlow and Dr. Diane Bolger provided valuable editorial comment.

REFERENCES

Baird, Douglas
1986 The Chalcolithic Ceramics of Kalavasos-
 Ayious. In Vasilikos Valley Project: Fifth
 Preliminary Report 1980-1984, by Ian A. Todd.
 RDAC, 20-24.

forthcoming a
 Ceramics. In *Excavations at Kalavasos-*Ayious,
 edited by Ian A. Todd. SIMA LXXI:8.
 Göteborg.

forthcoming b
 Ceramics. In *Excavations at Kalavasos-*Tenta
 II, edited by Ian A. Todd. SIMA LXXI:7.
 Göteborg.

Barlow, Jane A. & Phillip Idziak
1989 Selective Use of Clays at a Middle Bronze Age
 Site in Cyprus. *Archaeometry* 31, 66-76.

Bolger, Diane
1985 From Typology to Ethnology: Techniques of
 the Erimi Potters. *RDAC*, 22-36.

Dikaios, Porphyrios
1961 *Sotira.* Philadelphia.

Frankel, David
1974 *Middle Cypriot White Painted Pottery: An*
 Analytical Study of the Decoration. SIMA
 XLII. Göteborg.

Lehavy, Y.M.
1974 Excavations at Neolithic Dhali-*Agridihi*. In
 American Expedition to Idalion, First Prelimi-
 nary Report: Seasons of 1971 and 1972, edited
 by Lawrence Stager, A. Walker & G.E. Wright,
 pp. 85-102. BASOR Supplement. Cambridge.

Peltenburg, Edgar J.
1980 Lemba Archaeological Project, Cyprus, 1978:
 Preliminary Report. *Levant* XII, 1-21.

1982 *Vrysi.* Warminster.

Peltenburg, Edgar J., *et al.*
1985 *Lemba Archaeological Project I: Excavations*
 at Lemba-Lakkous, 1976-1983. SIMA LXX:1.
 Göteborg.

Stanley Price, Nicholas P.
1979 *Early Prehistoric Settlement in Cyprus 6500-*
 3000. BAR International Series 65. Oxford.

Stewart, Jennifer D.
1978 Preliminary Remarks on the Chalcolithic Pot-
 tery Wares from Lemba-*Lakkous. RDAC*, 8-20.

III

Early Red Polished Ware and the Origin of the "Philia Culture"

Diane L. Bolger

Since the 1940s, when Dikaios first identified Red Polished pottery at Philia-*Laksia tou Kasinou* ("Vasiliko") and other sites in the Ovgos Valley, scholarly interest in early Red Polished Ware has focused almost exclusively on its value as a signpost for historical events attending the start of the Bronze Age in Cyprus and the end of Early Bronze II in Anatolia. Dikaios himself (*SCE* IV Pt.1A, 202) interpreted the ceramic changes in the archaeological record at that time as evidence of a new cultural element on the island whose interaction with local cultural elements achieved nothing short of "an aesthetic miracle" whose "profound consequences may be compared with the Mycenaean colonization of Cyprus toward the end of the second millennium." Similar views have since been echoed in more muted forms by others, perhaps most forcefully by Gjerstad (1980, 1-16), who characterized the transition to the Bronze Age in Cyprus as "an epoch-making era of foreign character."

A rather different viewpoint had been adopted by Dikaios earlier in the century (1936): namely, that Red Polished ware, although distinctive in some respects, demonstrated continuity with earlier, Chalcolithic traditions on the island. Dikaios ultimately abandoned this view (*SCE* IV Pt.1A) which at the same time found its strongest proponent in the work of J.R. Stewart (*SCE* IV Pt.1A) who coined the term *Philia Culture* and judged it to be a short-lived regional aberration which never exerted a profound impact upon the essentially unbroken sequence from the Chalcolithic, as represented at Erimi and Ambelikou, to the Early Bronze "mainstream" of Bellapais-*Vounous*. The antecedents of this Early Bronze Age culture lay, in his words, "in the shadowy Chalcolithic" (*SCE* IV Pt.1A, 211), a view also adopted by Catling (1971, 808-809).

The absence of substantial evidence from well-stratified, datable settlement contexts continues to pose obstacles to the resolution of the debate between Stewart and Dikaios as to whether the artifactual assemblages known collectively as the Philia Group or Culture represent a cultural or chronological entity. Fundamentally lacking from all these discussions, from a ceramicist's point of view, have been technical and compositional details concerning fabrics and surface treatments of Red Polished (Philia) ware. In contrast, discussion of vessel morphology has been given too much emphasis, since the comparison of shapes provides the most convenient method of tracing cultural contacts for historical purposes. Indeed, the widespread conviction that the advent of Philia Red Polished ware signaled sudden cultural changes on the island, associated with refugees or invaders, has precluded detailed consideration of stylistic and technical attributes that may demonstrate continuity from earlier indigenous ceramic traditions. I hope in this brief presentation to take a small step toward the correction of some of these earlier biases.

Identification of Philia Group sites in all regions of the island warrants a revision of Stewart's belief that the Philia Culture was a geographically restricted offshoot of the Vounous culture; moreover, the two cultures may represent chronological rather than culturally distinct entities. We now know that Philia sites are located islandwide (see Fig. 3.1), although more have been discovered in the north and south of the island than in the east or west. Until recently in the west, for example, Red Polished (Philia) ware was known only from a single tomb at Polis. However, excavations by the Lemba Archaeological Project since 1982 at Kissonerga-*Mosphilia* have yielded over 300 sherds of Red Polished (Philia) ware (Bolger 1986). Most of the sherds are derived from upper, plow-disturbed levels forming the final occupation horizon of the site. The greatest concentration was found directly above a Late Chalcolithic building at the northwest limit of the excavations. All the pottery exhibits traits diagnostic of standard Philia Red Polished ware, including lustrous red slips that are highly burnished, and shapes such as a small jar with lime-filled

incision (Fig. 3.2: 6), a juglet (similar to Fig. 3.2: 13), and fragments of jugs with flat bases, cut-away spouts, and plugged rod handles (Fig. 3.2: 1-5).

Table 3.1 shows how the relevant material has been classified at *Mosphilia* and indicates the corresponding nomenclature used previously by Dikaios and Stewart. A "lumping" rather than a "splitting" approach to the classification of the handmade wares from *Mosphilia* has led to the abandonment of many of Stewart's and Dikaios' ware terms (e.g., Band Burnished, RP I [Philia], Coarse and Red and Black Polished). More important than the terminology for present purposes, however, is a detailed characterization of Red Polished (Philia) ware according to its constituent components of shape, surface decoration and fabric. Comparison of Red Polished ware from *Mosphilia* and other sites in Cyprus suggests that many of its technical attributes were known and utilized by potters during the Chalcolithic period. This

can best be demonstrated through examination of several key aspects of morphology and surface treatment of Red Polished (Philia) and relevant wares of the Late Chalcolithic period.

MORPHOLOGY

The Red Polished vessels from *Mosphilia* cited above (Fig. 3.2: 1-6) represent only a small portion of the full range of Red Polished (Philia) shapes: the ceramic assemblage from Philia-*Laksia tou Kasinou* provides a more complete picture (*SCE* IV Pt.1A, figs. 80-83). To be sure, some types, such as the juglet, amphora, and perhaps the jug, attest to morphological change at the beginning of the Bronze Age. Other types are more familiar: for example, a collared storage jar from Philia (*SCE IV* Pt.1A, fig. 82.29) and a spouted bowl from Khrysiliou-*Ammos* (Fig. 3.2: 7; Bolger 1983) are types known at *Mosphilia* in Middle to Late Chalcolithic con-

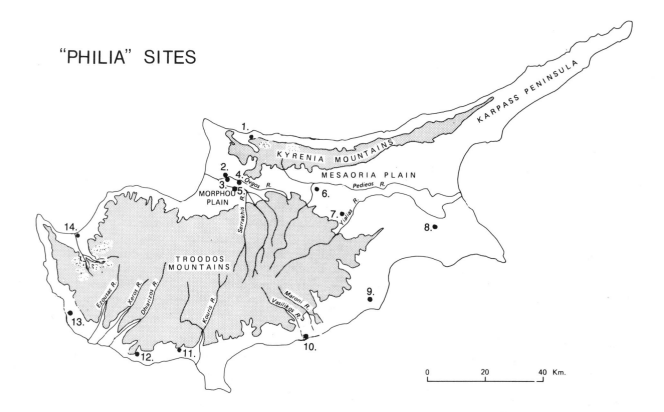

Figure 3.1. Map of Cyprus indicating sites where Red Polished (Philia) ware has been found: 1. Vasilia-Evreman, 2. Khrysiliou-Ammos, 3. Kyra-Alonia, -Kaminia, 4. Philia-Laksia tou Kasinou, 5. Dhenia-Kafkalla, 6. Nicosia-Ayia Paraskevi, 7. Margi-Alonia, 8. Kalopsidha, 9. Arpera, 10. Kalavasos-Archangelos, 11. Sotira-Kaminoudhia, 12. Anoyira-Trapezi, 13. Kissonerga-Mosphilia, 14. Polis-Evretades

texts, where they appear in Red-on-White and Stroke Burnished Wares. A spouted flask from a Late Chalcolithic chamber tomb (Fig. 3.3: 3) and a spouted jar from a pit grave (KM 2337), both from *Mosphilia*, have no direct parallels at Philia but are certainly akin to well-known Philia types such as the teapot and the spouted bowl (Fig. 3.2: 10-12; *SCE* IV Pt.1A, fig. 80.1-4).

The shape occurring most frequently in the Red Polished sherdage at *Mosphilia*, and the one that has generally received most attention in the archaeological literature, is the globular jug with vertical cut-away spout (Fig. 3.2: 8, 9; Fig. 3.3: 1, 2, 4-6). This morphological type is usually traced to Cilicia, and particularly to Tarsus, where Dikaios had identified several sherds of Erimi-type Red-on-White ware (Goldman 1956, 104, pl. 263); but in fact this precise jug type occurs only once at Tarsus (Goldman 1956, pl. 262.356), and Goldman reckoned it to be so uncommon a shape as to have been imported from Cyprus (Goldman 1956, 112). Whereas jugs at Tarsus have squat trefoil or pointed spouts, the

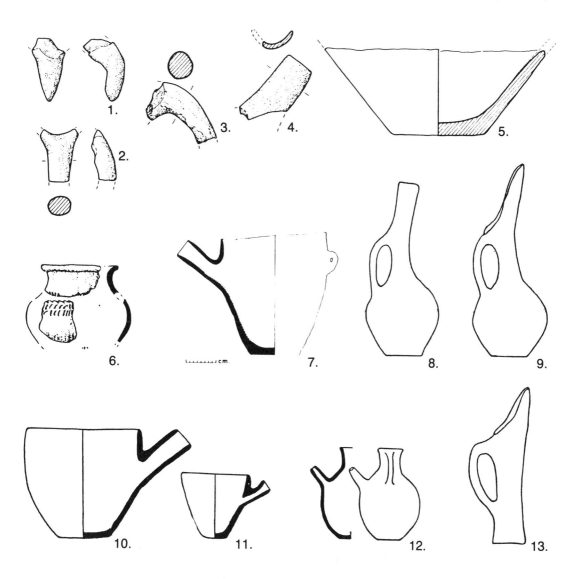

Figure 3.2. Red Polished (Philia) pottery from Cyprus: 1-4) jug fragments from Kissonerga-Mosphilia; 6) fragmentary incised jar from Kissonerga-Mosphilia; 7) spouted bowl from Khrysiliou-Ammos; 8-9) jugs from Philia-Laksia tou Kasinou; 10-11) spouted bowls from Philia-Laksia tou Kasinou; 12) "teapot" from Philia-Laksia tou Kasinou; 13) juglet from Philia-Laksia tou Kasinou. Scale: nos. 1-6, 1:2; nos. 7-13, 1:6

TABLE 3.1

Comparative Terminologies
for RP (Philia) Ware

Bolger (1986)	Dikaios *SCE* IV Pt.1A	Stewart *SCE* IV Pt.1A
Red Polished (Philia)	Red Polished	RP I (Philia)
(with pattern burnish)	Band Burnished	RP I (Philia) Stroke Burnished
(with coarser fabric)	Red Slip	RP I (Philia) Coarse
(with differential firing)	Red & Black Polished	RP I (Philia)

plain Philia type with high beaked or cut-away spout is much more common in Western Anatolia, at sites such as Beycesultan, Çaykenar, Bozüyük and Hissarlik (Troy). Influence from this part of Anatolia has been recognized by others (Ormerod 1911-1912, 83; *SCE* IV Pt.1A; Gjerstad 1980, 9-11) and would appear to constitute a link worthy of further investigation. By the same token, the ceramic record at *Mosphilia* hints at the earlier existence of the Philia-type jug in Late Chalcolithic contexts: a rod handle in Stroke Burnished Ware and a fragmentary Red Polished-type flat base from a closed vessel may provide evidence for the existence of the type well before the Early Bronze Age horizon mentioned earlier.

SURFACE TREATMENT

The evidence from *Mosphilia* suggests that the painted pottery tradition of the Middle Chalcolithic period gave way almost entirely to a monochrome vogue during the Late Chalcolithic. At that time, potters began to develop and utilize new techniques, such as the attainment of higher firing temperatures and experimentation with burnished and relief decoration. In many respects, the technical innovations of Red Polished (Philia) ware represent a continuation of these trends. Burnishing on Red Polished ware may cover the vessel completely, with few traces of individual burnishing strokes; but frequently it employs vertical, horizontal, or diagonal strokes arranged deliberately to achieve patterned effects (Dikaios' Band Burnished ware, *SCE* IV Pt.1A). By the

beginning of the Early Bronze Age, Cyprus could already point to a long tradition of highly burnished monochrome wares. Deliberate pattern burnishing, however, does not appear until the Late Chalcolithic period, when changes in the previous ceramic repertoire begin to take place and a high degree of experimentation is attested. Stroke Burnished bowls at *Mosphilia*, for example, often reveal the use of burnishing strokes to create deliberately pleasing effects; other bowls show potters in the act of experimenting with the effects of light and dark produced by differential firing, a technique observed as early as the Middle Chalcolithic period on Black Topped bowls (e.g., Peltenburg *et al.* 1985, pl. 34.9). Technical innovations such as these suggest that many ceramic changes customarily associated with the start of the Early Bronze Age in Cyprus had Chalcolithic antecedents.

Incised decoration on Red Polished ware at *Mosphilia* is limited to a single example cited above, the small jar with everted rim (Fig. 3.2: 6). Its simple incised design contrasts markedly with the more elaborate designs on Red Polished ware at *Vounous*, where incision occurs more frequently. Incised decoration at Philia was likewise rare, accounting for only four of the total number of jugs, for example. In technical terms, incision on Red Polished (Philia) ware appears to have been executed when the clay was moist, i.e. not dry but not fully plastic. This can be deduced from the technique of the incised lines, which exhibit neither the chipped edges associated with incision into dry clay or the raised edges that result from incision into wet clay. At Tarsus, Goldman observed that incision on Incised Red Burnished ware was carried out when the clay was leather hard (Goldman 1956, 111-112). Incision into moist clay was noted by Matson on a group of Black Incised ware sherds from the same site, which also dated to an Early Bronze II context (Matson 1956, 356). Elsewhere in Anatolia, incision into moist clay is not widely attested, although Ormerod specifically included it as a feature of Red Polished pottery at Çaykenar, where incised motifs are filled with powdered limestone (Fig. 3.3: 2). Goldman reports that there is no clear case for lime filling in Incised Red Burnished ware at Tarsus. In Cyprus, meanwhile, incision as a decorative technique is practically unknown before the Late Chalcolithic period. At *Mosphilia* several sherds of Stroke Burnished ware have straight, blunt incisions, but they bear no resemblance to Red Polished (Philia) incision and are never filled with powdered lime. It is therefore fair to single out this new type of filled incised decoration as the only decorative element of Philia Red Polished ware to have no indigenous antecedent.

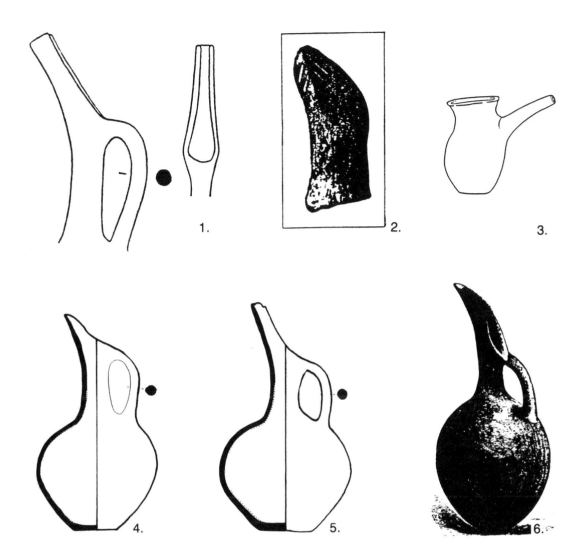

Figure 3.3. Chalcolithic and Early Bronze Age Pottery from Cyprus and Anatolia: 1) Red Polished jug fragment from Western Anatolia (exact provenance unknown); 2) Red Polished incised jug fragment from Çaykenar, Western Anatolia; 3) Red and Black Stroke Burnished spouted jar from Kissonerga-Mosphilia; 4-5) Red Polished (Philia) jugs with cut-away spouts from Khrysiliou-Ammos; 6) Red Polished jug with cut-away spout from Troy III. Scales: nos. 1-2, unknown; no. 3, 1:3; nos. 4-5, 1:6; no. 6, unknown.

FABRIC

Overriding concern with morphological and other superficial features of Red Polished (Philia) ware has served to discourage a detailed analysis of fabric, and ironically fabric is the ware's most radically innovative element. A Red Polished jug section is a typical example. The fabric is soft and well levigated and contains small quantities of gritty filler (quartzose sandstone, volcaniclastic sandstone and serpentinite) as well as inclusions of chalk and thin-walled shell. It varies in color from buff to orangey-brown and is sometimes through-fired; but in most cases it exhibits a distinctly laminated gray core that forms about one-third of the section.

Peltenburg (this volume) has demonstrated the strong regional tendencies among monochrome ware fabrics of the Late Chalcolithic period, even when shapes and surface treatments exhibit fairly high degrees of uniformity. In contrast, the evidence of Red Polished (Philia) pottery from sites such as Nicosia-*Ayia Paraskevi* (Bolger 1983), Khrysiliou-*Ammos* (Bolger 1983), Sotira-*Kaminoudhia* (Swiny 1985), Margi (Brown & Catling 1980), *Kalopsidha* (Merrillees 1966), Philia and

Mosphilia reveals that for the first time ever in Cyprus uniformity of fabric was attained by potters working in all regions (the other, less likely explanation is that the ware was manufactured at a single center and exported to other regions). This radical departure from previous tradition is astonishing and calls for an explanation. One hypothesis that must be considered, in light of the invasion theories alluded to above, is that Red Polished (Philia) ware was largely a mainland innovation manufactured abroad and imported lock, stock and barrel into Cyprus by merchants or refugees. Further analysis of the relevant mainland burnished monochromes is needed to rule out this thesis entirely, but the existing evidence already speaks against it. Plain Red Burnished ware at Tarsus, for example, has fabric varying from buff to orangey-brown and containing dense concentrations of gritty white igneous filler (Goldman 1956, 111-112). Although some sherds are through-fired, the vast majority have black cores forming about 90% of the section. Macroscopic observation, then, clearly demonstrates that different clays and fillers were being used for the Cypriot and mainland monochromes; and if Red Polished (Philia) were an import, we would have expected to find similar fabrics at some site in Anatolia.

On the contrary, preliminary petrographic analysis of thin sections taken from sherds of Mosphilia Red Polished indicate local outcrops in the vicinity of Kissonerga (Pakhna, Mamonia and Kannaviou formations) as the most likely clay sources (Robertson 1989).

The fact that many technical attributes of Red Polished (Philia) ware were known and employed in Cyprus before the Bronze Age renders the ascription of the ware to a foreign source unnecessary and even implausible. This does not mean, of course, that developments on the mainland and even farther afield did not profoundly affect Cyprus at that time. Even in ceramic terms, the adoption of incised decoration, better levigated fabrics, and a variety of new forms clearly suggests the opposite. It lies beyond the scope of this paper to speculate upon the precise nature and extent of that influence. But if we begin to examine early Red Polished ware in the context of ceramic traditions in Cyprus as well as abroad, we must conclude that simplistic theories of invasion and adaptation will not sufficiently account for the complexities presented by the ceramic record, and that the role played by Cyprus itself in the transition from Copper to Bronze was far more dynamic than has customarily been granted.

REFERENCES

Bolger, Diane
1983 Khrysiliou-*Ammos*, Nicosia-*Ayia Paraskevi*, and the Philia Culture of Cyprus. *RDAC*, 60-73.

1986 Pottery of the Chalcolithic/Early Bronze Age Transition. In Excavations at Kissonerga-*Mosphilia* 1985, by Edgar J. Peltenburg *et al*. *RDAC*, 37-39.

Brown, Ann & Hector Catling
1980 Additions to the Cypriot Collection in the Ashmolean Collection, Oxford, 1963-77. *OpAth* XIII, 91-137.

Catling, Hector
1971 Cyprus in the Early Bronze Age. *CAH* Vol. I. Pt.2, XXVI(B), 808-823. Cambridge.

Dikaios, Porphyrios
1936 The Excavations at Erimi, 1933-35: Final Report. *RDAC*, 1-81.

Gjerstad, Einar
1980 The Origin and Chronology of the Early Bronze Age in Cyprus. *RDAC*, 1-16.

Goldman, Hetty
1956 *Excavations at Gözlü Kule, Tarsus*. Princeton.

Matson, Frederick
1956 Techniques of the Early Bronze Potters at Tarsus. In *Excavations at Gözlü Kule, Tarsus*, by Hetty Goldman, pp. 352-361. Princeton.

Merrillees, Robert S.
1966 Finds from Kalopsidha Tomb 34. In *Excavations at Kalopsidha and Ayios Iakovos in Cyprus*, by Paul Åström, pp. 31-35. SIMA II. Lund.

Ormerod, H.A.
1911-1912
 Prehistoric Remains in S.W. Asia Minor. *BSA* XVIII, 80-94.

Peltenburg, Edgar J., *et al*.
1985 *Lemba Archaeological Project I: Excavations at Lemba*-Lakkous *1976-1983*. SIMA LXX:1. Göteborg.

Robertson, Alistair
1989 Preliminary Report on Petrographic Analysis of Sherds from Cyprus. Department of Geology, Edinburgh University.

Swiny, Stuart
1985 The CAARI Excavations at Sotira-*Kaminoudhia* and the Origins of the Philia Culture. In *Acts* 1986, 13-26.

Reading the Prehistoric Record: A View from the South in the Late Third Millennium B.C.

Stuart Swiny

The continuing interest in the transitional phases of the later Prehistoric period in Cyprus is most gratifying to witness. By coincidence initially, and now by intent, I have found myself involved with three most problematic transitions that, to complicate the issue, were approached in reverse chronological order. Ultimately, in an attempt to understand why the neat chronological framework established for the northern half of the island was unsatisfactory south of the mountain range, I decided to investigate the most controversial transition of all: Chalcolithic to Bronze Age.

Many researchers concerned with this period appear to disagree, an intellectually challenging state of affairs which is mostly a disagreement caused by the lack of a firm chronological framework. At the present time I am not prepared, or able, to make any statements on chronology. A series of dates is required, ideally absolute, but relative dates would be almost as useful. In the absence of stratified settlements it is quite simply impossible to establish a reliable chronology for the Early and Middle Cypriot periods, due to the lack of short life linkages with foreign cultures. The most recent and exhaustive study of the Levantine imports to Bellapais-*Vounous* by James Ross (forthcoming), suggests that Early Cypriot I should end in the twenty-fourth century BC and that the transition to Middle Cypriot takes place around 2000 BC.

When excavations began at Sotira-*Kaminoudhia* in 1981 (S. Swiny 1985b), with intent to cast light on the beginning of the Bronze Age in Cyprus, I had some preconceived ideas concerning the manner in which the assemblage should be classified. These were based on the surface material collected by a survey undertaken in 1978 (Table 4.1; S. Swiny 1981) which located both the cemeteries and the settlement. The ceramics from *Kaminoudhia* were recorded as follows:

1. The cemeteries produced quantities of what was then called Red Polished Chalcolithic III, described as having a buff colored, fine grit and chaff tempered fabric with a gray or buff core. It had a rather thick red-brown slip and was lightly burnished, often with clearly visible burnish marks. This last characteristic was the only means of differentiating it from Red Polished III ware in sherd form. Some of the handles and body sherds bore deep incised decoration, performed before the slip was applied. The incision had been carefully executed with a slightly pointed instrument, unlike the shallow, apparently hastily applied incision on later Drab Polished Blue Core and Red Polished Punctured wares.

2. The second pottery type recorded by the survey was Dark Red Polished ware, so-called because it had a dark brown, from fine to medium grit tempered fabric with a gray or brown core. The thin brown slip, sometimes highly burnished, showed occasional signs of mottling. The fabric was not so hard as, and appeared to be sandier than, diagnostic southern Cypriot Red Polished III Mottled ware (see 3, below). None of the Dark Red Polished ware recovered showed evidence of plastic or relief decoration.

3. Red Polished III Mottled ware, as defined at Episkopi-*Phaneromeni* and elsewhere south of the Troodos massif (S. Swiny 1981, 58; H. Swiny 1982, 180; Herscher 1981, 80, fig. 4: 2), had a hard, dark, red-brown coarse grit tempered fabric. The less common, smaller shapes had a finer, almost sandy fabric. All vessels were covered with a lustrous, well-burnished slip of medium thickness which never showed brush or rag marks. The red-brown slip was usually mottled with well-defined gray to black areas exhibiting a matte and often crackled surface. Though common on handles and lugs, the deep incised decoration was otherwise very rare, and always executed *prior* to the application of the slip, in contrast with

TABLE 4.1

Pottery chart with percentages of the most common wares from sites in southern central Cyprus. The Groups are arranged in chronological order, from the earliest manifestation of the Bronze Age (Gr. I) to pure Early Bronze Age (Gr. II), Early/Middle Bronze Age (Gr. III) and finally to mature and late Middle Bronze Age (Gr. IV)

	RP	Dark RP	RPI South Coast	RP III	Blck Top Bowl	RP Mot.	DP Blue Core	RP Punct.	RP IV	Coarse	Misc.	Total Sherd/Total Vessels	% Total Vessels
Gr. I													
Trapezi Cem.	50	50										4	100
Kaminoudhia Cem.	40	14.5				40	1.7				4	118	100
Kaminoudhia Set.	4	21.5				25				1.5	48	200	100
Kannavokambos Cem.		14.5	1	39.5		3	10		1		30	89	99
Gr. II													
Amolo Cem. C.			36	38		15	2			2	2	78	99
Ambelovonous Cem.			31	26		39	3.5					114	99
Ambelovonous Set.						68	8			24		25	100
Amolo Cem. A.			6	65		24	25				1.5	190	99
Gr. III													
Amolo Cem. B.			3	37		41	12			5	8	185	100
Stympouli Cem.			3	39		33	24					33	99
Mandra tou Pouppou Cem.			2	4.3	2	30	48	2	6.5		2	46	99
Alatomi Cem.				14	3	46	36					67	99
Alatomi Set.				3		38	25	2?		5	26	87	99
Balies Set.				7		72	3	11	0.6	6		170	99
Gr. IV													
Stympouli Set.				5	0.3	52	18		2	20	2.5	160	100
Kafkalla Set.						11	32	1	4	36	16	81	100
Kafkalla Cem.				7		60	10	6	3	4	9	286	99
Beyouk Tarla Cem.				13	5	41	26	0.3	9	2	4	275	100
Beyouk Tarla Set.				2		43	11	2	10	21	11	217	100
Peralijithias Set.				3		40	14	0.9	6	11	25	228	99
Livadhia Set.				8		31	33	2	7	12	6	189	99
Kolokos Set.				5		20	25		10	40		20	100
Mandra tou Pouppou Set.						20	15.5	13	11	13	26.6	45	99
Shilles Set.						14	27		20		39	131	100
Phaneromeni Set. G.				4.5		59	3	10.5	1.2	14	8	3275	100
Phaneromeni Set. A.		0.03		0.7		2.7	8.4	37	35	11.6	4.2	50953	99
Phaneromeni A (Surf).						5	26	25	32		12.7	143	100

other, later, south coast incised wares. The walls were thick in relation to vessel size. Vessels belonging to this ware were predominantly functional.

4. A few sherds of Drab Polished Blue Core ware of diagnostic Episkopi-*Phaneromeni* type (S. Swiny 1981, 58; H. Swiny 1982, 180; Herscher 1981, 81, fig. 4: 5; Tatton-Brown 1979, fig. 85) were also recorded. The fine, buff to orange grit tempered fabric was apparently fired at a high temperature for a short time. Typically, the core was blue-gray with only the surface oxidized, and the surface was usually pockmarked due to the uncontrolled expansion of the limestone or shell tempering material. Vessels had a thin slip which was not always burnished, and incised decoration was rare, shallow and rather carelessly executed.

The pottery from both *Kaminoudhia* cemeteries and the settlement at *Kaminoudhia* was essentially the same (Table 4.1), although no Drab Polished Blue Core came from the settlement. Thus, filled with enthusiasm and confidence in a well-ordered ceramic future, I had sherd count sheets printed and we began excavations at *Kaminoudhia* in 1981 (S. Swiny 1985b). The ceramic classification system adopted for the first season used the above categories as a starting point, but problems soon began to emerge.

Unlike the assemblage from Episkopi-*Phaneromeni* (see *Phaneromeni* in Table 4.1) which was easily subdivided and classified into five basic wares—namely Red Polished III Mottled, Red Polished IV, Drab Polished Blue Core, Red Polished Punctured and Coarse—the *Kaminoudhia* ceramics were far more difficult to sort objectively. Dark Red Polished proved impossible to isolate systematically as a separate type, because it graded gradually into Red Polished Mottled ware. It also became obvious that Red Polished I South Coast (S. Swiny 1981, 57; H. Swiny 1982, 179; Herscher 1981, 80)—a category that had been included because it was assumed that it would be found in the excavation—had to be amalgamated within a broad Red Polished category.

North of the Troodos Massif the Philia culture ceramic tradition is characterized by an overwhelmingly Red Polished assemblage with numerous flat based jugs with cut away spouts, amphorae with flaring rims and tubular spouted bowls. Their surfaces are sometimes covered with simple linear incised or band burnished decoration. Alongside the Red Polished types there belong smaller numbers of White Painted IA (Philia) and rare Black Slip and Combed ware bowls and amphorae (*SCE* IV Pt.1A, 165-173; figs 80, 81, 82; 223-225).

For a site that was believed to belong to the Philia culture ceramic tradition, as defined by the above noted north coast criteria, the common occurrence of Chalcolithic Red-on-White ware at Kaminoudhia (*SCE* IV Pt.1A, 118, fig. 58) was, naturally, quite unexpected. The

Black Topped ware bowls (Stewart 1985, 261) and other pottery in the mainphase Chalcolithic tradition also came as a surprise.

At the end of the first season of excavation, the view of the Sotira-*Kaminoudhia* ceramic assemblage was the following: four categories of Chalcolithic type pottery were recorded at the settlement, but the main body of the assemblage consisted of Red Polished ware, manufactured in a wide variety of different fabrics. Diagnostic Drab Polished Blue Core was found in small quantities as were coarse Red Polished wares used for storage vessels and basins, slipped and burnished or left plain. Beginning with the pottery in the Chalcolithic tradition, each type is described as follows:

RED-ON-WHITE WARE
(figs. 4.1, top row; 4.2)

Even the most doubting Thomas could hardly fail to recognize the similarities between the Red-on-White ware excavated in Phase I at the Sotira-*Kaminoudhia* settlement and that from Erimi-*Pamboula* (*SCE* IV Pt.1A, 118).

All the Red-on-White at *Kaminoudhia* has a red-brown fabric (10R 5/6-2.5YR 6/4) tempered both with chaff and grit. This mixture produces a friable ware with an irregular fracture. The method of firing had regularly produced incompletely oxidized cores.

The 1 to 1.5 mm. thick off-white chalky slip, crisscrossed by hairline cracks, flakes easily from the surface of the sherd. The red-brown (2.5YR 4/8) to reddish yellow (5YR 6/8) lustrous painted decoration tends to be thin and fugitive.

Comparison between Red-on-White sherds from *Kaminoudhia* with Red-on-White sherds from the upper levels at Erimi-*Pamboula* (Heywood *et al*. 1981, 36) stored in the Kourion Museum, reveals the following points: first, the *Kaminoudhia* white slip is thicker, less white and more friable. Second, the paint used for decoration at *Kaminoudhia* tends to be thinner and more mottled. Third, the decorative motifs used at both sites are not noticeably different, and all the motifs recorded at *Kaminoudhia* are also found at *Pamboula* (Heywood *et al*. 1981, fig. 6; Dikaios 1936, pls. XVIII-XXV).

Dikaios (1936, 28; *SCE* IV Pt.1A, 118) distinguished two qualities of Red-on-White fabric and three qualities of slip at Erimi-*Pamboula*. One fabric is fine and white, the other coarser, darker and less well fired. The latter is most common in the upper levels, and as to be expected, it is the one that best resembles the *Kaminoudhia* material. One quality of slip found at *Pamboula* is also very close to that in use at *Kaminoudhia*. It should be noted that only one type of fabric and slip was used for

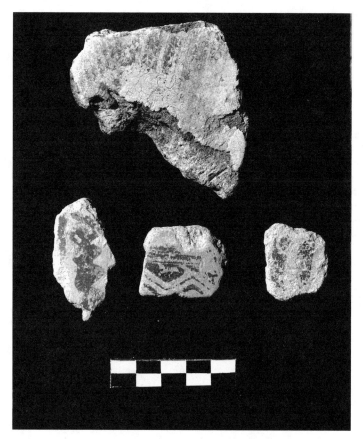

Figure 4.1. Top row: typical Red-on-White body sherd from the Sotira-Kaminoudhia settlement, Area A, Room 5. Bottom row: three White Painted 1A (Philia) body sherds from (L to R) Areas A, B and C.

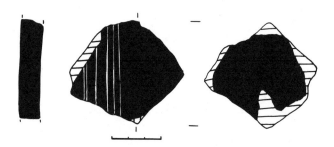

Figure 4.2. Typical Red-on-White sherd from Area A, Room 3. Body sherd from a large bowl. Red (10R 4/6) fabric with chaff and grit temper. Chalky white slip, 1 mm. thick. Seven parallel bands of reddish yellow (5YR 6/8) paint creating a reserve slip effect of 6 thin (1-2 mm.) white streaks. The interior is Red Monochrome Painted.

the manufacture of the Red-on-White sherds at *Kaminoudhia*, a fact which suggests that its chronological span at this site was narrow.

From the evidence supplied by the sherds, it seems that a limited repertoire of Red-on-White shapes was in use at *Kaminoudhia*: it consists of large and small deep bowls with simple pinched rims, medium sized flasks and globular closed vessels of indeterminate shape.

RED MONOCHROME PAINTED WARE

The fabric of this ware, which ranges in color from dark red to red (2.5YR 3/6-6/8), is identical to that used for Red-on-White. The surface is covered with a thin lustrous reddish slip (2.5YR 3/4; 5YR 7/6), often with brush or cloth marks visible, applied to an orange/cream underslip (2.5YR 6/4; 5YR 6/6), thinner than that in use for Red-on-White ware.

Red Monochrome Painted sherds from Erimi-*Pamboula* (labeled as Red Slip in Heywood *et al.* [1981, 35M] and Dikaios [1936, 26]) and Sotira-*Kaminoudhia* are identical both in terms of fabric and surface treatment.

The similarity does not extend, however, to the Red Monochrome Painted from Lemba-*Lakkous* that lacks the buff slip beneath the paint which is directly applied to the wet smoothed, burnished or self-slipped surface of the vessel (Stewart 1978, 12).

Red Monochrome Painted ware seems to have been made in the same range of shapes as Red-on-White.

RED AND BLACK STROKE BURNISHED WARE

This ware has a distinctive brick-red fabric (10R 5/8) with blue/gray (limestone?) grit temper. The fabric is immediately distinguishable from all others at *Kaminoudhia*. The mottled brick-red surface (2.5YR 5/8-6/8) is wet-smoothed or more rarely self-slipped and burnish marks are sometimes visible. Both bowls and closed shapes are recorded in this ware. Good parallels may be drawn with Erimi-*Pamboula* (Heywood *et al.* 1981, 37), Lemba-*Lakkous* (Stewart 1985, 262) and especially the upper levels at Ambelikou-*Ayios Georghios* (Walz n.d.).

RED AND BLACK LUSTROUS WARE

The chaff and grit tempered Lustrous ware is usually incompletely oxidized, resulting in dark brown-gray to black fabric (2.5YR 5/4; 2.5YR N3-N6). The surface of the vessel is covered with a thin, lightly to well-burnished slip, usually mottled, with the darkest areas toward the base of the vessel. Despite the apparent similarity of name between this ware and Red and Black Stroke Burnished ware, the types are totally different in fabric color and tempering, surface color and treatment, and are therefore immediately distinguishable from one another. Shapes consist of jars and deep bowls with slightly flaring rims.

Red and Black Lustrous ware does not seem to be well represented at Lemba-*Lakkous* (Peltenburg 1985, 14, table 1), but is very common at Ambelikou-*Ayios Georghios* (*SCE* IV Pt.1A, 143).

WHITE PAINTED IA (PHILIA) WARE
(Fig. 4.1: bottom row)

This ware, which is described by Stewart (*SCE* IV Pt.1A, 224) as White Painted IA (Philia) and Dikaios (*SCE* IV Pt.1A, 172) as Red-on-White has, according to their definition, a buff grit and straw tempered fabric, "a cream or buff slip, usually hand-smoothed, on which a design is painted in matte dark red pigment, sometimes applied rather thickly. Occasionally the interior of the pot is red-slipped and is normal Red Polished I (Philia), thus making a composite ware" (*SCE* IV Pt.1A, 224). In the course of studies undertaken by the author and Clark Walz, which involved the inspection of every piece of

White Painted IA (Philia) pottery known in Europe, Australia and Cyprus, not one piece was noted as having a slip beneath the painted decoration (S. Swiny 1986, 31).

The sherds from eight White Painted IA (Philia) open and closed vessels were excavated at the *Kaminoudhia* settlement. The fairly hard grit tempered fabric is buff to red-brown in color (7.5YR 7/4), often with a light gray core (7.5YR; 7.5YR 7/N7). The lustrous red paint (2.5YR 4/6-4/8) is usually applied directly to the surface of the vessel, but in one instance was applied to a thin matte slip. Sometimes the decoration has been applied with extreme care.

This ware is atypical, with one exception, of the White Painted IA (Philia) pottery excavated in the Ovgos valley (*SCE* IV Pt.1A, 172, 224), at Nicosia-*Ayia Paraskevi* (*SCE* IV Pt.1A, 224; Hennessy *et al.* 1988) and Margi-*Tavari* (personal observation). The exception consists of two so-called Red-on-White sherds from the Philia culture tomb at Khrysiliou-*Ammos* (Bolger 1983), the westernmost of the Ovgos group of sites. Both are decorated with red lustrous paint applied directly to the unslipped surface of the bowl and as such are identical to our examples of the ware at *Kaminoudhia*.

RED POLISHED WARES

The pottery in the Red Polished tradition at *Kaminoudhia* resists strict categorization, therefore no attempt will be made to describe each subtype separately. It will be more useful to limit the discussion to general comments on the pottery from the *Kaminoudhia* settlement (Figs. 4.3, 4.4) and cemetery (S. Swiny 1985b figs. 4: 1-3; 7: 1-5) assemblages and seek to demonstrate their relationships with other sites in the region and further afield.

In the absence of absolute dates there has been considerable speculation about the chronological span of the settlement. It has been suggested that the cemetery alone has Philia culture connections and that the settlement is substantially later (Hennessy *et al.* 1988, 41). Pending the detailed study of all aspects of the site, the question must remain open.

When comparing the *Kaminoudhia* fabrics *in toto* with those from the Early and Middle Cypriot cemetery and settlements at Episkopi-*Phaneromeni* the following observations may be made:

First, at *Kaminoudhia* the fabrics are generally softer and less well fired.

Second, there are many more intermediate types. At *Phaneromeni* Settlement G, of Middle Cypriot date, miscellaneous sherds make up only 8% of the total assemblage, whereas at *Kaminoudhia* the percentage is far higher.

Sotira-*Kaminoudhia* is eight kilometers away from Episkopi-*Phaneromeni* and it could be argued that some

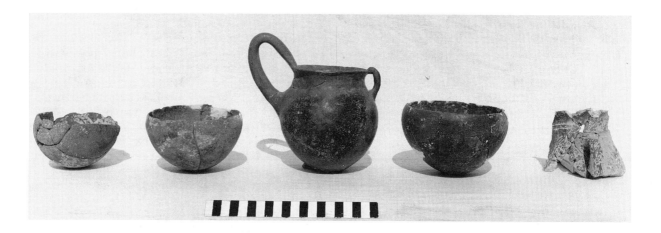

Figure 4.3. Red Polished vessels from Area A, Room 5. From L to R: P16, P20, P50, P13, P82. Note that P82, the neck and handle fragment on the right bears incised decoration.

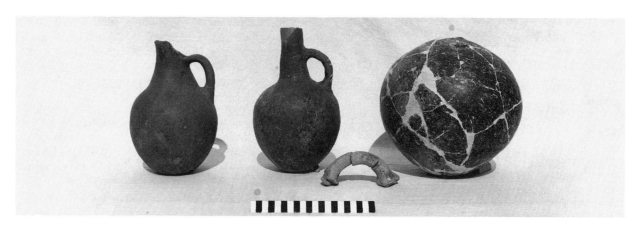

Figure 4.4. Red Polished vessels from Area C, Room 8. From L to R: P60, P33, P70, P106. Note that the neck of P106, on the right, is missing.

of the differences were caused by the use of different clays or even the effects of regionalism—an unlikely prospect in view of the proximity of the two sites—but such arguments cannot be used for Sotira-*Troulli tou Nicola* (Held 1988, 56), a site located exactly one kilometer southwest of the *Kaminoudhia* settlement.

A systematic surface collection at *Troulli tou Nicola* produced quantities of diagnostic Red Polished Mottled, Red Polished IV (for a description of this ware see S. Swiny 1981, 58; Herscher 1981, 81, fig. 4: 4; Carpenter 1981, fig. 3: 14) and a high percentage of Drab Polished Blue Core, as defined on southern Cypriot sites (S. Swiny 1981, 57-58; H. Swiny 1982, 180; Herscher 1981, 81). Although many sherds were weathered, the fabrics are

generally much harder and lighter in color than at *Kaminoudhia*, having been fired in an oxidizing atmosphere.

If the criteria (S. Swiny 1981) used for dating other sites in the region are applied to *Troulli tou Nicola*, the presence of Red Polished IV associated with numerous Drab Polished Blue Core sherds would classify it in the Group IV category (Table 4.1), of Middle Cypriot date. The differences between the *Kaminoudhia* and the *Troulli tou Nicola* settlements are surely chronological and not regional and the former must have been last occupied considerably earlier than the mature Middle Cypriot period.

A connection between the funerary ceramics at *Kaminoudhia* and those deposited in Philia culture

graves in the western Mesoria was first noted when Dikaios excavated a burial at *Kaminoudhia* in 1948 (Dikaios 1948).

Although the elegant jugs with cut-away spouts, so characteristic of the northern Philia culture sites (*SCE* IV Pt.1A, figs. 80-82; S. Swiny 1986, fig. 1: 26, 27), have yet to be recorded at the *Kaminoudhia* settlement, a small trough spouted jug (Ka. P14) from Tomb 6 in the cemetery does have a good Philia pedigree. Note that Dikaios also appears to have excavated a fragmentary trough spouted jug in Cemetery A, clearly shown in his photograph of the excavation (see Dikaios 1948, pl. VI: b) but not recorded in the Cyprus Museum inventory.

Flat bottomed bowls with filiform spouts (*SCE* IV Pt.1A, fig. 80: 3; H. Swiny 1982, 20, fig. 11; S. Swiny 1986, fig. 1: 21) and the so-called mosque lamp jars (*SCE* IV Pt.1A, fig. 81: 11; S. Swiny 1986, fig. 1: 31) are other characteristic Philia culture features.

Good parallels may also be drawn with Red Polished I flasks, pots and deep bowls from Bellapais-*Vounous* (*SCE* IV Pt.1A, figs. XCIX, C, CII, CIII) and Episkopi-*Phaneromeni* (Herscher 1981, fig. 4: 1; H. Swiny 1982, 179). The Black and Brown Polished bottles from both the settlement and cemetery invite comparisons with those from *Phaneromeni* (S. Swiny 1976, figs. 8, 9) and elsewhere south of the Troodos (Karageorghis 1958, type AI).

It is disconcerting that the most morphologically developed funerary ceramics came from a crude bottle-shaped burial chamber (S. Swiny 1985a, fig. 4: 2) which finds its best parallels in the Chalcolithic, especially at Souskiou-*Vathyrkakas* (Christou 1989, fig. 12.3). The hemispherical bowls with or without flaring tubular spouts from this burial are characteristic of Middle Cypriot spouted bowls from Episkopi-*Phaneromeni* (*Chypre* 1982, 20, 1; Carpenter 1981, fig. 25, middle top row). The fabrics too are reminiscent of those known from *Phaneromeni*. The same chamber yielded a Drab Polished Blue Core jug but without the incised decoration typical at *Phaneromeni*, and the bowls are typical of Red Polished Mottled ware.

The relationship of the non-Chalcolithic ceramic assemblage (Figs. 4.3, 4.4) in use at the settlement with other sites is more difficult to establish. It would seem that a number of shapes, especially the globular narrow necked jugs (Fig. 4.4, P106, neck missing) have no good parallels elsewhere.

It is clear that much more work is necessary before we can begin to understand fully the ceramic sequence and its ramifications at Sotira-*Kaminoudhia*, a task which Ellen Herscher is in the process of tackling. Her work, in combination with the results of a comprehensive C14 dating project, should enable us, at last, to understand what really went on in southern Cyprus between the Chalcolithic and the Late Bronze Age.

REFERENCES

Bolger, Diane
1983 Khrysiliou-*Ammos*, Nicosia-*Ayia Paraskevi* and the Philia Culture of Cyprus. *RDAC*, 60-73.

Carpenter, James R.
1981 Excavations at Phaneromeni, 1975-1978. In *Studies in Cypriote Archaeology*, edited by J.C. Biers & David Soren, pp. 59-78. Institute of Archaeology Monograph XVIII. University of California, Los Angeles.

Christou, Demos
1989 The Chalcolithic Cemetery 1 at Souskiou-*Vathyrkakas*. In *Early Society in Cyprus*, edited by Edgar J. Peltenburg, pp. 82-94. Edinburgh.

Chypre
1982 *Chypre, les travaux et les jours*. Musée de l'Homme. Palais de Chaillot, Paris. Association Français d'Action Artistique, Paris.

Dikaios, Porphyrios
1936 The Excavations at Erimi, 1933-1935, Final Report. *RDAC*, 1-88.

1948 Excavations at Sotira, Site Teppes. *UPMB* XIII.3, 16-23.

Held, Steve O.
1988 Sotira-*Kaminoudhia* Survey: Preliminary Report of the 1983 and 1984 Seasons. *RDAC*, 53-62.

Hennessy, J. Basil, Kathryn O. Eriksson, & Ina C. Kehrberg
1988 *Ayia Paraskevi and Vasilia*. SIMA LXXXII. Göteborg.

Herscher, Ellen
1981 Southern Cyprus, the Disappearing Early Bronze Age and the Evidence from Phaneromeni. In *Studies in Cypriote Archaeology*, edited by J.C. Biers & David Soren, pp. 79-85. Institute of Archaeology Monograph XVIII. University of California, Los Angeles.

Heywood, Harry C., Stuart Swiny, Deborah Whittingham, & Paul Croft
1981 Erimi Revisited. *RDAC*, 24-42.

Karageorghis, Vassos
1958 Finds from Early Cypriot Cemeteries. *RDAC*, 115-152.

Peltenburg, Edgar J., *et al.*
1985 *Lemba Archaeological Project I: Excavations at Lemba*-Lakkous, *1976-1983*. SIMA LXX:1. Göteborg.

Ross, James F.
forthcoming
 The Vounous Jar Revisited.

Stewart, Jennifer D.
1978 Preliminary Remarks on the Chalcolithic Pottery Wares from Lemba-*Lakkous*. *RDAC*, 8-19.

1985 Discussion of Areas I and II Ceramics. In *Lemba Archaeological Project I: Excavations at Lemba*-Lakkous, *1976-1983*, edited by Edgar J. Peltenburg, pp. 249-270. SIMA LXX:1. Göteborg.

Swiny, Helena W., ed.
1982 *An Archaeological Guide to the Ancient Kourion Area and the Akrotiri Peninsula*. Department of Antiquities, Nicosia.

Swiny, Stuart
1976 Stone "Offering Tables" from Episkopi-*Phaneromeni*. *RDAC*, 43-56.

1981 Bronze Age Settlement Patterns in Southwest Cyprus. *Levant* XIII, 51-87.

1985a Sotira-*Kaminoudhia* and the Chalcolithic/Early Bronze Age Transition in Cyprus. In *Archaeology in Cyprus 1960-1965*, edited by Vassos Karageorghis, pp. 115-124. Nicosia.

1985b The Cyprus American Archaeological Research Institute Excavations at Sotira-*Kaminoudhia* and the Origins of the Philia Culture. In *Acts* 1985, 13-26.

1986 The Philia Culture and its Foreign Relations. In *Acts* 1986, 29-44.

Tatton-Brown, Veronica, ed.
1979 *Cyprus BC: 7000 Years of History*. Exhibition Catalogue. British Museum Publications, London.

Walz, Clark A.
n.d. Pottery from Sotira-*Kaminoudhia* in the Chalcolithic Tradition. Manuscript.

V

Beyond Regionalism: Toward an Islandwide Early and Middle Cypriot Sequence

Ellen Herscher

Paul Åström (*SCE* IV Pt. 1B) and J.R. Stewart (*SCE* IV Pt.1A, 205-391) developed the standard typologies for Early and Middle Bronze Age Cypriot pottery principally by utilizing material excavated from the North Coast cemeteries at Lapithos-*Vrysi tou Barba* and Bellapais-*Vounous*. They considered pottery from more limited excavations at other sites that did not conform to this standard system to be minor regional variations of the norm. Among the Red Polished ware deviations, Stewart noted particularly the "Philia culture" and also suggested the existence of a south coast style, while Åström discussed regions that used a more linear version of White Painted ware.

Since these publications, excavations of settlements and tombs in central, southern, eastern and western Cyprus have demonstrated that, in fact, regionalism was the *norm* before the Late Bronze Age. Of principal importance are major systematic excavations at Alambra-*Mouttes*, Episkopi-*Phaneromeni* and Sotira-*Kaminoudhia*, as well as extensive accidental discoveries at Larnaca, Kalavasos, and in the Limassol area. Comprehensive surveys around Paphos and Episkopi have supplied some supplementary material.[1]

Thus enough data from known contexts are now available to formulate at least preliminary descriptions of the ceramic characteristics of several regions of the island during the period between Chalcolithic and the beginning of the Late Bronze Age. These descriptions have been possible, however, only by disengaging them from the standard classification systems, since the new

material did not conform to the north coast styles upon which the systems were based (cf. Merrillees, this volume; Herscher 1976; 1981, 80-81). Hence the proliferation of terms such as Red Polished Mottled ware, Red Polished Punctured ware, Drab Polished Blue Core ware, etc., which are proving helpful in comparing ceramics from various sites and clarifying the essential differences. A critical problem with the current state of the regional characterizations and the accompanying terminology, however, is its lack of chronological framework.

It is now clear that sites such as Episkopi-*Phaneromeni* and Sotira-*Kaminoudhia* have long histories of their own. Since all relative and absolute chronologies for the Early and Middle Cypriot periods are based upon the standard developmental sequences, as constructed by Åström and Stewart, the true nature of this period will not be understood until the parallel sequences from the other parts of Cyprus can be linked to those from the north coast. But a corollary to regionalism is isolationism. This makes it difficult to establish the synchronisms that would connect the pottery from the various areas.

While the various regions appear to have been isolated in most ways, fortunately a few "imports" from other areas can be recognized at most sites. For example, the presence of Proto White Slip ware at Episkopi-*Phaneromeni* provided a final date for the destruction of the settlement (LC IA), even though the prevalence of Red Polished ware had originally suggested an Early Cypriot date for the site (Weinberg 1956). The more

1. Most of this material is unpublished or published either in brief accounts or preliminary reports. For Alambra-*Mouttes*, see Barlow 1982; Barlow & Coleman 1982; Coleman 1977, 1985; Coleman & Barlow 1979; Coleman *et al.* 1981; Coleman *et al.* 1983. For Episkopi-*Phaneromeni*, see Carpenter 1981; Herscher 1976, 1981; Swiny 1976, 1979; Weinberg 1956. For Sotira-*Kaminoudhia*, see Swiny 1985a, 1985b, 1986. For accidental discoveries in the Larnaca area, see Herscher 1988, with references. For Kalavasos, see Karageorghis 1958, 116-141; Karageorghis 1985, 915-922; Karageor-

ghis 1988, 846-849; Karageorghis 1989, 793-794; Pearlman 1985, 164; Todd 1986. For the Limassol area, see Herscher 1976; Karageorghis 1958, 142-146; Karageorghis 1960, 266-267; Karageorghis 1964, 324-327; Karageorghis 1967, 306-308; Karageorghis 1971, 357-358; Karageorghis 1972, 1030; Karageorghis 1973, 618; Karageorghis 1983, 907-908. For surveys in the Paphos area, see Hadjisavvas 1977, 224-225; Peltenburg *et al.* 1983, 46-53; Peltenburg *et al.* 1987, 15-17; Sørensen 1983, 285; Sørensen *et al.* 1987, 262-266. For Episkopi area survey, see Swiny 1979, 1981.

extensive excavations by Kent State University also produced scant amounts of White Painted ware (including WP V) and Black-on-Red ware, clear indications that the occupation of Episkopi-*Phaneromeni* had extended at least until late in Middle Cypriot (Herscher 1976, 15; Carpenter 1981, 64, fig. 3-12).

To synchronize fully the various regions, many more such cross-links must be found and recognized. Thus it may be useful to summarize the types that, according to the current state of evidence, seem to be some of the most important kinds of intra-island trade pottery.

NORTH COAST STYLE TYPES

A very distinct type of Red Polished III black-topped bottle is known from both Lapithos-*Vrysi tou Barba* and Bellapais-*Vounous* and can be dated to EC IIIB/MC I (Herscher 1978, 590, 592; *SCE* IV Pt.1A, fig. CI: 5). It has a piriform body, tapering neck, and flaring rim with two opposed holes piercing it. Its standard incised decoration consists of a horizontal zigzag band, composed of parallel lines around the body, and groups of concentric circles strung on a horizontal line on the neck and sometimes the upper body. Examples found at southern sites include one from Tomb 23D at Episkopi-*Phaneromeni* (Fig. 5.1; Carpenter 1981, fig. 3-5), one from Sotira-*Kaminoudhia*, Area A, Room 5, and one from Kalavasos-*Panayia Church* (Todd 1986, fig. 36: 1). Chronologically, the *Kaminoudhia* example comes

from the latest occupation of the settlement, while the tomb from which the Kalavasos bottle comes is described as the earliest one excavated in this cemetery. This tomb (Tomb 46) also contained a black-topped juglet decorated with bands of neatly incised concentric circles (Todd 1986, fig. 36: 4) like those on a black-topped bowl from Lapithos-*Vrysi tou Barba* dated to EC III (Herscher 1975, fig. 22).

Also found at Episkopi-*Phaneromeni* were two Red Polished III gourd juglets decorated with incised concentric circles of a type common on the North Coast (cf. e.g., *SCE* IV Pt.1A, fig. XC: 10, XCI: 4, 5, 16) and dating there to EC IIIB/MC I. These juglets however, were found in Area J, a part of the site excavated only to a very limited extent but probably contemporary with Area A, that is, LC IA. They thus serve as a cautionary reminder that imports can provide nothing more than a *terminus post quem* for the context in which they are found.

A final close connection between Lapithos-*Vrysi tou Barba* and Episkopi-*Phaneromeni* is found in several Red Polished II black-topped vessels with a very distinctive wheel motif. Three of these jars are from three different Lapithos tombs, dating to EC II (821A.17, 822B.8, 823.7: Herscher 1975, fig. 2; Herscher 1978, 449, 460-461, 470). They find a close parallel in a black-topped bottle from Episkopi-*Phaneromeni* Tomb 12 (Fig. 5.2; Duryea 1965, pl. LX: 1), probably decorated by the same hand,

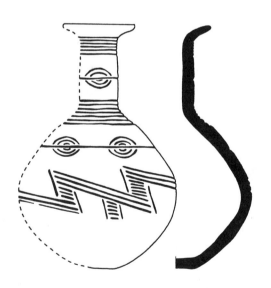

Figure 5.1. *Red Polished III black-topped bottle (Episkopi-Phaneromeni P46, T. 23D.9).*

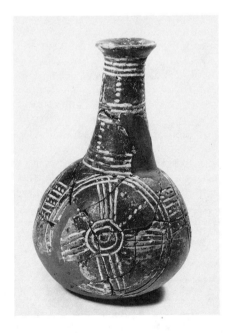

Figure 5.2. *Red Polished II bottle (Episkopi-Phaneromeni, T.12.28); illustrated with the kind permission of Saul Weinberg, courtesy of the Museum of Art and Archaeology, University of Missouri-Columbia.*

which is the earliest datable object known from Episkopi-*Phaneromeni.*

SOUTH COAST STYLE TYPES

Characteristic of the south and southeastern coast and distributed at a number of sites is a group of small Brown Polished vessels. Most are bottles, although some juglets, spindle whorls, and a few bowls are known as well. They are made from a very fine soft light gray-brown fabric with a thin lustrous dark brown or gray-brown slip, suggesting Red Polished ware that has not been fired in a fully oxidizing atmosphere (cf. Barlow 1989, 56). They are decorated with fine linear incision, distinguished in particular by bands filled with lines or dots or short strokes. Often they occur in groups, that is, several within a single tomb, and because of the fragile nature of the fabric, they are frequently in an extremely fragmentary condition.

The greatest number and variety of these vessels has so far been found at Kalavasos-*Panayia Church* (e.g., Karageorghis 1958, figs. 5: 6, 12: 7, 14, 18: GI; Todd 1986, fig. 36: 5-10). Several of these bottles were found in tombs from Cemetery C at Episkopi-*Phaneromeni* (Fig. 5.3; Swiny 1976, figs. 8, 9) and a juglet of this type was found in Area J there. Such bottles were also found in Tombs 4, 8, and 12 at Sotira-*Kaminoudhia.* In Kalavasos-*Panayia Church* Tomb 46, examples (K-PC 397, K-PC 405, K-PC 409, K-PC 412, K-PC 424) occurred with north coast style Red Polished III black-topped bottles and juglets, suggesting an Early Cypriot III to Middle Cypriot I date for the type. None of the Sotira-*Kaminoudhia* examples came from tombs containing Philia-style pottery, but rather were found with Red Polished South Coast, Drab Polished Blue Core, and Red Polished Mottled wares.

One of the most distinctive wares of the south coast is Red Polished Punctured ware, found so far most plentifully in Settlement A at Episkopi-*Phaneromeni* (Carpenter 1981, figs. 3-15, 3-16, 3-17; Herscher 1981, 81, fig. 4-3) and dated there to LC IA because of its association with Proto White Slip ware. It is most easily identified by the meticulous incised and punctured geometric

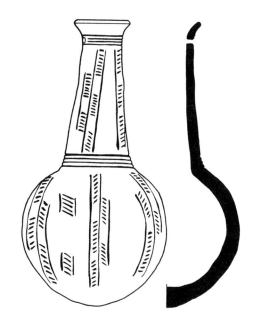

Figure 5.3. Brown Polished bottle (Episkopi-Phaneromeni P7, T.23B.1).

decoration that occurs on the shoulders and necks of closed vessels such as small jugs and amphorae. A few examples of this ware have been found at other sites around the island: a "feeding bottle" from a looted tomb found during survey at Kalavasos-*Mitsingites* (Todd 1978, fig. 18: 6); a fragmentary (probable) juglet from the dromos of Maroni-*Kapsaloudhia* Tomb 2[2] (found with, e.g., Proto White Slip, White Painted V-VI, Black Slip, and Tell el-Yahudiyeh wares); a juglet from Myres' excavations at Kalopsidha (Frankel 1983, 97, pl. 30: 898); and a fragmentary juglet from Tomb 804D at Lapithos-*Vrysi tou Barba* (Herscher 1976, pl. II: 8). The presence of Red Polished Punctured ware in this last tomb clearly indicates that the use of the ware began *before* LC IA: while one of the latest tombs in the Lapithos-*Vrysi tou Barba* cemetery, the last burial in 804D was still only late in MC III.

CONCLUSION

Almost all the intra-island imports that have been recognized are small closed vessels, with small flasks or

bottles by far the most common shape, suggesting that they were containers for traded substances. Furthermore,

2. I wish to thank Gerald Cadogan for his kind permission to mention this piece.

each type has a very distinctive, almost stereotyped, shape and decoration which could have served as a recognizable "trademark" for its source or contents (cf. Merrillees 1968, 156-157). Could any of these vessels indicate the antecedents of the opium trade that has been postulated for the Late Bronze Age (Merrillees 1989, with references)?

Finally, the very fragmentary nature of many of these pieces indicates the need for alert excavation and sherd sorting. The examples mentioned here can, when their contexts are fully examined, help to establish an islandwide chronological framework for the Early and Middle Cypriot periods, but the evidence is still insufficient to develop a fully reliable chronology. Perhaps this brief discussion will help increase awareness and recognition of these and similar types in the field.

REFERENCES

Barlow, Jane A.
1982 The Stratified Pottery of the Bronze Age Settlement at Alambra, Cyprus. Ph.D. dissertation, Department of Classics, Cornell University. Ithaca, New York.

1989 Red Polished Ware: Toward Clarifying the Categories. *RDAC*, 51-58.

Barlow, Jane A. & John E. Coleman
1982 Alambra and the Earlier Phases of the Cypriot Bronze Age. *RDAC*, 31-36.

Carpenter, J.R.
1981 Excavations at Phaneromeni: 1975-1978. In *Studies in Cypriote Archaeology*, edited by J.C. Biers & David Soren, pp. 59-78. Institute of Archaeology Monograph XVIII. University of California, Los Angeles.

Coleman, John E.
1977 Cornell Excavations at Alambra, 1976. *RDAC*, 71-79.

1985 Investigations at Alambra, 1974-1984. In *Archaeology in Cyprus, 1960-1985*, edited by Vassos Karageorghis, pp. 125-140. Nicosia.

Coleman, John E. & Jane A. Barlow
1979 Cornell Excavations at Alambra, 1978. *RDAC*, 159-167.

Coleman, John E., Jane A. Barlow, & K.W. Schaar
1981 Cornell Excavations at Alambra, 1980. *RDAC*, 81-98.

Coleman, John E., K.W. Schaar, L.F. Decker, Jane A. Barlow, & Walter Fasnacht
1983 Cornell Excavations at Alambra, 1982. *RDAC*, 76-91.

Duryea, Diane
1965 *The Necropolis of Phaneromeni and its Relation to Other Early Bronze Age Sites in Cyprus.* M.A. thesis, University of Missouri.

Frankel, David
1983 *Corpus of Cypriote Antiquities 7. Early and Middle Bronze Age Material in the Ashmolean Museum, Oxford.* SIMA XX:7. Göteborg.

Hadjisavvas, Sophocles
1977 The Archaeological Survey of Paphos. A Preliminary Report. *RDAC*, 222-231.

Herscher, Ellen
1975 New Light from Lapithos. In *The Archaeology of Cyprus: Recent Developments*, edited by Noel Robertson, pp. 39-60. Park Ridge, New Jersey.

1976 South Coast Ceramic Styles at the End of the Middle Cypriote. *RDAC*, 11-19.

1978 The Bronze Age Cemetery at Lapithos, Vrysi tou Barba, Cyprus: Results of the University of Pennsylvania Museum Excavation, 1931. Ph.D. dissertation, Department of Classical Archaeology, University of Pennsylvania. Philadelphia.

1981 Southern Cyprus, the Disappearing Early Bronze Age and the Evidence from Phaneromeni. In *Studies in Cypriote Archaeology*, edited by J.C. Biers & David Soren, pp. 79-85. Institute of Archaeology Monograph XVIII. University of California, Los Angeles.

1988 Kition in the Middle Bronze Age: The Tombs at Larnaca-*Ayios Prodromos*. *RDAC*, 141-166.

Karageorghis, Vassos
1958 Finds from Early Cypriot Cemeteries. *RDAC* 1940-48, 115-152.

1960 Chronique des fouilles et découvertes archéologiques à Chypre en 1959. *BCH* 84, 242-299.

1964 Chronique des fouilles et découvertes archéologiques à Chypre en 1963. *BCH* 88, 289-379.

1967 Chronique des fouilles et découvertes archéologiques à Chypre en 1966. *BCH* 91, 275-370.

1971 Chronique des fouilles et découvertes archéologiques à Chypre en 1970. *BCH* 95, 335-432.

1972 Chronique des fouilles et découvertes archéologiques à Chypre en 1971. *BCH* 96, 1005-1088.

1973 Chronique des fouilles et découvertes archéologiques à Chypre en 1972. *BCH* 97, 601-689.

1983 Chronique des fouilles et découvertes archéologiques à Chypre en 1982. *BCH* 107, 905-953.

1985 Chronique des fouilles et découvertes archéologiques à Chypre en 1984. *BCH* 109, 897-967.

1988 Chronique des fouilles et découvertes archéologiques à Chypre en 1987. *BCH* 112, 793-855.

1989 Chronique des fouilles et découvertes archéologiques à Chypre en 1988. *BCH* 113, 789-853.

Merrillees, Robert S.
1968 *The Cypriote Bronze Age Pottery Found in Egypt.* SIMA XVIII. Lund.

1989 Highs and Lows in the Holy Land: Opium in Biblical Times. *Eretz-Israel* 20, 148-154.

Pearlman, David
1985 Kalavasos Village Tomb 51: Tomb of an Unknown Soldier. *RDAC*, 164-179.

Peltenburg, Edgar J. *et al.*
1983 The Prehistory of West Cyprus: Ktima Lowlands Investigations 1979-1982. *RDAC*, 9-55.

1987 Excavations at Kissonerga-*Mosphilia* 1986. *RDAC*, 1-18.

Sørensen, Lone W.
1983 Canadian Palaipaphos Survey Project: Preliminary Report of the 1980 Ceramic Finds. *RDAC*, 283-299.

Sørensen, Lone W., P. Guldager, M. Korsholm, J. Lund, & T.E. Gregory
1987 Canadian Palaipaphos Survey Project: Second Preliminary Report of the Ceramic Finds, 1982-1983. *RDAC*, 259-278.

Swiny, Stuart
1976 Stone "Offering Tables" from Episkopi-*Phaneromeni*. *RDAC*, 43-56.

1979 Southern Cyprus, c. 2000-1500 B.C. Ph.D. dissertation, Institute of Archaeology, University of London.

1981 Bronze Age Settlement Patterns in Southwest Cyprus. *Levant* XIII, 51-87.

1985a Sotira-*Kaminoudhia* and the Chalcolithic/Early Bronze Age Transition in Cyprus. In *Archaeology in Cyprus, 1960-1985*, edited by Vassos Karageorghis, pp. 115-124. Nicosia.

1985b The Cyprus American Archaeological Research Institute Excavations at Sotira-*Kaminoudhia* and the Origins of the Philia Culture. In *Acts* 1985, 13-26.

1986 The Philia Culture and its Foreign Relations. In *Acts* 1986, 29-44.

Todd, Ian A.
1978 Vasilikos Valley Project: Second Preliminary Report, 1977. *JFA* 5, 161-195.

1986 *The Vasilikos Valley Project 1: The Bronze Age Cemetery in Kalavasos Village.* SIMA LXXI:1. Göteborg.

Weinberg, Saul
1956 Exploring the Early Bronze Age in Cyprus. *Archaeology* 9, 112-121.

VI

New Light on Red Polished Ware

Jane A. Barlow

Three distinguished archaeologists have labored to construct a classification system for Red Polished ware, the predominant pottery in Cyprus throughout the Early and Middle Bronze Age periods. The young John L. Myres conceived the original classification system (Myres & Ohnefalsch-Richter 1899, 36-46), Einar Gjerstad developed it (Gjerstad 1926, 89-131) and James R. Stewart refined it further (*SCE* IV Pt.1A, 225-230, 303-348; Stewart 1988). It is now among the most detailed typologies in all of Cypriot archaeology. Why, then, has it proved so difficult to use this classification system at recently excavated settlement sites? What kinds of adaptations would help us to read the prehistoric record more clearly?

Red Polished ware spans a very long period of time, perhaps as long as 600 years. It appears in a large variety of pastes, shapes and surface finishes. Pottery used for luxury vessels, table wares, storage vessels and cooking pots has all been subsumed within the Red Polished category. All of it is handbuilt, not wheelmade, and all of it has a red surface that is sometimes actually polished and sometimes not. It was fired at temperatures under, probably well under, 750° Centigrade.

The problems in the history of Red Polished classification are problems all archaeologists cope with constantly. Myres strove to devise a coherent sequence for Red Polished ware when, under British administration, "Even in the [Cyprus] Museum, the condition of the Collection was in 1894 deplorable..." and many of the records had been lost (Myres & Ohnefalsch-Richter 1899, vii). This tenuous connection to excavated material was only a slightly lesser problem for Gjerstad who subdivided the ware into four major categories, Red Polished I-IV (Gjerstad 1926, 89-131). Stewart defined shapes and fabrics more closely and also discerned some regional distinctions, even within material largely restricted to sites in the north of the island (*SCE* IV Pt.1A, 223-229 *passim*).

All Cypriot archaeologists working in the prehistoric Bronze Age must take into account the fact that most of the theoretical constructions used for this period derive from material excavated primarily in one area of the island, the north. Not only has our perspective been limited geographically, the EB/MB material has, until recently, come almost exclusively from tombs, largely from the cemeteries of Bellapais-*Vounous* (Stewart & Stewart 1950; Dikaios 1940) and Lapithos-*Vrysi tou Barba* (*SCE* I, 33-172; Schaeffer 1936; Herscher 1978). Cypriot tombs of this period pose further problems since most are chamber tombs containing several burials. Thus it is often difficult, if not impossible, to know which grave goods are associated with any one burial and therefore to establish a chronological sequence. The problem of gleaning information has been further complicated by tombs that frequently have been disturbed by illegal activities, flooding and erosion.

Recent excavations of settlements in addition to cemeteries and new projects undertaken since 1974 in geographical areas of Cyprus hitherto unexplored have revealed further difficulties. Currently, there are three major settlement excavations within the Early and Middle Cypriot periods, all recently completed and all still awaiting final publication. The Sotira-*Kaminoudhia* site, excavated by Stuart Swiny of the Cyprus American Archaeological Research Institute, probably falls early in the period (Swiny 1985, 116-118; Swiny 1989, 14). The Alambra-*Mouttes* site, excavated by John Coleman of Cornell University, can be dated somewhere in the middle of the time span (Coleman 1985, 136-138). The Episkopi-*Phaneromeni* site, excavated by James Carpenter of Kent State University, falls at the very end of Middle Bronze and the beginning of Late Bronze (Carpenter 1981). These sites do not appear to overlap chronologically. There are three other much smaller settlement sites, each comprising only one building: a house at Alambra (Gjerstad 1926, 19-27), another dwelling at Kalopsidha (Gjerstad 1926, 27-37) and a building at Ambelikou-*Aletri* (Dikaios 1946, 244-245) which have never been satisfactorily related to the tomb sequence (Barlow 1985).

With the new excavations, Cypriot archaeologists are now faced with three large bodies of settlement pottery that do not fit easily into the conventional Red Polished ware sequence. The pottery from Episkopi-

Phaneromeni, while it can be tied to the end of Middle Bronze and the beginning of Late Bronze by the presence of Proto-White Slip, has stimulated the use of several new terms in order to describe fabrics that were not part of the assemblage in the northern cemeteries. Neither of the other two bodies of material, one from Sotira-*Kaminoudhia* and one from Alambra-*Mouttes*, easily fits the pattern that has been derived from the tombs.[1]

The nature of the problems can be demonstrated at Alambra-*Mouttes*, a habitation site located about twelve miles south of Nicosia. Excavations, which took place in four seasons between 1976 and 1982, revealed part of a settlement (Coleman 1985). There were parts or all of at least seven multi-roomed buildings, closely packed, with party walls. That the excavated area was part of a much larger town or village could be shown not only by surface scatter but also by evidence of walls, hearths, stone tools and pottery that appeared in two military trenches some distance away that were dug just after excavation ended (Coleman *et al.* forthcoming, fig. 9a).

The pottery from the Alambra settlement was almost entirely Red Polished ware; it was, in the conventional terminology, Red Polished III. There were also a few pieces that might be termed Red Polished II and some sherds, perhaps, of Red Polished IV. There were well over 110,000 sherds, and 99% fell one way or another into the RP III category.

However, placement within the RP III category did not in itself provide very much information. Red Polished III occurs in time periods from the late Early Cypriot all the way to the end of Middle Cypriot. Unlike RP I and RP II which appear in the north of the island, RP III is represented in most regions of Cyprus. Moreover, the overwhelming preponderance of the pottery from the settlement excavation was in the form of sherds. The sherds could be grouped into broad categories of shapes correlating with more complete vessels, but the full range of variations within each shape was impossible to determine. A further problem was that each numerically designated category comprised several different fabrics (*SCE* IV Pt.1A, 223). Stewart described Red Polished III in particular as including "a variety of fabrics, of which only the commonest can be mentioned" (*SCE* IV Pt.1A, 228). Stewart himself deplored this situation, stating in the introduction to his section of the *Swedish Cyprus Expedition*, "Except for my pottery from Vounous information about fabrics was almost entirely lacking, which made a normal ceramic classification impossible" (*SCE* IV Pt.1A, 212). The dearth of specific information on fabrics made it extremely difficult to deal with the Alambra sherds (for further com-

ments on the problems of using Stewart's classification system, see Frankel, this volume).

In sum, the traditional typology, based primarily on shape and decoration and set forth in the *Swedish Cyprus Expedition*, provided insufficient help. The variations at Alambra within each category of pastes, shapes and surface finishes were extraordinarily wide. As the ceramic specialist, I was convinced that it was essential to find ways of subdividing the material in order to make sense of it and to compare it more precisely with pottery from sites that had already been excavated or from sites to be excavated in the future.

Along with the Red Polished ware there were a few pieces of two different kinds of White Painted ware, White Painted II and a subvariety of White Painted IV, to use the conventional terminology. These two varieties of White Painted, according to the traditional tomb pottery sequence, would be unlikely to appear together (*SCE* IV Pt.1B, 179, 198-199), yet they occurred at Alambra on the same levels in the same rooms. In addition, there were very small quantities of both Black Polished ware and of the black-topped variation of Red Polished ware. Rather than seeking explanations for this somewhat unorthodox assemblage, it seemed wiser to attempt to confront the material on its own terms.

This was easier said than done. Efforts extending over several seasons to find sustainable subdivisions for the large quantities of Red Polished sherds failed repeatedly. Although extremes in fabric and finish were obvious, variations seemed infinite and dividing lines shifted constantly. A kaleidoscope of pastes, shapes and surface finishes seemed to have no underlying rationale. The decision was finally made to commission some technical analyses of the pottery to define its composition in an objective fashion so that other excavators would have a basis for comparison. We also hoped to ascertain whether there were any physical or chemical properties that were not obvious in the field tests.

The projected analyses were of the most basic variety, a petrographic study of the rock and mineral inclusions and a chemical study to identify the most important elements in the pastes and slips. Details of the completed analyses have been published in *Archaeometry* (Barlow & Idziak 1989, 66-76) with further information also set out in the forthcoming Alambra site report (Coleman *et al.* forthcoming).

There were two major surprises that emerged in the course of the studies. The first came from the petrographic analysis of thin sections made from sherds that represented a wide range of the Red Polished fabrics at the site. The Alambra Red Polished ware, the analysis showed, contained two different kinds of clay. That was

1. For a discussion of the problems of Sotira-*Kaminoudhia*, see Swiny 1985, 115-118; *contra* Henessey *et al.* 1988, 40-41; for

Alambra-*Mouttes*, see Barlow & Coleman 1982; *contra* Merrillees 1985, 15-16; *contra* Coleman 1985, 138-140.

not news in itself since Liliane Courtois, the French geologist and pottery specialist, had already demonstrated this (Courtois 1970, 81-82). Courtois, however, had suggested that the Red Polished sherds she examined reflected, in the composition of their pastes, two different production centers (Courtois 1970, 82). What was surprising then, to the Alambra investigators, was that the two clays appeared in abundance at Alambra both separately and as a mixture. This meant that the bodies of the pots were made from three different pastes, sometimes distinctly different and sometimes not, and all were covered with a red finish that was made from one of the two clays. In light of the large quantities of both types of clay and the wide distribution of the two types among the repertoire of shapes, it seemed highly unlikely that we were seeing a reflection of trade from two different production centers.

The two varieties of clay originated in two separate geological rings that encircle the Troodos mountains. The site of the Alambra settlement is located almost exactly on the dividing line between these two formations (Barlow 1989, fig. 1). During the course of the excavations at Alambra, we had naturally been aware of the two different soil types (*asprogi* and *mavrogi* to local residents and to earlier archaeologists), but we had remained unaware of the possible implications for the pottery. The light colored calcareous clay came from the chalks and limestones of the Lefkara formation, a soil that is very obvious not only at Alambra but also in the region of Dhali. The dark red non-calcareous clay came from the adjacent ring of pillow lavas which happens also to be very conspicuous near Stavrovouni and Kornos. The two types of clay appear all around the Troodos and would have been accessible to potters in ancient times throughout a very large part of Cyprus.

Once we knew what to look for, we could see that the color and texture of the Red Polished pastes related to the known characteristics of the clays. The pastes made entirely from the light calcareous clay were easy to identify. They were soft (Mohs 2 to 3), buff or pink in hue (Munsell 5YR to 7.5YR), light in value (6/ to 8/) and rather strong in chroma (/6 to /8). The pastes contained sparse to moderate numbers of fine to medium-size inclusions (0.25-0.125 mm. to 0.5-0.25 mm. on the Wentworth scale; see thin section, Fig. 6.1b).

However, although it was easy to separate the wholly calcareous pastes from pastes that contained the dark red non-calcareous clay, it was not always easy to distinguish the wholly non-calcareous paste from the mixture of the two clay types. The wholly non-calcareous pastes were generally moderately hard (averaging about Mohs 3 but ranging from Mohs 2 to Mohs 5.5), red in hue (Munsell 10R to 2.5YR), rather dark in value (usually 4/) and strong in chroma (/6 to /8). These pastes contained numerous inclusions that ranged from medium up to coarse or very coarse on the Wentworth scale (0.5-0.25 mm. to 1.0-0.5 or 2.0-1.0 mm.; see thin section, Fig. 6.2b). The third category of pastes, those that were made from the mixture, varied widely and often resembled the wholly non-calcareous pastes. Both the wholly non-calcareous pastes and the pastes made from the mixture of calcareous and non-calcareous clays fired red and contained a moderate to high number of inclusions. To the naked eye or even under 10x magnification, they were often very much alike.

After a few frustrating attempts to find a common field test that would differentiate these two pastes, elementary chemistry came to the rescue. A drop of a 10% solution of hydrochloric acid on a fresh break would effervesce when it came in contact with a coarse red paste that contained some of the limey calcareous clay. To confirm the validity of this acid test, we performed a semi-quantitative chemical analysis using the microprobe attachment of a scanning electron microscope (Barlow & Idziak 1989, 68). Nineteen specimens of Red Polished sherds representing the various pastes and shapes found at Alambra were analyzed. In every instance, a sherd that had reacted positively to HCl could be shown to contain a high proportion of calcium.

Pastes are generally considered calcareous if they contain 6% or more of calcium oxide (Maniatis & Tite 1981, 68-69). The concern that we might be observing calcium that had leached into the sherds from the soil was allayed by the consistency of the HCl results when the test was used on very large quantities of sherds. Although the field test cannot be considered absolutely definitive in any single case, the clear variations in calcium content among vessels of different shapes and fabrics that had been exposed to the same conditions confirmed that we were indeed observing endemic characteristics (Barlow & Idziak 1989, 71, table 1; 73).

At this point in the research, we had begun to realize that the picture was much more complex than predicted. We knew that under the surface of the Alambra Red Polished ware were two different clays used selectively in different ways. We knew the general geological areas from which the clays originated. And, in addition, we had a field test that would tell us what we wanted to know, namely which kinds of clays were being used in a particular vessel. The hydrochloric acid field test made it possible to answer one specific question about a large number of sherds quickly, easily and above all inexpensively.

The following season, we returned to Alambra with a bottle of hydrochloric acid and we got our second surprise. We tested 454 pieces of Red Polished pottery, each representing a single vessel identifiable by shape (Barlow & Idziak 1989, 71, table 1). As we had suspected, the fine calcareous clay was used for fancy incised pots and the coarse non-calcareous clay was used for cooking

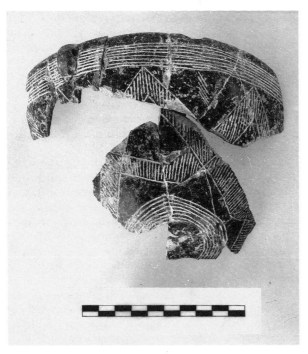

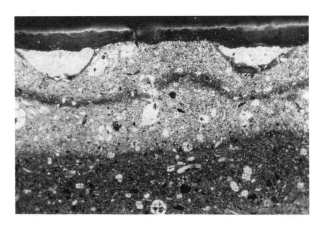

Figure 6.1a. Fragments of a small bowl with incised decoration, Red Polished ware with fabric made from calcareous clay. Alambra vessel AP.109.

Figure 6.1b. Thin section from vessel similar to that shown in Fig. 6.1a. Note abundant microfossils, incised decoration with calcareous filling at surface (top). Alambra specimen SS 83.67; photograph taken with crossed polars at magnification 40.

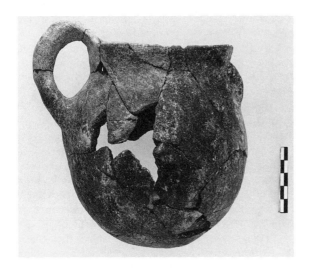

Figure 6.2a. Cooking pot, Red Polished ware with fabric made from wholly non-calcareous clay. Alambra vessel AP.12.

Figure 6.2b. Thin section from vessel similar to that shown in Fig. 6.2a. Note three large volcanic rock fragments (large light areas). Alambra specimen SS 83.43; photograph taken with crossed polars at magnification 40.

vessels. The unexpected finding was that the mixture of the two was used almost exclusively for closed shapes, that is, jugs and jars and pots that were probably intended to contain liquids; large bowls, the paste of which looked very much like the paste of the closed shapes, were nearly all non-calcareous. Other shapes were less clearly differentiated, but it seemed certain that the potters were selecting clays that would impart desired qualities to certain kinds of vessels. The calcareous clay which has low shrinkage and high plasticity was suitable for highly decorated pots (Figs. 6.1a, b). The non-calcareous clay which originated in a volcanic soil was resistant to thermal shock and was very good for cooking vessels (Figs. 6.2a, b). The mixture of the two could be expected to increase porosity and produce a closed vessel that would cool the liquid within (Maniatis & Tite 1975, 22).

The Alambra studies came to a close. The next step was obvious. I went to Cyprus in order to examine and test with hydrochloric acid Red Polished pottery from eight further settlement, cemetery or survey sites.[2] The sites were: Sotira-*Kaminoudhia* Area A, Episkopi-*Phaneromeni* Area G and Episkopi-*Phaneromeni* Area A (settlements); Kalavasos-*Cinema Area*, Kalavasos-*Panayia Church* and Nicosia-*Ayia Paraskevi* (Pente Pigadhion St.) Tomb 6 (cemeteries); Kalavasos-*Laroumena* and Psematismenos-*Trelloukkas* (surface survey sites).

The study now encompasses the results of the hydrochloric acid field test on more than 2500 sherds that come from vessels of defined shapes. The new groups of sherds from these sites include the full range of Red Polished ware, much of which would fall into the various traditional numerical categories of Red Polished I, II, III and IV. Statistical work on the results of the field test is only beginning, but it is already clear that at each site the combination of the two clay types was used more frequently for closed shapes than for open shapes. More specific correlations of shapes with clay types will require further analysis, as will comparisons among the various sites. Petrological studies of a representative sample of sherds from the various sites will also be a major part of this research. Dr. Sarah J. Vaughan is currently pursuing this work at the Fitch Laboratory of the British School at Athens.[3]

When the investigation is complete, there will be information from more than one site in each of three major geographical areas of Cyprus: the central plain, the Vasilikos Valley and the Kouris River drainage. Results

from these areas will yield a picture of how clays were used in Red Polished ware throughout a large part of Cyprus for an extensive period of time. We do know now that Red Polished ware at all the sites tested was composed of the two different clay types and that they were used both separately and in varying combinations. This simple fact goes a long way toward explaining why it has been so difficult for archaeologists to agree on subcategories for Red Polished ware and why regional and chronological development as seen through the pottery has been so difficult to discern. Subcategories stemming from the use of each clay separately are now beginning to emerge. Associated shapes, surface finish and decoration as well as the color of the paste and its inclusions form divisions, some of which can even now be defined.

The Red Polished category that uses only calcareous clay is so easy to identify by the color of the paste and the character of the inclusions as well as by associated shapes, surface finish and decoration that I feel confident in suggesting it as a broad subdivision of Red Polished ware (Barlow 1989). This new division, tentatively termed Red Polished A, cuts across the traditional categories of Red Polished I, II and III and is one which the ancient potters themselves probably recognized. Refinements that will help to specify chronological or regional characteristics within the new category will undoubtedly prove to be desirable as work on the pottery continues.

Proposals for further subdivisions will entail a great deal more study. It is not yet clear how the use of mixed clays or non-calcareous clay correlates with shape or surface finish. The pattern that occurred in the Alambra pottery (Barlow & Idziak 1989, table 1) appears to be reproduced only in certain aspects in pottery from other sites. Neither is it yet clear how the varieties of Red Polished ware at a given site correlate with the local geological resources.

The studies do support suggestions put forth by David Frankel (Frankel 1981, 96) and others that it was techniques of pottery manufacture that spread from one part of the island to the other. If that is so, detailed work may now be more precisely focused, and further analyses may reveal that there are minor differences within each clay type in different regions of Cyprus.

An understanding of the clays may also reveal the relationships between wares. For example, at Alambra, the calcareous Red Polished fabric is very close in both petrographic and chemical characteristics to early White

2. It is a pleasure to thank the Fulbright Commission for an award which enabled me to spend ten months in Cyprus in 1988-89. I wish also to thank the following for permission to examine and test Red Polished ware from the sites mentioned: Dr. James R. Carpenter, Dr. Vassos Karageorghis, Dr. Stuart Swiny and Dr. Ian A. Todd.

3. I am grateful to the Institute for Aegean Prehistory for a grant which has made this work possible.

Painted ware (Barlow & Idziak 1989, 71, 74). The rapid spread of early White Painted ware (White Painted II) is easy to account for if the White Painted technology was simply a variation of a Red Polished technology that was already familiar to the potters. Furthermore, within the very large collection of pottery from Nicosia-*Ayia Paraskevi* (Pente Pigadhion St.) Tomb 6, an apparently later higher-fired calcareous fabric (not named or identified in the literature) seems to develop into Black Slip, a ware that appears toward the end of the Middle Bronze Age (Personal observation[4]).

These investigations have made progress for several reasons that are easy to see in retrospect but were not clear at the outset. First, the initial objective was a very broad one—simply to characterize the pottery. If we had attempted to pinpoint provenience, for example, perhaps by searching for key trace elements with the use of neutron activation analysis, it would not have been possible to discern the two basic types of clay that were clearly significant to the ancient potters. Second, in the Alambra studies we restricted the sample by using only sherds from the lowest levels of the single period settlement site, setting aside surface sherds or sherds from the five tombs of differing dates that were also excavated. The broader field tests done in 1988-89 included cemetery and survey sites as well as settlements, but each sample is clearly defined so that results of the new tests can be linked to appropriate sites or chronological periods. Third, the greatest leaps in understanding were made in discussions between the field archaeologist and the person doing the technical work. Time spent learning to understand the problems from each perspective yielded unpredictable dividends. Finally, although we needed a large sample of sherds in order to draw valid conclusions, we only gradually realized the value of using the laboratory studies to find a field test or a method of observation that could be specifically focused and rapidly and inexpensively used.

If, as now seems likely, we have a key to understanding the variations within Red Polished ware not simply at one site but throughout Cyprus, what does this mean? The structure of a typology determines the kinds of questions that can be asked. Earlier scholars such as Myres, Gjerstad and Stewart, were primarily concerned with chronological questions. Further study of the technical differences present in Red Polished ware that have been revealed by this study may provide answers to other types of questions such as locations of production centers, relationships to local resources and the nature of intra-island trade. As Stephen Jay Gould recently said, "Taxonomies...channel our thinking into fruitful paths when a classification properly captures causes of order..." (Gould 1989).

4. Dr. Vassos Karageorghis and Dr. Maria Hadjicosti graciously allowed me to examine this material.

REFERENCES

Barlow, Jane A.
1985 Middle Cypriot Settlement Evidence: A Perspective on the Chronological Foundations. *RDAC*, 47-54.

1989 Red Polished Ware: Toward Clarifying the Categories. *RDAC*, 51-58.

Barlow, Jane A. & John E. Coleman
1982 Alambra and the Earlier Phases of the Cypriot Bronze Age. *RDAC*, 71-79.

Barlow, Jane A. & Phillip Idziak
1989 Selective Use of Clays at a Middle Bronze Age Site in Cyprus. *Archaeometry* 31, 66-76.

Carpenter, James R.
1981 Excavations at Phaneromeni. In *Studies in Cypriote Archaeology*, edited by J.C. Biers & David Soren, pp. 59-78. Institute of Archaeology Monograph XVIII. University of California, Los Angeles.

Coleman, John E.
1985 Investigations at Alambra, 1974-1984. In *Archaeology in Cyprus 1960-1985*, edited by Vassos Karageorghis, pp. 125-140. Nicosia.

Coleman, John E., Jane A. Barlow, Marcia K. Mogelonsky & Kenneth W. Schaar, eds.
forthcoming
 Alambra: A Middle Bronze Age Site in Cyprus; Investigations by Cornell University 1974-1985. SIMA.

Courtois, Liliane
1970 Note préliminaire sur l'origine des différentes fabriques de la poterie du chypriote récent. *RDAC*, 81-85.

Dikaios, Porphyrios
1940 *Excavations at Vounous*-Bellapais *in Cyprus, 1931-2*. Oxford.

1946 Wartime Discoveries of the Earliest Copper Age. *Illustrated London News*, March 2, pp. 244-245.

Frankel, David
1981 Uniformity and Variation in a Cypriot Ceramic Tradition: Two Approaches. *Levant* XIII, 88-106.

Gjerstad, Einar
1926 *Studies on Prehistoric Cyprus*. Uppsala.

Gould, Stephen Jay
1989 Judging the Perils of Official Hostility to Scientific Error. *New York Times* July 30,

News of the Week in Review, p. 4.

Hennessy, J. Basil, Kathryn O. Eriksson & Ina C. Kehrberg
1988 *Ayia Paraskevi and Vasilia: Excavations by J.R.B. Stewart*. SIMA LXXXII. Göteborg.

Herscher, Ellen C.
1978 The Bronze Age Cemetery at Lapithos, Vrysi tou Barba, Cyprus: Results of the University of Pennsylvania Museum Excavation, 1931. Ph.D. dissertation, Department of Classical Archaeology, University of Pennsylvania. Philadelphia.

Maniatis, Yannis & M.S. Tite
1975 Scanning Electron Microscopy of Fired Calcareous Clays. *Transactions and Journal of the British Ceramic Society* 74, 19-22.

1981 Technological Examination of Neolithic-Bronze Age Pottery from Central and Southeast Europe and from the Near East. *Journal of Archaeological Science* 8, 59-76.

Merrillees, Robert S.
1985 Twenty-five Years of Cypriot Archaeology: the Stone Age and Early and Middle Bronze Ages. In *Archaeology in Cyprus 1960-1985*, edited by Vassos Karageorghis, pp. 11-19. Nicosia.

Myres, John L. & Max Ohnefalsch-Richter
1899 *A Catalogue of the Cyprus Museum*. Oxford.

Schaeffer, C.F.A.
1936 *Missions en Chypre 1932-1935*. Paris.

Stewart, Eleanor & James Stewart
1950 *Vounous 1937-38: Field-report on the Excavations Sponsored by the British School of Archaeology at Athens*. Lund.

Stewart, James R.
1988 *Corpus of Cypriot Artefacts of the Early Bronze Age*, edited by Eleanor Stewart & Paul Åström. SIMA III:1. Göteborg.

Swiny, Stuart
1985 Sotira-*Kaminoudhia* and the Chalcolithic/Early Bronze Age Transition in Cyprus. In *Archaeology in Cyprus 1960-1985*, edited by Vassos Karageorghis, pp. 115-124. Nicosia.

1989 From Round House to Duplex: A Re-assessment of Prehistoric Cypriot Bronze Age Society. In *Early Society in Cyprus*, edited by Edgar J. Peltenburg, pp. 14-31. Edinburgh.

The Classification of Middle Bronze Age Painted Pottery: Wares, Styles...Workshops?

Louise C. Maguire

The ultimate concern of this paper is to acknowledge that while discrepancies exist within the current classification sequence of Middle Bronze Age pottery, there is scope for review and refinement without totally demolishing that classification. With particular reference to White Painted V Ware (*SCE* IV Pt.1B 66-78; Åström 1966, 87-90), it is possible to extract from the study of stylistic variation, indications of the mode of pottery production and the pattern of pottery distribution within Cyprus. This information is essential before the ramifications of Cypriot pottery found outside Cyprus can be tackled.

The standard White Painted system is entrenched in a paradigm of chronological succession, crystallized in the numerical divisions I-VI. It is a sequence which draws on material biased by the very nature of the evidence. The paucity of settlement material coupled with the abundance of looted, disturbed and reused tombs, particularly in the north of the island, has led to inconsistencies in the analysis of artifactual data. Gjerstad, working essentially from the broad framework of Myres and Ohnefalsch-Richter (1899), introduced through a *type* series an inherent chronological denotation. He "tried typologically to arrange the material in each vase-class, and...indicated the various types with Roman numerals" (Gjerstad, 1926, 88). The definitive meaning of these numerical divisions as chronological indicators, however, was not attempted. While an overall development can be traced from White Painted I to V, outlined in his excavations at Alambra and Kalopsidha (1926, 268-273), the evidence for the chronological succession of each type over the whole of the island is lacking (Barlow 1985, 50-51; Coleman 1985, 138-140).

Coleman (1985, 136 n.7) further demonstrates the confusion and lack of correlation between Åström and Gjerstad in identifying WP II, III and IV—especially where Åström has moved Gjerstad's types from WP III to IV, for example, on the dating of Lapithos and Ayios Iakovos:

In consequence of the view held here that the Lapithos sequence comes down later, and the Ayios Iakovos sequence starts earlier, some alterations in the previous classification have been made....the later of these groups has been classified as White Painted IV and part of the former White Painted III Ware has also been included in White Painted V Ware.

(*SCE* IV Pt.1B, 11)

The lack of cross correlation between Åström and Gjerstad (Coleman 1985, 138-140) highlights the amount of subjectivity involved in the structure of the classification sequence and the dependence on typologies when they are used as tools of relative chronologies.

A major contribution to the study of the White Painted Wares, therefore, was the identification of individual styles from the standard types, and the isolation of these styles into the discrete classes of White Painted III-IV Pendent Line Style, IV-VI Cross Line Style and similarly WP V Framed Broad Band Style and WP VI Soft Triglyphic Style (Åström 1966, 90, 92-93). In identifying these styles Åström acknowledged that the standard White Painted sequence set up by Gjerstad was representative of the pottery in the northern and central parts of the island, although he continued to place increasing importance on the chronological succession of each ware. It is recognized that these styles have their own temporal and spatial distributions (*SCE* IV Pt.1B, 11; Merrillees 1978, 20-21). These Styles can be studied virtually independently of the White Painted II-V type series, especially since the type series has proved incapable of satisfactorily absorbing new material from excavations within Cyprus as well as exported Cypriot pottery.

In his stylistic analysis of the Middle Cypriot White Painted Pottery, Frankel (1974) assessed the proportional occurrence of the designs on vessels in different tomb assemblages, although the isolation of these particular groups studied through time was not attempted. The

results of this analysis, which showed that certain motifs were popular in specific locations, demonstrated a degree of interregional contact over the whole of the island. Broadly speaking, the Karpass region is the most distinct, with a high frequency of Wavy Line motif and the linear motifs of the eastern sites. In the center of the island geometric motifs such as double checkerboard rows alternating with crosshatched zigzags, lozenges or triangles are more popular, and toward the north coast vertical crosshatched panels and wavy lines are more common.

In contrast to the east/west dichotomy advocated by Åström (*SCE* IV Pt.1B, 275 and n. 7), Catling (1973, 170) and Merrillees (1971, 72), Frankel's analysis concludes that ceramic diversity is evident, although the island can be divided into a series of overlapping regions (1974, 47). He proposes greater contact between neighboring sites on the basis of similarity of motifs and paints a picture of strong interaction between different villages, against a background of trade or intermarriage with more peaceful conditions than those invoked by Merrillees (Frankel 1974, 48-51; Merrillees 1971, 77). Whatever the intensity of these relations, it is very clear that the White Painted pottery repertoire is being used to reflect the cultural distinctions of different areas in Cyprus.

That these results could be produced using only decoration as a varying element without considering other technological factors in the pottery suggests that the relative popularity of combinations of motifs on individual pots within assemblages, together with technique, should be taken into account. If we expand these preliminary definitions of style to include peculiarities and similarities in the execution of various elements such as combinations of decoration, shape and form by individual potters, artists or workshops, rather than identifying regional groups from motif popularity alone (Frankel 1974), it may be possible to identify the mechanics of pottery circulation and distribution on a specific level (Frankel, this volume).

The pottery type is frequently identified by recognizing uniform groups, though realistically, as Shepard states, the type is "artificial in so far as it is selected to serve as a means of outlining relative chronologies, a purpose that has no relation to the conditions of production or original functions of pottery" (1985, 307). Through the varying classification sequences of prehistoric pottery, the tendency to dehumanize decorated pottery via the terminology of artificial type series inadvertently masks the very identity of a potter or artist and the concept of a potter's workshop. Classification essentially facilitates the sorting of large amounts of pottery, allowing interpretations of a chronological and cultural order to be made; yet increasingly we are aware as ceramicists that the rift between potter and pottery artifact is very great.

The humanizing terms, *potter*, *artist* and *workshop*, however, are loaded with archaeological as well as social implications. Their use rests on the supposition that individual stylistic variability is manifest in the artifacts created and as such is identifiable from the archaeological record. The familiar means by which individual artists or workshops have been recognized are predominantly subjective when they rely strongly on the "educated eye" or "sensory feel" of the researcher. However, they should not be ignored because of their subjectivity but should be welcomed in view of the crucial amount of intuition required to identify convincingly stylistic variability.

The difficulty in consistently identifying the work of individuals is exemplified by the adoption of such terms as "analytical individuals" (Muller 1977, 25) and "smallest interaction groups" (Redman 1977, 44), where the similarity in styles is great but may be the work of closely related persons, rather than one individual. In the vocabulary of the art historian, the terms *schools* or *workshops* are more frequently used to encompass degrees of stylistic similarity and difference. The objective in using *workshop* is to collate what would appear to be a closely related body of material, which has been identified by similarity in intent, design and distribution (Adelman 1976, 2). For the moment, *workshop* does not hold connotations of specialized potters or specialized trade, nor does it assume a purely household or domestic mode of production (Frankel 1988, 28-32).

The importance of identifying individual workmanship or the collective traits of a particular workshop lies in the potential to map specific artifact distributions on a definitive localized scale, rather than solely as part of an all-encompassing regional style. In mapping the distribution of Red-on-Black Ware, Merrillees successfully defined a regional grouping in the Karpass Peninsula and in the southeast of the island, as well as a more confined distribution to the west (Merrillees 1979, 115-134). He also suggested the extent of specialized trading activity in that ware over the whole of the island. The distribution, however, is solely of a ware type. It would be profitable to re-examine this material to identify style and microstyle (Muller 1977, 25-30) through which the complexities of pottery production could be more adequately gauged.

The criteria for identifying individual variation amount to a degree of uniformity in vessel form and shape, design content and/or design execution combined with the identification of peculiar traits which display distinctive similarities or differences indicative of individual hands or the same character of workmanship. Similar constructs have been outlined by M. Hardin (1977, 111, 113); in analyzing the characteristics of "personal graphic style" she identified the work of each individual artist.

In several instances, individual artists or potters operating as individuals or within workshops can be isolated from the record. Frankel recognized from the pottery in Lapithos Tombs 316.2 and 702 individual artists within the White Painted pottery repertoire (1974, 50 and n. 29; this volume). He mentions other instances of individual potters from Livadhia, Ayia Paraskevi and Politiko (1974, 50, 52 n. 30). Ellen Herscher identified a so-called Spongy group, found especially in examples from Lapithos Tomb 702 (1972, 23-24). The high porosity value in some pieces was suggested to be the product of one potter or workshop. The ultimate aim, therefore, is to build on these types of associations to form core reference groups, and map a distribution of either individual artists' work, or repertoires of a school or workshop. Frankel (this volume) illustrates the difficulties of identifying individual stylistic variability. Although we can identify with some degree of confidence the work of individual artists (Frankel, this volume, fig. 25.3, Lapithos Tomb 316), we are less certain of constituent artists within the core reference groups when our identification procedure extends beyond *identical* sets of ceramic material.

In terms of its technique and decorative motifs, White Painted V forms one of the most cohesive groupings of the White Painted Ware sequence. It is easily recognized by a pale light brown, mostly hard fabric with few inclusions. The surface is often unslipped with dark brown to black matte paint. In the south of the island this group is characterized by the application of the paint in broad linear bands on jugs, juglets and tankards, as exemplified in the Tangent Line and Framed Broad Band Styles (Åström 1966, 89, 90). In the northern and central parts of the island, similar well-fired fabrics and highly geometric—checkerboard and crosshatched—motifs are employed (e.g., *SCE* IV Pt.1B, fig. XVII.2, 10, 11).

In cataloguing the more northern distribution of WP V, Åström and colleagues applied the term White Painted V Fine Line Style to a "whole group of bowls, juglets and jars decorated with similar thin lines in purplish red paint which may originate from the same workshop" (1979, 17). In collating this Fine Line Style material, the very notion of a pottery workshop began to take form.

First, in the overall repertoire of shapes in the White Painted V sequence, an obvious predilection for individual forms by the potter is self-evident. White Painted V Fine Line Style draws on one particular shape of jug; the body is globular, the neck is short and cut away to form a spout which is sometimes sliced. There is a preference for a small handle at the neck base, often square topped (Bulas n.d., pl. 3.5; Bernhard-Walcher 1984, pl. 24.4; *SCE* IV Pt.1B, fig. XVII.3). String-holes, both functional and decorative—some fairly elaborate—appear mainly on the upper body, neck and handle

(Bernhard-Walcher 1984, pl. 24.1, 2; Villa 1969, pl. XIV.62, .63). The delightful feature of this group is the creation of zoomorphic and anthropomorphic terminals on bottles and flasks and the fashioning of complete animal vessels (Tatton-Brown 1987, pls. 36 second left, 36 left; *CVA France* 5, pl. 4.4; Åström 1969, 72 no. 85). Standard bowls and uniform small jars are complemented by innovative designs in baskets and cups (Frankel 1983, pl. 14.169; *SCE* IV Pt.1B, fig. XVI.13) both of which display particular elements most likely characteristic of one artist—for example, compare handle, protrusions, design content and positioning especially on handle and neck (Unpublished Cyprus Museum 1952 III-13.3, Dhenia-*Kafkalla*; *SCE* IV Pt.1B, fig. XVI.1; Smith 1925, pl. 5.22; *SCE* IV Pt.1B, fig. XVI.8). In contrast to the highly uniform jugs of the White Painted V Eastern Mesoria Styles (Merrillees 1974, 53), the complexities of vessel shape and decoration may well reflect the difference between minimum production at one workshop where the time and effort involved is at its maximum, and those workshops where mass production is evident and minimum time and effort expended (Frankel 1988, 35).

Secondly, the clay is well levigated and fired to a constantly high temperature; it is often unslipped and matte, and is decorated in even, solid matte paint which is fired black, red-brown or purplish red.

Finally, the field of decoration and in particular the finely executed motifs are by far the most unifying elements in this workshop. The major factor which determines the orientation or field of decoration for the artist is the consistent demarcation of zonal areas, using horizontal friezes or registers. These registers in themselves are marked out by divider motifs such as framed wavy lines or double parallel horizontal lines (Fig. 7.1: 1-4, Figs. 7.2-5). The maximum number of registers for the main body of the vessel is three (Figs. 7.4-5). The neck is decorated with horizontal lines, interrupted by vertical lines, rather than continuous encircling bands (Fig. 7.1: 3-4), and the base is filled primarily with oblique lines (Fig. 7.1: 4).

The most predominant motifs are hatched triangles (Fig. 7.1: 1-4; Figs. 7.4-5), cross-hatched panels (Fig. 7.3) and reserved zigzags; many of the same motifs are found on alternate vessel forms within the classic repertoire. A rather individualistic touch is created by intermittent elements such as squiggles, dotted circles and dashes (Fig. 7.1: 3-4; Smith 1925, pl. 6.15; *SCE* IV Pt.1B, fig. XVI.2; Frankel 1983, pl. 14.169). Probably the most distinctive feature of this style is the execution of the decorative elements by the artist, using an exceptionally steady hand and fine brush. The intricate and complicated mesh of cross lattice elements is smoothly and evenly applied without blemish. The distribution of this workshop's product lies mainly in the central and north-

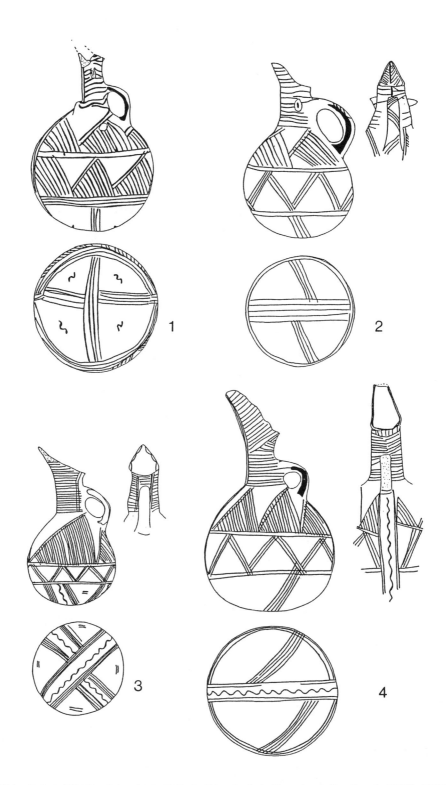

Figure 7.1. White Painted V Fine Line Style (1:2). 1. Nicosia-Ayia Paraskevi (after Frankel 1983, 1268); 2. Nicosia-Ayia Paraskevi (after Frankel 1983, 1264); 3. Unknown provenance (after Frankel 1983, 176); 4. Unknown provenance (after Frankel 1983, 178).

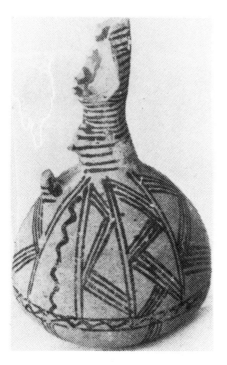

Figure 7.2. Nicosia-Ayia Paraskevi (after Frankel 1983, pl. 35.1267).

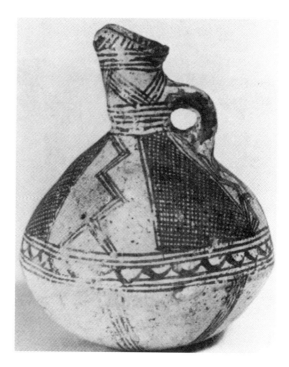

Figure 7.3. Unknown provenance (after Åström 1979, 46, no. 25).

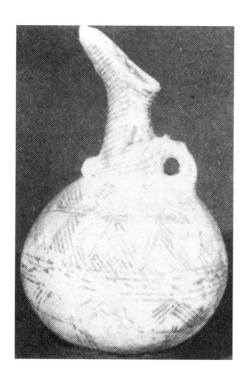

Figure 7.4. ?Alambra (after Villa 1969, pl. XIV.62).

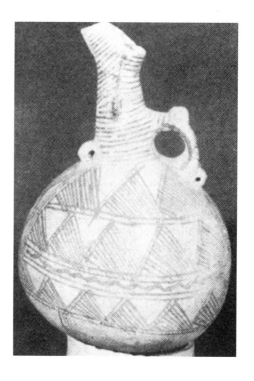

Figure 7.5. ?Alambra (after Villa 1969, pl. XIV.62).

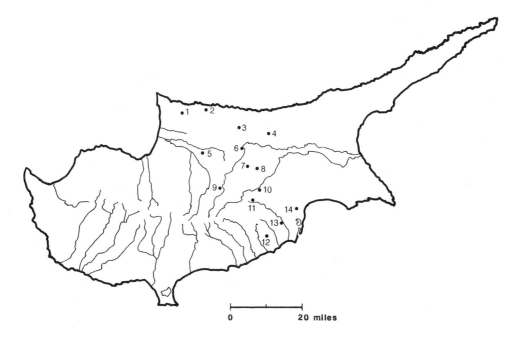

Figure 7.6. Distribution of White Painted V Fine Line Style: 1. Dhiorios, 2. Lapithos, 3. Dhikomo, 4. Kythrea, 5. Dhenia, 6. Ayia Paraskevi, 7. Leondari-Vounou, 8. Yeri, 9. Politiko, 10. Dhali, 11. Alambra, 12. Anglisidhes, 13. Klavdhia, 14. Livadhia.

ern sites (Fig 7.6). The pottery of this workshop, from whatever source, was circulated over a wide area, found for the most part in tomb groups; more than one example from the same workshop has been found in the same tomb.

The definition of styles to the extent of recognizing workshops has implications for the circulation of White Painted pottery outside Cyprus. Of the White Painted tradition, Pendent Line Style, Cross Line Style and White Painted V Style, predominantly southeastern styles, form the largest component of exported pottery at over thirty sites in the Levant and at Tell el Dab'a, Egypt (Maguire 1986). In contrast, only one rim fragment from a small jar of the White Painted V Fine Line workshop was found at Tell el Dab'a; there are at present no other known examples of this Fine Line Style from sites in the Levant or elsewhere in Egypt. Åström illustrates parallels in shape (*SCE* IV Pt.1B, fig. XVI.7, 8) and decoration (*SCE* IV Pt.1B, fig. XVI.13 [hatched triangle]). While the popular contemporary styles of the White Painted V series exported to the Levant and Egypt are of the "broad band" tradition, it is striking that only one example from the Fine Line workshop reached Egypt.

Within the sphere of ceramic production, it may well be that channels of exchange were specific and controlled in different localities. It is almost impossible to identify those responsible for conducting trade, since three groups could be involved—the workshop itself; middlemen responsible for the commodity contained within the pots, who communicated both with the workshop and trader; or independent traders. Similarly, the traded pottery might simply be the offshoot of bulk produce being exchanged, either within the island or abroad. It is evident, in the first instance, that *separate* distributions of contemporary styles exist on the island and, secondly, that a dichotomy is also noticeable in the distribution of their numbers abroad.

The overall conclusion which this research conveys is that inevitably very many workshops exist within each style. To some extent we have been restricted by the chronological and typological angles posed by the existing ceramic classification sequence. Yet if we allow our classification sequence to include the possibility that individual workshops or styles are recognizable from the record, we will be one step closer to accepting the complexities of interpreting ceramic material.

Acknowledgments

I am very grateful to Dr. Diane Bolger for comments on an earlier draft of this paper, to Dr. David Frankel for his invaluable discussions and advice, and to Dr. E.J. Peltenburg for his constant encouragement and supervision. The pottery photographs and drawings are reproduced here with permission from Professor Paul Åström and Dr. David Frankel.

REFERENCES

Adelman, C.M.
1976 *Cypro-Geometric Pottery: Refinements in Classification.* SIMA XLVII. Göteborg.

Åström, Paul
1966 *Excavations at Kalopsidha and Ayios Iakovos in Cyprus.* SIMA II. Lund.
1969 The Economy of Cyprus and Its Development in the IInd Millennium. *Archaeologia Viva* II.3, 72-80.

Astróm, Paul, *et al.*
1979 *Corpus of Cypriote Antiquities 2. The Cypriote Collection of the Museum of Art and Archaeology, University of Missouri-Columbia.* SIMA XX:2. Göteborg.

Barlow, Jane A.
1985 Middle Cypriot Settlement Evidence. A Perspective on the Chronological Foundations. *RDAC*, 47-54.

Bernhard-Walcher, Alfred
1984 *Corpus Vasorum Antiquorum, Österreich, Wien, Kunsthistorishes Museum.* Band 4. Vienna.

Bulas, Kazimierz
n.d. *Corpus Vasorum Antiquorum Pologne 1.* Goluchów, Musée Czartoryski.

Catling, Hector W.
1973 Cyprus in the Middle Bronze Age. *CAH* 3 Vol. II Pt. 1, Chap IV(c), 165-175.

Coleman, John E.
1985 Investigations at Alambra, 1974-1984. In *Archaeology in Cyprus, 1960-1985*, edited by Vassos Karageorghis, pp. 125-141. Nicosia.

CVA France
n.d. *Corpus Vasorum Antiquorum France 5.* Musée du Louvre 4 IICa, Paris.

Frankel, David
1974 *Middle Cypriot White Painted Pottery: An Analytical Study of the Decoration.* SIMA XLII. Göteborg.
1983 *Corpus of Cypriote Antiquities 7. Early and Middle Bronze Age Material in the Ashmolean Museum, Oxford.* SIMA XX:7. Göteborg.
1988 Pottery Production in Prehistoric Bronze Age Cyprus: Assessing the Problem. *Journal of Mediterranean Archaeology* 1/2, 27-55.

Gjerstad, Einar
1926 *Studies in Prehistoric Cyprus.* Uppsala.

Herscher, Ellen
1972 A Potter's Error. Aspects of Middle Cypriote III. *RDAC*, 22-34.

Hardin, M.A.
1977 Individual Style in San José Pottery Painting: The Role of Deliberate Choice. In *The Individual in Prehistory*, edited by J.N. Hill & J. Gunn, pp. 109-136. New York.

Maguire, Louise C.
1986 The Middle Cypriot Pottery from Tell el Dab'a, Egypt. MA Thesis, University of Edinburgh.

Merrillees, Robert S.
1971 The Early History of Late Cypriote I. *Levant* 3, 56-79.
1974 *Trade and Transcendence in the Bronze Age Levant.* SIMA XXXIX. Göteborg.
1978 *Introduction to the Bronze Age Archaeology of Cyprus.* SIMA Pocket-book IX. Göteborg.
1979 Pottery Trade in Bronze Age Cyprus. *RDAC*, 115-134.

Muller, J.
1977 Individual Variation in Art Styles. In *The Individual in Prehistory*, edited by J.N. Hill & J. Gunn, pp. 23-39. New York.

Myres, J.L. & M. Ohnefalsch-Richter
1899 *A Catalogue of the Cyprus Museum.* Oxford.

Redman, C.L.
1977 The "Analytical Individual" and Prehistoric Style Variability. In *The Individual in Prehistory*, edited by J.N. Hill & J. Gunn, pp. 41-53. New York.

Shepard, Anna O.
1985 *Ceramics for the Archaeologist.* Fifth reprint. Carnegie Institute of Washington Publication 609, Washington, D.C.

Smith, A.H.
1925 *Corpus Vasorum Antiquorum, Great Britain 1.* British Museum. London.

Tatton-Brown, Veronica
1987 *Ancient Cyprus.* Cambridge, Massachusetts.

Villa, P.
1969 *Corpus of Cypriote Antiquities. Early and Middle Bronze Age Pottery of the Cesnola Collection in the Stanford University Museum.* SIMA XX:1. Lund.

VIII

Problems of Definition of Local and Imported Fabrics of Late Cypriot "Canaanite" Ware

Paul Åström

It is symptomatic that the first recorded so-called Canaanite jar in Cyprus was probably found in 1897 in a tomb at Hala Sultan Tekke—where else?—by Walters during excavations sponsored by the British Museum. It was published by D.M. Bailey and attributed to Egypt, where similar jars have been found (*HST* 1, 15-16, pl. XVd). The number of Canaanite jars recorded at Hala Sultan Tekke is now greater than at any other site in Cyprus.

By Canaanite jar we mean an ovoid or conical jar with two, or rarely four, opposing vertical handles on the shoulder. The term is a misnomer, as these jars were made in Egypt, Syria, Palestine, Cyprus and perhaps elsewhere.

Such jars were found early in Greece in the Tholos Tomb of Menidi in 1878 and at Mycenae in the 1880s and 1890s (Lolling 1880, 21, 24, 32, 48, pl. IX: 1-4; Tsountas & Manatt 1897, 268-269, 291). Pendlebury (1930, 56, 76) believed that these specimens—seven in all—were of Egyptian manufacture, while Furumark (1941, 74-76, shape 13a: 1-3, 5-8) considered it highly probable that they were made in Syria or in southern Anatolia. Later finds (bibliography in Raison 1968, 194, n. 8) were made at Argos, Asine (Furumark 1941, FS 73:1; Åkerström 1975, 185-192), Athens, Pylos, Koukaki at Athens (Onasoglou 1986, 15-42), Mycenae, Tiryns (Kilian 1988, 123), on Thera (Marinatos 1976, pl. 49: 2) and at Chania (Kilian 1988, 123) and Kommos in Crete (e.g., Shaw 1986, 261, n. 87, 269, pl. 58a; Haskell 1989, 90).

Canaanite jars were found in Egypt, for example, at Tell el Amarna (Peet & Woolley 1923, pls. LI-LII) and Deir el Medineh dating from the New Kingdom and no doubt made in Egypt (Nagel 1938, 4-5, 15-29, 121-127, 135). Numerous examples turned up in Palestine, and Duncan (1930, pl. 43) illustrated many of them. Schaeffer and later expeditions discovered many Canaanite jars at

Minet el Beidah and Ras Shamra (Schaeffer 1939, pl. IX, fig. 69:1, no.5; Schaeffer 1969, 121-123, 126, 134-135; Yon 1987, 80, fig. 58a).

The excavations at Tarsus (Goldman *et al.* 1950) and of the shipwrecks at Cape Gelidonya (Hennessy & Taylor 1967, 122, 123, 125) and at Ulu Burun near Kaş (e.g., Bass 1986, 277-279, ill. 7; Pulak 1988, 10-11; Bass *et al.* 1989, 12) have produced Canaanite jars with remains of their contents.

In Cyprus such jars were found in 1924 by Gjerstad at Kalopsidha (1926, 36; 1980, 192; Åström 1966, 9), but the shape was hardly identified by the Swedish Cyprus Expedition. Sjöqvist with the aid of a magnifying glass recognized such a jar (1940, 185) on a plan of Schaeffer's Tomb 10 at Enkomi (Schaeffer 1936, 70, fig. 29), which dates from Late Cypriot IIA1 (*SCE* IV Pt.1C, 260; *SCE* IV Pt.1D, 684, 829). Westholm mentioned a pair of what he called Syrian jars from either Idalion or Ayia Irini (1943, 95-96). The ware was not mentioned in *SCE* nor in the pottery classification by Taylor and Seton-Williams (1938).

Actually, the Swedish Cyprus Expedition had found a Canaanite jar in Enkomi Tomb 7 (recorded correctly in *SCE* IV Pt.1C, 260, type IDa1), but it was not published until much later and then erroneously classified as "Plain White Wheel-made I" (Andersson 1980, 27, Acc. 355d, pl. 4).

Virginia Grace presented an overall survey of the subject and mentioned briefly jars found in Cyprus at Enkomi, Myrtou-*Pigadhes* and Pyla in her important paper on the Canaanite jar in 1956, which has become a classic.

In 1957 Hector Catling recorded several Syrian storage jars from Myrtou-*Pigadhes* stating that it was an "uncommon type imported into Cyprus from a manufacturing center in Syria or Palestine" (Catling 1957, 53-55). He mentioned unpublished specimens

from the settlement at Enkomi and from a tomb at Pyla-*Verghi*. The excavations at Kalopsidha in 1959 produced a Syrian jar of the conical type in a disturbed Late Cypriot layer (Åström 1964, 120; 1966, 76, 139, 142).

In 1964, I published a handle stamped with the cartouche of Seti I from Hala Sultan Tekke (Åström 1964, 115-121). It was a surface find, but important as it is no doubt an Egyptian import. In the same article (1964, 120) an illustration was given of a conical jar from Arpera-*Mosphilos*, which was later published by Merrillees (1974, 47, 59, figs. 29 and 35). It dates from Middle Cypriot III (Åström 1987, 57-58).

Dikaios' monumental publication of the results of the excavations at Enkomi contains many references to the discovery of what he called Syro-Palestinian jars (*Enkomi*, e.g., 28-29, 36, 97, 107, 115-116, 139, 157, 193-194, 199, 201, 245, 329, pls. 65: 10, 77: 22-23, 120: 11-12). Some contained the skeletal remains of infants.

Ruth Amiran (1970, 140-143) distinguished two main classes of jars: the plain Canaanite jars made for trading and decorated jars. She discussed the export of the jars to Egypt and the Aegean and traced their development.

At least twenty jars were found at Enkomi in the Sanctuary of the Ingot God which was published in 1971 (Courtois 1971, 248, fig. 89; 251, fig. 91; 256, fig. 96).

When a comprehensive study of the Late Cypriot Bronze Age was published in 1972 only a score of Canaanite jars from eight sites was known (*SCE* IV Pt.1C, 260-261): Enkomi, Hala Sultan Tekke, Idalion (or Ayia Irini), Kalopsidha, Myrtou-*Pigadhes*, Pendayia-*Exomilia*, Pyla-*Verghi*, and Sinda.

In their study of Bronze Age trade between the Aegean and Egypt, Merrillees and Winter assumed that the Canaanite jars were wine containers and they pointed out the presence of such jars in an Egyptian tomb painting (1972, 114-115, 126; with references).

Canaanite jars have been found at Hala Sultan Tekke from the beginning of the Swedish excavations in 1971. They have been published successively in *HST* 1, 3-9 (see *HST* 9, index s.v. Canaanite and Syrian jar; Åström 1986, 65). At first we did not identify all of them among the plain wares, but gradually we began to recognize the characteristic conical or ovoid shape and the typical handles and bases. About 10,000 sherds from Canaanite jars have now been recorded.

A collection of storage jars from the Early Bronze Age to the Crusader period found in the sea and preserved in the National Maritime Museum in Haifa was published by A. Zemer in 1977.

An important dissertation by Avner Raban on what was called the commercial jar appeared in 1980. It is a thorough study of all aspects of the jars: historical background, functions, chronology, typology, provenance, standard measure and volumes, marking, stamping and distribution. Raban classified the jar into five variants:

the oval type characteristic of the south and north coastal regions; the biconical type from the coastal region from Philistia to Byblos; the Byblos type; the angular jar from around Tyre and Sidon, imitated in Egypt; and the small conical jar from the Phoenician coast. Sherds from Hala Sultan Tekke were submitted to neutron activation analysis; some of these were found to be locally made, others imported from Ugarit and Cilicia (Raban 1980, 6, 148, 167, table D-5: 21-24).

An early conical jar with two vertical handles in Bichrome Wheelmade Ware was found in a tomb at Enkomi (Courtois 1981, 37-38, fig. 15: 3). It dates from Late Cypriot I and has some parallels in White Painted V-VI Ware (Gjerstad 1926, 173: 3, from the Cesnola collection; *SCE* IV Pt.1B, 76, pl. XVIII:10; *SCE* IV Pt.1C, 63, type XIIDb).

Antonio Sagona (1982, 73-110) has traced the development of the Levantine storage jars from the thirteenth to the fourth century B.C.

Several Canaanite jars were found in the recent excavations at Pyla-*Kokkinokremos* (Karageorghis & Demas 1984, 51, pls. XXXVII-XXXVIII), Kition (*Kition* V, indices s.v. Canaanite jars), Kouklia (Maier 1986, 88) and Alassa (Hadjisavvas 1986, 62-67). A tomb in Kalavasos village contained a Cannaanite jar of Late Cypriot IA date (Pearlman 1985, 164-179).

A Canaanite jar fragment from Enkomi Tomb 11 was submitted to neutron activation analysis and found to have been made in Ashdod or environs. (Gunneweg *et al.* 1987, 168-171). Twenty elements in the clay were analyzed. It is interesting that the sherd had initially been classified as Plain White Ware by the Swedish Cyprus Expedition. The authors claim that their analysis was "the first real evidence that articles of trade went from Canaan to Cyprus"—an astonishing statement in view of Raban's results published nine years earlier. Amihai Mazar (1988, 224-226) rightly pointed out that the reconstruction of the jar from Enkomi was incorrect, but it should also be pointed out that Enkomi Tomb 11, from which it came, was used for a long time, from Late Cypriot IIB1 to IIC2 (*SCE* IV Pt.1D, 687-688, 691, 830) before the Sanctuary of the Ingot God was constructed.

In the monumental publication of Maa there is a long and useful chapter on Canaanite jars (M. Hadjicosti *et al.* 1988, 340-396). A minimum of 84 jars were represented by the 5022 sherds that were found throughout the site. Hadjicosti discerned three types: button-toe base, rounded base, four-handled jar. A fourth type, with knobbed base, did not occur at Maa, but is found elsewhere in Cyprus. Forty-two fabrics could be identified by eye. Petrographic and chemical analyses showed that there were more Cypriot fabrics of calcareous clays than previously thought. The imported specimens came from a number of production centers, Group A from the

TABLE 8.1

Canaanite Jar Fragments in F 1725 at Hala Sultan Tekke

1	Brick	Gray	Brown, dark gray outer face
1	Brick	Brown	Black, brown exterior
15	Brick	Gray	Gray, gritty, brick outer face
1	Brick	Sandy	Dark Gray, gritty with brown outer faces
2	Brick	Sandy	Gray, brown outer face
2	Brick	Purplish	Brick, gritty
1	Brick	Purplish	Gray, brick outer faces
3	Brick	Brown	Gray, gritty, tile outer faces
1	Brick	Brick	Gray, brick outer faces
3	Orange	Orange	Gray orange
9	Orange	Orange	Gray, red-brown outer faces
2	Gray-brown	Gray	Gray, gritty, brown outer face
1	Gray-brown	Sandy Brown	Gray, light brown outer faces
1	Yellow	Yellow	Gray, yellow outer faces
2	Orange	Gray	Gray, gritty, orange outer face
1	Orange	Brick	Orange
2	Orange	Orange	Orange, gritty
2	Light Gray	Dark Gray	Light Gray
2	Light Gray	Dark Gray	Dark Gray
1	Reddish White	Gray	Gray, brown outer face
2	White	Orange	Thin purplish, brown outer face
1	Gray-white	Brown	Gray, brown outer faces
2	Gray-white	Brick	Brick
1	Gray-white	Purplish	Gray, red-brown outer faces
2	Gray-white	Gray	Gray, gritty, brown outer face
2	Gray-white	Dark Gray	Gray, gritty, brown outer face
1	Purple	Dark Gray	Gray, gritty, black inner face
1	Light Brown	Light Brown	Gray, brown outer faces
1	Gray	Brown	Gray, brown outer faces
1	White	Brown	Light Brick

30 varieties

Derived from a total of 77 sherds (10 unclassified).

central Levant and Group B from center(s) to the south. Others were produced in southern Cyprus. Pieces which Raban had claimed to be from Ugarit or Cilicia were regarded as Cypriot.

At Hala Sultan Tekke, fragments of Canaanite jars are found everywhere. In two instances they were found in groups together with a plain krater and a plain jug. In one case, a Canaanite jar was found sunk in the floor

at the entrance to a room. The jars are usually plain, but some painted examples occur. Canaanite signs, both painted and inscribed before firing, occur on them. Pot marks, which may be Cypro-Minoan signs, are also present on the handles of some jars.

The classification of sherds of Canaanite jars is full of problems in view of the great variety of fabrics. It is possible to separate them into different groups by visual inspection. As an example, I would like to show the results of a classification which I made together with my students of 77 sherds from a single feature (F 1725) at Hala Sultan Tekke. Thirty varieties were observed and the colors of the fabric and the interior and exterior surfaces were described (Table 8.1). Describing colors by autopsy is, of course, a subjective method. Even when the Munsell Soil Color Charts are used, a subjective element cannot be avoided. In order to achieve an objective description of colors a Portable Micro Color instrument may be used (Fischer 1988). The results of a Micro Colour Analysis (MCA) of Canaanite sherds from Hala Sultan Tekke are shown by Peter Fischer (this volume).

Another modern method, Secondary Ion Mass Spectrometry (SIMS), which Peter Fischer has applied on Canaanite sherds from Hala Sultan Tekke, was presented at the conference on Bronze Age Trade in the Mediterranean at Oxford in December 1989. Alexander Lodding described the method at a Conference on Absolute Chronology in Göteborg in 1987:

> In this method the surface is bombarded by energetic ions and sputtering is induced, that is to say the atomic layers are peeled off, one after another; atoms of each successive removed layer are immediately ionized and separated in a mass spectrometer according to the ratio of mass to charge. The size of the area needed is about 0.1 micron. Of all the surface physical analysis methods this is the most sensitive on the detection of elements and isotopes. It is fast and relatively exact in quantitation. The in-depth profiles of 23 elements at a time are recorded. The technique can thus be regarded as at least as sophisticated as Neutron Activation Analysis.

The advances in natural sciences take place at an ever accelerated rate. We archaeologists can only follow in the steps of the scientists, applying their methods to our problems. The studies of the so-called Canaanite jars are only in their beginnings. Useful pilot studies have been made by Virginia Grace, Avner Raban, Maria Hadjicosti, Richard Jones, Sarah Vaughan and others, but much more remains to be done. Two new, sensitive and objective methods—MCA and SIMS—are promising and should be tested along with other methods such as visual inspection, petrographic and chemical analyses and neutron activation analysis.

REFERENCES

Åkerström, Åke
1975 More Canaanite Jars from Greece. *OpAth* XI,
 185-192.

Amiran, Ruth
1970 *Ancient Pottery of the Holy Land.* New
 Brunswick, New Jersey.

Andersson, Kjell
1980 Supplementary Material from Enkomi Tombs
 3, 7, 11 and 18 s.c. *MedMusB* 15, 25-40.

Åström, Paul
1964 A Handle Stamped with the Cartouche of Seti
 I from Hala Sultan Tekke in Cyprus. *OpAth* V,
 114-121.

1966 *Excavations at Kalopsidha and Ayios Iakovos
 in Cyprus.* SIMA II. Lund.

1986 Hala Sultan Tekke and its Foreign Relations.
 In *Acts* 1986, 63-68.

1987 The Chronology of the Middle Cypriote
 Bronze Age. In *High, Middle or Low? Acts of
 an International Colloquium on Absolute
 Chronology Held at the University of Gothen-
 burg, 20-22 August 1987,* edited by Paul
 Åström, pp. 57-66. SIMA Pocketbook LVI.
 Göteborg.

Bass, George F.
1986 A Bronze Age Shipwreck at Ulu Burun (Kaş):
 1984 Campaign. *AJA* 90, 269-296.

Bass, George E., Cemal Pulak, Dominique Collon &
James Weinstein
1989 The Bronze Age Shipwreck at Ulu Burun: 1986
 Campaign. *AJA* 93, 1-29.

Catling, Hector W.
1957 The Bronze Age Pottery. In *Myrtou*-Pigadhes
 by Joan du Plat Taylor, pp. 26-59. Oxford.

Courtois, Jacques-Claude
1971 Le sanctuaire du dieu au lingot d'Enkomi-
 Alasia. In *Alasia I*, pp. 151-362. Paris.

1981 *Alasia II.* Paris.

Duncan, J. Garrow
1930 *Corpus of Palestinian Pottery.* London.

Fischer, Peter M.
1988 Classification of Pottery by Micro Colour
 Analysis. A Pilot Study. *Hydra* 5, 36-41.

Furumark, Arne
1941 *The Mycenaean Pottery.* Stockholm.

Gjerstad, Einar
1926 *Studies on Prehistoric Cyprus.* Uppsala.

1980 My First Archaeological Activity in Cyprus.
 Folia Orientalia XXI, 187-198.

Goldman, Hetty, D.H. Cox, Virginia Grace, F.F. Jones
& A.E. Raubitschek
1950 *Excavations at Gözlü Kule, Tarsus I.* Prince-
 ton, New Jersey.

Grace, Virginia
1956 The Canaanite Jar. In *The Aegean and the
 Near East. Studies Presented to Hetty
 Goldman,* edited by S. Weinberg, pp. 80-109.
 Locust Valley, New York.

Gunneweg, Jan, Isadore Perlman, & Frank Asaro
1987 A Canaanite Jar From Enkomi. *IEJ* 37.2-3, 168-
 172.

Hadjicosti, Maria, Richard E. Jones & Sarah J. Vaughan
1988 Appendix IV. In *Excavations at Maa-
 Palaeokastro 1979-1986,* by Vassos Karageor-
 ghis & Martha Demas, pp. 340-398. Nicosia.

Hadjisavvas, Sophocles
1986 Alassa. A New Late Cypriote Site. *RDAC*, 62-
 67.

Haskell, Halford W.
1989 LM III Knossos: Evidence Beyond the Palace.
 SMEA XXVII, 81-110.

Hennessy, J. Basil & Joan du Plat Taylor
1967 The Pottery. In Cape Gelidonya: A Bronze Age
 Shipwreck, by George Bass. *TAPS* N.S. 57.8,
 122-125.

Karageorghis, V. & Martha Demas
1984 *Pyla-Kokkinokremos.* Nicosia.

Kilian, Klaus
1988 Mycenaeans up to Date, Trends and Changes in
 Recent Research. In *Problems in Greek Prehis-
 tory. Papers Presented at the Centenary Con-
 ference of the British School of Archaeology at
 Athens, Manchester April 1986,* edited by
 Elizabeth B. French & K.A. Wardle, pp. 115-
 152. Bristol.

Lolling, H.G.
1880 *Das Kuppelgrab bei Menidi.* Athens.

Lodding, Alexander
1987 Paper delivered at the International Collo-
 quium on Absolute Chronology held at the
 University of Gothenburg 20th-22nd August,
 1987. Unpublished.

Maier, Franz-Georg
1986 Intervention. In *Acts* 1986, 88.

Marinatos, Spyridon
1976 *Excavations at Thera VII.* Athens.

Mazar, Amihai
1988 A Note on Canaanite Jars from Enkomi. *IEJ*
 38.4, 224-226.

Merrillees, Robert S.
1974 *Trade and Transcendence in the Bronze Age Levant*. SIMA XXXIX. Göteborg.

Merrillees, Robert S. & J. Winter
1972 Bronze Age Trade Between the Aegean and Egypt. Minoan and Mycenaean Pottery from Egypt in the Brooklyn Museum. In *Miscellanea Wilbouriana* 1, pp. 101-133. Brooklyn, New York.

Nagel, Georges
1938 *Le céramique du Nouvel Empire à Deir el Médineh* I. Cairo.

Onasoglou, Artemis
1986 Enas neos mykenaïkos thalamoeides tafos sto Koukaki. *ArchDelt* 34 (1979), 15-42.

Pearlman, David
1985 Kalavasos Village Tomb 51: Tomb of an Unknown Soldier. *RDAC*, 164-179.

Peet, T. Eric & C. Leonard Woolley
1923 *The City of Akhenaten I*. London.

Pendlebury, J.D.S.
1930 *Aegyptiaca*. Cambridge.

Pulak, Cemal
1988 The Bronze Age Shipwreck at Ulu Burun, Turkey: 1985 Campaign. *AJA* 92, 1-37.

Raban, Avner
1980 The Commercial Jar in the Ancient Near East: Its Evidence for Interconnections Amongst Biblical Lands. Ph.D. disseratation, Hebrew University. Jerusalem.

Raison, Jacques
1968 *Les vases à inscriptions peintes de l'âge Mycénien et leur contexte archéologique*. Rome.

Sagona, Antonio
1982 Storage Jars of the 13th and 14th Century B.C. *OpAth* XIV, 73-110.

Schaeffer, Claude F.A.
1936 *Missions en Chypre 1932-1935*. Paris.
1939 *Ugaritica I*. Paris.
1969 *Ugaritica VI*. Paris.

Shaw, Joseph W.
1986 Excavations at Kommos (Crete) during 1984-1985. *Hesperia* 55, 221-269.

Sjöqvist, Erik
1940 *Problems of the Late Cypriote Bronze Age*. Stockholm.

Taylor, Joan du Plat & Veronica Seton-Williams
1938 *Classification of Pottery in the Cyprus Museum*. Nicosia.

Tsountas, Christos & J. Irving Manatt
1897 *The Mycenaean Age*. London.

Westholm, Alfred
1943 En senmykensk pithos från Cypern. *Konsthistorisk tidskrift* XII, 93-97. Stockholm.

Yon, Marguerite
1987 *Ras Shamra-Ougarit III. Le centre de la ville*. Paris.

Zemer, A.
1977 *Storage Jars in Ancient Sea Trade*. Haifa.

Canaanite Pottery from Hala Sultan Tekke: Traditional Classification and Micro Colour Analysis (MCA)

Peter M. Fischer

INTRODUCTION

Until recently no thorough study has been performed on pottery excavated in Cyprus and generally described as Canaanite (e.g., Grace 1956, 80-109; Amiran 1970, 140-143, pl. 43, 138-139). In 1988 a multivariate analysis on Canaanite pottery, excavated at Maa-*Palaeokastro*, was published by Hadjicosti, Jones and Vaughan (1988). Traditional classification methods were combined with petrographic studies and chemical analysis (atomic absorption spectrometry). An attempt was made to assign the samples to different production centers located probably in southern Palestine and the central Levant, but also on the southern coast of Cyprus.

In this study of Canaanite pottery from Hala Sultan Tekke, the groupings of a number of Canaanite fabrics, as defined by traditional classification methods, are compared with the groupings achieved by Micro Colour Analysis (MCA) (Fischer 1988, 36-41). The goals of this work are to determine whether groups made by a traditional pottery classification method agree with those groupings done by MCA, and whether the inexpensive and fast method of MCA can complement or even be an alternative to other, expensive chemical and physical methods in provenance studies.

Because of the need for reference material from different regions and the lack of an MCA data base no attempt has been made in this study to trace the provenance of the present samples from Hala Sultan Tekke. Therefore, this investigation should be considered a pilot study until it is possible to extend its scope.

METHOD

The samples consist of sherds excavated at Hala Sultan Tekke, Cyprus (*HST* 9, index s.v. Canaanite; Åström 1986, 65). They were collected from representative stratified layers. The section of each sample was polished with silicon carbide grinding paper, grit 180. From these sherds a subjective selection of 25 specimens was taken using conventional pottery classification, thus obviating the investigation of identical or almost identical sherds. No conclusions could be drawn regarding the shape of the vessels (Oval, Biconical, Byblos, Angular, or Small Conical jar type [Raban 1980, 5-7]).

Part 1 of this study deals with conventional pottery classification methods used. The material was divided into two groups, A and B. The A group consists of sherds with a limey coating (nos. 1-15), possibly created by dumping the unbaked jars into sea water (Raban 1980, 9; Rice 1987, 119). The B sherds are those with self-slip and without a limey coating (nos. 16-25). The two divisions were done on purely subjective criteria. Roman numerals indicate sherd groups within A or B, which

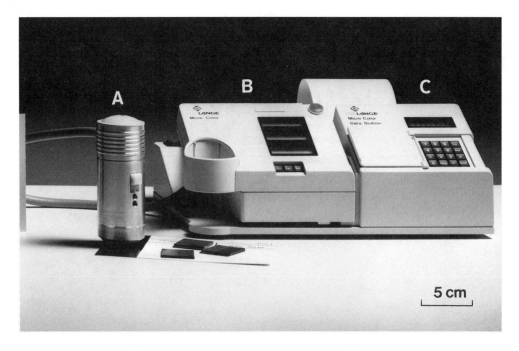

Figure 9.1. The MCA device. A) Measuring head, B) Measuring unit, C) Data station.

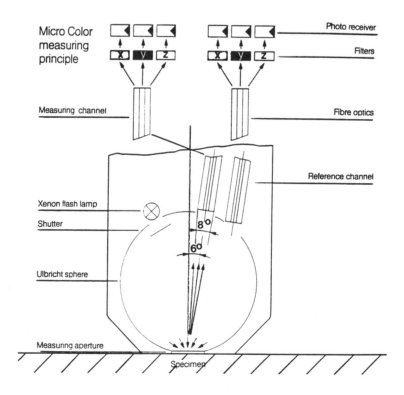

Figure 9.2. The MCA measuring principle.

show signs of kinship as determined by subjective pottery classification (clay, inclusions and color estimation).

Part 2 deals with the MCA of the samples using a Portable Micro Colour measuring device and a Micro Colour measuring station LDC 10 produced by Dr. Bruno Lange GmbH, Düsseldorf (Fig. 9.1). A measuring head (A) is flexibly linked to the measuring unit (B). The measuring unit is integrated with the data station (C) and is portable; thus, it can be used in the field as a self-contained battery-powered unit. It will store up to 100 measurements for subsequent analyses. The approximate price for the complete instrument is $12,000.

The Micro Colour measuring principle is shown in Figure 9.2. The measured surface can be varied between 10 and 200 mm^2. A 2 mm. x 5 mm. surface was chosen,

thus making it possible to measure different parts of the section and surface. In this study only the polished section was investigated. Each measurement takes about ten seconds. In order to achieve the most reliable results each measurement was repeated a minimum of three times and the average values were recorded (Table 9.1).

According to the system developed by Judd-Hunter (DIN 6174, CIE-LAB 1976),[1] the following calculated values can be read (see Fig. 9.3). Black is denoted by L=0 and white by L=100 (i.e. the intensity of a color); +a corresponds to red, -a to green, +b to yellow and -b to blue. The central axis corresponds to the region of neutral colors. The radius r, extending out from the central axis, corresponds to hue (color shade), and the distance from the central axis on the radius to chroma (C, saturation). The closer a color lies to the central axis, the

TABLE 9.1

Average MCA Values for Sherds 1-25

Sherd	Code	+a (red)	+b (yellow)	L	C
1	A I	10.25	20.07	55.80	22.53
2	A I	17.66	22.96	52.20	28.97
3	A II	6.03	13.51	49.81	14.80
4	A II	4.02	9.49	43.09	10.31
5	A II	8.33	15.45	48.18	17.55
6	A III	13.33	18.37	51.13	22.70
7	A III	10.05	16.50	51.40	19.32
8	A IV	9.73	19.27	55.85	21.58
9	A IV	5.60	11.90	47.58	13.15
10	A IV	8.49	12.80	46.25	15.36
11	A V	7.31	13.31	48.63	15.18
12	A V	3.78	12.82	56.17	13.37
13	A VI	2.00	10.17	58.95	10.37
14	A VI	2.69	9.59	53.62	9.96
15	A VI	4.40	11.30	53.48	12.13
16	B I	17.01	22.30	48.88	28.04
17	B I	14.41	21.17	49.66	25.60
18	B II	14.94	20.56	51.26	25.41
19	B II	11.82	17.98	53.05	21.52
20	B II	12.25	16.61	50.69	20.63
21	B III	6.10	17.11	57.43	18.16
22	B III	8.21	19.35	57.10	21.02
23	B IV	8.12	17.08	55.25	18.91
24	B IV	6.48	16.06	53.55	17.32
25	B IV	3.87	13.36	59.90	13.91

1. The Deutsche Industrie Norm (DIN) is a color standard identical to the American CIE-LAB, 1976; both are based on the Munsell system.

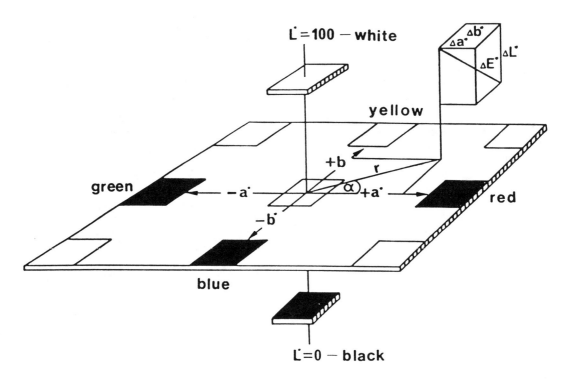

Figure 9.3. The CIE-LAB-Colour system:
+a corresponds to red, -a to green, +b to yellow, and -b to blue; black is denoted by L=0, white by L=100 (i.e., the intensity of a color); central axis corresponds to neutral colors; r corresponds to hue (color shade); the distance on r corresponds to chroma (C, saturation).

grayer and more indistinct it appears to the human eye; conversely, colors far away from the central axis appear purer and brighter. Hue and chroma vary in intensity along the central axis, with dark colors at the lower and lighter colors at the upper end, i.e., percentage of L (see also Rice 1987, 339-343).

RESULTS

PART 1: SUBJECTIVE POTTERY CLASSIFICATION OF CANAANITE SHERDS FROM HALA SULTAN TEKKE
(HST find labels within brackets)

The results of this traditional pottery classification indicate that, within the sample of 25 sherds, ten sherd groups could be recognized with similar sherds: six in the coated group (AI-AVI) and four in the uncoated group (BI-BIV).

COATED SHERDS

1. AI. (Room 82 L 2) bottom: yellowish white coating on outside; fine, light brown ware, fired hard under oxidizing conditions; no coating on inside.

2. AI. (Room 82 L 2-3): pinkish white coating on outside; fine, light reddish brown ware; fired hard under oxidizing conditions; no coating on inside.

3. AII. (F 1748): pinkish and white coating on outside; medium fine, brown ware with reddish brown paste

and grayish brown core; small, mainly gray inclusions; fired hard under nearly reducing conditions; no coating on inside.

4. AII. (Room 33 Layer 3): yellowish white coating on outside; medium fine, brown ware with light brown paste and grayish brown core; small inclusions of different colors; fired hard under reducing conditions; no coating but brownish gray discolorations on inside.

5. AII. (F 1754 L 3): yellowish white coating on outside; homogeneous, medium fine, brown ware with light brown paste and grayish brown core; small, mainly gray inclusions; fired hard under almost reducing conditions and certainly refired; no coating on inside.

6. AIII. (F 1756 L 2): pinkish white coating on outside; medium fine, brownish red ware; small gray and white inclusions; fired hard under oxidizing conditions; no coating on inside.

7. AIII. (Room 82 L 2 bottom): pinkish white coating on outside; medium fine, brownish red ware with grayish red-brown core; small, mainly light gray inclusions; fired under almost oxidizing conditions; no coating on inside.

8. AIV. (Room 83 L 2 bottom): beige to white coating on outside; medium fine, light reddish brown ware; mainly light gray small inclusions; fired medium hard under almost reducing conditions; no coating but gray discolorations on inside.

9. AIV. (Room 83 L 2 bottom): beige coating on outside; homogeneous, medium fine, gray brown ware; small gray inclusions; fired medium hard under almost reducing conditions; no coating on inside.

10. AIV. (F 1754 Layer 2): beige, pinkish white coating; medium fine, brown ware with reddish brown paste; gray and brown inclusions; fired hard under almost reducing conditions; no coating on inside.

11. AV. (F 1756 L 2): yellowish white coating on outside; medium coarse, brownish red ware with gray core, whitish gray inclusions; fired medium hard under almost oxidizing conditions; no coating on inside.

12. AV. (F 1754 L 2): pinkish white coating; for further description see 11.

13. AVI. (West of West Wall of Room 70 L 3): grayish white coating on outside and inside; medium coarse, beige-gray ware with somewhat grayer core; white, brown-red and gray inclusions; fired medium hard under almost reducing conditions.

14. AVI. (L 3): yellowish white coating on outside and inside (?); for further description see 13.

15. AVI. (L 2 bottom): pinkish white coating on outside and inside; fired medium soft; for further description see 13.

UNCOATED SHERDS

16. BI. (F 1751 L 3): fine, light brownish red ware; self-slip in and out; very small inclusions; fired hard under oxidizing conditions.

17. BI. (F 1748 L 1-2): see 16, but fired medium hard.

18. BII. (Room 33 L 3): medium coarse, light brownish red ware; self slip in and out; medium large brown, gray and white inclusions; fired medium hard under oxidizing conditions.

19. BII. (F 1744 L 3): see 18, but with gray-brown core.

TABLE 9.2

Grouping According to Descending Red/Green Values

Group	Sherds	+a (red)	+b (yellow)	Traditional Groups
1	2, 16	17.34	22.63	AI, BI
2	6, 17, 18, 19, 20	13.35	18.94	AIII, BI, BII (3)
3	1, 8, 22	9.40	19.56	AI, AIV, BIII
4	5, 7, 21, 23, 24	7.82	16.44	AII, AIII, BIII, BIV (2)
5	3, 10, 11	7.28	13.21	AII, AIV, AV
6	4, 9, 12, 15, 25	4.33	11.77	AII, AIV, AV, AVI, BIV
7	13, 14	2.34	9.88	AVI (2)

20. BII. (F 1751 L 3): see 18, but with gray-brown core and denser inclusions.

21. BIII. (Room 33 L 3): medium coarse, buff ware with grayish buff core; self-slip in and out; porous gray inclusions; fired medium hard under almost oxidizing conditions.

22. BIII. (Room 33 L 3): see 21.

23. BIV. (F 1748 L 1-2): medium coarse to coarse, buff ware with grayish buff core; self-slip in and out; medium large to large white inclusions; fired medium hard under medium oxidizing conditions.

24. BIV. (no provenance): see 23.

25. BIV. (Room 33 L 3): see 23, but the ware is grayish buff.

PART 2: COLOR MEASUREMENT—MCA

Care was taken to cover the entire section during the measurements of each sample. Neither green (-a) nor blue (-b) values could be measured. The average color values can be seen in Table 9.1. Considering particularly the +a (red) and +b (yellow) values a tentative grouping according to descending red values can be demonstrated (Table 9.2). The +a and +b values are averages of the sherds included in each group. The subjective codes, as assigned in Part 1, are included in each of the MCA groups.

DISCUSSION

The subjective, provisional grouping by a traditional pottery classification method resulted in six groups with coated (A) and four groups with uncoated (B) sherds. Among the coated groups were specimens resembling sherds of the uncoated group in fabric, inclusions and color.

The classification based on MCA defined seven groups. The tentative grouping is based on descending red and yellow values according to DIN 6174, CIE-LAB 1976. Although there is a distinction between groups 1 and 2, similarities between these two groups exist, e.g., the difference between the red and yellow values. The same observations can be made for groups 3 and 4, and 6 and 7. Group 5 resembles groups 3/4 and 6/7. An attempt to reduce the number of groups would result in three combined groups: 1/2, 3/4 and 6/7. Group 5 can be ascribed either to 3/4 or 6/7, but evidently forms a fourth combined group also.

A comparison between the grouping based on a traditional subjective method and the grouping based on objective MCA values offers the following observations:

1. BII concurs with group 2; all three BII sherds are found in group 2.

2. AVI exists in groups 6/7, BI in 1/2, and BIII in 3/4; if one considers 6/7, 1/2 and 3/4 as three groups, the agreement is convincing.

3. AV and BIV are found in 5/6 and 4/5; the agreement is good, since group 5 holds a position between 3/4 and 6/7.

Among the remaining four "traditional" groups—AI, AII, AIII and AIV—the spread over the MCA groups is considerable: AI is found in 1 and 3; AII in 4, 5 and 6; AIII in 2 and 4; and AIV in 3, 5 and 6.

There are many possible reasons for the discrepancies between the traditional system and MCA: e.g., during classification, different inclusions or porosities in the clay certainly impart a stronger impression on the examiner than on the MCA. Other subjective factors are described below.

In traditional pottery classification styles, morphology, manufacturing technique, fabric and colors play an important role. Color is one ceramic property that allows facile visual differentiation. In a technical sense, the color of a single minor sherd fragment can tell us about the clay used and the firing techniques (cf. Rice 1987, 331). It is evident that the choice of a special color in any special case depends particularly on the person estimating the color, no matter how the color is subjectively described, even when using a Munsell color atlas (cf. Fischer 1988, 36-37). Light conditions, background, the condition of the reference atlas all influence the choice. Since colors are of great importance, the need for an objective method is manifest.

Firing conditions varying from well oxidized to reduced and smudged affect the color of a ware (see Rice 1987, 345, table 11.3). In the section of a sherd, colors ranging from bright orange-red, identical throughout the whole section, to dark gray-black shades can be seen. There are, of course, misfired and refired sherds within a certain ware as seen through color differences in the section. However, generally the firing conditions are identical within a special ware with the same provenance. The diagnosis "misfired" or "refired" is traditionally based on visual observations, which can be complemented also by objective methods.

The use of colors in the classification of a ware, for studies of manufacturing and provenance, should be indisputable. Especially if pottery with a dubious provenance is involved, colors should, as far as possible, not be estimated by a subjective description. In such cases the value of an objective system like MCA is apparent.

At present, for Canaanite pottery material, MCA grouping to determine provenance is not possible, since no comparative MCA data from Cyprus or Palestine are available. There are, however, indications that point to three or four production areas. Another interesting observation is that some of the coated sherds and uncoated sherds show striking similarities in the MCA values of their sections. The process which is assumed to be responsible for the whitish limey coating, namely the adding of salt or salt water to calcareous clay, seems to be applied in the same centers.

MCA alone is most certainly not the solution for classification or provenance problems. But, supplemented by both chemical and physical analyses, such as petrographic analysis, atomic absorption spectrometry (AAS), neutron activation analysis (NAA) or secondary ion mass spectrometry (SIMS), it can contribute to a more accurate pottery classification. Sherds already analyzed by different chemical and physical methods should be investigated by MCA, which is inexpensive and fast. If the agreement between the other methods and MCA is satisfactory, in many cases the latter could replace more expensive and time consuming methods.

In order to find if there is any possible, positive correlation between the analysis results gained from MCA and methods like SIMS, I am currently applying SIMS to the Canaanite sherds presented here (Fischer 1989, forthcoming). SIMS is a method of surface analysis and microstructural characterization of solids with detection limits of *ca.* 10-14 to 10 atom ppm. It is expensive and relatively time consuming, but it allows for the comparison between its sensitive and detailed results with those obtained by traditional analyzing methods, such as AAS and NAA, in tracing the provenance of the samples.

MCA can also be used as a recording device. The colors of all excavated objects are influenced by our environment—air pollution, ultraviolet light and other hostile agents which result in bleaching. In my opinion MCA should be applied on all objects, as soon as possible after they have been excavated. If the objects require preservation/conservation in the future, the recorded MCA values can be utilized.

REFERENCES

Amiran, Ruth
 1970 *Ancient Pottery of the Holy Land*. New Brunswick, New Jersey.

Åström, Paul
 1986 Hala Sultan Tekke and its Foreign Relations. In *Acts* 1986, 63-68.

Fischer, Peter M.
 1988 Classification of Pottery by Micro Colour Analysis. A Pilot Study. *Hydra* 5, 36-41.

 forthcoming
 Canaanite Pottery from Hala Sultan Tekke: Analysis with Secondary Ion Mass Spectrometry (SIMS). In Proceedings of *Bronze Age Trade in the Mediterranean*, Oxford, 15-17 December 1989.

Grace, Virginia R.
 1956 The Canaanite Jar. In *The Aegean and the Near East. Studies Presented to Hetty Goldman*, edited by S. Weinberg, pp. 80-109. Locust Valley, New York.

Hadjicosti, Maria, Richard E. Jones & Sarah J. Vaughn
 1988 Appendix IV. Part 1: Canaanite Jar from Maa-*Palaeokastro*. Part 2: A Study of some Canaanite Jar Fragments from Maa-*Palaeokastro* by Petrographic and Chemical Analysis. In *Excavations at Maa-Palaeokastro 1979-1986*, by Vassos Karageorghis and Martha Demas, pp. 340-396. Nicosia.

Raban, Avner
 1980 The Commercial Jar in the Ancient Near East: Its Evidence for Interconnections Amongst Biblical Lands. Ph.D. dissertation, Hebrew University. Jerusalem.

Rice, Prudence M.
 1987 *Pottery Analysis. A Sourcebook*. Chicago.

X

Red Lustrous Wheelmade Ware: A Product of Late Bronze Age Cyprus

Kathryn Eriksson

Red Lustrous Wheelmade ware is distinguished not only by its fine red fabric but also by the shapes that were manufactured in this ware, some of which are peculiar to it. Establishing a homeland and/or manufacturing center(s) for it remains an unsettled question although the popular view is that it originates and was manufactured somewhere in North Syria or possibly Cilicia, with other centers of manufacture perhaps located on Cyprus (Table 10.1).

During my study of this ware, I have been impressed by the quantity of Red Lustrous Wheelmade found on Cyprus, by the range of shapes represented there and by the fact that many of the vessels bear pot marks which closely resemble some of the characters of the Cypro-Minoan script. The time has surely passed for rejecting Cyprus as a possible homeland for Red Lustrous Wheelmade on the grounds that the spindle bottle was a novelty in the Cypriot repertoire, or that the method of manufacture of all the shapes was too advanced for the Cypriot potters, or that the technique of burnishing used to finish the ware had been obsolete since the Middle Cypriot Period (Sjöqvist 1940, 85). It is well known now that the ancient Cypriots were, from the end of the Middle Cypriot period, acquainted with the potter's wheel; thus Plain White Wheelmade I ware and more recently Bichrome Wheelmade ware are happily accepted as being of Cypriot manufacture (see Sjöqvist 1940, 88; Knapp & Marchant 1982, 19 with references). Red Lustrous Wheelmade may show an advanced technique of manufacturing but, as it does not appear in the archaeological record until the end of the Late Cypriot IA period, at least fifty years or so after the introduction of the potter's wheel in Cyprus, one could expect that there were some potters who were aware of what could be achieved with this device. The claim that the fabric and technique of manufacture of this ware are too advanced to be of Cypriot manufacture must also be seriously reconsidered. The island had a strong ceramic tradition and the quality, for example, of the Base Ring juglets

that were used most probably to export opium to many sites in the eastern Mediterranean was extremely high (Merrillees 1968, 154, 156-157). That so much Red Lustrous Wheelmade is known from Cyprus may indeed result from the fact that we know more about both settlement and cemetery sites there than in any other of the neighboring areas because of the favorable conditions available for excavation. For example, Egyptologists have, in the past, concentrated on retrieving material from funerary contexts before settlement sites while Levantine scholars deal mainly with large, multiperiod settlement sites. It is claimed by some that North Syria and Cilicia may be the areas in which Red Lustrous Wheelmade originates (Table 10.1), even though thorough surveys, let alone excavation of these areas are lacking. However, looking at the facts as they are available today, that this ware is closely associated with Cyprus and the ancient Cypriots cannot be doubted. To me, it seems that this very fine class of pottery can claim Cyprus as its homeland.

A map showing the distribution of the ware on Cyprus (Fig. 10.1) indicates that it is found at sites located throughout the island, although it is not well represented in the far southwest (see *SCE* IV Pt.1C, 198-206 for a record of occurrences). Major concentrations can be noted for Kazaphani (LC I-LC II) in the north, Enkomi (LC I-LC III) on the east coast and Hala Sultan Tekke (LC III) on the island's southeast coast. Outside Cyprus (Fig. 10.2) the ware is found all the way down the Nile Valley into Nubia, extensively throughout Palestine and at some sites in Lebanon and Syria, up into Cilicia and at sites on the Anatolian Plateau, and at sites on a few Mediterranean islands. However, the pattern of distribution provides only a general picture outside of the bounds of a relative chronological framework. It is only when the deposits in which Red Lustrous Wheelmade has been found are placed within such a framework that we come a step closer to reading the prehistoric record as witnessed by this class of ceramic.

TABLE 10.1
History of Research (to 1984)

Reference	Comments/Notes	Date Range	Proposed Center of Origin and or Manufacture
Macalister (1912, 177)	Reference to a spindle bottle from Gezer, Palestine		"...recognizably of Egyptian origin
Myres (1914, 41)	Classified it as wheelmade Red Ware	Recorded in Cyprus between 1400-1200 BC	"...probably not of Cypriote manufacture
Wainwright (1920, 62)	Reference to a spindle bottle from Balabish, Egypt		Not Cypriot or Egyptian
Frankfort (1924, 108)			North Syrian
Gjerstad (1926, 201, 232-324)	Renamed it Red Lustrous III	LC I-LC III	Foreign to Cyprus. Probably from North Syria, Cilicia or an unexplored region
Robinson et al. (1930, 19)			May be Cypriot but called it Syrian
Schaeffer (1933, 94-95, and 1936, 71)			Made in Syrian workshops but of indeterminate origin
Casson (1937, 81)			Perhaps not a Cypriot ware as it occurs in Palestine
Sjöqvist (1940, 51-54, 85-86)	Renamed it Red Lustrous Wheelmade Ware	LC IA-LC II	Definitely not Cypriot, most probably from North Syria
Daniel (1941, 278)			Not Cypriot but unsure of where it was made
Stewart (1948, 154)	Similar in technique with Hittite Red Polished ware	LC IA-LC IIA	North Syrian
Woolley (1955, 360)			Not Cypriot
Schaeffer (1956, 254)		15th-14th centuries BC	Proposes that it was manufactured in Cyprus and North Syria
Bittel (1957, 33-42)	Study of the arm-shaped vessel	Type dates from mid-15th to 13th centuries BC	Probably North Syrian
Stewart (1960, 291)	Spindle bottle developed from an Egyptian ware of the XVIIIth Dynasty with a 17th century antecedent		Probably several centers of manufacture located in Western Asia and Egypt
Merrillees (1963, 194)	Study of some spindle bottles of unknown provenance		Manufactured in Cyprus and North Syria
Merrillees (1968)	Study of Cypriot pottery in Egypt including RL	End Second Intermediate Period to Thutmosis IV	Imported from Syria where they were manufactured
Amiran (1969, 167)	Spindle bottle shows a combination of Hittite and Canaanite features	LB I-LB II	Possibly a Syrian import, definitely foreign to Cyprus and Palestine
Aström (1969, 16-21)		LC IB-LC IIC, 1525-1225 BC	Cypriot center of manufacture may also have been made in Syria

TABLE 10.1
History of Research (to 1984)

Reference	Comments/Notes	Date Range	Proposed Center of Origin and or Manufacture
Holmes (1969, 34-35)	Includes it among the Syro-Palestinian imports to Cyprus		Origin is obscure
SCE IV Pt.1C, 199-207	Lists finds of RL in Cyprus		
SCE IV Pt.1D, 701		LC IA:2-LC IIIA:2	
Saideh (1978, see Merrillees 1983, 188)		LC IB-LC IIA	North Syrian origin
Courtois (1979, 85-95)	Study of the arm-shaped vessels, notes three main areas of distribution, Central Anatolia, Cyprus and North Syria		Their place of origin may be Cilicia

Although the ware had its longest chronological range on Cyprus, I would like first to examine the evidence from Egypt because it provides synchronisms between the appearance and use of Red Lustrous Wheelmade in Egypt with some of the XVIIIth Dynasty pharaohs. Knowing when the ware first appears in Egypt allows us then to make a synchronism with the appearance of the ware in Cyprus during LC I, thus assisting in linking the chronology of the island with surrounding lands. Contrary to Dr. Merrillees' proposal that Red Lustrous Wheelmade appears in Egypt, along with other Late Cypriot wares, as early as the end of the Second Intermediate Period (Merrillees 1968, 171), a re-examination of the contexts showed that an initial date for it much before the reign of Amenhotep I is highly unlikely. The evidence for this early XVIIIth Dynasty date comes from two tomb groups, one of which is the famous Gurob Tomb 27 (Brunton & Engelbach 1927, pl. XII). Sjöqvist (1940, 193) used the evidence from this tomb to support a similar date for the initial appearance of Base Ring I in Egypt. Added support for an early XVIIIth Dynasty appearance of Red Lustrous Wheelmade comes from the excavations at Kom Rabia, Memphis, where fragments of a spindle bottle were recorded

in a settlement context along with Base Ring I and a scarab of Thutmosis I, the latter providing a *terminus ante quem* (Bourriau 1989, 9). However, these are the only contexts which provide solid evidence for the date of the earliest appearance of Red Lustrous Wheelmade in Egypt. The remainder of the evidence falls clearly within the reign of Thutmosis III and there are few deposits that can be dated securely to after the reign of this pharaoh.[1] It is also of interest that in Egypt this ware is often found in association with Base Ring I, there being only one published context in which it is found with Base Ring II.[2] As for Red Lustrous Wheelmade's association with Aegean pottery in Egypt, it has been found together with Late Minoan IA/B (?) and with Late Helladic IIB, combinations that again synchronize with the reign of Thutmosis III and Late Cypriot IB.[3]

In terms of a relative chronological framework, the reign of Thutmosis III falls within the Late Cypriot I period. It was believed by Sjöqvist (1940, 197) to occur during the second half of his Late Cypriot IA,[4] while Åström (*SCE* IV Pt.1D, 762) preferred to link it with Late Cypriot IB, a correlation that suits better the evidence of Red Lustrous Wheelmade in Egypt and Cyprus.[5]

1. Most of the tomb deposits in question can be dated to the time spanning the reigns of Hatshepsut and Thutmosis III. However, there are a few mixed deposits after the reign of Amenhotep III which can be used to suggest that Red Lustrous Wheelmade was known in Egypt at least until the reign of Horemheb. A new piece of information, from Janine Bourriau, which came to my attention recently is that a sherd from a lentoid flask was recorded in a context at Kom Rabia which also contained a scarab bearing the cartouche of Horemheb.

2. In Gurob Tomb 051, see Merrillees 1968, 51.

3. Late Minoan IA style is said to be imitated by the alabastron found in Aniba Cemetery S Tomb SA 17 (Steindorff 1937, pl. 89), although Betancourt (1987, 46-47) seems justified in finding a Late Minoan IIIA:1 parallel for the piece. Late Helladic IIB pottery has

been recorded in the Tomb of Maket at Kahun (Petrie 1891, pl. XXVI: 44); and in Saqqara Tomb NE. 1 (Firth & Gunn 1926, pl. 42D).

4. Sjöqvist dated his Late Cypriot IA in absolute terms from 1550-1450 BC, which corresponded with a period 30 years *after* the beginning of the XVIIIth Dynasty (a beginning which was generally accepted as occurring *ca.* 1580 BC) till the end of the reign of Thutmosis III.

5. Åström began the Late Cypriot IA Period at *ca.* 1575 BC, which was 25 years *before* the beginning of the XVIIIth Dynasty (the beginning of which was then accepted as dating to *ca.* 1550 BC). His Late Cypriot IB was dated, in absolute terms, to *ca.* 1550/25-1450/25 which was then inclusive of the reigns of Ahmose to the end of Thutmosis III/beginning of Amenhotep II.

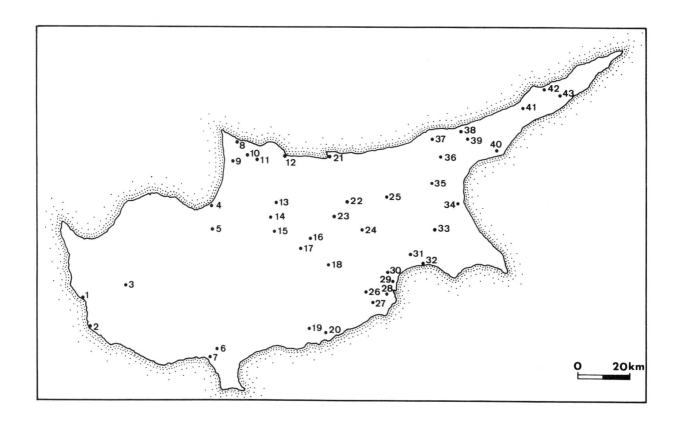

Figure 10.1. Distribution of Red Lustrous Wheelmade Ware on Cyprus

1. Maa-*Palaeokastro*
2. Paphos
3. Ayios Dhimitrianos-*Vouni*
4. Pendayia-*Exomilia*
5. Katydhata
6. Erimi-*Kafkalla*
7. Kourion-*Bamboula*
8. Kormakiti-*Ayious*
9. Ayia Irini
10. Stephania
11. Myrtou-*Pigadhes*
12. Lapithos
13. Dhenia-*Kafkalla*
14. Akaki-*Trounalli*
15. Akhera-*Paradhisi*
16. Pera
17. Politiko
18. Lythrodonda-*Moutti tou Kadou*
19. Kalavasos
20. Maroni
21. Kazaphani-*Ayios Andronikos*
22. Kaimakli-*Evretadhes*
23. Nicosia-*Ayia Paraskevi*
24. Ayios Sozomenos-*Ambelia*
25. Angastina
26. Klavdhia
27. Arpera
28. Hala Sultan Tekke-*Vizaja*
29. Kition
30. Aradhippou
31. Pyla-*Kokkinokremos*
32. Dhekelia-*Steno*
33. Kalopsidha
34. Enkomi
35. Milia
36. Ayios Iakovos
37. Akanthou-*Rombos*
38. Phlamoudi-*Melissa*
39. Kantara
40. Ayios Theodoros-*Petra Stiti*
41. Arkades
42. Ayios Thyrsos-*Vikla*
43. Galinoporni

Figure 10.2. Distribution of Red Lustrous Wheelmade Ware in the Eastern Mediterranean

1. Kommos
2. Gournia
3. Ayia Trianda
4. Gournia
5. Troy
6. Beycesultan
7. Maşat Höyük
8. Alaca Höyük
9. Boğazköy
10. Alışar
11. Kültepe
12. Mersin
13. Tarsus
14. Korucutepe
15. Çatal Hüyük
16. Tell Jedeideh
17. Tell Atchana
18. Meskene-Emar
19. Ras Shamra
20. Minet el-Beida
21. Byblos
22. Sidon
23. Tyre
24. Hazor
25. Tell Abu Hawam
26. Megiddo
27. Pella
28. Bahan
29. Shechem
30. Tell Jerishe
31. Azor
32. Gezer
33. Jericho
34. Jerusalem
35. Amman
36. Askalon
37. Tell el-Ajjul
38. Tell el-Hesy
39. Lachish
40. Khirbet Judur
41. Tell el-Rataba
42. Tell el-Yahudiya
43. Giza
44. Zawyet el-Aryan
45. Abusir
46. Saqqara
47. Memphis
48. El-Riqqa
49. Maidum
50. El-Haraga
51. Gurob
52. El-Lahun

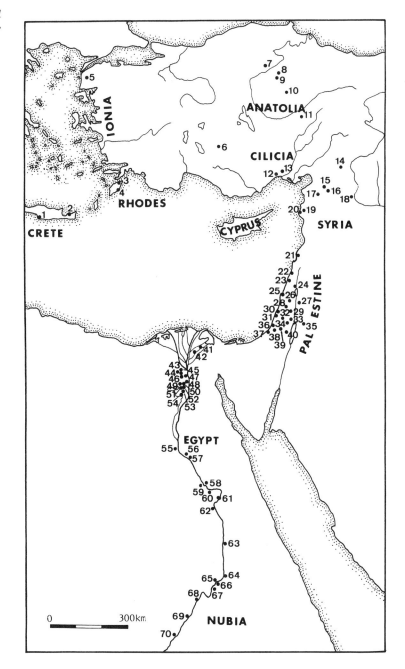

53. Kahun
54. Sidmant
55. Deir Rifa
56. Qaw el-Qebir
57. El-Sawama
58. El-Balabish
59. Abydos
60. Hu
61. Thebes

62. Esna
63. El-Shallal
64. Moalla
65. El-Dakka
66. Quban
67. El-Maharraqa
68. Aniba
69. Buhen
70. Semna

TABLE 10.2
Some Dated Contexts for Red Lustrous (RL) Wheelmade in Cyprus

Context	Late Cypriot Period							RL Type(s) (SCE IV Pt.1C)	References
	IA	IB	IIA	IIB	IIC	IIIA	IIIB		
Enkomi Area I Level IA	**							Sherds 0.74%	*Enkomi*, 444
Kourion-*Bamboula* Tomb 9	**	**						VIA1a	Benson (1972, 15, 105, pl. 28)
Ayia Irini Tomb 21	**	**						IVB2b VIA1b (2)	Pecorella (1977, 145, 147-148, 167, figs. 351, 364, 431 and 461:20, 33, 109)
Kourion-*Bamboula* Tomb 12B	*	*						VIA1a (2)	Benson (1972, 16, 105 pl. 28)
Enkomi Area I Level IB		**						Sherds 0.84%	*Enkomi*, 444
Enkomi Area III Level IB		**						Sherds 1.1%	*Enkomi*, 444
Enkomi French Tomb 3(1)		**						IIIa	Schaeffer (1936, 71-72, 157, fig. 32:47)
Enkomi French Tomb 8		**						VIA1a	Schaeffer (1936, 71, 80, 139, fig. 33:8)
Enkomi Swedish Tomb 8(1)		**						VIA1b (3)	*SCE* I, 503, pl. LXXX:1, rows 1-6, 2:6 and 2:9
Myrtou-*Pigadhes* Phase IIB		**	**					VIA1 sherds	Taylor (1957, 7, 35)
Enkomi Swedish Tomb 17(1)		**	**					VIA1a	*SCE* I, pl. LXXXVI:3, row 6:1
Enkomi French Tomb 5		**	***					VIA1b	Schaeffer (1952, 197, fig. 72: 280, fig. 80: 20)
Enkomi French Tomb 15		*	*					VIA1b	Schaeffer (1952, 109, fig. 40: 20)
Kourion-*Bamboula* Area C Level A:5			*					5 sherds	Benson (1970, 40, table 6B: *SCE* IV Pt. 1D, 682)
Katydhata Tomb 26			*					VIA1b	*SCE* IV Pt. 1D, 685
Kalavasos-*Mavrovouni* Tomb 1			*					VIA1b	*SCE* IV Pt. 1D, 685
Kalavasos Tomb near Mosque			*					VIA1a	*SCE* IV Pt. 1D, 685, n. 2
Enkomi Area III Level IIA Room 13, Floor V			***					VIA1 (2)	*Enkomi*, 236, 557, pl. 60:11-12

TABLE 10.2 (continued)
Some Dated Contexts for Red Lustrous (RL) Wheelmade in Cyprus

Context	Late Cypriot Period							RL Type(s) (*SCE* IV Pt.1C)	References
	IA	IB	IIA	IIB	IIC	IIIA	IIIB		
Kourion-*Bamboula* Area C Level A:6			***					10 sherds	Benson (1970, 40, table 6B)
Kourion-*Bamboula* Tomb 2			***					10 sherds	Benson (1972, 37, table: 2a)
Nicosia-*Ayia Paraskevi* Tomb 15			***					VIA1a	Kromholz (1982, 42, 316-317)
Myrtou-*Pigadhes* Period III			***					VIA1a	Taylor (1957, 35, fig. 17: 131)
Kalavasos-*Ayios Dhimitrios* Tomb 11			***					Numerous examples VIA1b VIIa	South *et al.* (forthcoming)
Enkomi Area III Level IIA Room 5			***	***				VIA1	*Enkomi*, 236, 557, pl. 60:10
Kourion-*Bamboula* Area E Level A:6			*					1 sherd	Benson (1970, 40, table 8B; *SCE* IV Pt. 1D, 682)
Ayios Iakovos Sanctuary			*					VIA1b, VII VIIIb (6+)	*SCE* I, 358, pl. LXVI: I
Enkomi French Tomb 2			*					Ia, IIIa IVB2a, VIAb VIIa, VIIIb	Schaeffer (1952, 110, 124-125, fig. 42:3, 9-13)
Enkomi French Tomb 11			*					VIA1b (10)	Schaeffer (1952, 139, 148,152-3, fig. 59:3-4, pl. XXVII)
Katydhata Tomb 100			*					VIIc	*SCE* IV Pt. 1D 685
Dhekelia—*Steno* Tomb 2			*	***				VIA1b	*SCE* IV Pt. 1D, 685
Kourion-*Bamboula* Area A Level B:6				***				1 sherd	Benson (1970, 41, table 1B)
Kourion-*Bamboula* Area C Level B				***				1 sherd	Benson (1970, 41, table 7B)
Enkomi Swedish Tomb 11 (IA)				***				VIIa	*SCE* I, 521, pls. LXXXII, row 4:14. CXV: 8
Kalavasos-*Ayios Dhimitrios* Tomb 1				***	***			VIA1	Heuck (1981, 69)

TABLE 10.2 (continued)
Some Dated Contexts for Red Lustrous (RL) Wheelmade in Cyprus

Context	Late Cypriot Period							RL Type(s) (SCE IV Pt.1C)	References
	IA	IB	IIA	IIB	IIC	IIIA	IIIB		
Enkomi Swedish Tomb 3				***	***			VIAla (2), VIAlb (3) VIIa, VIIc	SCE I, 478-479, 481-482, 484, pl. LXXVII, row 2: 6-12
Enkomi French Tomb 12				***	***			VIAlb (2)	Schaeffer (1936, 75, 88, 140, fig. 36)
Kition Tomb 1				***	***			VIIc (3)	Karageorghis (1960, 534, 538, figs. 34 and 35)
Politiko Tomb VI				***	***			VIAlb	Karageorghis 1965b, 18
Enkomi Cypriot Tomb 10 (3)				**	*			VIIc	Enkomi, 378, pl. 206:34
Hala Sultan Tekke Tomb 1				*	***	*		VIIa	Karageorghis (1976, 75, 89, pl. LXVII: 93)
Enkomi Area I Level IIb Room 106					***			VIAl	Enkomi, 244, 565, pl. 64: 15
Enkomi Area III Level IIB Room 5					***			VII	Enkomi, 244, 567, pl. 64:16
Hala Sultan Tekke Trench 3					***			Sherds	HST 1, 115, 117
Kourion- Bamboula Area C Level C:1					***			1 sherd	Benson (1970, 41, table 7B)
Kourion- Bamboula Area C Level C:2					***			2 sherds	Benson (1970, 41, table 7B)
Akhera Tomb 2					***			VII	Karageorghis (1965a, 116)
Akera Tomb 3					***			VIAla, VIAlb	Karageorghis 1965a, 126, 132, fig. 35:18 and 57
Myrtou- Pigadhes Period VI					***	***		VIIc VIId	Taylor (1957, 19, 35, fig. 17: 128 and 130)
Enkomi Cypriot Tomb 10 (4)					*			VIIa	Enkomi, 372, pls. 209: 20, 210:21
Enkomi Swedish Tomb 11 (III)					*			VIIa	SCE I, 518, pl. LXXXIII, row 6:17
Maa-Palaeokastro					*			Sherds	Karageorghis (1982, 86)
Enkomi Area III Level IIIA Court 87						**		VIId	Enkomi, 258, 586, pls. 69: 4-5, 123: 1
Hala Sultan Tekke Area 22 F 6182						**		VII	HST 5, 37, 93

TABLE 10.2 (continued)
Some Dated Contexts for Red Lustrous (RL) Wheelmade in Cyprus

| Context | Late Cypriot Period | | | | | | | RL Type(s) (*SCE* IV Pt. 1C) | References |
	IA	IB	IIA	IIB	IIC	IIIA	IIIB		
Kourion-*Bamboula* Area A Level D:2						****		2 sherds	Benson (1970, 41, tables 2B, 3B)
Kourion-*Bamboula* Area A Level D:3						****		VIA1 2 sherds	Benson (1970, 41, table 3B)
Kourion-*Bamboula* Area E Level D:2b						****		1 sherd	Benson (1970, 41, table 9B)
Kourion-*Bamboula* Area A Level D:2c						****		3 sherds	Benson (1970, 41, table 9B)
Kourion-*Bamboula* Area A Level D:2e						****		3 sherds	Benson (1970, 41, table 9B)
Enkomi Area III Level IIIB Room 43						****	*	VIA1	*Enkomi*, 280, 464, 607, pl. 77:1
Kourion-*Bamboula* Tomb 33							****	Sherd	Benson (1972, 39, table 33 t)

On Cyprus, Red Lustrous Wheelmade has been recorded in both settlement and tomb deposits dated to Late Cypriot IA but in very small percentages only (Table 10.2). It would seem, therefore, that while the ware had its beginning toward the end of Late Cypriot IA, it became relatively more common during Late Cypriot IB (Table 10.2). However, even though Red Lustrous Wheelmade is recorded in Late Cypriot IB deposits, if this phase is contemporary with the time of Thutmosis III, then the Egyptian evidence is far more substantial than the Cypriot in terms of quantity. This discrepancy may result from an imbalance in the archaeological record as there have been a greater number of tombs excavated in Egypt than for the same time period in Cyprus.[6]

It is not until Late Cypriot IIA that Red Lustrous Wheelmade reaches its peak period on Cyprus, one that continues until Late Cypriot IIC. It is also during Late Cypriot IIA that a greater range of shapes is known in contrast with the preceding period when the spindle bottle was the predominant shape (Table 10.2). This period, Late Cypriot IIA, is also marked by the appearance of Mycenaean IIIA:1 pottery which thus links it with the reign of Amenhotep III, a time when Red Lustrous Wheelmade has almost disappeared from the archaeological record in Egypt.[7]

Red Lustrous Wheelmade continues to appear in contexts on Cyprus dated to Late Cypriot IIB and IIC; in fact, it is found later in contexts dated to Late Cypriot III, although its presence in the latter may represent survival only (Table 10.2). It may be noted here that Cyprus is the only land (and in particular the site of Hala Sultan Tekke), where this ware continues to appear after the end of the Late Bronze Age (Table 10.3, cf. Cyprus and Syria/Palestine chronologies *ca.* 1200 BC).

In the Levantine area we are confronted again with a different chronological distribution pattern in comparison with Cyprus and Egypt. The evidence from Palestine suggests that the ware appears first in Late Bronze I deposits. A tomb excavated at Pella in Jordan produced a fine example of a spindle bottle in a context that had been preliminarily dated to Middle Bronze IIC-Late Bronze I (Potts *et al.* 1985, 205-206; Potts & Smith forthcoming 1991). However, as the tomb contained over 1,500 pots, and as some of the local pottery types are found in other contexts dated right down until the end of Late Bronze I, the spindle bottle may belong to a later period of use of the tomb. A good, early context for Red Lustrous Wheelmade in Palestine is in the Fosse Temple, Structure I at Lachish. Here a spindle bottle was found near the altar along with local and Egyptian pottery and also with Base Ring, White Slip I-II and Late Helladic IIB, (Tufnell *et al.* 1940, 88). The date for this

6. For example, see *SCE* IV Pt.1D, 828-831, where *ca.* 63 tombs are recorded as containing Late Cypriot I burials.

7. Although Dr. P. Russell informed me that it does occur at Marsa Matruh in association with Late Minoan IIIA:1 pottery.

structure is from some time during the reign of Thutmosis III to no later than an early stage in the reign of Amenhotep III (Tufnell *et al*. 1940, 69). The Pella spindle bottle should not be much earlier than the reign of Thutmosis III in accordance with both the Cypriot and Egyptian evidence. The remaining evidence from Palestine, and there is little, dates solidly within Late Bronze II and down to the end of this period (*SCE* IV Pt.1D, 741 for references).

In Syria, at the few sites where Red Lustrous Wheelmade has been found, there are only a few published occurrences which I consider to be earlier than the reign of Thutmosis III (*SCE* IV Pt.1D, 741-742 for references). At Tell Atchana the fragmentary spindle bottle from Yarim Lim's level VII palace must be regarded as being intrusive and the doubtful attribution of a pilgrim flask to either level VI or V must also be scrutinized (Woolley 1955, 358). The attribution of a grave which contained two spindle bottles to level V may be correct (Woolley 1955, 358), and at any rate would fit with the evidence presented above as the following level IV is in part contemporary with the reign of Thutmosis III. This level has been linked with the transition of Late Cypriot IB:2 and Late Cypriot IIA:1 (McClellan 1989, 211). The remaining evidence comes from, or is attributed to, level IV (Woolley 1955, 358). Interestingly, there are only three published pieces, one spindle bottle and two pilgrim flasks, from the later level II of end XVIIIth-early XIXth Dynasty date (Woolley 1955, 358), so again a large percentage of the published material from Tell Atchana belongs to the time of Thutmosis III or shortly after.

At Ras Shamra and Minet el-Beida there is a burial containing two spindle bottles that may certainly date to before the time of Thutmosis III (Schaeffer 1949, fig. 51: tombs 1, 2). The remaining evidence falls again mainly within the time from the reign of Thutmosis III until Amenhotep III with only a few of the published occurrences dating to after this time ie., down to the end of the Late Bronze Age (*SCE* IV Pt.1D, 741-742 for references). So, surprisingly, the evidence from Syria adds little to the knowledge already gained from the examination of the Cypriot evidence, although the continuing excavations at Ras Shamra should alter this situation.

There are no known early occurrences of Red Lustrous Wheelmade in Anatolia with the evidence for dating falling entirely within the Late Bronze II Period, from the reign of Tudhaliyas I until the fall of the Hittite Empire.[8]

The finds from the Aegean are also late. At Ayia Trianda on Rhodes in stratum IIb, the lower body of a spindle bottle was found associated with, among other things, Late Mycenaean IIIA:1 and Late Minoan IIIA:1 pottery (Furumark 1950, 176). The same picture is presented at Kommos on Crete where sherds of a spindle bottle were found (Shaw 1981, 219); while at Gournia, a spindle bottle was found with Late Minoan II Palace style pottery according to Miss Hawes (Hawes *et al.* 1908, pl. 25).[9] Relating this evidence with Egypt then, we are looking at a period from between the reigns of Amenhotep II to Amenhotep III for the Aegean evidence for the dating of this ware.

This then is a very brief summary of the distribution and chronology of this ware in the lands where it has been found. One should add to this the fact that once away from Cyprus the shapes that are found on the mainland or on the Aegean islands present a very limited range of the ware's repertoire. It is only on Cyprus that the eight main types and their variants as defined by Åström (*SCE* IV Pt.1C, 199-206) have been recorded (for some of these see Fig. 10.3). In Egypt, although the lentoid pilgrim flask (Fig. 10.3: i) is known, it is the spindle bottle (Fig. 10.3: h) that is most common. In Palestine the spindle bottle, pilgrim flask and one arm-shaped vessel (Fig. 10.3: l) have been recorded. In Syria the spindle bottle, pilgrim flask, arm-shaped vessel and some of the bowl forms (Fig. 10.3: a, b) are known. Anatolia has, to date, the most recorded examples of the arm shaped vessel, including the short form (Fig. 10.3: k), in comparison with any other area. The spindle bottle is also found, including the long form (Fig. 10.3: h), while the pointed base jug (Fig. 10.3: e) has been found in Cilicia and fragments of arm-shaped vessels (?) are known from Ionia. On the islands of Rhodes and Crete only the spindle bottle has been recorded. A rather unusual and rare form is the lentoid flask with an incised and fenestrated stand (Fig. 10.3: j). This shape is known from a few sites only: Enkomi and Myrtou-*Pigadhes* on Cyprus, Ras Shamra/Minet el-Beida in Syria and three examples from Tarsus in Cilicia. Finally, there are some shapes that have not yet been found outside Cyprus. These include some of the bowl types, the krater (Fig. 10.3: c), the juglet types (Fig. 10.3: d, f). Although there is unpublished mainland material which may or may not alter this picture, that these shapes are not known outside Cyprus must indicate that they were produced in smaller quantities to satisfy a local demand.[10]

8. See *SCE* IV Pt.1D, 741 for references.

9. According to Hawes *et al.* (1908, pl. 25), the building in which the Red Lustrous Wheelmade was found belongs to the later architectural phase of the site. It is with this phase that she records Late Minoan II Palace style pottery. However, Professor Betancourt informed me after my paper that only Late Minoan I and Late Minoan III pottery are recorded at Gournia.

10. Perhaps some added evidence in support of a Cypriot manufacture for this ware is that in terms of sheer numbers I have recorded about 400 vessels and 1,000 sherds from Cyprus, 188 vessels from Egypt, 35 from Palestine, 67 from Syria, 102 from Anatolia and a mere four from the islands of Crete and Rhodes.

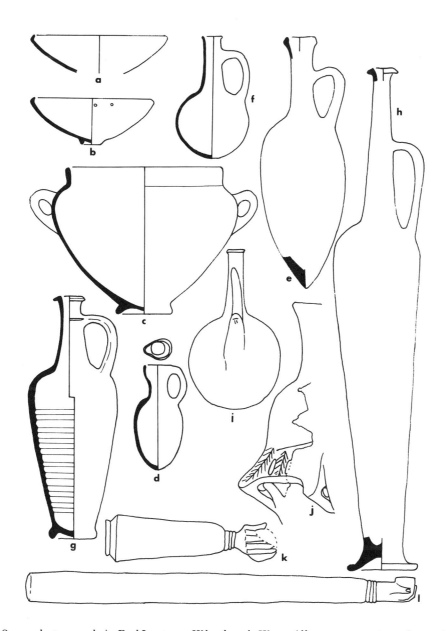

Figure 10.3. Some shapes made in Red Lustrous Wheelmade Ware. All measurements are in centimeters.
a. *Wide bowl. Type Ia. Enkomi Swedish Tomb 7. SCE IV Pt.1C, fig. LV: 2*
b. *Wide bowl. Type Ia. Enkomi French Tomb 2: 264. Schaeffer 1952, fig. 42: 3. H. 7.7; D. 21.6*
c. *Jar. Type IIIb. Enkomi French Tomb 2: 251. Schaeffer 1952, fig. 42: 11. H. 24.0; D. 33.0*
d. *Juglet. Type IVA1a. Museum of Mediterranean Antiquities, Stockholm, acc. 245. SCE IV Pt.1C, fig. LV: 3*
e. *Jug. Type IVB2a. Enkomi French Tomb 2: 233. Schaeffer 1952, fig. 42: 10. H. 40.0*
f. *Juglet. Type IVB2b. Ayia Irini Tomb 21: 109. Pecorella 1977, fig. 431. H. 14.9; max. D. 9.0*
g. *Spindle bottle. Type VIA1a. Stephania Tomb 9: 1. Hennessy 1963, pl. XLIV: 1. Max. H. 24.4; max. D. 9.2*
h. *Spindle bottle. Type VIA1b. Enkomi French Tomb 2. Schaeffer 1949, fig. 42: 12. H. 79.0*
i. *Lentoid flask. Type VIIa. Enkomi Swedish Tomb 11A: 229. Sjöqvist 1940, fig. 13; SCE IV Pt.1C, fig. LV: 1*
j. *Lentoid flask. Type VIId. Enkomi Area III, Level IIIA. Enkomi, pls. 69: 4-5, 123: 1*
k. *Arm-shaped vessel. Type VIIIa. Enkomi British Tomb 57. SCE IV Pt.1C, fig. LV: 5. Preserved L. 28.6*
l. *Arm-shaped vessel. Type VIIIb. Enkomi French Tomb 2: 7. Schaeffer 1952, fig. 42-13. L. 69.0*

TABLE 10.3
Chronological Chart

BC	Cyprus	Crete[1]	Greece[1]	Egypt[2]	Syria/Palestine
—1530		MMIII		Ahmose	MB IIC
—	LC IA			(1530-1504)	
—				Amenhotep I	
—1500			(1504-1483)	
—				Thutmosis I	
—		LM 1A	LH I	(1483-1470)
—				Thutmosis II	
—		———— ———— ————		(1470-1467)	
—1450		LM IB	LH IIA	Hatshepsut	LB I
—	LC IB			(1467-1443)	
—		———— ————		Thutmosis III	
—		LM II	LH IIB	(1467-1414)	
—				Amenhotep II	
—1400				(1414-1388)	————
—				Thutmosis IV	
—		———— ————		(1388-1379)	
—	————			Amenhotep III	
—	LC IIA	LM IIIA:1	LH IIIA:1	(1379-1340)	
—1350		———— ————		Amenhotep IV	
—	————	LM IIIA:2	LH IIIA:2e	(1340-1324)	
—	LC IIB		LH IIIA:2l	Smenkhare	LB IIA
—				Tutankhamun	
—			Ay	
—1300	————			Horemheb	————
—				Ramses I	
—				Seti I	
—				Ramses II	LB IIB
—			LH IIIB	(1279-1213)	

TABLE 10.3 (continued)
Chronological Chart

BC	Cyprus	Crete[1]	Greece[1]	Egypt[2]	Syria/Palestine
—1250	LC IIC				
—					
—				Mereneptah	
—				(1213-1203)	
—				Amenmesses	
—1200	LC IIIA		LH IIIC	(1203-1200)	
—					Iron Age

[1]Based on Hankey (1987, 53).
[2]Based on Helck (1987, 26).

Another quite important aspect of this ware is the frequent occurrence of a pot mark, made before firing, on the base of some spindle bottles, kraters and arm-shaped vessels or on the lower handle of spindle bottles and more commonly on lentoid flasks. There are enough pot marks to form a large corpus (*SCE* IV Pt.1C, 206-207). They resemble signs of the Cypro-Minoan syllabary, although the more complex characters of that script rarely appear on the vessels. The marking of these vessels before firing was surely an integral part of their production, and as the potter was often using Cypro-Minoan signs this would seem to indicate that a workshop was located on the island. This production may have included not only the manufacture of the container but the filling of it also. Although the results of some residue analyses are known, we cannot, as yet, state with certainty whether or not these vessels contained a standard content (for some results see Åström 1969, 21; Carriveau *et al.*, 1986, 26).

That Red Lustrous Wheelmade, with or without contents, was highly regarded can be seen by its inclusion among grave goods and temple offerings throughout the eastern Mediterranean. It does occur in settlement debris but infrequently and in minute percentages, (e.g., on Cyprus see Table 10.2). At this stage of my study it can be noted that a large percentage of the vessels come from female burials. In those burials where there has been little or no disturbance, a position close to the skull or upper torso has been observed in both female and male burials.

Having summarized the evidence for the distribution and chronology of this ware, what does it tell us? A picture has emerged of a general archaeological horizon for the appearance of Red Lustrous Wheelmade toward the end of Late Cypriot IA:2; the second half of Late Bronze I in Syria-Palestine and in Egypt, not before the reign of Amenhotep I. The occurrences are few and it is not until the long reign of Thutmosis III that the ware's popularity peaked in Egypt, after which it almost entirely disappears from the archaeological record there. The reason behind this seemingly short-lived *floruit* of Red Lustrous Wheelmade in Egypt is of interest in the wider sphere of the history of this period and, in turn, aids us in understanding a little more the role that Cyprus played during the Late Bronze Age.

The evidence for Egyptian presence on Cyprus at this time is virtually nonexistent, so it seems unlikely that there was regular and direct contact between the two. Thutmosis III marched his armies into Palestine but it seems unlikely that they would have procured Red Lustrous Wheelmade there as so little has been recorded from that area. Perhaps the ware was seized as war booty during his Syrian campaigns.[11] The fact that its popularity was short-lived may indicate this, although

11. It is possible that the association with the military may also explain the initial appearance of this ware in Egypt which is thought to occur during the reign of Amenhotep I or perhaps not until the reign of his successor Thutmosis I. If it does not appear until the reign of Thutmosis I, then we can again consider that the ware may have come back to Egypt after his Syrian campaigns.

the Egyptian market was selective at the best of times. Red Lustrous Wheelmade does not seem to have been well suited to the Palestinian market when one compares the number known with the quantities of other Cypriot pottery that has been found there (see e.g., Gittlen 1978). If the ware reached Egypt from Syria it is hard to explain the rarity with which it is found in Palestine unless a direct sea route to Egypt was in use more often than an overland one. Sea trade certainly carried it to places such as Crete and Rhodes in the years after the reign of Thutmosis III, although with the growing strength of the Hittites the situation in the eastern Mediterranean began to change. It is with the appearance of the Hittites in Syria and their eventual take-over of the region that we see a new direction in the dispersal of Red Lustrous Wheelmade as large quantities begin to appear in Anatolia. Again the trade probably went through Syria as there is little evidence for any Hittite presence on Cyprus and practically no other Cypriot pottery is known in Anatolia.[12] If Red Lustrous Wheelmade is made on Cyprus as suggested here, does this change in the direction of trade indicate a change of foreign policy for the island? Perhaps the ability of large empires like Egypt and the Hittites to swallow up the available goods indicates that the production of this ware was a small localized affair, but where? I have been impressed by the large quantities of this ware that have turned up in tombs of Late Cypriot I-Late Cypriot III date at the northern Cypriot site of Kazaphani where over 100 vessels that demonstrate a wide variety of shapes including some new ones are known.[13] However, at this stage, that the production center(s) may be located in the north of the island remains purely speculative and one is still left with more questions than answers.

Throughout this paper I have avoided using absolute dates while trying to construct a relative framework for the chronology of the ware. Were I forced to attach absolute dates to this framework they would be based on the low chronology for Egypt (Table 10.3; Helck 1987, 53).

The evidence from the known distribution and chronology of the ware would suggest strongly that Cyprus was the center of production because:

(a) There is numerically more Red Lustrous Wheelmade in Cyprus than in the rest of the Near East and Egypt combined.

(b) It is only on Cyprus that there is the full range of known shapes.

(c) It is only on Cyprus that there is a complete temporal distribution of the ware throughout the entire Late Bronze Age and into the Early Iron Age. In Egypt and Anatolia in particular, the ware has a narrow time range.

In support of the above, Dr Michal Artzy (personal communication) has informed me that neutron activation analysis probably indicates that the fabric is very similar to that of Base Ring ware but that it also shows an affiliation with samples from clay beds near Boğazköy in Anatolia. Neutron activation analysis of a spindle bottle from Egypt showed that its fabric matched that of Cypriot ceramics (Carriveau et al. 1986, 26). More fabric analyses of a range of shapes, from different chronological periods, and from all areas where this ware has been found, will be the aim of a planned provenance study. The results will be of great interest but, until these are available, the evidence from a study of the distribution and chronology, supported by the use of Cypro-Minoan characters on these vessels, support a claim for Cyprus as the homeland for Red Lustrous Wheelmade ware.

Acknowledgments

I would like to express my thanks to both Professor J.B. Hennessy and Mr. Stephen Bourke for their time given to discussing some of the points that appear in this paper. Needless to say, I alone accept full responsibility for the interpretation of the material. I would also like to acknowledge Janine Bourriau and Professor H. Smith who not only enlightened me as regards the Egyptian evidence and historical scene but also allowed me to mention here some of the material from Kom Rabia, Memphis. This paper deals exclusively with the very fine fabric of this ware since those coarse red variants that are known from Egypt, Cyprus, Syria and Palestine form only a small, but interesting, group of material which will be dealt with in my thesis.

12. White Slip has been found at Maşat, see Özgüç 1978, 66.

13. See unpublished tombs in the Cyprus Survey Museum and the forthcoming publication of Kazaphani Tombs 2a and 2b by Dr. I. Nicolaou and others.

REFERENCES

Amiran, Ruth
1969 *Ancient Pottery of the Holy Land. From its Beginnings in the Neolithic Period to the End of the Iron Age.* Jerusalem.

Åström, Paul
1969 A Red Lustrous Wheel-made Spindle Bottle and its Contents. *MedMusB* 5, 16-21.

Benson, Jack L.
1970 Bamboula at Kourion. The Stratification of the Settlement. *RDAC*, 25-74.

1972 *Bamboula at Kourion.* Philadelphia.

Betancourt, Philip P.
1987 Dating the Aegean Late Bronze Age with Radiocarbon. *Archaeometry* 29, 45-49.

Bittel, Kurt
1957 Arm-förmige Libationsgefässe. In *Bogazköy III. Funde aus den Grabungen 1952-1955*, edited by Kurt Bittel, R. Naumann, T. Beran, R. Hachmann & G. Kurth, pp. 33-42. Berlin.

Bourriau, Janine
1989 *Aegean Pottery from Stratified Contexts at Memphis, Kom Rabia.* Paper given to the Aegean Bronze Age Seminar in New York on 15 February 1989 and to the Department of Classical Archaeology in the University Museum, Philadelphia, on 16 February 1989. Copyright J. Bourriau and EES.

Brunton, Guy & Reginald Engelbach
1927 *Gurob.* London.

Carriveau, G.W., R. Hood & P. Cefaratti
1986 Examination of the Contents of a Bronze Age Spindle Bottle. *International Symposium on Archaeometry 1986 Abstracts*, 26. Athens, Greece.

Casson, Stanley
1937 *Ancient Cyprus: Its Art and Archaeology.* London.

Courtois, Jacques-Claude
1979 A propos des tuyaux rituels ou bras de libation en Anatolie et à Chypre. In *Florilegium Anatolicum: Mélanges offerts à Emmanuel Laroche*, pp. 85-95. Paris.

Daniel, J.F.
1941 *Prolegomena* to the Cypro-Minoan Script. *AJA* 45, 249-282.

Firth, Cecil M. & Battiscombe Gunn
1926 *Teti Pyramid Cemeteries* I-II. Cairo.

Frankfort, Henri
1924 *Studies in the Early Pottery of the Near East* I. Royal Anthropological Institute Occasional Papers 6. London.

Furumark, Arne
1950 The Settlement of Ialysos and Aegean History c. 1550-1400 B.C. *OpArch* VI, 150-271.

Gittlen, Barry M.
1978 Studies in the Late Cypriote Pottery Found in Palestine. Ph.D. disseratation, University of Pennsylvania. Philadelphia. University Microfilms International, Ann Arbor, Michigan.

Gjerstad, Einar
1926 *Studies on Prehistoric Cyprus.* Uppsala.

Hankey, Vronwy
1987 The Chronology of the Aegean Late Bronze Age. In *High, Middle or Low?* Part 2, edited by Paul Åström, pp. 39-59. Göteborg.

Hawes, Harriet B., Blanche E. Williams, Richard B. Seager & Edith H. Hall
1908 *Gournia, Vasiliki and Other Prehistoric Sites on the Isthmus of Hierapetra, Crete.* The American Exploration Society, Philadelphia.

Helck, Wolfgang
1987 Was kann die Ägyptologie wirklich zum Problem der absoluten Chronologie in der Bronzezeit beitragen? In *High, Middle or Low?* Part 1, edited by Paul Åström, pp. 18-26. Göteborg.

Hennessy, J. Basil
1963 *Stephania. A Middle and Late Bronze Age Cemetery in Cyprus.* London.

Heuck, Susan A.
1981 Kalavasos-*Ayios Dhimitrios* 1979: A Preliminary Ceramic Analysis. *RDAC*, 64-80.

Holmes, Yulssus L.
1969 The Foreign Relations of Cyprus during the Late Bronze Age. Ph.D. disseratation, Brandeis University. University Microfilms International, Ann Arbor, Michigan.

Karageorghis, Vassos
1960 Fouilles de Kition 1959. *BCH* 84, pp. 504-588.

1965a Fouilles de tombes du Chypriote Récent à Akhéra. In *Nouveaux documents pour l'étude du Bronze Récent à Chypre*, by Vassos Karageorghis, pp. 71-138. Études Chypriotes III. Paris.

1965b A Late Cypriote Tomb at Tamassos. *RDAC*, 11-29.

1976 Two Late Bronze Age Tombs from Hala Sultan Tekke. In *HST* 1, 70-89.

1982 *Cyprus. From the Stone Age to the Romans.* London.

Knapp, A. Bernard & Anne Marchant
1982 Cyprus, Cypro-Minoan and Hurrians. *RDAC*, 15-30.

Kromholz, S.F.
1982 *The Bronze Age Necropolis at Ayia Paraskevi (Nicosia): Unpublished Tombs in the Cyprus Museum.* SIMA Pocketbook XVII. Göteborg.

Macalister, R.A.S.
1912 *The Excavation of Gezer.* Vol II. London.

McClellan, Tom L.
1989 The Chronology and Ceramic Assembliages of Alalakh. In *Essays in Ancient Civilization Presented to Helene J. Kantor*, edited by Albert Leonard, Jr. & D. Beyer Williams, pp. 181-212. SAOC 47. Chicago.

McNicoll, Antony, Robert H. Smith, Pamela Watson & Sandra Gordon, eds.
forthcoming
 Pella in Jordan 2. Mediterranean Archaeology Supplement 2. Sydney.

Merrillees, Robert S.
1963 Bronze Age Spindle Bottles from the Levant. *OpAth* IV, 187-196.
1968 *The Cypriot Bronze Age Pottery found in Egypt.* SIMA XVIII. Lund.
1983 Late Cypriote Pottery from Byblos. *RDAC*, 181-192.

Myres, John L.
1914 *Handbook of the Cesnola Collection of Antiquities from Cyprus.* New York.

Özgüç, Tahsin
1978 *Maşat Höyük Kazilari.* Ankara.

Pecorella, Paolo E.
1977 *La tombe dell' Età del Bronzo Tardo della necropoli a mare de Ayia Irini "Paleokastro."* Rome.

Petrie, W.M. Flinders
1891 *Ilahun, Kahun and Gurob.* London.

Potts, Timothy F., Sue M. Colledge & Phillip C. Edwards
1985 Preliminary Report on a Sixth Season of Excavation by the University of Sydney at Pella in Jordan 1983/4. *ADAJ* 181-210.

Potts, Timothy F. & Robert H. Smith
forthcoming
 The Middle and Late Bronze Age. In *Pella in Jordan 2*, edited by Antony McNicoll, Robert H. Smith, Pamela Watson & Sandra Gordon. Mediterranean Archaeology Supplement 2. Sydney.

Robinson, D.M., C.G. Harcum & J.H. Iliffe
1930 *A Catalogue of the Greek Vases in the Royal Ontario Museum of Archaeology, Toronto.* Vol. 1. Toronto.

Saideh, Roger
1978 Sidon et la Phénicie méridionale au XIVe s. av. J.C. dans le contexte proche-oriental et egéen. Ph.D. dissertation, University of Paris.

Schaeffer, Claude F.A.
1933 Les fouilles de Minet-et Beida et de Ras Shamra. Quatrième campagne (1932).*Syria* XIV, 94-127.
1936 *Missions en Chypre* 1932-35. Paris.
1949 *Ugaritica* II. Paris.
1952 *Enkomi-Alasia* I. Paris.
1956 *Ugaritica* III. Paris.

Shaw, Joseph W.
1981 Excavations at Kommos (Crete) during 1980. *Hesperia* 50, 211-251.

Sjöqvist, Erik
1940 *Problems of the Late Cypriote Bronze Age.* Stockholm.

South, Alison K. *et al.*
forthcoming
 Vasilikos Valley Project 4: Kalavasos-Ayios Dhimitrios III: The Tombs. SIMA LXXI:4. Göteborg.

Steindorff, Georg
1937 *Aniba* II. Glückstadt.

Stewart, James R.
1948 Cyprus. In *Handbook of the Nicholson Museum*, by A.D. Trendall & J.R. Stewart, pp. 115-199. Sydney.
1960 Review of *Myrtou*-Pigadhes. *A Late Bronze Age Sanctuary in Cyprus* by Joan du Plat Taylor. *AJA* 64, 290-292.

Taylor, Joan du Plat
1957 *Myrtou*-Pigadhes. *A Late Bronze Age Sanctuary in Cyprus.* Oxford.

Tufnell, Olga C., Charles Inge & G. Lankester Harding
1940 *Lachish II: The Fosse Temple.* Oxford.

Wainwright, G.A.
1920 *Balabish.* London.

Woolley, Leonard
1955 *Alalakh. An Account of the Excavations at Tell Atchana in the Hatay, 1937-1949.* Oxford.

XI

A Preliminary Investigation of Systems of Ceramic Production and Distribution in Cyprus During the Late Bronze Age

Priscilla Schuster Keswani

INTRODUCTION

The Late Bronze Age (*ca.* 1650-1050 BC) was a period of major cultural change in Cyprus, marked by the emergence of numerous small urban centers, intensified copper production, the expansion of trade with other Eastern Mediterranean polities, and increasing socio-political hierarchy both within and between settlements (cf. Muhly 1982, 1985, 1986; Knapp 1986, 1988; Keswani 1989a, 1989b). In conjunction with these developments, it is probable that other aspects of economic organization were also undergoing important transformations. The production of ceramics, for example, is one craft which may have been significantly affected. It has sometimes been suggested that the principal Late Cypriot ceramic wares display less diversity and regional variability than those of earlier periods (e.g., *SCE* IV Pt.1D, 769; Herscher 1981, 81; Karageorghis 1982, 63), a phenomenon which may be reflective not only of closer socio-political ties or interaction between different parts of the island, but also of the increasing centralization of pottery manufacture, with most ceramics being produced in a few regional workshops rather than by diverse local groups, as was probably the case in the Middle Bronze Age (cf. Frankel 1981, 1988).

However, the organization of Late Cypriot ceramic production is a problem which has received relatively little attention to date. There is some evidence to suggest that pottery manufacture may have been centered under elite or official control at sites such as Toumba tou Skourou (Vermeule 1974) and Athienou (Dothan and Ben-Tor 1983), but the regional distribution of the products of these workshops cannot as yet be precisely defined. Little or no evidence for ceramic production

facilities has been observed at other Late Cypriot centers up to the present, although the recent discovery in the upper Vasilikos Valley of a possible White Slip production or slipping site (Todd, forthcoming) presents exciting possibilities.

For the present, any efforts to investigate the organization of this craft activity must be focused upon the products themselves and on the evidence of their regional distribution. The degree of standardization evinced by various ceramic types may be related to prevailing systems of ceramic production, as Frankel has recently noted:

A general correlation can be made between a low level of uniformity or standardization and a low level of craft specialization or organization (such as is found with part-time domestic production) on the grounds that the greater the number of potters, the smaller their individual output, and the more infrequent their activities, the greater will be the variation within and between their individual products. At the other end of this scale is the highly uniform output regarded as characteristic of organized mass-production by full-time specialists (Frankel 1988, 34-35; see also Rice 1987, 201-204).

The spatial distribution of the products of specialized workshops and their relative frequency within a given geographical region maybe an indication of the extent to which pottery production is centralized (cf. Sinopoli 1988, 581-582).

Here I will be concerned first with examining the evidence for standardization in those ceramic wares which are widely referred to as Plain White[1]: Plain White

1. In another context (Keswani 1989c) I have chosen to refer to these wares simply as "Plain" inasmuch as the fabrics commonly

subsumed under the rubric of "Plain White" are highly variable in color and frequently anything but "white." This is also true of the

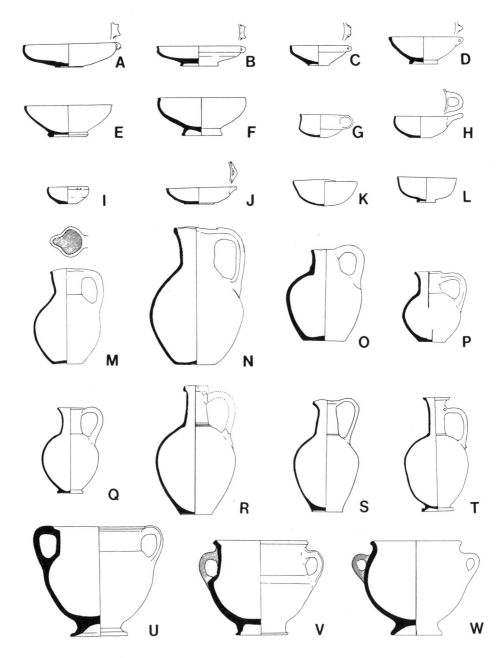

Figure 11.1. Examples of basic ceramic types discussed throughout this paper, selected from SCE IV, Pt. 1C. A-D: bowls with stringhole projection or lug (class 1). E-F: handleless bowls (class 2). G: carinated bowl with strap handle (class 3). H: bowl with Monochrome-type loop handle (class 4). I: bowl with pair of pierced stringholes (class 5). J: bowl with bent or triangular handle of Mycenaean type (class 6). K-L: handleless bowls of PWWM II fabric (class 7). M: PWHM trefoil jug. N: PWWM I trefoil jug. O: PWHM jug with circular mouth. P: PWWM I jug with circular mouth. Q: PWWM I/II jug. R-T: PWWM II jugs. U: amphroid krater. V: open carinated krater. W: open uncarinated krater. For more extensive illustrations of the range of variability within these basic types, see SCE IV, Pt. 1C, plates LIX-LXXII.

Handmade (PWHM), Plain White Wheelmade I (PWWM I) and Plain White Wheelmade II (PWWM II) from the important town center of Enkomi in eastern Cyprus. I will then examine the distribution of Plain White ceramics in general and of certain specific types in collections from other Late Cypriot sites, and I will offer

a tentative construct of the organization of production and exchange in these wares. It must be stressed that the discussion presented here is based on an ongoing program of research, and the interpretations advanced should be regarded as propositions subject to further testing, rather than as definitive conclusions.

CHARACTERISTICS OF THE ENKOMI PLAIN WHITE ASSEMBLAGE

Because of the desirability of working with whole vessels rather than fragmentary material, the following typological analysis is concerned with ceramics derived from mortuary rather than settlement contexts.[2] From the published tombs excavated by the Swedish (*SCE* I), French (Schaeffer 1936, 1952; Courtois 1981), and Cypriot (*Enkomi*) expeditions at Enkomi, there are well over 800 plain pots, comprising approximately 24% of the entire sample of published tomb pottery from this site. Plain wares were also common in settlement contexts, although the frequency of handmade sherds relative to other wares in settlement strata is difficult to estimate (cf. *Enkomi*, 441, 447, 451, 471).[3]

The essential characteristics of PWHM, PWWM I and PWWM II fabrics are described in some detail by Åström (*SCE* IV Pt.1C, 225, 232, 252; see also Catling 1957, 48-59). In modification of the *SCE* descriptions, I would note that in attributes such as fabric color (commonly pink, pale brown, light reddish brown etc., see specific Munsell code below), size and density of the characteristic black "grit" inclusions, thickness, and hardness (subjectively assessed), the PWHM and PWWM I wares are frequently very similar, and were often used to make similar vessel forms. The category of PWWM I, however, encompasses a more diverse range of fabrics, some of

which, including those vessels referred to as PWWM I/II, are relatively thin-walled, with finer and/or less dense inclusions. The PWWM II ware is very different from PWWM I; it is commonly a very thin, hard fabric, of metallic quality, often dark reddish brown in color, treated with a thick yellowish white or pinkish slip.

In the following section I discuss a series of types of Plain White bowls, jugs, and kraters which are differentiated on the basis of morphological characteristics: bowls according to handle type, jugs according to mouth form, and kraters according to body profile (see Fig. 11.1 for an overview of basic types). With limited exceptions, the groups which result from partitioning according to these attributes share an additional complex of related formal and technical characteristics which further distinguish the groups from one another.[4] Future analyses may permit the identification of subgroups representing the products of specific workshops in some categories. For the present time, the ceramics within the categories defined may be viewed as the products of one or more either successive or contemporaneous groups of producers, working in a related ceramic tradition.

Objects included in this study are derived from 20 or more tomb groups located in different areas of the Enkomi settlement.

Enkomi plain wares, but I will retain the use of Plain White in this discussion so as to avoid confusion with earlier literature on Enkomi ceramics which makes use of the Plain White designation (e.g., *SCE* I; Sjöqvist 1940; *SCE* IV Pt.1C).

2. While a substantial number of Plain White vessels found in the tombs appear to have been freshly made, the essentially utilitarian characteristics of this ware, the evidence of use-wear on many tomb pots, and the occurrence of a majority of types in settlement as well as mortuary contexts (*Enkomi*, pls. 113-120) make it highly unlikely that the forms represented in tomb contexts were made exclusively for mortuary use. However, it is possible that Plain White ceramics were especially favored for mortuary use by all but the highest status social groups because of their relatively low cost.

3. At Kourion-*Bamboula*, plain ceramics constituted as much

as 60-80% of ceramic finds in some areas and levels (Benson 1969, 1970).

4. This typology differs considerably from the ordering system employed by Åström (*SCE* IV Pt.1C) in his extremely valuable compilation of Late Cypriot ceramic material. Åström categorizes Plain White bowls first according to body profile, then by base and/or rim form; jugs are categorized first by handle elevation or placement (e.g., handle from rim to shoulder, handle from slightly below rim to shoulder), then by mouth form; kraters are similarly categorized first by handle placement, then by body profile. This classification system sometimes results in the grouping together of very disparate ceramic types which were almost certainly produced in different workshops, and in the separation of types which display only minor differences. The classification system employed in this paper attempts to maximize the internal consistency or homogeneity of each type based on key stylistic and technical features.

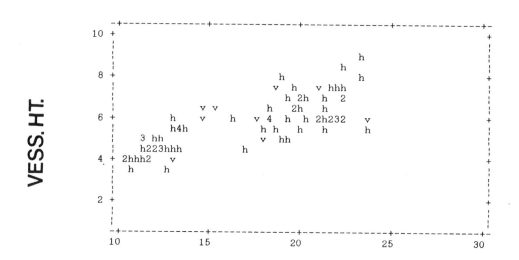

Figure 11.2. Scatterplot of vessel height and rim diameter for bowls with stringhole projections or lugs. Each h represents a bowl with a relatively wide (1.5 cm. or larger), horizontally placed lug (e.g., Figure 1, A-C). Each v represents a bowl with a narrower (less than 1.5 cm.), vertically placed lug (e.g., Fig. 1, D). A numeral indicates multiple occurrences of bowls with identical height and rim diameter measurements. All measurements are in centimeters.

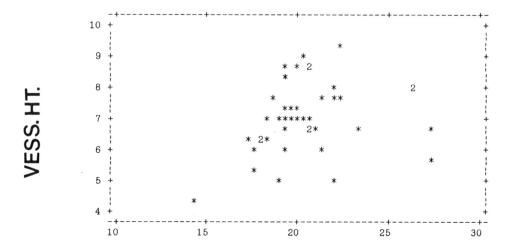

Figure 11.3. Scatterplot of vessel height and rim diameter for handleless bowls (PWHM and PWWM I).

PLAIN WHITE BOWLS

Plain White bowls make up anywhere from 31%-87% of the total assemblage of Plain White vessels in Enkomi tombs, 49% on average. The Enkomi bowls fall into seven general categories based on the presence/absence or type of handle provided, an attribute with which other aspects of fabric and form are generally correlated. The following descriptions are based on the observation of a sample of 197 bowls from diverse tomb groups.

1) Bowls with stringhole projections at or below the rim (PWHM and PWWM I; Fig. 11.1 A-D):

The fabric is most commonly pink (5YR 7/3, 5YR 7/4, 7.5YR 7/4) or light reddish brown (5YR 6/3, 5YR 6/4), sometimes pale brown or gray (10YR 7/2, 10YR 7/3), greenish gray (5Y 7/2) or reddish yellow (5YR 7/6, 5YR 6/6). The slip is white (10YR 8/1, 10YR 8/2), light gray or brown (10YR 7/2, 10YR 7/3), yellowish white (2.5Y 8/2, 2.5Y 7/2) or greenish gray (5Y 7/2). Wall thickness as measured immediately below the rim varies from 0.3-1.1 cm. (mean = 0.6 cm.).

The wheelmade and handmade bowls were almost certainly the products of different workshops. Both display considerable formal variation in the size and placement of the stringhole projection or lug, rim angle (straight, inverted, or everted), body profile (curving, inbent, carinated, or carinated with concave upper body profile), and base form (ring bases of variable height, flat bases, rounded bases, etc.). Such variation is probably to be associated with the work of multiple potters, but the identification of distinctive workshop products is problematic, except as indicated below.

Considerable size variation is apparent in the statistics presented in Table 11.1. The scatterplot of vessel height and rim diameter shown in Figure 11.2 suggests the presence of two size classes, the smaller group having rim diameters between 10-16 cm., the larger with rim diameters between 17-24 cm. Each of these groups is

TABLE 11.1

N=87	Rim Dm.	Vess. Ht.	Vess. Ht./ Rim Dm.	Base Dm./ Rim Dm.
Range	10.5-23.8	3.3-9.0	.023-0.43	0.30-0.57
Mean	17.1	5.6	0.33	0.42
Std. Dev.	4.3	1.2	0.05	0.05

Size and proportional variation in bowls with stringhole projections from Enkomi.

relatively more standardized in size than the category overall. It is not clear whether this bimodality in size is to be associated with different workshops or with functional variation.

However, several bowls which might be assigned to an intermediate category (the larger of the small group and the smaller of the large group) are also characterized by a distinctive variant of handle form, a relatively narrow, vertical lug (less than 1.5 cm. thick) as opposed to the more common, wider horizontal type. These distinctive examples, indicated by the symbol *v* on the scatterplot, were probably produced in a different workshop(s) from the rest.

Bowls with stringhole projections occur in Enkomi French Tombs 110 and 1907, Cypriot Tombs 10 and 19, Swedish Tombs 3, 6, 10, 11, 13, 19, and other contexts not itemized here. These contexts suggest that the bowls may have been produced as early as LC I and throughout LC II. Inasmuch as both handmade and wheelmade examples, as well as both horizontal and vertical lug-types occur in some of the same tombs, further chronological distinctions within the category cannot be made at present.

2) Handleless bowls (PWHM and PWWM I; Fig. 11.1 E, F)

The fabric is usually pink (5YR 7/3, 5YR 7/4, 7.5YR 7/4) or light reddish brown (5YR 6/4). The slip, when present, is white (10YR 8/1, 10YR 8/2, 2.5Y 8/2, 2.5Y 7/2), pinkish white (7.5YR 8/2, 5YR 8/2), or very pale brown (10YR 8/3, 10YR 7/3). The wall thickness ranges from 0.5-1.1 cm., mean = 0.7 cm. Nearly all examples are wheelmade.

The primary dimensions of formal variation within this category are body profile (conical to incurving) and vessel height. Otherwise the bowls appear quite uniform, with undifferentiated rims having flat or rounded edges, usually straight but sometimes slightly inverted, and wheel-formed ring bases varying somewhat in height and thickness. In some cases the ring base may have been applied after the bowl was made; two examples with flat bases were noted. The majority of the bowls may have been produced within a single workshop, with the limited variability observed being associated with the work of different potters.

The statistics in Table 11.2 suggest a wide range of size variation in this category, but the scatterplot shown in Figure 11.3 indicates that the bowls are fairly standardized in rim diameter, although vessel height varies considerably. The variation in vessel height is weakly correlated with base height (varying from 0-1.8 cm.): Pearson's r = 0.537. Discrete size categories are not apparent.

Some of the tomb contexts in which these bowls occur include Enkomi French Tombs 126, 110, and 1851,

TABLE 11.2

N=43	Rim Dm.	Vess. Ht.	Vess. Ht./ Rim Dm.	Base Dm./ Rim Dm.
Range	14.3-27.5	4.2-9.2	0.20-.045	0.34-0.49
Mean	20.5	7.0	0.34	0.40
Std. Dev.	2.7	1.1	0.06	0.04

Size and proportional variation in handleless bowls from Enkomi.

Cypriot Tomb 10, and Swedish Tombs 3, 11, 13, and 19. Their presence in the earliest burial level of Cypriot Tomb 10, and in French Tombs 126 and 1851 suggests that production began in LC I, possibly continuing in LC II, but their absence from tombs of later LC II date such as Swedish Tombs 6 and 10 may indicate that they were not produced throughout this period (cf. also Lagarce & Lagarce 1985, 47, 150).

3) Carinated bowls with strap handles (PWWM I?; Fig. 11.1G)

The fabric is pink (7.5YR 7/4, 5YR 7/4) to reddish yellow (7.5YR 7/6, 5YR 7/6). The slip is white (10YR 8/2, 7.5YR 8/2) to pinkish gray (7.5YR 7/2). Nearly all these bowls have an unusually fine, hard, thin-walled fabric (wall thickness is uniformly 0.3-0.4 cm.), which is quite distinct from the typically coarser, grittier Plain White fabrics of contemporaneous types.[5] All examples observed are wheelmade.

These bowls invariably have a flat strap handle attached from rim to body. The body profile is carinated, with concave sides and everted rim. Most bowls have a rounded base, but one example with a disc base and another with a ring base were observed. These two also had slightly larger rim diameters. Overall, the bowls are very standardized in both form and size (Table 11.3).

Examples of this category of bowls come from Enkomi Cypriot Tomb 10 (at least five from the first burial level), Swedish Tomb 19, French Tomb 32, and French Tomb 390. These contexts suggest a date of LC I for the production of the bowls.

4) Bowls with Monochrome-type loop or wishbone handles (PWHM and PWWM I; Fig. 11.1H)

The fabric is pink (5YR 7/3, 5YR 7/4), very pale brown (10YR 8/3) or light gray (2.5Y 7/2). The slip is white (10YR 8/2, 2.5Y 8/2), pale brown (10YR 7/3, 10YR 8/3), or pinkish white to pinkish gray (7.5YR 8/2, 7.5YR 7/2). Wall thickness ranges from 0.3-0.8 cm. (mean = 0.5 cm.). The majority of the examples observed were wheelmade, but two or three handmade bowls were also noted.

The main aspect of formal variation in this comparatively rare category of bowls is in the handle shape; most bowls have loop handles, variably horizontal or upraised, usually attached below the rim, but three examples of wishbone handles were noted, possibly repre-

TABLE 11.3

N=11	Rim Dm.	Vess. Ht.	Vess. Ht./ Rim Dm.
Range	9.1-11.9	4.7-6.0	0.51-0.63
Mean	9.5	5.5	0.58
Std. Dev.	0.4	0.4	0.05

Size and proportional variation in carinated bowls with strap handles from Enkomi.

TABLE 11.4

N=10	Rim Dm.	Vess. Ht.	Vess. Ht./ Rim Dm.	Base Dm./ Rim Dm.
Range	10.5-20.3	4.4-6.6	0.30-0.54	0.33-0.56
Mean	13.1	5.6	0.44	0.41
Std. Dev.	2.8	0.7	0.07	0.07

Size and proportional variation in bowls with Monochrome-type handles from Enkomi.

5. Parallels for the carinated bowls may be noted at Milia-*Vikla Trachonas* (Westholm 1939) and Kalopsidha (Åström 1966, 19), but the largest number of examples known to date comes from Enkomi. The relative scarcity of the type and the distinctiveness of the fabric, which Furumark described as "PWWM II, early" (*SCE* IV Pt.1C,

235), suggest the possibility that the bowls were of nonlocal origin. At the proceedings of this conference, Dr. Sarah Vaughan noted the existence of parallels from Troy; I have not been able to confirm these as yet, thus the origin of the Cypriot examples remains uncertain for the present.

senting the work of a different potter. In other aspects the bowls were more or less uniform, with straight or slightly inverted, undifferentiated rims, flat bases, and curving to conical profiles (varying with vessel height).

Nine of the ten bowls had rim diameters between 10-15 cm.; only one example was significantly wider, measuring 20.3 cm. (Table 11.4). Three of the four examples which were relatively deep (vessel heights between 6.0-6.6 cm.) also had wishbone handles.

The relative infrequency of this type raises some question as to whether it was in fact produced at Enkomi; as discussed further on, a much larger sample was observed at Angastina.

Some of the contexts in which these bowls were observed include Enkomi Cypriot Tomb 10 and Swedish Tombs 3, 6, 11, 19, and 22; their presence in Swedish Tombs 6 and 22 in particular suggests a date in the second half of Late Cypriot II (LC IIB-LC IIC).

5) Bowls with pair of pierced stringholes slightly below the rim (PWWM I or I/II; Fig. 11.1I)

The fabric is usually pink (5YR 7/3, 5YR 7/4, 7.5YR 7/4) or reddish yellow (5YR 7/6), sometimes light gray (10YR 7/2). The slip is generally white (10YR 8/2, 5YR 8/2, 2.5Y 8/2), very pale brown (10YR 8/3) or pink (5YR 7/3); the surface is often reddened from firing. Vessel wall thickness ranges from 0.3-0.8 cm., but is usually quite thin (mean = 0.4 cm.), and the fabric is relatively hard. All examples observed are wheelmade. Åström characterizes these bowls as PWWM I/II; Furumark described them as PWWM II (SCE IV Pt.1C, 233).

This category displays a low level of formal variation. Rims are usually straight or slightly inverted, sometimes slightly recessed from the body. Body profiles are curving, sometimes hemispherical. Of fifteen examples studied, fourteen had flat bases and one had a ring base.

A majority of the bowls (12 of 15) have rim diameters between 8-12 cm., so that with a few exceptions the ves-

sels of this category seem fairly standardized in size as well as form (Table 11.5).

Bowls with pierced stringholes occur in Enkomi Cypriot Tomb 10, French Tomb 110, and Swedish Tombs 3, 6, 10, 10A, 13, and 19, as well as other contexts. Their presence in Swedish Tombs 6, 10, and 10A may indicate that they were produced in the later part of LC II (LC IIB-LC IIC).

6) Bowls with bent or triangular handles of Mycenaean style (PWWM I or I/II; Fig. 11.1J)

The fabric ranges from very pale brown (10YR 7/3) to pink (7.5YR 7/4) to reddish yellow (5YR 7/6). The slip is either white (10YR 8/2) or pink (7.5YR 7/4). Wall thicknesses range from 0.4-0.6 cm. All examples observed are wheelmade.

These bowls are quite similar to various bowls of Mycenaean IIIB or White Painted Wheelmade III style. Body profiles are curving to incurving, rims straight or slightly inverted, bases flat to slightly concave; one disc base was observed.

TABLE 11.6

N=6	Rim Dm.	Vess. Ht.	Vess. Ht./ Rim Dm.	Base Dm./ Rim Dm.
Range	10.0-16.8	3.2-5.5	0.28-0.45	0.33-0.44
Mean	12.9	4.3	0.34	0.40
Std. Dev.	2.7	0.8	0.07	0.04

Size and proportional variation in bowls with Mycenaean-style handles from Enkomi.

The small size of the sample precludes an assessment of size standardization; summary statistics are given in Table 11.6.

Contexts in which this bowl type occurs include Enkomi Cypriot Tomb 10 and Swedish Tombs 3, 11, 18, and 19. Their presence in Swedish Tomb 18 suggests that they may have been produced in LC IIC, which is consistent with the apparent imitation of the Mycenaean handle type.

7) Bowls of PWWM II fabric, usually without handles (Fig. 11.1K, L)

The fabric ranges from light gray (2.5Y 7/2, 10YR 7/2) to pink (5YR 7/3) or reddish yellow (5YR 6/6). The slip is white (10YR 8/2, 2.5Y 8/2), pale brown (10YR 8/3), pink (5YR 7/3), or occasionally red (5YR 6/4, 5YR 5/6). The fabric is thin-walled (0.3-0.4 cm.), hard-fired,

TABLE 11.5

N=15	Rim Dm.	Vess. Ht.	Vess. Ht./ Rim Dm.	Base Dm./ Rim Dm.
Range	8.9-14.6	3.7-5.0	0.34-0.52	0.37-0.48
Mean	10.5	4.4	0.43	0.42
Std. Dev.	1.7	0.4	0.05	0.04

Size and proportional variation in bowls with pierced stringholes from Enkomi.

and usually quite fine, although a few grainier examples were noted.

The bowls usually have curving or hemispherical profiles with undifferentiated straight or slightly inverted rims. Handles are usually absent, but one example from Enkomi French Tomb 6 (1934) was provided with a tiny horizontal lug. Bases are variably flat, convex, concave or were provided with a ring or disc.

TABLE 11.7

N=10	Rim Dm.	Vess. Ht.	Vess. Ht./ Rim Dm.	Base Dm./ Rim Dm.
Range	9.7-14.5	4.2-6.8	0.40-0.51	0.00-0.46
Mean	12.5	5.6	0.45	
Std. Dev.	1.7	0.9	0.03	

Size and proportional variation in bowls of PWWM II fabric, usually handleless, from Enkomi. Base Dm./Rim Dm. statistics are omitted because several bowls have rounded bases which have been coded with 0 values.

Statistics given in Table 11.7 reveal that bowls of this category are generally small in size and quite standardized in the ratio of vessel height to rim diameter.

Contexts in which these bowls have been observed include Cypriot Tomb 10, French Tombs 6 and 108, and Swedish Tombs 10, 18, and 19. Production is thus probably to be dated to the later part of LC IIC and LC IIIA.

DISCUSSION: EVIDENCE OF STANDARDIZATION IN PLAIN WHITE BOWLS

Since we cannot predefine in absolute terms the range of variation to be expected in the work of a single potter or in the products of a single workshop, the issue of standardization is one which must be examined in relative terms. The calculation of a coefficient of variation (the standard deviation of a variable divided by the mean and multiplied by 100) as illustrated by Frankel (1988) is one way of comparing the degree of variation among different ceramic types.

Figure 11.4 graphs the coefficients of variation for the proportions of vessel height to rim diameter and base diameter to rim diameter in the seven classes of Plain White bowls discussed here. It would seem that classes 3, 5 and 7 (the carinated bowls, bowls with pierced stringholes and PWWM II bowls) are very standardized in their proportions relative to the other types. The high

coefficient of variation for the proportion of vessel height to rim diameter in class 2 handleless wheelmade bowls is somewhat misleading, because vessel height is perhaps the single most variable attribute of this otherwise homogeneous type, one which was clearly a workshop/specialist product. The relatively wide range of variation evident in the class 1 bowls with stringhole projections (lugs) may be reflective of the longer time span over which these bowls were produced and the greater number of potters or workshops involved in their production. The relative lack of standardization in bowls with Monochrome and Mycenaean type handles (classes 4 and 6) is difficult to evaluate or interpret given the small sizes of these samples.

PLAIN WHITE JUGS

Plain White Handmade and Plain White Wheelmade I jugs comprise anywhere from 13%-69% of the total assemblage of Plain White vessels in Enkomi tombs, 40% on average. The jugs may be grouped into two broad formal categories characterized by trefoil or circular mouth forms. Plain White Wheelmade I/II jugs and Plain White Wheelmade II jugs are each treated here as a single category, although the latter subsumes at least three distinctive formal variants which require more detailed future study. The following discussion is based on the observation of a total of 156 jugs.

1) Trefoil jugs (PWHM and PWWM I; Fig. 11.1: M, N)

The fabric is most commonly pink (5YR 7/3, 5YR 7/4, 7.5YR 7/4), very pale brown (10YR 7/3), or reddish (5YR 7/6, 5YR 6/3, 5YR 6/4). The slip is white (10YR 8/1, 10YR 8/2, 5YR 8/2, 2.5Y 8/2), very pale brown (10YR 8/3), or pink (5YR 8/3, 5YR 7/4, 7.5YR 7/4). The fabric of both the wheelmade and handmade examples is extremely gritty and coarse, with wall thicknesses ranging from 0.5-1.4 cm. (mean = 0.7 cm.). Approximately 20% of the jugs were handmade, and were almost certainly not made in the same workshop(s) as the wheelmade jugs. Many of the PWWM trefoil jugs are characterized by deep, closely spaced wheel marks visible on the interior of the neck, and are comparatively thin-walled in relation to their overall size. Some examples are nearly identical in both fabric and form to jugs of the so-called White Painted Wheelmade II fabric; the main difference often appears to consist only in the presence or absence of painted decoration, and it is possible that the PWWM I trefoil jugs were the chronological successors of the White Painted Wheelmade II.

Formal variation among both handmade and wheelmade jugs is fairly minimal, consisting mainly of very subtle aspects of body profile and proportions. Some of the earlier jugs have rounded bases but most are flat. Not

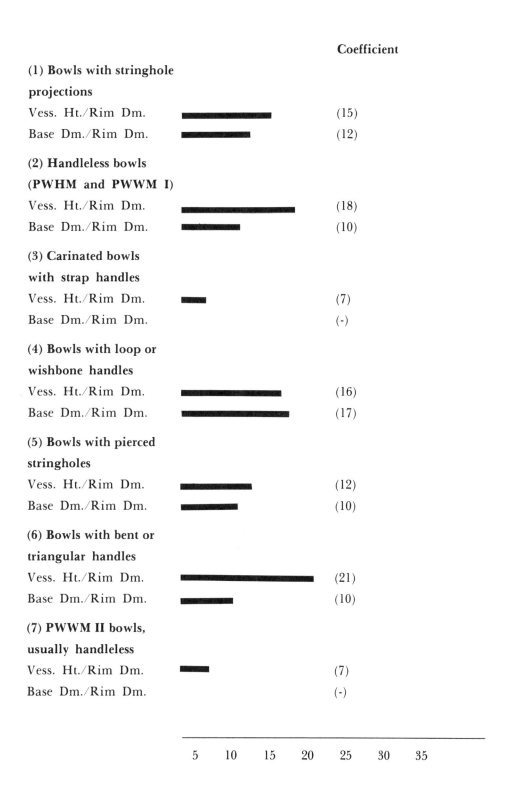

Figure 11.4. Coefficients of variation for the ratios of vessel height to rim diameter and base diameter to rim diameter for Plain White bowl types from Enkomi. Coefficients are calculated by taking the standard deviation divided by the mean, multiplied by 100, for each variable. Coefficients for the ratio of base diameter to rim diameter were omitted where a significant number of vessels had rounded or convex bases.

TABLE 11.8

N=15	Vess. Ht.	Max. Dm.	Neck Ht./ Vess. Ht.	Max. Dm./ Base Dm.	Ht. Max. Dm./Ht.
Range	16.0-30.2	13.1-23.7	0.17-0.40	1.75-2.71	0.49-0.64
Mean	20.4	15.6	0.30	2.09	0.56
Std. Dev.	4.1	2.7	0.05	0.27	0.04

Size and proportional variation in PWHM trefoil jugs from Enkomi.

TABLE 11.9

N=55	Vess. Ht.	Max. Dm.	Neck Ht./ Vess. Ht.	Max. Dm./ Base Dm.	Ht. Max. Dm./Ht.
Range	14.4-37.9	12.2-25.9	0.26-0.38	1.59-2.66	0.47-0.70
Mean	23.5	17.3	0.31	2.10	0.57
Std. Dev.	5.4	3.3	0.03	0.23	0.05

Size and proportional variation in PWWM I trefoil jugs from Enkomi.

surprisingly, the wheelmade jugs seem more standardized than the handmade, which are often rather clumsy and irregular in appearance.

The handmade jugs tend to fall at the smaller end of the size range overall (Tables 11.8, 11.9). There is a wide range of size variation in both groups, but this is especially apparent in the wheelmade jugs. Vessel proportions are relatively standardized however, and it is possible that size variation pertains to differences in function rather than to differences in workshops. Preliminary studies indicate that jug volumes range most commonly from 1.0 to 3.5 liters; a few have even greater volumes ranging up to six liters and beyond. However, it is not as yet possible to determine whether a series of standardized volumetric classes were present.

PWHM and PWWM I trefoil jugs occur (sometimes together) in many different tombs including Cypriot Tombs 10 and 19, French Tombs 110 and 126, and Swedish Tombs 3, 10, 10A, 11, 13, and 19. They were probably produced from LC I until nearly the end of LC II, when PWWM II types came into use.

2) Jugs with circular mouths (PWHM and PWWM I; Fig. 11.1 O, P)

Fabric and slip Munsells are virtually identical to those recorded for the trefoil jugs and will not be repeated here. Wall thicknesses range between 0.5-1.0 cm., with a mean of 0.8 cm. for the handmade jugs and 0.7 cm. for the wheelmade. Once again, roughly 20% of the examples studied are handmade, and were presumably made by a different group of potters.

The wheelmade circular-mouthed jugs differ technically from the wheelmade trefoil jugs; they are heavier and coarser relative to their (smaller) size and the wheel marks are wider and shallower. The circular-mouthed jugs are also considerably smaller overall (Fig. 11.5). There can be little doubt that these two groups were the products of different workshops.

Both the wheelmade and the handmade circular-mouthed jugs are fairly homogeneous in form, with the principal dimensions of formal variation being observed in the shape of the body, which is most often globular, but occasionally piriform or depressed, and in the shape of the neck (widening, cylindrical, or tapering). The

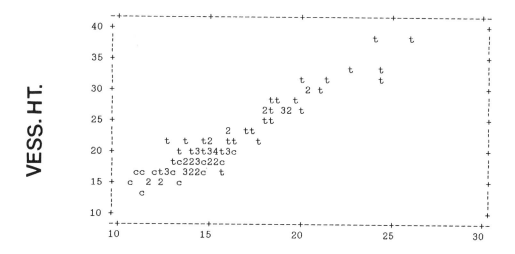

MAX. DIAM.

Figure 11.5. Scatterplot of vessel height and maximum diameter in PWWM I jugs. Each c *represents a circular-mouthed jug; each* t *represents a trefoil jug.*

TABLE 11.10

N=9	Vess. Ht.	Max. Dm.	Neck Ht./ Vess. Ht.	Max. Dm./ Base Dm.	Ht. Max. Dm./Ht.
Range	16.0-28.2	13.2-19.5	0.24-0.32	1.53-2.41	0.48-0.63
Mean	20.3	15.1	0.29	1.85	0.54
Std. Dev.	3.6	2.1	0.02	0.27	0.06

Size and proportional variation in PWHM jugs with circular mouths from Enkomi.

TABLE 11.11

N=41	Vess. Ht.	Max. Dm.	Neck Ht./ Vess. Ht.	Max. Dm./ Base Dm.	Ht. Max. Dm./Ht.
Range	13.0-22.0	10.8-16.3	0.22-0.35	1.93-2.60	0.47-0.65
Mean	16.9	13.8	0.29	2.31	0.54
Std. Dev.	1.8	1.5	0.03	0.15	0.04

Size and proportional variation in PWWM I jugs with circular mouths from Enkomi.

TABLE 11.12

N=12	Vess. Ht.	Max. Dm.	Neck Ht./ Vess. Ht.	Max. Dm./ Base Dm.	Ht. Max. Dm./Ht.
Range	12.5-26.5	10.8-18.6	0.27-0.38	2.25-2.55	0.53-0.67
Mean	18.1	12.8	0.32	2.38	0.61
Std. Dev.	4.5	2.4	0.03	0.10	0.05

Size and proportional variation in PWWM I/II jugs from Enkomi.

TABLE 11.13

N=25	Vess. Ht.	Max. Dm.	Neck Ht./ Vess. Ht.	Max. Dm./ Base Dm.	Ht. Max. Dm./Ht.
Range	15.4-48.3	10.2-30.5	0.20-0.36	1.84-2.59	0.55-0.72
Mean	28.0	17.2	0.31	2.28	0.63
Std. Dev.	8.1	4.9	0.05	0.20	0.05

Size and proportional variation in PWWM II jugs from Enkomi.

handmade jugs tend to be somewhat larger than the wheelmade (Tables 11.10, 11.11).

Circular-mouthed jugs occur in Enkomi Cypriot Tomb 10, French Tomb 110, and Swedish Tombs 3, 6, 11, 13, 18, and 19, as well as in other contexts. Their high concentrations in Swedish Tombs 6, 11, and 18 and in the upper burial levels of Cypriot Tomb 10 suggest a date in the later part of LC II.

3) PWWM I/II jugs (Fig. 11.1Q)

The fabric ranges from light gray (2.5Y 7/2, 7.5YR 7/2) to very pale brown (10YR 7/3), pink (5YR 7/3, 7.5YR 7/4), or light reddish brown (5YR 6/4). The slip is white (10YR 8/2), light gray (10YR 7/2, 7.5YR 7/2), very pale brown (10YR 8/3, 10YR 7/3), or pink (5YR 7/4). This fabric is generally finer, thinner and harder than regular PWWM I. Wall thicknesses range from 0.5-0.7 cm.

Jugs of this fabric are usually circular-mouthed, although one or more trefoil examples have been observed. The jugs have relatively everted rims, necks which are often distinctly concave in profile, and ring or disc bases as opposed to the flat bases of PWWM I jugs. Some

display close formal affinities with the wheelmade circular-mouthed jugs of the preceding category.

The statistics in Table 11.12 indicate that there is a fair amount of size variation within the category, but the jugs are quite standardized in overall vessel proportions. It is possible that all the examples considered here were the products of the same workshop.

Contexts in which these jugs occur include Enkomi Swedish Tombs 3, 6, 11, 18, and 19. They were probably produced in the later part of LC IIC.

4) PWWM II jugs (Fig. 11.1R-T)

The fabric is pink (5YR 7/3, 5YR 7/4) or reddish brown (5YR 6/4). The slip is white (10YR 8/2, 2.5Y 8/2), light gray (10YR 7/2) or pale brown (10YR 7/3). PWWM II vessels are characterized by a thin (ranging from 0.3-0.5 cm. thick below the rim), hard fabric with a metallic quality.

There are at least three distinctive formal variants: large circular-mouthed or trefoil jugs (25-48 cm. in height) with widening necks and multiple concentric grooves or bands at the base (Fig. 11.1R); medium-sized

Coefficient

(1) PWHM trefoil jugs

Neck Ht./Vess. Ht. (17)

Max. Dm./Base Dm. (13)

Ht. Max. Dm./Ht. (7)

(2) PWWM I trefoil jugs

Neck Ht./Vess. Ht. (10)

Max. Dm./Base Dm. (11)

Ht. Max. Dm./Ht. (9)

(3) PWHM jugs with

circular mouths

Neck Ht./Vess. Ht. (7)

Max. Dm./Base Dm. (15)

Ht. Max. Dm./Ht. (11)

(4) PWWM I jugs with

circular mouths

Neck Ht./Vess. Ht. (10)

Max. Dm./Base Dm. (6)

Ht. Max. Dm./Ht. (7)

(5) PWWM I/II jugs

Neck Ht./Vess. Ht. (9)

Max. Dm./Base Dm. (4)

Ht. Max. Dm./Ht. (8)

(6) PWWM II jugs

Neck Ht./Vess. Ht. (16)

Max. Dm./Base Dm. (9)

Ht. Max. Dm./Ht. (8)

 5 10 15 20 25 30 35

Figure 11.6. Coefficients of variation for the ratios of neck height to vessel height, maximum diameter to base diameter, and height of maximum diameter to overall vessel height for various types of Plain White jugs from Enkomi.

TABLE 11.14

N=28	Vess. Ht.	Max. Dm.	Neck Ht./ Bod. Ht.	Max. Dm./ Basal Bod. Dm.	Ped. Ht./ Bod. Ht.
Range	16.0-35.4	22.1-33.8	0.10-0.30	2.24-3.60	0.03-0.22
Mean	25.6	27.7	0.20	2.75	0.11
Std. Dev.	4.6	2.8	0.05	0.42	0.05

Size and proportional variation in amphoroid craters from Enkomi.

TABLE 11.15

N=14	Vess. Ht.	Max. Dm.	Neck Ht./ Bod. Ht.	Max. Dm./ Basal Bod. Dm.	Ped. Ht./ Bod. Ht.
Range	15.0-24.0	21.9-31.3	0.00-0.45	2.06-2.88	0.06-0.22
Mean	19.5	25.8	0.25	2.53	0.11
Std. Dev.	2.7	2.8	0.19	0.27	0.05

Size and proportional variation in open carinated craters from Enkomi.

TABLE 11.16

N=10	Vess. Ht.	Max. Dm.	Neck Ht./ Bod. Ht.	Max. Dm./ Basal Bod. Dm.	Ped. Ht./ Bod. Ht.
Range	17.6-26.1	24.4-33.4	0.00-0.17	1.87-4.01	0.04-0.13
Mean	21.3	27.3	0.10	2.77	0.09
Std. Dev.	2.6	2.7	0.06	0.69	0.03

Size and proportional variation in open uncarinated craters from Enkomi.

trefoil jugs with very narrow necks (heights: 22-27 cm.; Fig. 11.1S); and medium-sized jugs (heights 18-30 cm.) with horizontal, circular rims, ring bases, sometimes with "rivets" at the handle joins imitating current forms of metal vessels (Fig. 11.1T). These and other, possibly intermediate forms may represent the products of at least two or three different contemporaneous workshops, which would account for much of the statistical variability (Table 11.13).

The contexts in which PWWM II jugs occur, including Enkomi French Tombs 108 and 6 (1934) and Swedish

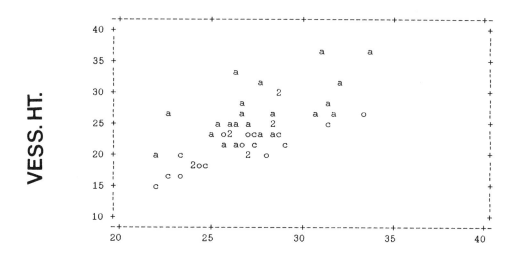

*Figure 11.7. Scatterplot of vessel height and maximum diameter of Plain White
kraters from Enkomi; a = amphoroid, c = open carinated, o = open uncarinated.*

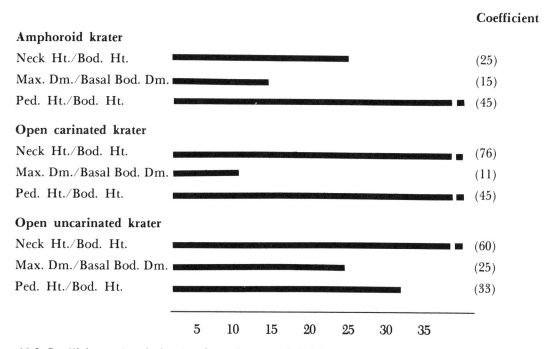

*Figure 11.8 Coefficients of variation for the ratios of neck height to body height, maximum diameter to basal
body diameter, and pedestal height to body height for Plain White kraters from Enkomi. The extremely high
coefficients for the ratio of neck height to body height in the open carinated and open uncarinated kraters are
partly attributable to the inclusion of vessels with undifferentiated necks, which were assigned zero values for
neck height.*

Tombs 7A, 10, 14, 19, and 19A, all support the dating of production to LC IIC and LC IIIA.

DISCUSSION: EVIDENCE OF STANDARDIZATION IN PLAIN WHITE JUGS

Figure 11.6 graphs the coefficients of variation for the classes of Plain White jugs discussed above. Overall, the jugs display relatively less proportional variation than the bowls, a uniformity which, as Frankel (1988, 48) has noted, may stem in part from purely technical requirements of jug form. The individual classes of Plain White jugs (especially the wheelmade classes 2, 4, and 5) are more standardized than the Middle Cypriot handmade White Painted and Red Polished jugs graphed by Frankel (1988, fig. 9), as might be expected of wheelmade workshop products; they are also more standardized than PWHM jugs of similar form.

PLAIN WHITE KRATERS

Plain White kraters occur much less frequently in LC tombs than PW jugs and bowls, comprising anywhere from 0 to 18% of the entire Plain White assemblage in a single tomb. The following discussion is based on the observation of 52 kraters.

The fabric is pink (5YR 7/3, 5YR 7/4, 7.5YR 7/4), reddish (5YR 6/4, 5YR 7/6, 5YR 6/6), or sometimes lighter (10YR 7/3, 2.5Y 8/2, 2.5Y 7/2). The slip is white (10YR 8/1, 10YR 8/2, 2.5Y 8/2, 5YR 8/2), pink (5YR 7/3) or pale brown (5YR 8/3, 10YR 8/3, 10YR 7/3). Wall thicknesses range from 0.5-2.5 cm. (mean = 1.3 cm.). Approximately one-third of the kraters are handmade; handmade examples occur in both earlier and later tombs.

I would define three broad formal categories on the basis of body profile: amphoroid (Fig. 11.1U), open carinated (Fig. 11.1V), and open uncarinated (Fig. 11.1W). Within these subdivisions there is considerable variation in proportions such as the ratio of neck height to vessel height and of pedestal height to vessel height overall (Tables 11.14-11.16). While the amphoroid kraters are fairly standardized in lip form (predominantly everted ledges) and handle type (ribbed or flat straps from rim to body), the open carinated and uncarinated forms vary widely in lip form (thickened, rounded, thinned, undifferentiated) and handle type (convex, flat, ribbed, horned). There is also considerable size variation (Tables 11.14-11.16, Fig. 11.7).

DISCUSSION: EVIDENCE OF STANDARDIZATION IN PLAIN WHITE KRATERS

Figure 11.8 shows the coefficients of variation for various proportional attributes of the three classes of kraters discussed above. One of the most striking aspects of the assemblage of Plain White kraters from Enkomi is the overall lack of standardization in the formal variants distinguished by profile. Only rarely do we see two or more vessels which were clearly products of the same workshop in a single tomb, and only occasionally do we find good matches between tombs. This lack of standardization may stem from a combination of two reasons: (1) the infrequent occurrence of kraters may reflect a lower level of demand, a lower frequency of production, and consequently less likelihood of replication than was characteristic of jugs and bowls and (2) if the kraters were deposited at a rate of one or two every burial or every generation, then they would be very likely to display significant chronological variation, perhaps more obviously than other, more plentiful types. However, any sequence of chronological variation is at present difficult to define. Kraters occur in Enkomi tombs dating from LC I to LC IIC, including Enkomi Cypriot Tombs 10 and 19, French Tomb 110, and Swedish Tombs 6, 10, 11, 13, 19, and 22, as well as other contexts.

PATTERNS IN THE DISTRIBUTION OF PLAIN WHITE CERAMICS

The large quantity of Plain White ceramics observed at Enkomi (over 800 complete or semi-complete vessels from tomb contexts alone) might in itself be taken as a probable indicator of local production, an argument which receives further support from the presence of numerous misfired pots in tombs excavated by Schaeffer (Schaeffer 1936, 135, 139; 1952, 148, 156, 217 n.2; SCE IV Pt.1C, 232).

It may also be significant that plain wares display such high relative, as well as absolute, concentrations in tomb contexts at Enkomi in comparison to other sites. In tombs used over very extended timespans from early LC I to late LC II at Enkomi, the average proportion of plain ceramics is 26%, a percentage which is much higher than that recorded for any other single ware. In tombs used exclusively in the later part of LC II (i.e. LC IIB-C), percentages vary from 12% in a very high status tomb

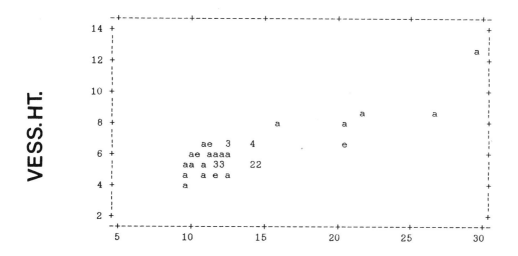

*Figure 11.9. Scatterplot of vessel height and rim diameter for Plain White bowls
with loop handles from Enkomi and Angastina; Angastina bowls are marked by the
letter* a *and Enkomi bowls by the letter* e.

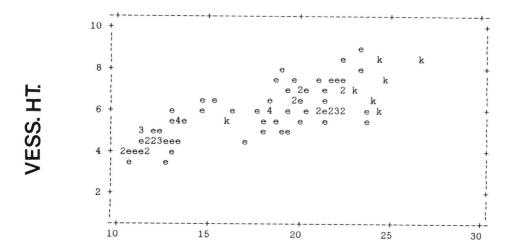

*Figure 11.10. Scatterplot of vessel height and rim diameter for bowls with stringhole
projections or lugs from Enkomi (e) and Kalavasos-Ayios Dhimitrios (k).*

(Swedish Tomb 18) to 43% in a much lower status tomb (Swedish Tomb 6). At neighboring sites such as Angastina (Nicolaou 1972; Karageorghis 1964) and Ayios Iakovos (*SCE* I, 302-370) in eastern Cyprus, percentages of plain wares are roughly comparable, varying from 15-33%. At more distant sites such as Akhera (Karageorghis 1965a), Politiko (Karageorghis 1965b), Kition (*Kition* I), and Hala Sultan Tekke (*HST* I), however, in tombs of later LC II date, the percentages of plain wares range from 4%-15%. In tombs of variable LC date at Kalavasos-*Ayios Dhimitrios* (South *et al.* 1989), of 181 tomb pots excavated and registered to date, only 14 (7.7%) are plain wares. Obviously the masses of plain wares recovered from Enkomi reflect the high intensity of archaeological investigations at this site, but the proportions of plain wares in individual Enkomi tombs versus those from other less intensively excavated sites may be suggestive of a cultural as well as a sampling phenomenon.

On the basis of these distributional figures, it might be hypothesized that Enkomi workshops supplied Plain White ceramics not only to Enkomi residents but to various settlements in eastern Cyprus and beyond. If Enkomi were the principal supplier, we would expect to see the products of Enkomi workshops predominating in the Plain White assemblages found at other sites. While I have not yet had the opportunity to examine all collections of Plain White from locations outside Enkomi, a preliminary evaluation of this hypothesis may be offered based on observation of small samples from Angastina-*Vounos*, Ayios Iakovos-*Melia*, and Kalavasos-*Ayios Dhimitrios*.

Angastina-*Vounos* Tombs 1, 3, and 5 produced numerous Plain White Wheelmade I and Plain White Handmade bowls with loop handles very similar to those observed at Enkomi (cf. Karageorghis 1964, fig. 6).

TABLE 11.17

N=30	Rim Dm.	Vess. Ht.	Vess. Ht./ Rim Dm.	Base Dm./ Rim Dm.
Range	9.4-29.5	3.5-12.0	0.30-0.56	0.32-0.54
Mean	13.9	5.9	0.43	0.42
Std. Dev.	4.8	1.6	0.06	0.05

Size and proportional variation in bowls with loop handles from Angastina.

TABLE 11.18

N=7	Rim Dm.	Vess. Ht.	Vess. Ht./ Rim Dm.	Base Dm./ Rim Dm.
Range	16.1-26.7	5.5-8.2	0.24-0.34	0.40-0.50
Mean	23.3	6.9	0.30	0.44
Std. Dev.	3.4	1.0	0.04	0.04

Size and proportional variation in bowls with stringhole projections from Kalavasos.

As the scatterplot in Figure 11.9 indicates, the Enkomi and Angastina bowls are more or less indistinguishable when interplotted on the attributes of vessel height and rim diameter (cf. also Tables 11.4 and 11.17). Student's *t*-tests for the independence of the two samples on these same attributes, as well as on proportional variables such as the ratio of vessel height to rim diameter and of base diameter to rim diameter, confirm that the differences between the two samples are statistically insignificant. It is quite possible that some of the bowls from these two sites were produced in the same workshop or workshops, but I would be hesitant to locate the center of production at Enkomi given the relative scarcity of the type at this site (7 examples in a sample of 197 bowls). It is perhaps more likely that the production of the loop-handled bowl type was centered somewhere in the vicinity of Angastina, or at another location outside of Enkomi. The examples from Enkomi may have been introduced to the site through various socio-economic exchange mechanisms, or some could perhaps have been local imitations.

A series of Plain White Handmade jugs from Ayios Iakovos Tomb 8 may constitute evidence that this site also acquired a significant portion of its Plain White ceramics from a workshop outside of Enkomi. These jugs (5 of a total of 8 observed in the tomb assemblage) differ markedly from all those which I have observed from Enkomi to date in having a pronounced carination at mid-body (*SCE* Pt.1C, fig. 67, nos. 7 and 8, 68, no. 8). Other individual Plain White vessels from this tomb (e.g., nos. 68, 72, 73—all bowls) have closer parallels at Enkomi and could conceivably have been acquired from the same workshops or potters, but the evidence of the carinated jugs suggests that Ayios Iakovos residents acquired their plain pots from at least one independent source.

Kalavasos-*Ayios Dhimitrios* Tombs 1, 4, and 5 yielded several shallow Plain White bowls[6] with string-hole projections similar to those observed in much greater quantity at Enkomi. As Table 11.18 and the scatterplot in Figure 11.10 indicate, the Kalavasos bowls are consistently larger in rim diameter and vessel height than the Enkomi bowls (although the ranges overlap), and Student's *t*-tests of the differences between the sample means on both of these variables and on base diameter are statistically significant at better than a 0.01 level of probability. However, differences between the means for proportional variables such as the ratio of vessel height to rim diameter and the ratio of base diameter to rim diameter are not statistically significant. It is conceivable that, rather than representing the work of different potters, the Kalavasos bowls simply represent larger examples of the same ceramic "population," perhaps having been deliberately selected for their size in the course of various exchange transactions between groups. Whether the Kalavasos bowls did indeed originate from one or more workshops in the east is a problem which can ultimately be resolved only by physico-chemical characterization studies.

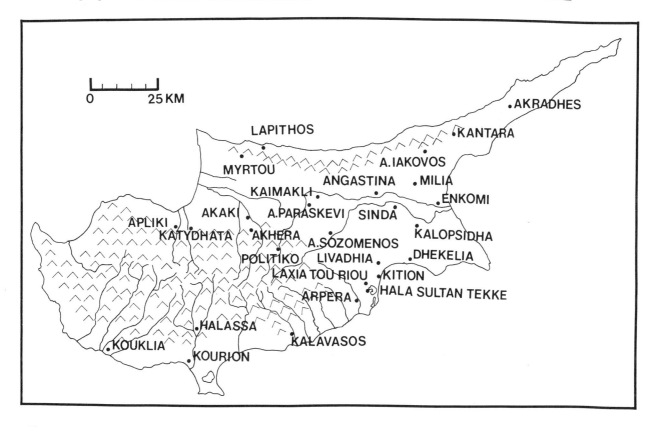

Figure 11.11. Distribution of Plain White ceramic types discussed in this paper, compiled from SCE IV, Pt. 1C and more recent discoveries.

6. As is the case with a number of bowls of this type from Enkomi which have been published as "Plain White Wheelmade" by the *SCE*, several of the bowls from Kalavasos described as "Plain White Wheelmade" in the publication (Keswani 1989c) were probably not wheel-thrown, although they may have been shaped and smoothed on some sort of tournette.

DISCUSSION: INTERPRETING THE EVIDENCE FOR THE PRODUCTION AND DISTRIBUTION OF PLAIN WHITE WARES IN THE LATE CYPRIOTE PERIOD

The map shown in Figure 11.11 illustrates the distribution of parallels for Enkomi Plain White vessels listed by Åström (*SCE* IV Pt.1C). A firsthand examination of collections from these sites, which are heavily concentrated in eastern Cyprus, might result in the identification of numerous items which were produced in the same workshops and exchanged over a wide area. But unless these parallels prove to outnumber types of local origin, it will be difficult to argue that other sites were dependent on Enkomi for their supplies of Plain White ceramics. Other settlements in the east almost certainly had their own local potters who produced plain white handmade wares, as is suggested by the distinctive series of Plain White Handmade jugs from Ayios Iakovos.[7]

While it is likely that numerous workshops producing PWWM I ceramics were located in the vicinities of Enkomi and Angastina, where wheelmade vessels occur with great frequency, at present there is little evidence to suggest that these ceramics were subject to a regional, politically regulated network of production and exchange as has sometimes been postulated for some early states in the Near East (e.g., Johnson 1973; Wright and Johnson 1975). However, the movement of ceramics between sites may reflect kinship and political alliances between sites on a less systematic basis.

Toward the end of LC II and later in LC III, other workshops producing PWWM II wares may very well have been located at centers such as Kition, Hala Sultan Tekke, and Kourion, but the distinctive characteristics of their products, assuming they existed, have yet to be defined. The publication of PWWM II vessels from Alassa by Mr. Sophocles Hadjissavvas will undoubtedly shed much new light on the manufacture of these ceramics.

Throughout the Late Cypriot period, plain handmade utilitarian jugs, bowls, basins and storage vessels much coarser in fabric than the items discussed here are extremely common in settlement contexts. The similarities to be observed in these types from sites as far apart as Kalavasos-*Ayios Dhimitrios* (Keswani 1984, 1989c), Pyla-*Kokkinokremos* (Karageorghis & Demas 1984), Kition (*Kition* V) and Myrtou-*Pigadhes* (Catling 1957) is often striking. However, whether these items were the products of a series of independent local workshops or of itinerant specialists is another problem which requires ongoing study.

Acknowledgments

I would like to express my gratitude to the Institute for Aegean Prehistory for funding my research on ceramic collections in Nicosia and Stockholm in 1989.

7. The recent publication of Late Cypriot ceramics from Idalion also notes that Plain White Handmade types similar in form to wheelmade vessels from elsewhere are predominant at this site (Adelman 1989, 166); similarly, at Kalavasos-*Ayios Dhimitrios*, handmade vessels vastly outnumber wheelmade items in settlement contexts.

REFERENCES

Adelman, Charles
1989 Artifactual Remains with Some Historical Observations. In *American Expedition to Idalion*, by Lawrence E. Stager and Anita M. Walker, pp. 138-166. Oriental Institute Communications 24. Chicago.

Åström, Paul
1966 *Excavations at Kalopsidha and Ayios Iakovos*. SIMA II. Göteborg.

Benson, J.L.
1969 Bamboula at Kourion, the Stratification of the Settlement. *RDAC*, 1-28.

1970 Bamboula at Kourion, the Stratification of the Settlement. *RDAC*, 25-74.

Catling, Hector W.
1957 The Bronze Age Pottery. In *Myrtou*-Pigadhes, *A Late Bronze Age Sanctuary in Cyprus*, by Joan du Plat Taylor, pp. 26-59. London.

Courtois, Jacques-Claude
1981 *Alasia II. Les tombes d'Enkomi: Le mobilier funéraire*. Paris.

Dothan, Trude K. & Amnon Ben-Tor
1983 *Excavations at Athienou, Cyprus, 1971-1972*. Qedem 16. Institute of Archaeology, Hebrew University. Jerusalem.

Frankel, David
1981 Uniformity and Variation in a Cypriot Ceramic Tradition: Two Approaches. *Levant* 13, 88-106.

1988 Pottery Production in Prehistoric Bronze Age Cyprus: Assessing the Problem. *Journal of Mediterranean Archaeology* 1.2, 25-55.

Herscher, Ellen
1981 Southern Cyprus, the Disappearing Early Bronze Age and the Evidence from Phaneromeni. In *Studies in Cypriote Archeology*, edited by J. Biers & David Soren., pp. 79-86. Institute of Archaeology Monograph XVIII. University of California, Los Angeles.

Johnson, Gregory A.
1973 *Local Exchange and Early State Development in Southwestern Iran*. University of Michigan Museum of Anthropology Papers 51. Ann Arbor, Michigan.

Karageorghis, Vassos
1964 A Late Cypriote Tomb at Angastina. *RDAC*, 1-28.

1965a Fouilles des tombes du Chypriote Récent à Akhéra. In *Nouveaux documents pour l'étude du Bronze Récent à Chypre*, by Vassos Karageorghis, pp. 71-138. Etudes Chypriotes 3. Paris.

1965b A Late Cypriote Tomb at Tamassos. *RDAC*, 11-29.

1972 Two Late Bronze Age Tombs from Hala Sultan Tekke. In *HST* I, 71-89.

1982 *Cyprus. From the Stone Age to the Romans*. London.

Karageorghis, Vassos & Martha Demas
1984 *Pyla*-Kokkinokremos. *A Late 13th Century Fortified Settlement in Cyprus*. Nicosia.

Keswani, Priscilla S.
1984 Utilitarian Ceramics: A Preliminary Report. In Ayios Dhimitrios 1983, by Alison K. South *et al. RDAC*, 29-39.

1989a Mortuary Ritual and Social Hierarchy in Bronze Age Cyprus. Ph.D. dissertation, Department of Anthropology, University of Michigan. Ann Arbor, Michigan.

1989b Dimensions of Social Hierarchy in Late Bronze Age Cyprus: An Analysis of the Mortuary Data from Enkomi. *Journal of Mediterranean Archaeology* 2.1, 49-86.

1989c The Pithoi and Other Plain Ware Vessels. In *Kalavasos*-Ayios Dhimitrios, Vol. II, by Alison K. South, Pamela Russell & Priscilla Schuster Keswani, pp. 12-21. SIMA 71:3. Göteborg.

Knapp, A. Bernard
1986 Production, Exchange, and Socio-Political Complexity on Bronze Age Cyprus. *Oxford Journal of Archaeology* 5, 35-60.

1988 Ideology, Archaeology, and Polity. *Man* (N.S.) 23, 133-163.

Lagarce, Jacques & Elizabeth Lagarce
1985 *Alasia IV. Deux tombes du Chypriote Récent d'Enkomi (Tombes 1851 et 1907)*. Editions recherche sur les civilisations. Memoire 51. Paris.

Muhly, J.D.
1982 The Nature of Trade in the Late Bronze Age Eastern Mediterranean: the Organization of the Metals' Trade and the Role of Cyprus. In *Acts of the International Archaeological Symposium: Early Metallurgy in Cyprus, 4000-500 B.C.*, edited by J.D. Muhly, Robert Maddin & Vassos Karageorghis, pp. 251-266. Nicosia.

1985 The Late Bronze Age in Cyprus: a 25 Year Retrospect. In *Archaeology in Cyprus 1960-85*, edited by Vassos Karageorghis, pp. 20-46. Nicosia.

1986 The Role of Cyprus in the Economy of the Eastern Mediterranean during the Second Millennium B.C. In *Acts* 1986, 45-62.

Nicolaou, Kyriakos
1972 A Late Cypriote Necropolis at Ankastina in the Mesaoria. *RDAC*, 58-108.

Rice, Prudence M.
1987 *Pottery Analysis. A Sourcebook*. Chicago.

Schaeffer, Claude F.A.
1936 *Missions en Chypre*. Paris.
1952 *Enkomi*-Alasia (*1946-1950*). Paris.

Sinopoli, Carla M.
1988 The Organization of Craft Production at Vijayanagara, South India. *American Anthropologist* 90, 580-597.

Sjöqvist, Erik
1940 *Problems of the Late Cypriote Bronze Age*. Stockholm.

South, Alison K., Pamela Russell & Priscilla S. Keswani
1989 *Vasilikos Valley Project 3: Kalavasos*-Ayios Dhimitrios II *Ceramics, Objects, Tombs, Specialist Studies*. SIMA LXXI.3. Göteborg.

Todd, Ian A.
forthcoming
 Sanidha-Moutti tou Ayiou Serkou: A Late Bronze Age Site in the Troodos Foothills. *Archaeologia Kypria*.

Vermeule, Emily T.
1974 *Toumba tou Skourou. The Mound of Darkness. A Bronze Age Town on Morphou Bay in Cyprus*. Boston, Massachusetts.

Westholm, Alfred
1939 Some Late Cypriote Tombs at Milia. *QDAP* 8, 1-20.

Wright, Henry T. & Gregory A. Johnson
1975 Population, Exchange, and Early State Formation in Southwestern Iran. *American Anthropologist* 77, 267-289.

XII

Material and Technical Characterization of Base Ring Ware: A New Fabric Typology

Sarah J. Vaughan

INTRODUCTION

Much has been written about Base Ring ware over the years, but the value of the accumulated observations has been limited by factors of subjectivity, technical inaccuracies, and the imposition of a clumsy chronological framework on the finds, resulting in ambiguous or inconsistent sets of archaeological data which preclude tenable assignment of sherds on any but the most general criteria. This is not a new problem—consider Benson's despair at *Bamboula* (Benson 1969, 3) and Wright's problems at Shechem (Wright 1967, 49-55)—and continues to frustrate scholars wishing to interpret Late Bronze Age levels at sites around the island. With repeated reference to the linear Swedish typology (*SCE* IV Pt.1C, 126-198), based in 95% of cases on tomb vessels, a casual and *perceived* familiarity with Base Ring ware has evolved, but without benefit of reference to materials, regionalism, functional limitations or parallel development—factors affecting ceramic production which operate independently of linear development. This *perceived* familiarity has proved to be perhaps the greatest inhibition to more comprehensive studies of the ware, and greatly undermines the potential contributions they might make to understanding the materials, technology, organization and development of the Late Cypriot ceramic industry as a whole.

The prevailing Swedish typology for Base Ring ware presents several specific and serious problems for those wishing to apply it both in the field and in more general studies of prehistoric pottery in Cyprus. The use of the word *Proto*, and Roman numerals *I* and *II* in the labels, instituted at a time when chronological periods were defined by changes in pottery styles, is unhelpful and misleading, particularly as it is well known such changes do *not* occur simultaneously throughout the island (see e.g., Merrillees 1971, 56; Herscher 1976, 11-19). These labels *imply* exclusivity of membership for the groups as

well as an artificial linear development of the ware not substantiated in the material evidence, a problem well articulated previously by Merrillees (1977, 34; 1978, 18; 1979, 117). The stated criteria for assignment of sherds or vessels to these groups overlap in many instances (relative hardness, degree of surface luster, colors, constituents) are too imprecise to justify distinctions (subjective assessments of the relative "coarseness" of fabric without reference to standards, or factors affecting this feature such as vessel size/function or locally available clays, "clumsiness," spalling, presence of gray cores); and in the course of this study have been found in many instances to be inaccurate (e.g., presence of straw in the fabric [*SCE* IV Pt.1C, 133], and firing temperature estimates [Sjöqvist 1940, 212]). The implied linear development is unsupported by evidence from any significant and coordinated sequences of stratified settlement material, a problem Daniel discussed in a review of *Problems of the Late Cypriot Bronze Age* over forty years ago, including his famous reference to "Procrustean beds" (1942, 286-287). Excavators have been frequently faced with vessels typed by shape or decoration as Base Ring I in this classification for example, which are also decorated in white paint, a feature supposedly characteristic of Base Ring II (Merrillees 1968, 3-4; Wright 1967, 49). The classification also omits any reference to factors affecting production such as changes in settlement patterns, cultural practices, economic climate and quality of available raw materials, or the varying proximity of production centers to cosmopolitan Cypriot markets (e.g., Arnold 1985, 231-234). In addition, the evidence for the Swedish Base Ring typology comes predominantly from tomb vessels whose stratigraphic contexts were not always as secure as less disturbed settlement levels (Daniel 1942, 286-287), and whose morphology, decoration (and other occasional technological features) repre-

sent a limited and *specialized* repertoire within the whole framework of the ware. Thus it is to be expected that excavators trying to apply this typology to stratified settlement material would encounter serious difficulties.

With a more sophisticated understanding of the multiple factors affecting variations in ceramic production, a comprehensive reassessment of Base Ring ware will trace more precisely not only its development in temporal as well as spatial terms, but should also illuminate the important and complex material, technical and stylistic relationships between this ware, and others such as Drab Polished and Red Polished (see Herscher's work at Phaneromeni for example, discussed by Carpenter 1981, 65, 81), Monochrome, Black Slip and Handmade Bucchero in particular (see also Åström & Wright 1962, 266-275; Merrillees 1965, 141-142; Merrillees 1971, 56-72). Such a study would define in specific terms the perceived fluidity and continuity of prehistoric Cypriot wares beginning to emerge in more recent ceramic studies (e.g., Bolger 1985, and papers in this volume by Peltenburg, Herscher, and Russell). Such detailed ware analysis will also allow hybrid ceramic products to be classified, and identified for the bridges in style and technology they represent, rather than isolating them in spurious and uninformative "ware" groups such as Red Slip Proto Base Ring ware (*SCE* IV Pt. 1C, 130-137).

The construction of any ceramic typology should be based, ideally, on as multivariate a base of data as possible, resulting in flexibility of purpose. The regional material and technological study of Base Ring ware, on which this paper is based, was felt to be both an important first step in a reassessment of the Late Cypriot ware, and an experiment in the application of a system of analysis to archaeological ceramics (particularly as found and studied in sherd form). The study aimed to establish a set of criteria defining fabric groups which, in turn, would form the basis of a system of classification for the ware as a whole. Future detailed analysis of less conservative features of morphology and decoration (i.e., those features more easily "borrowed" between wares, and better studied on whole vessels), would constitute the complementary data required for the ware's thorough reassessment. Within the scope of this paper, which is based on the results of a broad-based regional study of Base Ring ware materials and technology undertaken in 1981, it has been possible to present only summary statements of the raw data of the research, though references to more detailed discussions are provided. This paper will focus instead on the presentation and discussion of the proposed Fabric Typology for Base Ring ware, and its implications for the existing classification and concepts of the ware.

RESEARCH DESIGN AND METHODOLOGY

The research was designed both to characterize the raw materials used for Base Ring ware, identifying any individual fabrics and suggesting provenance in Cyprus of samples where possible, and to establish the specific technical attributes (and their values) which define the ware in general, and which were diagnostic of fabric groups in particular. A combination of macroscopic observation and instrumental techniques was employed to analyze sherd samples, and the combined material and technological data provided the basis for the Fabric Typology, which can be used by archaeologists to classify the ware *in sherd form* in the field.

The underlying principle of the investigation was the increase of both quantity *and* quality of reproducible data from the ware for classification, by means of increased precision, objectivity and consistency in observation. The degree of distortion inherent in reducing a continuous process (such as handmade pottery) to discrete values was minimized by using standardized technical terminology (see glossaries e.g., Rice 1987, 471-485; Vaughan 1987, 297-309), geological comparator charts and other recognized systems of measurement in the

evaluations. A detailed discussion of the system of macroscopic ware analysis for archaeological ceramics is in preparation (see also Vaughan & Guppy 1988, 56).

The Base Ring samples consisted of approximately 1,000 sherds from 46 sites throughout Cyprus, 46% from excavated contexts and the rest from survey collections (Table 12.1). Care was taken that the samples represented the full material and stylistic range of the ware present at each site. The thrust of the study was regional, but rudimentary chronological labels were given samples along *existing* criteria in the Swedish typology. The results could thus be examined in a preliminary way in the dimension of time as well, as it is perceived in that classification: for these labels "Base Ring I" denoted relief decoration and/or an "early" shape (*SCE* IV Pt.1C, figs. XLVII-LI); "Base Ring II" denoted very shallow carinated bowls (*SCE* IV Pt.1C, fig. LII:4), and white painted Base Ring samples were given their own category, "BR WP." For purposes of objectivity however, examinations and analytical procedures were carried out on unlabelled, numbered specimens only.

TABLE 12.1
Base Ring Sample Sites by Region

Troodos Mountains and Foothills
Katydhata, Lythrodonda, Sia, Kornos, Apliki

Northwest: Ovgos Valley to Nicosia
Akaki, Toumba tou Skourou, Kapouti, Pera, Akhera,
Strovolos, Pendayia, Asomatos

Eastern Mesoria, Nicosia to East Coast
Perachorio, Athienou, Ayios Sozomenos, Trikomo,
Angastina, Yeri, Monarga, Enkomi, Milia

North Coast and Kyrenia Range
Akanthou, Kormakiti, Kazaphani, Dhikomo, Myrtou,
Orga, Kyrenia, Phlamoudhi

Karpass Peninsula
Ayios Theodoros

West Coast
Kouklia, Yeroskipos, Souskiou, Polis, Maa-*Palaeokastro*

South Coast, Petra tou Romiou to Paralimni
Hala Sultan Tekke, Pyla, Arpera Chiflik, Kalohorio,
Kalavasos, Aradhippou, Klavdhia, Dhekelia, Kourion-
Bamboula, Maroni

The macroscopic study, done with a binocular microscope on sherds with fresh fractures, assessed a standard list of features, and established a range of values for each, beginning with those concerning the character of the raw materials and their preparation (i.e., the nature and distribution of inclusions and voids). Aspects of primary and secondary forming procedures were then noted (i.e., evidence of assembly, scraping, paring, degree of compaction, wall width, smoothing and trimming), and finishing techniques identified (evidence of wet-hand slurry or slip application, burnish or polish). Only those attributes known to occur throughout a whole vessel with good consistency were ultimately used as criteria for the typology. Experimental block clustering of the macroscopic data was successful in producing archaeologically meaningful groups of samples, coinciding with those previously formed by the author, and confirmed the importance of using inter-related variables which function *as sets* in forming meaningful ceramic clusters (Vaughan & Guppy 1988).

Following the macroscopic assessments, subsamples of the sherds were studied in thin section for detailed mineralogical data, and for detection of technological features such as very thin slip layers, or orientation of fine particles near the surface of fabrics affected by strong scraping, smoothing, or wet-hand slurry and burnishing. The samples were also analyzed geochemically by ICP (inductively-coupled plasma) spectrometry for material characterization and provenance data, by X-ray diffraction for further mineralogical data, and by scanning electron microscopy and microprobe for constituent and micromorphological data (Vaughan 1987, 113-252). A parallel program of comparative clay analysis was also conducted on 40 Cypriot clays collected by the author (Vaughan 1991, fig. 3), first used in replication experiments (bowls and briquettes), and then analyzed in fired form by the same procedures used on the sherds. These results were used to assist in the characterization and provenance assignment of the archaeological samples.

ATTRIBUTES OF BASE RING WARE IN GENERAL

MATERIAL

In material terms Base Ring ware presented a remarkably uniform profile, sufficiently consistent to preclude any significant degree of artificial mixing of clays or constituents (Vaughan 1987, 113-252). The combined analytical data pointed to the selection and use of low-refractory, mixed-layer clays consisting of ferric illite, with subordinate percentages of montmorillonite and chlorite, a characteristic profile of Cypriot sediments which have been redeposited and otherwise altered during regional metamorphism. The material profile was also consistent with technical aspects of the ware, in that some illite enrichment would have occurred as a result of settling, cleaning and aging procedures used by the potters, while the significant percentages of iron present (8.1% iron oxide on average) would have facilitated the achievement of reduced surface colors. In addition, a notable amount of montmorillonite was also to be expected, since the thin walls and complex profiles of Base Ring shapes would have required a clay with good thixotropic properties, such as those contributed by montmorillonite.

The petrographic data pointed to the use of clays which had been affected by low-grade metamorphism, and which contained varying percentages and types of carbonate impurities, consistent with deposits such as those of the northern Kythrea Flysch, south coast Moni Melange, and the Kannaviou Formation and Mamonia Complex in the west. The inclusion size variations and overall profile indicated preparation of the clay *without* sieving or tempering (except in the case of the Larnaca Bay local fabric, discussed below), though a certain amount of grinding probably took place to ensure the fine grain sizes required for the characteristic smooth surfaces, and giving some protection against the worst ravages of lime spalling. The finest grained samples of

the ware were uniformly "early," while relatively coarser fabrics were both "early" and "late," confirming a pattern suggested by Sjöqvist (1940, 34).

The existence of coarser Base Ring pastes was not simply the result of a chronological decline in skill, however, as implied in the Swedish characterizations (*SCE* IV Pt.1C, 173). These coarser fabrics must be considered in the light of such factors as vessel size, intended surface finish and function, regional variations in production skills and quality of raw materials, all factors which have a direct effect on the grain size of ceramic fabrics. In addition, the shifting concentration of population to sites on the South and West coasts of Cyprus during the Late Cypriot II-III period would mean the increasing use of compatible clays in only those regions for Base Ring ware. And these clays contained detrital constituents comparatively larger than similar deposits to the North and East of the Troodos Massif, where longer and more gradual slopes allow more weathering of detrital inclusions (for a detailed discussion of the petrographic data of both the sherds and fired Cypriot clays see Vaughan, 1991).

TECHNOLOGY

Although many technological data were more diagnostic of the individual fabric groups than of the ware in general, some attributes held true overall. Base Ring ware is handmade, though extensive use of turntables was demonstrated by the skillful secondary forming procedures which were vital to the ware's distinctive appearance (specifically the scraping and smoothing, and in some cases compaction, of the vessel surfaces) for reducing wall width and promoting reflective luster where desired in the finish. Skilled turntable pottery production can mimic wheelmade techniques, particularly if followed by an equally skilled surface finish, and it was probably this combination of skills which led some scholars to believe that a certain number of Base Ring shallow bowls were wheelmade (*SCE* IV Pt.1C, 197-198). However no evidence was found by the author on such bowls of sufficient centrifugal force having been applied to the pot to merit its classification as wheelmade.

Due to the notable percentages of montmorillonite present in the clay, the processes of scraping, compacting and smoothing (carried out on leather-hard vessels), would have been performed with a minimum of water to avoid the shrinkage associated with this component. Not all Base Ring ware is slipped, but when slips were present, they had been prepared from the finest fraction of the body clays, and applied either by dipping, or in other cases by means of cloth or brush before firing (cf. Lagarce & Lagarce 1972, 138). When the surface was reduced, the fired colors of the dipped slips were darker than those of the thinner brushed slips, which also erode along lines of application, enhancing their streaky appearance. Varying degrees of luster were achieved by mechanical alignment of the surface particles by burnishing, or in some cases polishing, a reflection of the ware's technical heritage from the local Red Polished traditions.

Base Ring ware is normally identified with dark fired colors, and these were achieved by firing in oxygen-poor conditions, not by carbon smoking or mineral pigment enhancement of the slips. The firings were rapid, initially oxidizing, but later sealed from the air, generally reaching temperatures of 750-850° C., except in the case of the Red Burnished type and a fabric more specific to Larnaca Bay. The fabrics showed vitrification ranging from initial to extensive (e.g., Maniatis & Tite 1981, 59-76), depending on variables such as location of the vessel in the firing, wall width and compaction, rate and duration of firing, and local temperatures. The range of vitrification was consistent with the range of hardness for most classes of the ware, between 5-7+ on a modified Mohs scale (e.g., Rice 1987, 356), and this hardness, combined with the thin compacted walls, would have been responsible for the "metallic chink" so often cited by excavators as characteristic of the ware, but in fact, a feature common to sherds of *any* ware with similar attributes (e.g., Red Polished IV).

There is *some* evidence for double baking as a firing procedure for Base Ring ware, uncovered in the course of geomagnetic intensity determinations carried out at the Research Laboratory for Archaeology at Oxford (Vaughan 1987, 82-84). Since this evidence indicates only that there were two distinct orientations for the vessels in question during heating phases, it may simply point to a pot being moved during the sealing of the firing in late stages to achieve reducing conditions. The evidence is also compatible however, with vessels having been removed while hot from a fire, perhaps so that their surfaces could be treated in some manner, and then returned briefly to the fire. This evidence is particularly intriguing since Gjerstad suggested (without elaboration) that Base Ring ware was produced "in the usual way," with two firings (1926, 185).

REGIONAL PATTERNS AND THE FABRIC TYPOLOGY

REGIONAL PATTERNS

The remaining material and technological data were useful in distinguishing regional features of the ware, and provided the basis for the fabric typology. Evidence for regional production of the ware came primarily from the petrographic data, but was reinforced by other analytical results. The geographic material patterns were identified mainly as a result of variations in percentages and/or types of inclusions which were common

to the ware in general, with occasionally unique constituents confirming the distinctions (Vaughan 1991). Very briefly, the thin section results showed that Base Ring clays could be divided into six regionally-specific groups consistent with the use of materials from particular reworked deposits in the northwest/Ovgos Valley area, north coast, central to eastern Mesoria area, the Karpass, the south and west coasts (Vaughan 1991, figs. 2, 15). The overall uniformity of the material profile for Base Ring ware strongly suggested the use of a relatively limited number of *regional* clay deposits, rather than more numerous, smaller and disparate *local* outcrops, and production at a relatively limited number of centers would be compatible with the ware's strongly uniform morphological and decorative traditions. These data may eventually help to isolate the traditional clay deposits for the ware, and more important, their related centers of production. The finer, more lustrous fabrics were common in the Ovgos Valley, central Mesoria and south coast areas, while the matte classes, with some overlap in the central Mesoria, occurred with more frequency at south and west coast sites, a pattern happily compatible with prevailing ideas for the development of the ware (Merrillees 1965, 140-141).

THE FABRIC TYPOLOGY

The combined material and technological data provided the basis for the fabric typology (Table 12.2). Four fabrics were identified which were given names wherever possible in keeping with the *visible intention* of the potter, as well as with what was already familiar in the literature. Thus, although the criteria for the groups consisted of both visible and invisible features, an effort was made to emphasize those which would most facilitate the application of the typology in the field. Method of decoration is mentioned where helpful, and the general chronological bias (based on the rudimentary labels) of the types is suggested, but *neither* attribute was found to correlate with the individual fabric types with sufficient exclusivity to merit becoming a diagnostic criterion of classification at this time. These results strongly support the inadequacy and inaccuracy of the Swedish typology for the ware, based as it is primarily on method of decoration and morphology as associated with tomb vessels.

The oxidized Red Burnished fabric, (illustrated in color by a tankard, Morris 1985, 34, pl. 25), an important exception to the rule of dark Base Ring fabrics, has been mentioned previously in the literature, briefly by Gjerstad (1926, 185), again by Courtois ([1971, 130] who called it "Leatherware," but whose material and technological criteria defining it were not consistent with these results), and by Johnstone, who recorded it at Enkomi in a mixed LC II context without elaboration (Johnstone 1972, 96). The type is fully substantiated by

a large body of both material and technological evidence. While there have always been mottled examples of Base Ring ware which account for fragments with a reddish surface color, such sherds *do not* match the other criteria for this fabric group, and on careful examination, would be classed with one of the reduced fabrics. In addition, the affiliation of this fabric with tomb vessels in over 80% of cases in this study constitutes an important example of the inadvisability of basing whole ware typologies primarily on the specialized ceramic repertoires of tomb pottery.

In addition to the four major fabric types (Table 12.2), an unusual and small group of samples (approximately 35) constituted what may represent the products of a single workshop, for purposes of this paper called the Base Ring *Larnaca Bay fabric* for its geographical bias. With respect to surface preparation and treatment, these samples are consistent with all three reduced Base Ring fabric types, with a transitional chronological bias (e.g., I, II and Base Ring, White Painted as rudimentarily defined in this study). However, there were significant differences in materials, and in firing procedures, which characterized these samples (Vaughan 1991, where the group was called "South Coast Sharp"). The firing horizons of this fabric were distinguished by strongly contrasting colors (Munsell references: dark reds 10R 3/6, 7.5R 3/4-6 and grays 7.5YR 3/0, 2.5YR 3-4/0), frequent multiple or reverse coring, a hackly fracture due to the angular nature of the shale inclusions in particular, and a very consistent and fired hardness (/= 7) and degrees of vitrification consistent with firing temperatures of 800-900° C.

In thin section the ferruginous matrix of these samples was punctuated by subordinate patches of non-ferruginous clay, subsequently identified as kaolinite. These samples were concentrated at sites in the Larnaca Bay area (Arpera, Klavdhia, Hala Sultan Tekke, Kalohorio, Aradhippou), though they also appeared infrequently at South Coast and more northern sites. The material distinctions were consistent with the use of the local South Coast Pakhna Formation clays from deposits associated with shale outcrops, such as exist at the eastern periphery of the Troodos, or surrounding the Trouilli Inlier on the Mesoria plain (Robertson 1977, 1765-1767), and may represent Base Ring pastes which were tempered to some extent (or natural clay mixtures) with small amounts of kaolinitic clay known to occur in the terra rossa soils of southeastern Cyprus (Georghiou & Morgan 1979; Vaughan 1987, 229).

DISCUSSION OF RESULTS

The superficial decorative and morphological homogeneity of Base Ring ware was found to be supported by material and technological traditions of com-

TABLE 12.2
Base Ring Ware Fabric Typology

Base Ring Metallic Slip Ware (e.g., Morris 1985, pl. 25f)
Very smooth surfaces (scraped, smoothed, compacted)
Dipped or brushed/wiped slip, surface fired dark gray/brown
Burnished or polished, subtle surface lustre
Fired hardness 5-7, wall incompletely oxidized or gray
Firing horizons sharp or diffuse, fired 750-850°C
Includes finest grained fabrics and thinnest walls (> = 1.5 mm)
(Early chronological bias, e.g., I, some II/WP)

Base Ring Matte Slip Ware (e.g., Morris 1985, pl. 25b)
Moderately smooth surfaces (scraped, smoothed)
Dipped or brushed/wiped slip, surface fired dark gray/brown
Matte surface finish
Fired hardness 5-7, wall incompletely oxidized or gray
Firing horizons sharp or diffuse, fired 750-850°C
No walls (< 1.5 mm. White Paint decoration common
(Later chronological bias, e.g., II/WP, some I)

Base Ring Uncoated Ware
Moderately smooth surfaces (scraped, smoothed)
Unslipped, surface fired dark gray/brown
Matte surface finish
Fired hardness 5-7, wall incompletely oxidized or gray
Firing horizons sharp or diffuse, fired 750-850°C
(Late chronological bias, e.g., II/WP)
South and west coast sites

Base Ring Red Burnished Ware (e.g., Morris 1985, pl. 25e)
Very smooth surfaces (scraped, smoothed compacted)
Dipped slip or wet-hand slurry surface finish with good coverage and adherence
High degree of reflective surface luster (glossy) from burnish or polish
Surfaces and walls fired reds/red-browns/pale browns
Fired hardness 3 (pale browns) to 5 (redder colors)
Often soft/powdery or laminated fracture
Fired horizons rare, diffuse when present; fired 700-750°C
Few visible inclusions, less quartz silt in matrix, clays distinguished geochemically by percentages Ba, La, Ce
Significantly lower percentage lime-spalling (due to finer grained carbonates and high quality surface finish)
(Early chronological bias, e.g., I, few II)
NW, central and south coast sites
Associated with tomb vessels in 80% of cases

parable strength and uniformity, probably achieved by production at a relatively limited number of regional workshops. While the shapes and decorations of the ware have their origins firmly in the prehistoric Cypriot ceramic repertoire (the features of the latter are associated variously with chthonic deities, death, fertility and medicine), the materials and manufacturing technology have been shown to represent innovations specific to the ware, with improvements in firing skills possibly derived from parallel developments in pyrotechnology required for the copper industry. The four fabrics were distinguished primarily by manufacturing, rather than by material criteria, though *chronological* patterns in the ware's production were shown to result from a combination of compositional and technical factors acting in concert with changing aesthetic requirements for the ware. These four fabrics do *not* represent types specific to individual workshops (except in the case of the Larnaca Bay fabric), but rather represent the four major classes of Base Ring ware manufactured during a period of approximately five hundred years in Cyprus. Only in the cases of Red Burnished Base Ring ware and Uncoated Base Ring ware were there significant geographic production patterns which parallel known patterns of settlement throughout the Late Cypriot period.

The remarkable *strength* of the traditions governing production of the ware has important archaeological implications. In a culture operating, as far as we know, in the absence of a central palace-structured economy and distribution system (Muhly 1985, 37-43), such uniformity must be attributed to the ware's association with limited and specialized cultural practices which became common to all areas of Cyprus during Late Cypriot IA and through the Late Cypriot IIC periods. Specific functions for the vessels are only hinted at, though, by contexts and commodities. For example, the carinated bowls were probably libation vessels (Åström 1987, 12-13), with unusual and strong morphological affinities to Middle Bronze Age Grey Minyan bowls found at Troy (Blegen *et al.* 1953, 54, pl. 317: A94, A96, pls. 333-335, 350), where they also appeared in funeral sets. Courtois also noted the affinity of the shape to Anatolian bowl profiles prevalent since the Early Bronze Age (L. Courtois 1971, 130). The bowls, the bull figurines, elaborate tomb vessels, tankards (which were *pouring*, not drinking, vessels), and the bilbils, filled with valuable unguents or opium (Merrillees 1989) for markets at home and abroad, constitute a significant percentage of a repertoire which seems to point to manufacture of the ware for special practices (governed perhaps by religious patronage), requiring a highly recognizable ceramic trademark.

Although Base Ring ware has some material and/or technical affinities with wares such as Red Polished IV, Drab Polished, Monochrome, Black Slip and Red-on-

Black (e.g., L. Courtois 1971), the specialized nature of its production was reinforced in this study by both material and manufacturing data. Craftsmen deliberately selected clays of a singular *and* similar type across the island. The complex, but relatively uniform appearance of the ware's shapes and decorative traditions, and its unique physical surface characteristics, required highly skilled work, as did the firing procedures. In what were probably nonkiln firings, control of temperature to within the 100° C. range suggested by the analytical results was not only vital (to obtain the required hardness without destroying surface sheen or structural strength through melting or spalling damage) but also a remarkable technical achievement. Hybrid vessels, with Base Ring clay and technology but shapes *and* decoration from other wares, are extremely rare. These facts all tend to suggest Base Ring ware was produced at a rather limited number of regional centers by specialist craftsmen (perhaps supported by patrons), and its wider geographical distribution occurred in conjunction with the spread of the practices with which it was associated.

The demise of Base Ring ware therefore should be seen in both technical *and* cultural terms. The disruptions at many settlements at the end of the LC IIC period would have meant disruptions in production and distribution patterns for the ware, loss of access to traditional clay sources, and perhaps changes in the very practices for which it was intended, though the tankard and libation bowl shapes briefly lingered on, primarily in Plain White Wheelmade ware (e.g., J.-C. Courtois 1972, 254-255).

Pejorative terms such as "clumsy," "degenerate" or "debased" have been applied in describing what were perceived to be the later stages of the ware's production (*SCE* IV Pt.1C, 173), suggesting an evaporation of skills and/or interest over time without evidence or explanation. Such subjective terminology is unhelpful, and would have to be specifically defined if it were to provide any useful criteria in assessing the ware's production, development and decline. Individual examples of features associated with lower standards of ceramic craft (i.e., uneven walls and surface finish, awkward or deformed shapes, great spalling damage due to careless paste preparation and firing) were found in this study to

exist in all the main classes of Base Ring ware, representing all periods, though a quantitative study will, no doubt, provide a clearer picture of relative proportions, in turn illuminating any patterns of occurrence.

Such "clumsy" ceramic products can be the result of a variety of factors, including provincial skills, loss of access for any reason to traditional clay deposits, firing fuels or even abundant water, as well as changes in market demand associated with broader cultural changes over time. Greater coarseness of clay pastes can be as much a function of locally available raw materials and skills as of intended surface appearance, functions independent of chronological factors. And the Matte Slip surface, coinciding frequently with painted decoration, would not have required such careful paste refinement as fabrics intended to have some degree of reflective surface luster. In other words, the impression given in the Swedish classification (undefined) of a simple chronological rise and decline in quality in the ware's production is misleading and uninformative on this aspect of the pottery.

An important clue to the cause of the decline in the ware's quality lies in the nature of its specific raw materials. The very plastic type of clay required for Base Ring production was incompatible with use of the fast potter's wheel as this clay is unable to withstand the centrifugal force of this technique (perhaps an answer to Hankey's remark about the reluctance with which potters of local Late Cypriot wares adopted the wheel: Hankey 1983, 169). In addition, these specific clays were introduced by Base Ring potters to allow the construction of complex, carinated vessels with very thin walls requiring complicated procedures of manufacturing and assembly, procedures and requirements also not compatible with production on a fast wheel in this case (Vaughan 1987, 44-112). Base Ring potters initially seem to have adapted their skills to a changing market by producing Handmade Bucchero ware (identical in materials and technology to its predecessor, a fact recognized by Gjerstad: 1926, 193), but the wheelmade version, made with different materials, soon prevailed. Thus, by LC IIIB (e.g., Ålin 1978, 102) a chapter was closed in Cyprus on a unique handmade ceramic tradition of remarkable technical achievement.

CONCLUSIONS

The conclusions of the current study constitute only the first part of a major reassessment of Base Ring ware, the value of which will be greatly enhanced by incorporation wherever possible of existing valid concepts concerning Base Ring ware. However, where components of the pre-existing classification have been

demonstrated to be inaccurate, there is a compelling argument for eliminating these misperceptions, no matter how familiar they may be.

For example, the combined results of the research confirmed the spurious nature of the two Swedish categories of Proto Base Ring ware, "Black Slip" and "Red Slip" (*SCE* IV Pt.1C, 130-137). Examination of these vessels showed the materials and firing to be securely rooted in the Middle Cypriot traditions governing the production of Black and Red Slip wares, and quite distinct from those of Base Ring ware. The soft fabric and flaking slip of so many of these pots, paralleled on transitional Middle Cypriot III pots of Black Slip IV-V and Red Slip IV-V (*SCE* IV Pt.1B, 71-72, 74, 79-80), are dramatic evidence that Base Ring potters required raw materials of different physical and mineralogical features than the clays of the ware's forerunners, with the special thixotropic, iron-rich and hard-firing properties essential for the ware's aesthetic requirements and manufacturing procedures. Because these vessels have many morphological and ornamental details which belong to the Base Ring repertoire, they should be seen (and classified) as the important hybrid Black and Red Slip products they are, valuable reflections of the strength of both stylistic and technical influences which were exerted within the early LC IA ceramic community by the new ware. This is especially true in the northwest/Ovgos Valley area which is the provenance of so many such vessels (though examples have been found as far away as Kouklia: Åström 1972, 49). Merrillees has also frequently (and eloquently) argued for the reclassification of these pots, with priority given to fabric (the most conservative feature of a ware) over attributes of shape and decoration (Merrillees 1965, 141-142; Merrillees 1971, 57; Merrillees 1978, 25; Merrillees 1986, 126).

The remaining Swedish category of Proto Base Ring ware (*SCE* IV Pt.1C, 126-130) should be retained as a subgroup, with the understanding that *proto* is defined to mean an early variant of the ware *without* (at this date) secure stratigraphic evidence of chronological precedence. This group is *not* comparable to the four main Base Ring fabrics, being distinguished by only a few decorative and morphological features as opposed to the large body of multivariate data defining the main Base Ring types in this study. Its members could be included in the appropriate fabric group, perhaps differentiated by the term *Proto*, or *Early* (in the chronological longevity column, Fig. 12.1) within the proposed structure for the new classification. The value of this group of early vessels remains, as with the group of Black Slip hybrids, however, in its demonstration of the depth of the stylistic roots of Base Ring ware in local Cypriot ceramic traditions.

Retention of the other two main Swedish classes of the ware, Base Ring I and II (*SCE* IV Pt.1C, 137, 173-174), is

more problematic. These groups are *not* defined with sufficient precision to allow the simple integration of their members into the new typology. A physical reassessment of the material and technological features of each member is impossible (though the most important pieces should be included in a comprehensive future study of features of morphology and ornament). Instead, a theoretical scheme for the reclassification of the ware is proposed, and it is hoped such a scheme will allow the ware to be perceived in a more sophisticated, yet flexible framework for the future (Figs. 12.1, 2). Roman numerals are removed, replaced by names of the four major classes of the ware: Metallic Slip, Red Burnished, Matte Slip and Uncoated. A similar procedure was recently applied with significant results to Middle Cypriot Red Polished Ware from Alambra, for purposes of creating a typology incorporating features of fabric and technology (Barlow & Idziak 1989, 66).

The proposed scheme (Fig. 12.2) in no way reflects a quantitative assessment of the ware as a whole, but rather focuses on the emerging pattern of overlapping development of its major classes, as well as Handmade Bucchero, recorded as early as LC IB at Myrtou-*Pighades* (Catling 1957, 39). Such an approach will facilitate the classification of Base Ring sherds in the field, which will, in turn, allow the precise recording of the chronological development of these types at sites around the island. Such a system might have alleviated Dikaios' problem at Enkomi where he found a long period of overlap in the occurrence of vessels variously identified as BR I and BR II (*Enkomi*, 441-472).

It is extremely doubtful that future archaeological evidence will point to the production of any of these types in any region having been limited to any single, historically-defined period in a way which would justify the use of numerical modifiers in the type labels. However, if any specific features of the ware (material, technological, morphological or ornamental) are found in subsequent studies to be limited in time (perhaps by region), then this information can be incorporated into the descriptions and criteria of classification for the types at a later time, the format being sufficiently flexible for such modifications (Fig. 12.1). In addition, since features of morphology and decoration have been demonstrated to be very fluid *between* prehistoric Cypriot wares, this classification format will allow the associations of these features to be traced independently over time to specific Base Ring Fabrics and (if the same format is used), to groups of other wares as well, an important asset since so many of these features were common to *several* contemporary wares. If there was linear development of any particular feature (perhaps bases, e.g., flat, ring base, trumpet base), the format would simply highlight the individual chronology of this specific feature without distorting the entire classification.

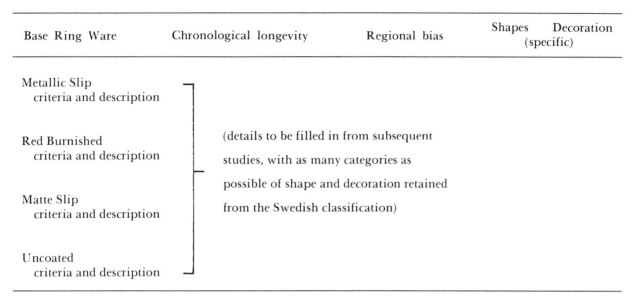

Figure 12.1. Classification format for Base Ring Ware.

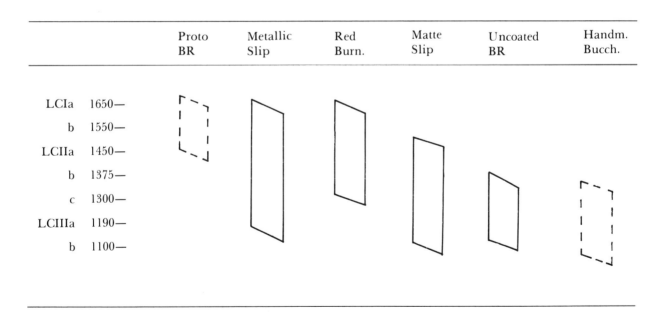

Figure 12.2. Schematic representation of typological overlaps in Base Ring Fabrics (and related groups).

The prevailing Swedish Base Ring classification has proved to be an important and durable exposition of this unique ware, and not a little of its popularity has derived from the *perceived* (but unsubstantiated) shorthand for dating which it has provided excavators in Cyprus and the Near East, approximated as follows: lustrous surface and relief decoration equal Base Ring I, approximately 1625 to 1400 BC, while coarser fabric, matte surface, white paint ornament and "clumsy" shapes equal Base Ring II, approximately 1400 to 1150 BC (e.g., Merrillees 1968, 3). As has been shown however, the ware presents a far more complex picture in its production, development and distribution than can be reliably reduced to such convenient shorthand concepts, and it would be a serious disservice to the sophistication of both this unique pottery, as well as to our current awareness of the multidimensional character of archaeological ceramics, to continue to fall back on unhelpful systems and nomenclature, no matter how familiar.

The conclusions of the present study constitute the first part of a major reassessment of Late Cypriot Base Ring ware. If followed up by similar and comparable studies of features of morphology and decoration for the ware, along with refinements arising from the application of the typology to regional sequences of stratified settlement material, the result will be a highly accurate and useful classification of the ware, based on a large body of multivariate data, but sensitive to excavated evidence on both regional and chronological bases. It will be after such subsequent study that identification of more individual Base Ring workshops may be possible. It is hoped the research demonstrated the value of applying multidisciplinary, and complementary systems of assessment to studies of archaeological ceramics, even those of a most "familiar" nature. It is also hoped that the success of this work has provided some courage to those scholars also contemplating, or in the midst of, similar reassessments of other prehistoric Cypriot ceramics in light of inadequacies common to the existing systems of classification of these wares.

Acknowledgments

The author gratefully acknowledges the generous contributions made to this study by Dr. Vassos Karageorghis, Professor J.N. Coldstream, Dr. Hector Catling, Dr. David Price, the staff of the Departments of Geological Sciences at University and Queen Mary Colleges, London, and by members of the British and Cyprus Geological Surveys. The author would also like to thank Professor Paul Åström in particular, whose unfailing and gracious support of such ceramic research has encouraged those who have come after, and the Conference organizers for the rare opportunity to gather to such good purpose.

REFERENCES

Ålin, Per
1978 Idalion Pottery from the Excavations of the
 Swedish Cyprus Expedition. *OpAth* XII, 91-
 109.

Arnold, Dean E.
1985 *Ceramic Theory and Cultural Process.*
 Cambridge.

Åström, Paul
1972 Some Aspects of the Late Cypriote I Period.
 RDAC, 46-57.

1987 Inverted Vases in Old World Religion. *Journal
 of Prehistoric Religion* 1, 7-16.

Åström, Paul & G.R.H. Wright
1962 Two Bronze Age Tombs at Dhenia in Cyprus.
 OpAth IV, 225-304.

Barlow, Jane A. & Phillip Idziak
1989 Selective Use of Clays at a Middle Bronze Age
 Site in Cyprus. *Archaeometry* 31, 66-76.

Benson, Jack L.
1969 Bamboula at Kourion, the Stratification of the
 Settlement. *RDAC*, 1-28.

Blegen, Carl W., John L. Caskey & M. Rawson
1953 *Troy, The Sixth Settlement.* Vol. III, Parts 1
 and 2. Princeton.

Bolger, Diane
1985 From Typology to Ethnology: Techniques of
 the Erimi Potters. *RDAC*, 22-36.

Carpenter, James R.
1981 Excavations at Phaneromeni, 1975-1978. In
 Studies in Cypriote Archaeology, edited by J.C.
 Biers, & David Soren, pp. 59-78. Institute of
 Archaeology Monograph XVIII. University of
 California, Los Angeles.

Catling, Hector W.
1957 The Bronze Age Pottery. In *Myrtou*-Pigadhes,
 A Late Bronze Age Sanctuary in Cyprus, by
 Joan du Plat Taylor, pp. 26-59. Oxford.

Courtois, Jacques-Claude
1972 Le sanctuaire du dieu au l'ingot d'Enkomi-
 Alasia. In *Mission archéologique d'Alasia,
 Alasia Tome IV*, edited by Claude F. Schaeffer,
 pp. 151-362. Paris.

Courtois, Liliane
1971 *Déscription physico-chimique de la
 céramique ancienne: la céramique de Chypre
 au Bronze Récent.* Thesis, Centre Nationale de
 la Recherche Scientifique. Paris.

Daniel, John F.
1942 Review of *Problems of the Late Cypriot Bronze
 Age* by Erik Sjöqvist. *AJA* 46, 286-293.

Georghiou, Eleni & D.J. Morgan
1979 *Investigation of Cyprus Clay Deposits as Raw
 Material for Structural Ceramics: Geology and
 Mineralogical Composition.* Report 239, Part
 1, Institute of Geological Sciences. London.

Gjerstad, Einar
1926 *Studies on Prehistoric Cyprus.* Uppsala.

Hankey, Vronwy
1983 The Ceramic Tradition in Late Bronze Age
 Cyprus. *RDAC*, 168-171.

Herscher, Ellen
1976 South Coast Ceramic Styles at the End of the
 Middle Cypriot. *RDAC*, 11-19.

Johnstone, W.
1972 A Late Bronze Age Tholos Tomb at Enkomi.
 *Mission Archéologique d'Alasia, Alasia Tome
 IV*, edited by Claude F. Schaeffer, pp. 51-122.
 Paris.

Lagarce, J. & E. Lagarce
1972 Notes sur quelques procédés de fabrication des
 céramiques Chypriotes au Bronze Récent.
 RDAC, 134-142.

Maniatis, Yannis & M.S. Tite
1981 Technological Examination of Neolithic-
 Bronze Age Pottery from Central and
 Southeast Europe and from the Near East.
 Journal of Archaeological Science 8, 59-76.

Merrillees, Robert S.
1965 Reflections on the Late Bronze Age in Cyprus.
 OpAth VI, 139-148.

1968 Two Late Cypriote Vases. *OpAth* VII, 1-10.

1971 The Early History of Late Cypriote I. *Levant*
 III, 56-79.

1977 The Absolute Chronology of the Bronze Age in
 Cyprus. *RDAC*, 33-50.

1978 *Introduction to the Bronze Age Archaeology of
 Cyprus.* SIMA Pocket-book IX. Göteborg.

1979 Pottery Trade in Bronze Age Cyprus. *RDAC*,
 115-134.

1986 A 16th Century BC Tomb Group from Central
 Cyprus with Links both East and West. In *Acts
 1986*, 114-148.

1989 Highs and Lows in the Holy Land: Opium in
 Biblical Times. *Eretz-Israel* 20, 148-154.

Morris, Desmond
1985 *The Art of Ancient Cyprus.* Oxford.

Muhly, J.D.

1985 The Late Bronze Age in Cyprus: A 25 Year Retrospect. In *Archaeology in Cyprus 1960-1985*, edited by Vassos Karageorghis, pp. 20-46. Nicosia.

Rice, Prudence M.

1987 *Pottery Analysis, A Sourcebook*. Chicago.

Robertson, A.H.F.

1977 Tertiary Uplift History of the Troodos Massif, Cyprus. *Geological Society of America Bulletin 88*, 1763-1772.

Sjöqvist, Erik

1940 *Problems of the Late Cypriot Bronze Age*. Stockholm.

Vaughan, Sarah J.

1987 A Fabric Analysis of Late Cypriot Base Ring Ware: Studies in Ceramic Technology, Petrology, Geochemistry and Mineralogy, Vols. 1 (text) and 2 (Appendix). Ph.D. Dissertation, University College, London.

1991 Late Cypriot Base Ring Ware: Studies in Raw Materials and Technology. In *Recent Developments in Ceramic Petrology*, edited by A. Middleton & Ian C. Freestone. British Museum Occasional Paper. London.

Vaughan, Sarah J. & D. Guppy

1988 Statistics and the Archaeological Sample. In *Computer and Quantitative Methods in Archaeology*, edited by C.L.N. Ruggles & S.P.Q. Rahtz, pp. 55-60. BAR International Series 393. Leicester.

Wright, G.R.H.

1967 Some Cypriote and Aegean Pottery Recovered from the Shechem Excavations 1964. *OpAth* VII, 47-75.

XIII

The Pot Calls the Kettle Reddish Brown (5YR 3/4): Distinguishing among Late Cypriot Monochrome Wares

Pamela J. Russell

Mr. Gould may be the last great apologist for a style of intellectual work that has mostly fallen from favor: the business of classifying, categorizing and pigeonholing. We think of this as a sterile occupation. Who cares, really, what the eras, periods, and epochs are named? And who cares whether a given specimen belongs in this phylum or that? Mr. Gould not only makes the case for memorizing the eras, periods and epochs; he also argues vehemently that classification is a high and creative calling. "Taxonomy is a fundamental and dynamic science," he says, "dedicated to exploring the causes of relationships and similarities among organisms. Classifications are theories about the basis of natural order, not dull catalogues compiled only to avoid chaos."...The work of placing fossils in categories, carefully weighing similarities and differences and occasionally discarding an old category and inventing a new one leads, inexorably, to a new view of the history of life.

— *James Gleick in his review of Stephen Jay Gould's* Wonderful Life: The Burgess Shale and the Nature of History *in* The New York Times Book Review, *October 22, 1989 (the final day of the Philadelphia conference).*

A problem in ceramic classification presented itself to me when I began my study of the ceramics from the Late Bronze Age site of Kalavasos-*Ayios Dhimitrios* in 1982.[1] Upon examination of the context pottery a number of familiar wares were easily recognized. Three stood out as the main decorated wares. Most common, of course, was White Slip II. The hemispherical bowl was virtually the only shape found in settlement areas and standard decorative schemes included the ladder pattern, dotted rows and lozenges. Second in quantity was White Painted Wheelmade III ware, found not only in the shallow bowl shape but also in jugs and jars. Quite rare, but

very noticeable, were the occasional imported Mycenaean sherds and vessels.

Another three fabrics appeared as the plain, undecorated wares. Of these, Base Ring II was by far the finest quality, having thin walls, few grit inclusions, and a good surface treatment. The familiar Y-shaped cup and small jug were the normal forms. A second plain ware was a coarse "cooking pot" fabric, usually found in the forms of, indeed, a pot or a jar. The fabric is dark brown or gray in color, the surfaces are usually unslipped, and vessels frequently show traces of burning. Cooking ware was the most plentiful of the ceramic types, making up

1. For publication of the ceramics from Kalavasos-*Ayios Dhimitrios*, see Heuck (1981); Russell (1983, 1984, 1986); South *et al* (1989).

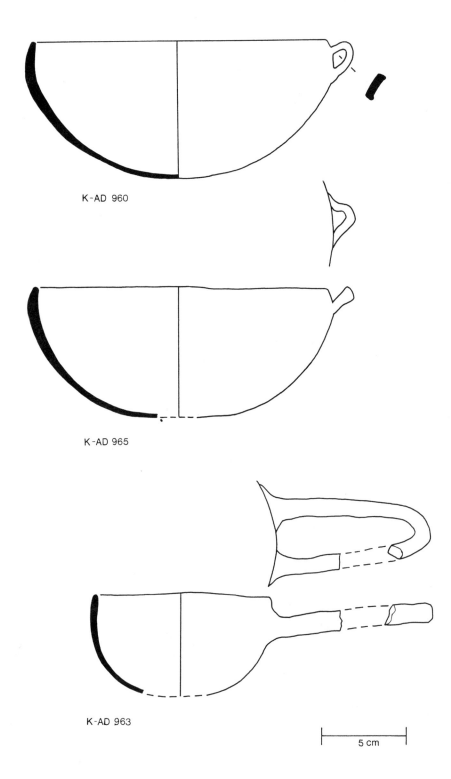

K-AD 960

K-AD 965

K-AD 963

5 cm

Figure 13.1. Monochrome C Bowls from Kalavasos-Ayios Dhimitrios.

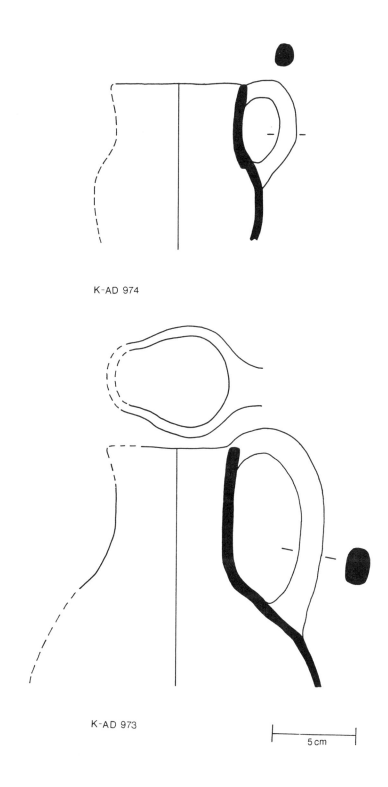

K-AD 974

K-AD 973

5 cm

*Figure 13.2. Monochrome C Jugs from Kalavasos-*Ayios Dhimitrios.

40% to 75% of the thin-walled sherds in deposits at *Ayios Dhimitrios*.

The third undecorated ware is the one on which I wish to focus. Sherds and vessels of a reddish brown or brown fabric with small and medium-sized grit inclusions made up about 5% to 20% of the ceramic material from the site's settlement deposits. The surface is slipped and often smoothed or burnished to give a faint luster. The surface color usually matches the fabric. Frequently the surface is mottled, producing red, brown, and black patches on a single pot.

Simple hemispherical bowls are the most common shape among the vessels of this ware at *Ayios Dhimitrios*. The normal rim diameter of these bowls is between 18 and 20 cm. The most common handle type is the small spool handle attached near the rim (Fig. 13.1, top, K-AD 960). A less common handle type is a small horizontal loop below the rim (Fig. 13.1, middle, K-AD 965). A special group of hemispherical bowls with smaller rim diameters (*ca.* 10 cm.) and long loop handles were probably used as ladles (Fig. 13.1, bottom, K-AD 963). The typical jug has a globular body, cylindrical neck, and a vertical handle which extends from rim to shoulder. The mouths are round (Fig. 13.2, top, K-AD 974) or pinched (Fig. 13.2, bottom, K-AD 973).

My problem during the classification process was that this plain ware did not seem to fall easily into the categories laid out in existing classification schemes (see *SCE* IV Pt.1C). For lack of anything better, I chose to call this ware "Monochrome," thereby, I'm afraid, contributing to what I have since found to be a larger problem in the terminology for plain, often burnished, handmade wares of the Late Bronze Age. Simply put, there are more distinct wares than there are terms. This situation is no doubt the result of the not surprising fact that plain wares, particularly those of minimal aesthetic value, have not received the same level of study as the more glamorous Late Cypriot wares, namely White Slip, Base Ring and the Mycenaean imports and imitations.

However, now, as archaeologists seek to examine all possible sources of information about ancient ways of life, more attention is being paid to the simple, undecorated fabrics. From them we can hope to learn more about the daily activities carried out by Bronze Age people, more about the chronological relationships of sites and more about regional autonomy and interaction. Enough is now known about some of the individual varieties of Cypriot plain wares that they can be defined more clearly, and therefore, it would seem appropriate that there should be some way of identifying these new categories; that is, they should receive new names.

Several discussions of Monochrome ware, however broadly defined, have already been published. Monochrome was treated as a distinct fabric in *Problems of the Late Cypriot Bronze Age* by Erik Sjöqvist (1940). He writes "The clay reminds one very much of that used in the thicker vases of the much more common Base Ring I ware. It is buff or reddish in colour, sometimes brick-red and in a few cases pink or grey" (Sjöqvist 1940, 30). The main shapes are the bowl with a wishbone handle and a carinated rim and the jug with a globular or biconical body and a pinched lip. Larger krater shapes are also known.

Sjöqvist's account, primarily based on material from Enkomi tombs, may stand as a basic definition of a thin-walled buff ware that was prevalent in LC I and LC IIA (e.g., *SCE* I, pl. CXII: 3-5). Carinated bowls of this monochrome ware were exported to Syro-Palestinian sites and have also been found in western Egypt at Marsa Matruh (Oren 1969, 140-142; White 1986, 76-77).

In 1972 Paul Åström expanded Sjöqvist's treatment of Monochrome (*SCE* IV Pt.1C, 90-111). In his description, key features include the hard or very hard clay, the brown to red fabric color, and the uneven surface which often shows evidence of vertical paring or trimming with a tool. Åström included more pots that greatly expanded the repertoire of shapes recognized by Sjöqvist.

Åström went on to introduce the term *Coarse Monochrome* in the same 1972 publication. He states that this ware was first isolated at the site of Apliki where it was called "Apliki Ware" (*SCE* IV Pt.1C, 103-104). Before proceeding, we need to go back twenty years from 1972 to 1952, when Joan du Plat Taylor published the report of her work at Apliki (Taylor 1952). She writes "Monochrome ware as found among the Swedish types is barely represented but is replaced by a coarser handmade red ware with stroke burnished surface" (Taylor 1952, 159). We can see that this scholar felt compelled to distinguish a fabric type from the quite well-defined Monochrome of Sjöqvist, but she chose a site name to do so, something most Cypriot archaeologists would no longer want to do. Åström then suggested as a positive alternative, "Coarse Monochrome." According to Åström's definition, key features of this ware include its usually brick-red color, the presence of many grit inclusions, and a surface that is often scratch burnished.

It seems to me that both of these definitions, for Monochrome and Coarse Monochrome, are broader than they now need be and have grouped together pots that might more helpfully be separated. Even Åström himself noted that J.R. Stewart believed that so-called Apliki Ware actually comprised a number of different fabrics (*SCE* IV Pt.1C, 103).

I would argue that the term *Coarse Monochrome* should be abandoned. First of all, I do not accept the implication that it is a cruder, lesser form of a finer, true Monochrome. Archaeological evidence suggests that at the time Coarse Monochrome or Apliki Ware or even my

Ayios Dhimitrios Ware was being produced, Sjöqvist's Monochrome, typical of LC I, was no longer being made.

Secondly, and more importantly, I am certain, along with Stewart, that more than one plain burnished ware was being produced in the latter parts of the Late Bronze Age. *Coarse Monochrome* as a term, masks important distinctions that need be made. Taylor herself had already described two variants at Apliki (Taylor 1952, 159-160). While I have had the opportunity to examine only briefly monochrome pottery from Apliki, it seems different enough, in terms of both fabric and shape, from what I have found at *Ayios Dhimitrios* that it should be designated something else. I strongly suspect we may be seeing chronological variations in this case, as well as regional ones.

Before concluding with my suggestions for a new terminology, I want to point out that not all archaeologists have taken a "lumping" approach to the problem of monochrome wares. J.L. Benson, following the work of J.F. Daniel in his publication of the ceramics from Kourion-*Bamboula*, has separated out at least eight fabrics, all seemingly members of the monochrome family (Benson 1972, 75-79). Each has its own name, for example, Fused Temper and even Indeterminate Burnished.

I have a special interest in Fused Temper since its published description matches well the features of a ware I have identified at Kalavasos-*Ayios Dhimitrios* and Maroni-*Vournes*. Sherds appear sporadically in settlement levels at *Ayios Dhimitrios* and have also been found at many sites surveyed by the Vasilikos Valley Project under the direction of Ian A. Todd. A complete krater, perhaps of this ware, was the only vessel found in *Ayios Dhimitrios* Tomb 3 (K-AD 496, see Catalogue below). Sherds have also been found at Maroni-*Vournes*, and complete vessels were recovered from a LC IIA tomb at Maroni-*Kapsaloudhia*.[2]

The fabric is very hard with a light gray core and gray or reddish brown matte surface. The common shapes are bowls with a single horizontal handle and a flaring lip, and jugs often with trefoil mouths (cf. Benson 1972, 76, pls. 19, 43, B314; pl. 53, B316-B329). The shapes are "rougher" than those of Base Ring, with ridges of clay left unsmoothed. Vessels of this type are unlike both the approximately contemporary Base Ring I with its lustrous slip and the Monochrome described by Sjöqvist with its somewhat softer and paler clay (Sjöqvist 1940). It is also clearly distinct from the monochrome ware excavated from settlement contexts at Kalavasos-*Ayios Dhimitrios*, both in terms of fabric and shapes. The fabric is harder with predominantly gray tones, and the bowl rims show greater articulation. I find it difficult to designate both groups simply Monochrome when the differences are so great.

As we all know, one of the most difficult questions ceramics specialists face is when it is best to lump and when to split. My basic tendency is to lump, but even as a lumper I am convinced we can and should do better in our descriptions of monochrome wares. While not necessarily leading to a new view of the history of life, as James Gleick suggested in the passage quoted at the beginning of this article, a new, more detailed classification will lead to a better understanding of Late Bronze Age Cyprus.

I propose that we continue to use the term *Monochrome* to designate a broad family of wares, as an umbrella for a group of Late Bronze Age plain wares, perhaps all having roots in the Middle Bronze Age Red Polished tradition. To distinguish among members of this family I suggest we append a letter of the alphabet, so we might specify, for example, Monochrome A, Monochrome B, Monochrome C, with the hope that no more than 26 varieties will ever be identified. To qualify for a separate designation, a group will have to be defined narrowly in terms of fabric characteristics and a limited range of vessel shapes. At the time of classification, a series of profile drawings will need to be published along with a fabric description which is as objective as possible. Furthermore, while we shall not include chronological or geographic designations in the new terminology, the published descriptions should include consideration of the questions of date and regional distribution of each newly defined monochrome variety.

As an example, I am confident that the vessels and sherds of the reddish brown fabric I originally encountered at *Ayios Dhimitrios* do form a distinct class. I have since identified this ware elsewhere, for example in a tomb at Dhali-*Kafkallia* where a bowl of this ware was classed as "plain handmade ware." John Overbeck wrote when publishing the vessel, "a careful and excellent piece of work. I have found no real parallels" (Overbeck & Swiny 1972, 129-131, no. 24, fig. 15). Now there are plenty of parallels from *Ayios Dhimitrios* (K-AD 960-962). A close parallel in shape has also been published from Pyla-*Kokkinokremos* (Karageorghis & Demas 1984, 40, 52, no. 95, pls. XX, XXXVI).

Let me propose that Monochrome A be used to designate the vessels as first defined by Sjöqvist. These date mainly to the Late Cypriot I and IIA periods. They were plentiful in the Enkomi tombs and were widely exported to the Levant.

2. Benson's Fused Temper, see Benson (1972, 76-77); South *et al.* (1989, K-AD 496); McClellan *et al.* (1988, 217-219); the remainder of the Kalavasos and Maroni material remains unpublished. Cadogan (1987, 81) for the LC IIA tomb at *Kapsaloudhia* which produced complete vessels.

Monochrome B will be used for the very hard, gray ware known from at least three south coast areas: Kourion-*Bamboula*, Maroni, and Kalavasos (see note 2). A probable *floruit* for this type is LC IIA and LC IIB.

Monochrome C can designate the ware defined on the basis of finds from Kalavasos-*Ayios Dhimitrios*. A selection of representative shapes is illustrated in Figures 13.1 and 13.2, and the fabric characteristics have been described above. On the basis of the settlement evidence, the ware seems to date to LC IIC.

Related wares will soon be distinguished. The monochrome wares from sites such as Apliki, Myrtou-*Pigadhes*, Kaimakli, and Maa-*Palaekastro* are in need of detailed study. The results of such an examination will reveal much about the range of fabrics and shapes that occurs in different parts of Cyprus at different times.[3]

As pottery specialists, it is our responsibility to make distinctions where we can in order to facilitate the comparison of ceramic assemblages among sites. By doing so we can identify chronological relationships and trace economic patterns, both fundamental goals in archaeological research. I hope that the modest and unassuming monochrome wares of the Late Bronze Age will soon join White Slip and Base Ring as important tools in the reconstruction of the prehistory of Cyprus.

CATALOGUE

(Kalavasos-*Ayios Dhimitrios* sherds and vessels mentioned in text)

K-AD 496 Krater
Tomb 3, 2.1
H=24 cm., Rim D=20.2 cm., Max D=27.2 cm., Base D=10 cm.
Fabric core=N 4/, Fabric surface=7.5YR 6/8, Surface=5YR 6/6 & 5YR 5/1
Near complete. Flat everted rim, concave neck, rounded body, low ring base, strap horizontal handle on shoulder. Hard gray fabric with scant grit inclusions.

K-AD 960 Bowl Fragment
Building III, Area 209, 3.1
L=10 cm., H=7.4 cm., Rim D=18 cm., Wall Th=0.4 cm.
Fabric=5YR 3/4, Slip=5YR 4/4
Rim sherd with handle. Hemispherical bowl with flattened rim, spool-like vertical strap handle from below lip to body. Reddish brown slip. Reddish brown fabric with black and white inclusions.

K-AD 963 Ladle Fragment
Building III, Area 212, 4.1
H=6.6 cm., Rim D=10 cm., Wall Th=0.3 cm., Handle L=9.5 cm.
Fabric=N 5/, Slip=10R 4/4
One-third of bowl and near complete handle. Hemispherical bowl with rounded lip and long horizontal loop handle, oval in section. Reddish brown slip. Gray fabric, redder near surface.

K-AD 965 Bowl Fragment
Building II, Area 28, 4.1
H=6-7 cm., Rim D=18 cm., Wall Th=0.4 cm.
Fabric core=2.5YR 4/8, Fabric surface=N 5/, Slip=5YR 4/2 to 2.5YR 5/6
One-third of bowl with handle. Hemispherical bowl with incurving rim and small horizontal loop handle applied below rim. Red slip with gray mottling. Red fabric with black and white inclusions, gray at exterior surfaces in places.

K-AD 973 Jug Fragment
Building IX, Area 44, 3.1 and 4.1
H=14.5 cm., Wall Th=0.5 cm.
Fabric=2.5YR 6/6, Slip=2.5YR 6/6
Rim, neck, handle fragment. Jug with trefoil mouth, cylindrical neck, rounded shoulder, handle from rim to shoulder, oval in section. Vertical paring on neck. Red slip. Red fabric, white and gray inclusions.

K-AD 974 Jug Fragment
Building III, Area 218, 3.1
H=8.6 cm., W=8.7 cm., Rim D=*ca.* 8 cm., Wall Th=0.5 cm.
Fabric=2.5YR 4/8, Slip=2.5YR 4/6
Rim, neck, handle fragment. Jug with rounded lip, short cylindrical neck, rounded shoulder, handle from rim to shoulder, oval in section. Vertical paring on neck. Red slip mottled to black in patches. Red fabric with black inclusions.

3. Mrs. Despo Pilides, currently a doctoral candidate at the University of London, is undertaking such a study; see her article in this volume.

REFERENCES

Benson, Jack L.
1972 *Bamboula at Kourion: The Necropolis and the Finds.* Philadelphia.

Cadogan, Gerald
1987 Maroni III. *RDAC*, 81-84.

Karageorghis, Vassos & Martha Demas
1984 *Pyla-Kokkinokremos: A Late 13th-Century B.C. Fortified Settlement in Cyprus.* Nicosia.

Heuck, Susan A.
1981 Kalavasos-*Ayios Dhimitrios* 1979: A Preliminary Ceramic Analysis. *RDAC*, 64-80.

McClellan, Murray C., Pamela J. Russell, & Ian A. Todd
1988 Kalavasos-*Mangia*: Rescue Excavations at a Late Bronze Age Cemetery. *RDAC*, 201-222.

Oren, Eliezer D.
1969 Cypriot Imports in the Palestinian Late Bronze Age I Context. *OpAth* IX, 127-150.

Overbeck, John & Stuart Swiny
1972 Two Cypriot Bronze Age Sites at Kafkallia (Dhali). SIMA XXXIII. Göteborg.

Russell, Pamela J.
1983 Ceramics. In Kalavasos-*Ayios Dhimitrios* 1982, by Alison K. South, *RDAC*, 104-113.

1984 Fine Ware Ceramics. In Kalavasos-*Ayios Dhimitrios* 1983, by Alison South, *RDAC*, 25-29.

1986 The Pottery from the Late Cypriot IIC Settlement at Kalavasos-Ayios Dhimitrios, Cyprus: The 1979-1984 Excavation Seasons. Ph.D. dissertation, Department of Classical Archaeology, University of Pennsylvania. Philadelphia.

Sjöqvist, Erik
1940 *Problems of the Late Cypriot Bronze Age.* Stockholm.

South, Alison K., Pamela J. Russell & Priscilla S. Keswani
1989 *Vasilikos Valley Project 3: Kalavasos*-Ayios Dhimitrios II: *Ceramics, Objects, Tombs, Special Studies.* SIMA LXXI:3. Göteborg.

Taylor, Joan du Plat
1952 A Late Bronze Age Settlement at Apliki, Cyprus. *AntJ* 32, 133-167.

White, Donald
1986 1985 Excavations on Bates's Island, Marsa Matruh. *JARCE* XXIII, 51-84.

XIV

Handmade Burnished Wares of the Late Bronze Age: Toward a Clearer Classification System

Despo Pilides

INTRODUCTION

The original purpose of my studies was to identify what is known as "Barbarian Ware" in Late Bronze Age contexts in Cyprus, to trace its chronological, geographic and quantitative distribution on the island and to place possible affinities outside Cyprus.

In the course of this research, problems were identified in the classification of other handmade wares, overlapping chronologically and covering the whole of the duration of the Late Bronze Age. These are Coarse Monochrome, Apliki Ware and Monochrome, the wares to be discussed in this paper.

Barbarian Ware, now referred to as Handmade Burnished Ware (HBW), was first found at Mycenae in 1964 in early LH IIIC contexts. (French & Rutter 1977, 111-112). The distinctive nature of this pottery and its sudden appearance in the initial stages of LH IIIC at a number of sites above destruction levels, caused lively discussions on the origins of this ware, its possible makers and whether it represented a local response to changed circumstances, or a foreign element in the local population, directly connected with the destruction of the Mycenaean palaces at the end of LH IIIB2 (Deger-Jalkotzy 1983, 167).

HBW was found at Lefkandi (Popham & Milburn 1971), Tiryns, (Kilian 1978), the Menelaion (Catling & Catling 1981), Korakou (Rutter 1975), Aigeira (Deger-Jalkotzy 1983) and a number of other sites in Greece as well as at Khania (Pålsson-Hallager 1983, 111-116) and Kommos (Watrous 1989) in Crete.

Excavators of sites where this ware was identified are convinced that it is an intrusive ware in view of the fact that there is no precedent in earlier Mycenaean ware; it is handmade, at a time when the wheel was in full use,

made of a coarse clay containing large inclusions, dark in color, although the color may vary, and burnished. Shapes include wide-mouthed jars, open bowls, cups and mugs often decorated with plastic decoration such as finger impressed cordons, plain applied or wavy cordons, ledges and especially horseshoe ledges; incised decoration also occurs. HBW is found in association with Mycenaean wares, always in relatively small quantities, with the exception of Aigeira (Deger-Jalkotzy 1983) where it was found directly above bedrock without any association with Mycenaean material.

An interesting feature of this ware is that it is not uniform but differs in various respects from site to site, although certain features, such as technique of manufacture, the fact that it is handmade and burnished, and certain decorative elements recur constantly. It has been argued that because it seems to disappear before the end of LH IIIC in Greece and because certain of its features are said to have been incorporated into Mycenaean ceramics, in each case the foreign element was integrated into the local tradition (Rutter 1975, 32). Parallels were sought in the material of Troy VIIb (Rutter 1975, 30), in the culture of Noua Sabatinovka and Coslogeni in Rumania (Rutter 1975, 30) and in South Italy (Pålsson-Hallager 1983, 111-116; Deger-Jalkotzy 1983, 166).

Kilian sees the makers of HBW at Tiryns as "Gastarbeiter" from northwestern Greece (Kilian 1978; 1988, 133); Schachermeyr attributes HBW to the Sea Peoples (Schachermeyr 1980, 95-98). Bankoff and Winter believe the origin of HBW is in the Lower Danube (Bankoff & Winter 1984). At the same time theories about the Dorian invasion have been revived in an effort to explain the presence of HBW (Bouzek 1969).

KITION AREA I

1. Kit. No. 654, Floor IIIA-IV
Body fragment of bowl?

2. Kit. Room 40, Floor IIIA-IV
Rim fragment of platter

3. Kit. No. 674, Well 3, Floor I-II

4. Kit. No. 646, Room 8, Floor I
Body fragment, carinated vessel

5. Kit. No. 372, City Wall
Base fragment, bowl/cup

6. Kit. No. 334, Floor I-II
Fragment of cup

KITION AREA II
(Floor II except as noted)

7. Kit. Room 16, tray 1, handle from bowl/cup,
Floor II-III

8. Kit. 1965.318

9. Kit. 350.360

10. Kit. tray 313

11. Kit. tray 313

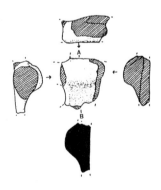

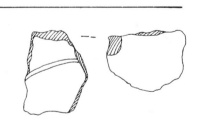

12. Kit. tray 299

13. Kit. 1965, City Wall
tray 299b, unstratified

14. Hala Sultan Tekke F3008

Figure 14.1. Handmade Burnished Ware from Kition Areas I and II and from Hala Sultan Tekke.

There have also been arguments supporting a local production of this ware by the native population who, as a result of the destruction of the Mycenaean citadels and the breakdown of cultural unity, had to depend on local clay sources and pottery made by hand (Walberg 1976). Such theories, however, cannot explain why wheelmade Mycenaean wares, both cooking vessels and fine-painted pottery, continued to be made as before, nor can they explain the appearance of this ware at Troy or Cyprus.

HANDMADE BURNISHED WARE IN CYPRUS

"BARBARIAN WARE" (HBW)

In Cyprus, HBW began to arouse interest after the discovery of a jar decorated with a finger impressed horizontal cordon and four lug handles on the site of Maa-*Palaeokastro*, excavated by Vassos Karageorghis (Karageorghis & Demas 1988, 249, pl. CLIII). It was found in association with Mycenaean IIIC:1b, on Floor I, period II (Karageorghis & Demas 1988, 256) dated by the excavator to LC IIIA:1, contemporary with Enkomi Level IIIA. Karageorghis, in collaboration with C. Podzuweit began a brief search in the material of Enkomi, Kition, Hala Sultan Tekke and Sinda to identify HBW and a preliminary study of this ware was published (*Kition* V Pt.II, app. X; Karageorghis 1986).

In the course of my study of this ware, which necessitated a search through the sherd material of past excavations of the major Late Bronze sites in Cyprus to find fragments of the ware, several problems of identification surfaced.

The criteria employed by Karageorghis to identify this pottery were that it was handmade of a brown/gray clay with a gray, gritty core and that it was burnished; such material, published as HBW in fact belonged to the categories of Coarse Monochrome and Apliki Wares (Karageorghis 1986, fig. 1: 3, 4, 5, 7). Also one of the specimens published as HBW in the same paper belongs to handmade, partly burnished coarse ware (*Kition* V Pt.II, app. X, pl. A-5).

As a result, the criteria for identifying HBW in Cyprus had to be modified. Indeed, HBW is much more than just handmade and burnished; it is very distinctive not only in its fabric but also in its shapes. Therefore, only if both the fabric and shape of a specimen are sufficiently different from Cypriot traditional forms and fall within the range of HBW shapes known in Greece can such a specimen be considered either an imported form or a local imitation of an imported shape. The criterion of chronological context should of course remain a major consideration, since HBW occurs for the first time in Greece in LH IIIB:2. (Rutter 1975, 31; Catling & Catling 1981, 74; Kilian 1981, 170), although in Crete it occurs earlier (Pålsson-Hallager 1983, 112; Watrous 1989, 76).

The evidence for the presence of this ware in Cyprus is meager; nevertheless it has been attested at such sites as Maa-*Palaeokastro*, Kition, Hala Sultan Tekke, Enkomi and perhaps Apliki. The earliest finds occur at Kition Area I, Floors IIIA-IV when Mycenaean IIIC:1b predominates, a period dated by the excavator to the

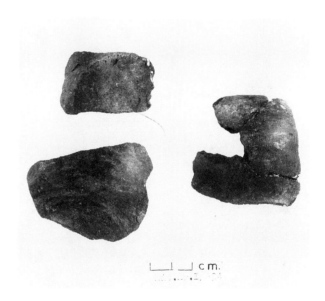

Figure 14.2. Fragments of HBW cups with flat bases from Kition Area I, Floor I and Floors I/II.

transition between the LC IIC and LC IIIA (*Kition* V Pt.I, 263-265, 273). No more HBW occurs at Kition Area I until some time later on Floors I + II and Floor I, dated by the excavator to LC IIIB and early Cypro-Geometric where there are a number of finds.

Shapes range from a platter (Fig. 14.1: 2) to a body fragment of, perhaps, a bowl (Fig. 14.1: 1), decorated with a horizontal row of incisions, a carinated vessel (Fig. 14.1: 4), a shallow dish with everted rim and perhaps a handle below the rim (Fig. 14.1: 3) and a number

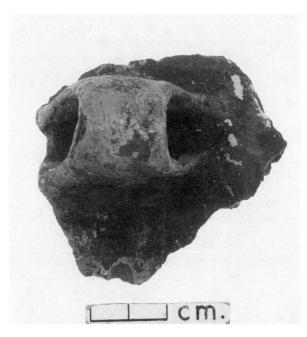

Figure 14.3. HBW vertical handle from a cup or bowl from Kition Area II, Room 16, Floors II/III.

of cups with flat bases (Fig. 14.1: 5, 6; Fig. 14.2), one with a circular groove round its perimeter, just above the base. The surface is usually lustrous, highly burnished, often showing distinct tool marks; the colors range from brown with patches of gray, to black, almost always with a very dark gray or black core, containing large inclusions which are also visible on the surface.

In Area II at Kition, HBW occurs later than in Area I, between Floors II and III, the time when the excavators report that Proto-White Painted Ware (*Kition* V Pt.1, 266-267) makes its appearance. The earliest find, (Fig. 14.1: 7; Fig. 14.3) is a body fragment from a cup or bowl with a vertical strap handle attached to it. The remainder of HBW finds from Area II belong to Floor II or they come from the City Wall and are unstratified. I have identified a total of nine shapes in Area II some of them similar to those of Area I (Fig. 14.1: 7-13).

Surprisingly, HBW from Enkomi and Hala Sultan Tekke is much smaller in quantity than that from Kition. At Enkomi, there are only six fragments, the earliest of which comes from the leveled surface of the destruction debris of Level IIB, a period dated by Dikaios to the end of LC IIC and the beginning of LC IIIA (*Enkomi* II, 486).

At Hala Sultan Tekke, only three finds have been identified. One is a jar with narrow neck and two horizontal handles on the shoulder, decorated with incisions between the handles (Fig. 14.4: 14; Fig. 14.5). There is also a small cup, similar to those from Kition,

with a deep incision on the inner surface (Fig. 14.4: 15) and the third fragment comes from a jar. The last two fragments were found among sherds labeled as coarse ware in the sherd material of HST.

The most characteristic find and the only complete specimen is the well-known jar from Maa-*Palaeokastro* (no. 255; Fig. 14.4: 16) found on Floor I, period II, when large quantities of Mycenaean IIIC:1b were in use. This shape is paralleled at various sites in Greece; very similar specimens were found at the Menelaion in Sparta (Catling & Catling 1981, 76, fig. 2), Korakou, a site near Corinth in the Peloponnese (Rutter 1975, 19, ill. 2) and Troy VIIb (Blegen *et al.* 1958, pl. 267: 32.13).

Sinda has produced a single find from period II, a fragment from a deep bowl with a plain rim (Fig. 14.4: 17), decorated with a horizontally applied cordon, 3 cm. below the rim. Period II was correlated by the excavator to Enkomi Level IIIA and dated to the LC IIIA period (Furumark 1965). A similar example was found at Korakou (Rutter 1975, fig. 15, pl. 3).

A closer examination of the fabric and shapes of the HBW found in Cyprus led to the identification of two distinct fabrics, each with a set of distinctive features. There is a brown fabric, soft and friable, with a dark gray to black core containing large inclusions. It is characterized by large shapes, mainly jars, one of which is decorated with an applied finger-impressed cordon (Maa-*Palaeokastro* no. 255, Fig. 14.4: 16); another jar is decorated with a plain horizontally applied cordon (Sinda RP 1.2, Fig. 14.4: 17); jars in a similar fabric from Enkomi (Fig. 14.4: 18) and Kition are undecorated.

The second category is characterized by a hard gray fabric with large inclusions, which is usually highly burnished to a luster; the shapes are smaller and the characteristic decoration consists of features such as punctured decoration (Kition no. 654, Fig. 14.1: 1), grooved decoration (Hala Sultan Tekke F3008, Fig. 14.4: 15; Kition no. 334, Fig. 14.1: 6, Fig. 14.2) and incised decoration (Hala Sultan Tekke N 1604, Fig. 14.4: 14).

It is interesting that a similar situation, two distinct fabrics with a set of distinct shapes, seems to be present at Troy and Korakou. There is no clear chronological division between the two fabrics in Cyprus; both occur between Floors IIIA and IV at Kition for the first time, although there is a higher frequency of the gray fabric in the later levels at Kition, Floors II and I.

It seems that the earliest occurrence of this pottery on the major Late Bronze Age sites in Cyprus is at a time when large quantities of Mycenaean IIIC:1b are in use at the beginning of LC IIIA. In my search through the finds, HBW has not been identified as far as I could find in earlier levels at Enkomi; it does not occur on Floor IV at Kition, at Maa period I or at Pyla-*Kokkinokremos*.

Trade does not seem to offer a satisfactory explanation for the presence of this pottery in Cyprus. A tentative

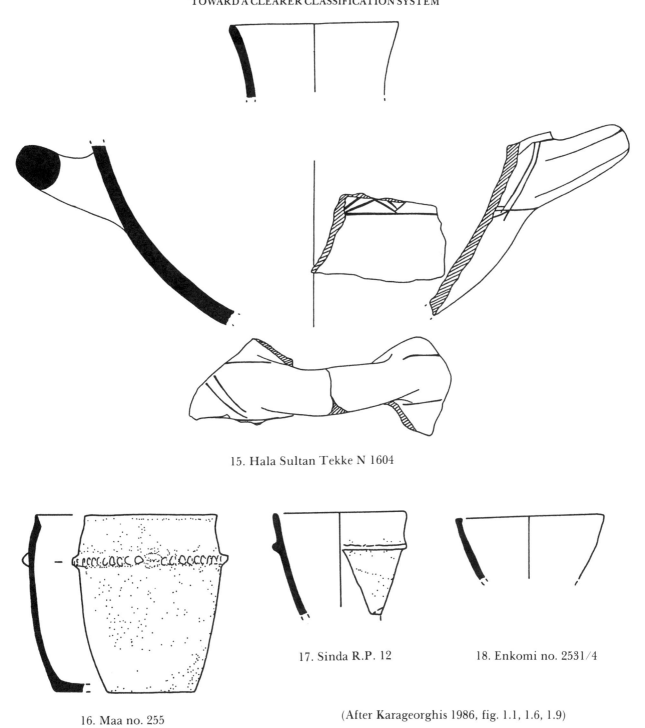

15. Hala Sultan Tekke N 1604

16. Maa no. 255

17. Sinda R.P. 12

18. Enkomi no. 2531/4

(After Karageorghis 1986, fig. 1.1, 1.6, 1.9)

Figure 14.4. Handmade Burnished Ware from various sites.

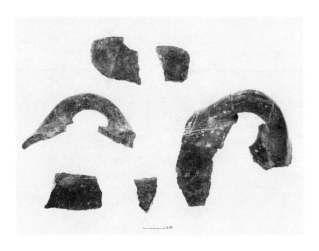

Figure 14.5. Fragments of HBW jar from Hala Sultan Tekke.

chemical analysis of a few fragments from Cyprus was carried out in 1985 (Jones 1986, 259) and showed that those fragments selected were made in the locality of their findspots, but the makers did not employ the habitual potters' sources. It is hoped that petrographic and neutron activation analysis, currently under way, may elucidate the problem.

The chronological correlation of the material found in Cyprus with Greece, Crete and Troy, where this pottery appears without precedents roughly at the beginning of the twelfth century BC, and its association with Mycenaean IIIC:1b in Cyprus seems to suggest that the same events or circumstances that led to the appearance of this ware in early LH IIIC levels in Greece also affected Cyprus but to a lesser extent. A point to be noted, however, is that HBW in Greece is reported as confined to the early phases of LH IIIC only (Rutter 1975). Handmade burnished wares occurring in the Submycenaean period are regarded as unrelated to the HBW of the early LH IIIC (Rutter 1979, 391). In Cyprus, on the other hand, HBW begins to occur at the very beginning of LC IIIA and continues to be found, always in very small numbers, down to the end of the Bronze Age and the beginning of the Cypro-Geometric period.

It seems that, for the moment, many questions concerning this ware must remain unanswered. Perhaps a fuller publication of the HBW found in Greece, its chronological distribution and its relation to later hand-made wares will help elucidate the problem of the appearance of this ware in Cyprus.

COARSE MONOCHROME AND APLIKI WARES

At least six specimens included in the preliminary study on Barbarian Ware (Karageorghis 1986, fig. 1: 3-5, 7) belonged to the category of Coarse Monochrome, which includes Apliki Ware (*SCE* IV Pt.1C, 103). Several fragments from Kition (*Kition* V Pt.II, app. X, pls. A.7, A.10, B.1, B.2, B.3) also belong to the same category. They have no connection with HBW (Barbarian Ware) since they begin to occur at a much earlier date and the shapes derive from local traditional types.

The most comprehensive classification of Coarse Monochrome was formulated by Åström (*SCE* IV Pt.1C, 103). He notes that this ware was first recognized at Apliki by Joan du Plat Taylor, who named it Apliki Ware. He also noted that this fabric is most common in northwestern Cyprus (*SCE* IV Pt.1C, 103). Further research has shown that Coarse Monochrome is a very widespread fabric, also found at Kition, Maa-*Palaeokastro*, Kalavasos-*Ayios Dhimitrios* but to a more limited extent than in the northwest. The term *Apliki Ware* was not used in the *Swedish Cyprus Expedition* on the principle that wares should not be named after particular sites (*SCE* IV Pt.1C, 103). However, Coarse Monochrome, as defined in the *Swedish Cyprus Expedition* covers such a long period of time, from LC IA when it first occurs in limited numbers, to LC IIIB and even slightly later, that it is inevitable that it should incorporate more than one fabric. It includes, apart from Apliki Ware, a thick-walled fabric with a matte, unburnished slip (Åström 1966, fig. 72) which I would consider as plain ware. Apliki Ware consists of at least two fabrics with distinct shapes, decoration, surface treatment and perhaps chronology.

The first category consists of jugs made of a gritty brown clay, brown surface with large black areas on the neck and body, decorated with two applied opposing hook-like band ornaments on the body. Most of these jugs are not, strictly speaking, burnished; deep scratch marks are visible on the body which run either in a horizontal direction or in short strokes in various directions in an attempt to achieve some form of pattern. One such jug from Dhenia was published under Coarse Monochrome by Åström (*SCE* IV Pt.1C, 107, fig. 33). Similar juglets come from Akaki and Katydhata in slightly varying forms (Fig. 14.6: 1, 2; Akaki T.4.3, *SCE* IV Pt.1C, 106, type 2a; Katydhata T.42.13, Cypr. Mus. A1007, *SCE* IV Pt.1C, 107), included by Åström in his typology of Coarse Monochrome jugs. Joan du Plat Taylor cites Katydhata A1007 as an example of what she termed "Apliki B" (Taylor 1952, 159).

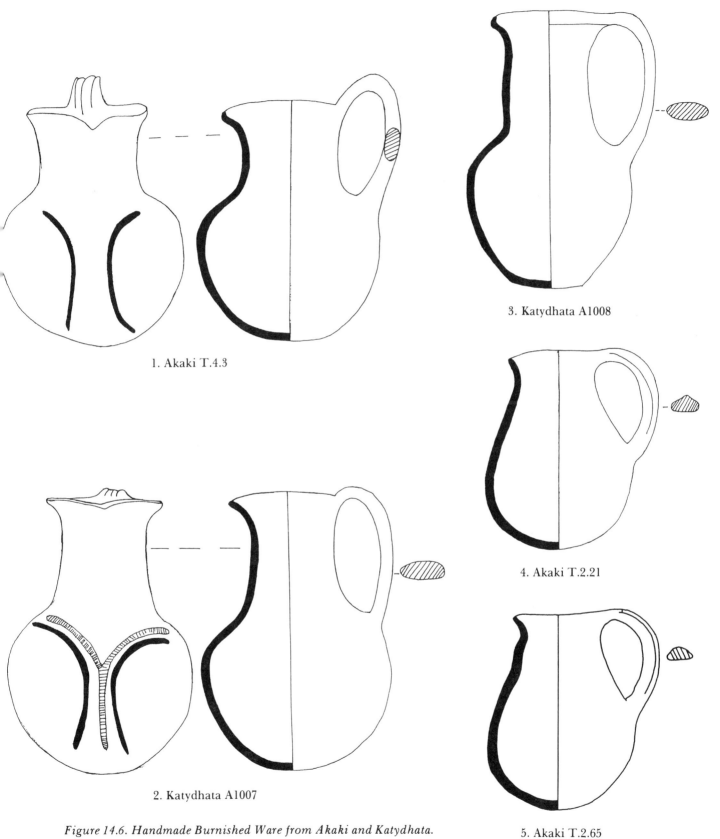

1. Akaki T.4.3

2. Katydhata A1007

3. Katydhata A1008

4. Akaki T.2.21

5. Akaki T.2.65

Figure 14.6. Handmade Burnished Ware from Akaki and Katydhata.

To the same group belong Katydhata Tomb 1.9 (unpublished) and the flask from Katydhata Tomb 1.11 (Fig. 14.7), showing a long cylindrical neck, flaring at the rim with a small vertical handle from mid-neck to shoulder, decorated with two applied parallel curves on the body and bearing a strong resemblance to Base Ring. The surface is brick red in color and scratch burnished. Borrowed features from Base Ring and Red Polished often appear on jugs of this type. The majority of these jugs come from tombs and cannot be closely dated, but it seems that they do not occur later than the end of LC II, since I have been unable to identify this fabric in the later levels of Enkomi. Alternatively, this group may be a local variation, with a concentration in northwestern Cyprus.

There is a second category which distinguishes itself from the first, in both its fabric and shapes. There is a particular shape of a jug with a tall flaring neck, ovoid body, flat base and vertical strap handle; examples are Katydhata A1008 (Fig. 14.6: 3) and a jug from Stephania

Tomb 5.32 (Hennessy 1963, pl. XXXV: 32). This particular shape with tall neck, vertical strap handle and flat base occurs more frequently in the LC I-II periods whereas in LC III the most prevalent "Apliki Ware" shape is the jug with short neck, globular body and rounded handle. It is also worth noting that Joan du Plat Taylor includes Katydhata A1008 in her "Apliki A" (Taylor 1952, 159). This ware is made of a reddish brown clay containing black and white inclusions; the fabric is medium hard, the surface reddish brown and carefully treated, the rim is burnished horizontally on both sides, the neck is pared vertically and the body is burnished horizontally to a faint luster. The spouted bowl with ring base from Apliki (Karageorghis 1986, pl. XIV: 1; Taylor 1952, pl. XXVI: 3) may also be included in this category. This fabric continues well into the LC III period, although shapes change and the fabric is less carefully made.

Two juglets characteristic of this ware were published in the above-mentioned paper on Barbarian Ware, one from Akaki-*Trounnali* (Karageorghis 1986, pl. XIV: 2) and a fragmentary one from Apliki (Karageorghis 1986, pl. XIV: 4). The surface is mottled and invariably pared vertically on the neck with horizontal marks often visible on the body; white inclusions are also visible on the surface, which is in many cases pitted. The interior shows unsmoothed ridges of clay and the handle is pierced through the wall of the vase. The characteristic shape in this fabric is the jug with short wide neck, gourd-like body, handle from rim to shoulder, often with a vertical ridge at its center (Fig. 14.6: 4, 5). It seems that this type of fabric appears later than those types which feature decorative elements taken from Base Ring (Fig. 14.6: 1, 2; Fig. 14.7). It is a common fabric at both Apliki and Enkomi Levels IIIA to IIIC, while at Myrtou-*Pigadhes* it occurs from periods III-VII, dated to the LC II-III periods (Catling 1957, 34). Applied decorative features are abandoned by this period, leaving Apliki Ware generally undecorated in the advanced stages of the Late Bronze Age.

A large number of jugs in both categories come from tombs, especially the Katydhata tombs, several of which are included by Åström in his various groups of Coarse Monochrome jugs (*SCE* IV Pt.1C, 106-110). Although the frequency of shapes may vary on particular sites, it seems that the favorite shape for Apliki Ware is the jug, judging from their numbers in the Katydhata tombs and their frequency in the sherd material from Enkomi. At Apliki, bowls are the most frequent among the sherd material, appearing in a diversity of shapes. In the later levels again, at Enkomi Levels IIIA-IIIC, the range of shapes in the sherd material is restricted to various forms of jugs.

An aspect of these wares to be researched further is whether a predominance of a particular shape relates to

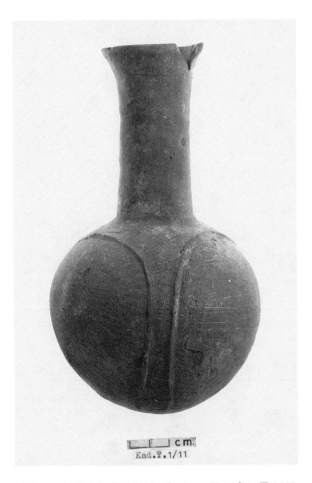

Figure 14.7. "Apliki B" juglet from Katydata T.1/11.

proximity to a production center and whether there is any consistency in the frequency of particular shapes in tombs compared to settlements.

MONOCHROME

The relationship of Apliki Ware to Monochrome should be established; Åström notes that Monochrome is difficult to distinguish from Red Polished V and Coarse Monochrome (*SCE* IV Pt.1C, 90). A number of specimens classified by other authors as Red Polished III or IV (Karageorghis 1965, fig. 23) are included in Åström's Proto-Monochrome and Monochrome (*SCE* IV Pt.1C, 92).

Coarse Monochrome from the site of Kalopsidha is described by Åström (1966, 66) as related to Monochrome but coarser, with thicker walls, made of a hard brick red or gray clay, a matte brown slip and usually a scratch burnished surface.

Benson in his publication of Kourion-*Bamboula* listed several categories of pottery under Monochrome (1972, 75). He noted that "Monochrome" is represented by a wide repertory of shapes but none corresponded with Sjöqvist's types (Sjöqvist 1940, 32, fig. 6). He therefore extended Sjöqvist's classifications of Monochrome Ware type 3 to type 7 in the case of bowls and from type 2 to type 4 for jugs. Benson also noted, referring to the bowls of type 7, that some of the types are not, strictly speaking, Monochrome since they are unslipped and may correspond to Apliki Ware (1972, 75). A type 7 bowl,

B294 (P997), is classified by Åström as Coarse Monochrome (*SCE* IV Pt.1C, 104, type 1b).

A number of jugs described by Benson as having "round, gourd like baseless bodies from which necks rise without articulation, with pinched lips, roll rims and handles from shoulder to rim, of rather coarse fabric and generally burnished without slip" (Benson 1972, 76) are assigned to type 4 and correspond in fabric to bowls of type 7. B306 and B307 under Benson's Monochrome type 4 (Benson 1972, pls. 43, 19) are classified as Coarse Monochrome by Åström (type 2C, *SCE*, 106-107). B303 and B304 (Benson 1972, pl. 19) included under Monochrome type 3 by Benson are also classified as Coarse Monochrome by Åström (*SCE* IV Pt.1C, 106).

It is obvious that a variety of terms is used in the literature to describe Monochrome, Coarse Monochrome and Apliki Wares, and that a large number of specimens are classified as Coarse Monochrome by some and as Monochrome by others. Another question to be resolved is whether there is a Proto-Monochrome fabric, a term introduced by Åström (*SCE* IV Pt.1C) to describe an "intermediate" fabric between Red Polished and the full-fledged Monochrome and whether we need to use such terms in classification systems. A clear definition of each of these fabrics with its characteristic shapes is, therefore, necessary. A reclassification of these wares should eliminate other terms used to denote the same fabric and would necessitate the establishment of the relationship of these wares to Monochrome.

CONCLUSIONS

HBW (Barbarian Ware) should be clearly defined as distinct from other handmade burnished wares occurring in the Late Bronze Age in Cyprus: it differs in both its fabric and shapes, which are foreign to the traditional Cypriot range, and it does not occur earlier than the end of LC IIC in Cyprus. Its affinities lie outside Cyprus in similar wares found in Greece at the end of LH IIIB, Crete and Troy.

An attempt has been made to establish a tentative framework for the handmade burnished pottery within the Cypriot tradition, which may incorporate the fabrics of Monochrome, Coarse Monochrome and Apliki Wares without, I hope, creating any further confusion. Such a proposal is still under study and may be modified or refined in the future, but it will eliminate the diversity of terms which have been used in different ways by different authors—thereby causing confusion.

This pottery can be divided into several groups on the basis of technical features. An attempt has also been made to distinguish particular or frequently occurring shapes in each fabric and to establish their chronological limits. Pamela Russell and I have made a proposal to use the term *Monochrome* to cover all the above-mentioned related wares. It seems there is sufficient evidence to show that the division into Monochrome A, B and C is justified. Fabric A, defined as a hard fine, buff fabric with an orange to red slip seems to have a regional distribution in the northern and eastern parts of the island (Kazaphani, Myrtou-*Stephania*, the Enkomi tombs). Monochrome B, a hard gray fabric with Base Ring affinities but coarser, occurs in small quantities at Enkomi, Apliki and Kalavasos-*Ayios Dhimitrios*. Monochrome C is a gritty reddish fabric with a mottled slip, probably the fabric with the most widespread dis-

tribution on the island. If the first category of Apliki Ware (possibly corresponding with Taylor's Ápliki B), representing a thicker fabric than that of Monochrome A, B and C, usually with a scratch burnished surface and applied ornament, is designated as Monochrome D, and if the second category (corresponding to Taylor's Ápliki A) is designated as Monochrome E, representing a fabric with a later chronological distribution, made of reddish brown clay with a large number of black and white inclusions, fired to a mottled surface, pared or burnished on the outer surface and scratch burnished on the interior, we may be able to define each ware more precisely. Such designations would not necessarily refer to chronological divisions since there is always a chronological overlap between the different wares; a clear definition of each fabric, its chronological distribution, and its characteristic shapes would certainly be of value in the general effort toward a clearer classification system.

REFERENCES

Åström, Paul
1966 *Excavations at Kalopsidha and Ayios Iakovos in Cyprus.* SIMA II. Lund.

Bankoff, H. Arthur & Frederick Winter
1984 Northern Intruders in LH IIIC Greece—A View from the North. *Journal of Indo-European Studies* 2, 1-30.

Benson, Jack L.
1972 *Bamboula at Kourion. The Necropolis and the Finds.* Philadelphia.

Blegen, Carl W., Marion Rawson & John L. Caskey
1958 *Troy* IV, Pt. I. Princeton.

Bouzek, Jan
1969 The Beginning of the PG Pottery and the "Dorian" Ware. *OpAth* IX, 41-57.

Catling, Hector W.
1957 The Bronze Age Pottery. In *Myrtou-Pigadhes: A Late Bronze Age Sanctuary,* by Joan du Plat Taylor, pp. 26-99. Oxford.

Catling, Hector W. & E.A. Catling
1981 Barbarian Pottery from the Mycenaean Settlement at the Menelaion, Sparta. *BSA* 76, 71-82.

Deger-Jalkotzy, Sigrid
1983 Das Problem der "Handmade Burnished Ware" von Mykenischen IIIC. Griechenland, die Ägäis und die Levante während der Dark Ages, vom 12 bis zum 9 J H.V.Chr. In *Acten des Symposions Von Stift Zwettle, Okt 1980,* edited by Sigrid Deger-Jalkotzy, pp. 162-177. Österreichische Akademie der Wissenschaften. Vienna.

French, Elizabeth & Jeremy B. Rutter
1977 The Handmade Burnished Ware of the Late Helladic IIIC. Its Modern Historical Context. *AJA* 81, 111-112.

Furumark, Arne
1965 The excavations at Sinda. Some Historical Results. *OpAth* VI, 99-116.

Hennessy, J. Basil
1963 *Stephania. A Middle and Late Bronze Age Cemetery in Cyprus.* London.

Jones, Richard E.
1986 Chemical Analysis of Barbarian Ware. In *Acts of the International Archaeological Symposion "Cyprus between the Orient and the Occident,"* edited by Vassos Karageorghis, pp. 259-264. Nicosia.

Karageorghis, Vassos
1965 *Nouveaux documents pour l'étude du Bronze Récent à Chypre.* Paris.

1986 Barbarian Ware in Cyprus. In *Acts of the International Archaeological Symposium Cyprus between the Orient and the Occident,* edited by Vassos Karageorghis, pp. 246-262. Nicosia.

Karageorghis, Vassos & Martha Demas
1988 *Excavations at Maa-Palaeokastro 1979-1986.* Nicosia.

Kilian, Klaus
1978 Nordwest Griechische Keramik aus der Argolis und ihre Entsprechungen in der Subapennin facies. In *Atti della XX Riunione Scientifica dell' Instituto di Preistoria e Protohistoria in Basilicata,* pp. 311-320. Florence.

1981 Ausgrabungen in Tiryns 1978, 1979. *AA,* 149-256.

1988 Mycenaeans up to Date, Trends and Changes in Recent Research. In *Problems in Greek Prehistory: Papers Presented at the Centenary Conference of the British School of Archaeology at Athens,* edited by E.B. French and K. Wardle, pp. 115-152. Bristol.

Pålsson-Hallager, Birgitta
1983 A New Social Class in Late Bronze Age Crete: Foreign Traders at Khania. In *Minoan Society, Proceedings of the Cambridge Colloquium,* edited by Olga Krzyszkowska & L. Nixon, pp. 111-119. Bristol.

Popham, Mervyn R. & Elizabeth Milburn
1971 The Late Helladic IIIC Pottery of Xeropolis (Lefkandi)—a Summary. *BSA* 66, 333-352.

Popham, Mervyn R. & L.H. Sackett
1968 *Excavations at Lefkandi 1964-1966, Preliminary Report.* London.

Rutter, Jeremy B.
1975 Ceramic Evidence for Northern Intruders in Southern Greece at the Beginning of the LH IIIC Period. *AJA* 79, 17-32.

1979 The Last Mycenaeans at Corinth. *Hesperia* 48, 348-392.

Schachermeyr, Fritz
1980 *Die Ägäische Frühzeit IV. Griechenland im Zeitalter der Wanderungen—vom Ende der Mykenischen Ära bisauf die Dorier.* Vienna.

Sjöqvist, Erik
1940 *Problems of the Late Cypriote Bronze Age.* Stockholm.

Taylor, Joan du Plat
1952 A Late Bronze Age Settlement at Apliki, Cyprus. *AntJ* 32, 133-163.

Walberg, Gisela
 1976 Northern Intruders in Myc. IIIC? *AJA* 80, 186-187.

Watrous, Livingston V.
 1989 A Preliminary Report on Imported "Italian" Wares from the Late Bronze Age Site of Kommos on Crete. SMEA XXVII, 69-79.

XV

Late Bronze Age Grey Wares in Cyprus

Susan Heuck Allen

Among the gray wares found on Cypriot sites of the second millennium and mentioned in the *SCE* (IV Pt.1D, 700-701) is a gray burnished wheelmade ware, the classification of which has long been problematic (Allen 1990). This Late Bronze Age gray ware has been known by a variety of names, the most common being Grey Minyan which refers to a northwestern Anatolian gray ware constituting the principal fine ware at Troy (Blegen *et al.* 1953, 9; Blegen *et al.* 1958). A lack of homogeneity as well as confusion in character and nomenclature warrants a comprehensive study of this ware to augment preliminary work by D.H. French (1969) and H.-G.Buchholz (1974) (Muhly 1985, 40).

Throughout this century scholars have wrestled with the problem of an appropriate classification of this pottery since inconsistency of nomenclature had obfuscated the study of the ware. Schliemann first called the pottery Lydian (*Lydisch*) because of its close resemblance to Etruscan pottery (1881, 128) and then "typical monochrome grey pottery."[1] Dörpfeld (1902, 16) and Schmidt (1902, viii) designated it Monochrome Grey Ware (*monochromen, meistgrauen Topfware*) and Local Trojan Monochrome Ware (*einheimeschen troisch-monochromen keramik*), respectively.

Wace and Thompson (1912, 251-252) concluded that the northwestern Anatolian Grey Ware was derived or imported from Orchomenos and called it Minyan, a term Schliemann had coined for pottery which he had excavated at the treasury of Minyas at Orchomenos (Forsdyke 1914, 128). Blegen and Caskey continued to characterize the gray ware from Troy as Grey Minyan. Despite a history of gray wares at the site from Troy V onward, they likewise preferred to connect this ware with Middle Helladic gray ware in Greece (Blegen *et al.* 1953, 34). Certain scholars working in Anatolia followed them

in this classification of the ware as Grey Minyan (Mellaart 1955, 61; Driehaus 1957, 81; Mee 1984, 45; Korfmann *et al.* 1984, 176; Korfmann 1988, 51) or "grau (minysche) Ware" (Korfmann *et al.* 1986, 328), while others, following Lamb (1936, 138), have referred to this pottery simply as Grey Ware (Boehlau & Schefold 1942, 21; Bittel 1950, 24, n. 3; Akurgal 1950, 58; Mellaart 1955, 61; Bayne 1963; D.H. French 1969, 70; Korfmann 1986, 23).[2]

In Cyprus, nomenclature is no less confusing. Grey Minyan was adopted in Cyprus by Dikaios who placed "Minyan" in quotation marks (1952, 1572; *Enkomi*, 258, 458, 518), and continued by L. Courtois (1971, 159), Åström (1985a, 175; 1986, 64; *SCE* IV Pt.1C, 408-409; *SCE* IV Pt.1D, 749) and J.-C. Courtois (1973, 146; Courtois & Courtois 1978, 364). Several scholars, loathe to give up the familiar Minyan, combined it with Trojan to distinguish it from the Middle Helladic variety (Catling 1963, 168; Catling 1986, 67; Åström 1980, 26; Åström 1985a, 175), while others place the whole name in quotations to indicate the problem (Yon & Caubet 1985, 156). Karageorghis began calling it Grey Lustrous Wheelmade Ware (Mycenaean) (*Kition* I, 56), then changed to Trojan Grey Polished or simply Trojan Ware (Karageorghis & Demas 1981, 141; *Kition* IV, 1), Anatolian Grey Ware (*Kition* V Pt.1, 268) or Anatolian Grey Polished Ware (Karageorghis & Demas 1981, 6; 1984, 43, 49; Karageorghis 1984, 20; *Kition* V Pt.2, 7). But, since the surface treatment is not polished, but burnished, these, too, are less than accurate. For reasons set forth below, I believe it is best to call this pottery Northwest Anatolian Grey Ware (NW Anatolian Grey Ware).

By means of macroscopic examination, scientific clay analysis,[3] and technological studies, I have been working to define the fabrics and clarify techniques of manufacture and production centers along the west

1. Translated by Döhl (1986, 106) from a letter written by Schliemann to the king of Greece, May 16, 1890 in which he correctly associated it with the painted pottery now well known to him from Mycenae and Tiryns.

2. Mellaart began by calling it Grey Minyan and then suggested that Grey Ware had been misnamed Minyan (1968, 200).

3. I would like to thank Dr. Sarah Vaughan of the Fitch Laboratory of the British School at Athens for conducting the petrographic analysis of samples from Troy. Dr. Elizabeth French kindly volunteered to include the analyses of my grey ware samples as part of the neutron activation analyses being performed at the Radiochemistry Laboratory of the University of Manchester under the auspices of the British Academy Project on Bronze Age Trade.

Anatolian coast, adjacent islands and elsewhere. Numerous questions have emerged. Was all the gray burnished wheelmade pottery found in Late Bronze Age contexts and identified as Anatolian Grey Ware really the same pottery? Where were the production centers? Was it exported, imitated elsewhere, or transported when people or potters migrated?

NW Anatolian Grey Ware is a highly burnished, reduced ware. The paste was fired gray throughout, often with a distinct subsurface layer, probably created by compacting the surface through burnishing. Within a fine-textured matrix are sparse to moderate medium-coarse inclusions, most commonly quartz and mica. Bands of straight and wavy lines, incised or impressed with a point or comb, decorate the vases characteristic of the Troad (Allen 1990, 44). Rims are ornamented with multiple wavy lines (Blegen *et al.* 1953, fig. 313: 37.1038). Handles were attached after incised decoration was completed on the body (Blegen *et al.* 1953, fig. 328: 37.1096). Loop and strap handles carry incised as well as applied decoration in the form of pellets imitating metal rivets (Blegen *et al.* 1953, figs. 313: 37.1038, 327: 37.1039; Blegen *et al.* 1958, fig. 241: 6).[4] Even surface color and luster often suggest metal prototypes. At Troy, nipples, knobs and protomes ornament the surfaces and rims of Grey Ware vessels (Blegen *et al.* 1953, fig. 332: 37.1066), although no such decoration has been found in the eastern Mediterranean where incised ornament is most common. Following decoration and handle attachment, most vessels seem to have been covered with a micaceous self-slip, close in color to the paste and varying from light to dark gray.[5] Others may simply have been burnished, for areas not easily reached by a burnishing tool reveal absence of slip. When leather hard, pots were burnished by hand or on the wheel with a water-worn pebble. The high sheen and "soapy" smoothness may have been achieved by the use of a soft stone, such as serpentine, which leaves a residue behind. Occasionally, vessels may also have been polished or wiped with a soft cloth or leather to remove the burnishing troughs. Surfaces also show flaking of "slip" and spalling or blowing out of calcites.

Grey Ware comes in numerous local Anatolian shapes; the most common are open, such as kraters, bowls, and cups (Figs. 15.1-4). Equally characteristic, however, are jugs, and storage jars, yet Trojan potters also created Mycenaean shapes in Grey Ware—kylikes (Fig. 15.5: A53, A54, A84, A85, A86); cups (Fig. 15.5: A81,

A83, A87); bell kraters (Fig. 15.5: C69); piriform jars (Fig. 15.5: C41); and stirrup jars (Fig. 15.5: D42) (Blegen *et al.* 1953, figs. 292a-295; Blegen *et al.* 1958, figs. 214a-217). Not all shapes are found outside Anatolia and the northeastern Aegean. Specialized shapes, such as the cult stand (Figs. 15.3: D45, 15.4: D45; Blegen *et al.* 1953, fig. 331: 35.610), have never been found outside the Troad. On Cyprus, large kraters are by far the most common forms, and open shapes (kraters, kylikes, bowls) predominate over closed vessels (jugs, amphorae, storage jars, strainers, and juglets) by two-to-one (Allen 1990, 144).

It should be stressed that the distribution of NW Anatolian Grey Ware within Anatolia seems to be limited to the coast with the exception of finds along some river valleys in the northwest (Fig. 15.6). Hence, Troy looked to the Aegean rather than inland and NW Anatolian Grey Ware can be thought of as essentially a provincial Aegean ware.

The distribution of NW Anatolian Grey Ware (Fig. 15.6), when it is found in well-dated contexts abroad, is of great interest to those concerned with trade and migration patterns at the end of the Late Bronze Age in the central and eastern Mediterranean (Wace and Blegen 1939; J.-C. Courtois 1973; Karageorghis 1984; Pålsson-Hallager 1985; E.B. French 1985, 298). It occurs in diminishing quantities in Lesbos (Lamb 1930-1931, 1932a, 1932b, 1936), Chios (Hood 1981, 158-161; Hood 1982, 579-580), Kos (Morricone 1965-1966) and Rhodes (Maiuri 1923-1924) and appears in Cyprus no earlier than the thirteenth century when there is evidence for considerable trade with Mycenaean Greece. Concentrated in the southeast, it comes from six settlement and cemetery sites clustered primarily around Larnaca Bay: Kition, Kition-*Bamboula*, Pyla-*Verghi*, Pyla-*Kokkinokremos*, Hala Sultan Tekke and Enkomi—all within a few kilometers of the sea. Settlements around Larnaca Bay—Kition (Floor IV) (*Kition* V Pt.2, 7) and Pyla-*Kokkinokremos* (Karageorghis & Demas 1984, 50-53)—produced sherds of open and closed gray ware shapes (Fig. 15.7: a, b), in association with Cypriot, "Canaanite," Minoan and Mycenaean wares. Also at Kition Tomb 9 (lower) (*Kition* V Pt.2, 57-60) and Pyla-*Verghi* Tomb 1 (*Enkomi*, 913-918); the vessels were part of an LC IIC assemblage, containing Cypriot, "Canaanite" and Late Mycenaean vases, Pastoral Style kraters, as well as a jug of what appears to be an alternative Mycenaean gray ware.[6] The NW Anatolian Grey

4. Matthäus (1980, 134) has drawn attention to the presence of Minoan-Mycenaean metalwork at Troy in the thirteenth century since the Trojan potters have copied the Aegean method of attaching riveted handles in bronze work on their local Grey Ware basins.

5. S.J. Vaughan has confirmed the presence of slip in her

preliminary petrographic analysis of Grey Ware from Troy (Vaughan 1990, 207-208).

6. Kilian discusses a Mycenaean Grey Ware at Tiryns and calls it Pseudo-Minyan (1988a, 146-148, figs. 25, 26; 1988b, 133, figs. 7, 8).

Ware consists of a shallow bowl or kylix from Kition (*Kition* I, 56) and a magnificent biconical krater from Pyla-*Verghi*, similar to several from Troy, with a Cypro-Minoan sign engraved on the base after firing (Fig. 15.8: a; *Enkomi*, 917, no. 53, pls. 234/4, 298/10).

In the twelfth century, at the beginning of LC IIIA, settlements are destroyed and abandoned or reorganized. At the same time the number of gray ware vessels increases, but contexts are not always clear. There are eleven vases from Hala Sultan Tekke, all LC IIIA in date, biconical kraters (Fig. 15.8: b; Åström 1986, 64), a strainer (Åström 1986, 64; cf. Blegen *et al.* 1958, fig. 242: 3), a large jug (Fig. 15.8: c; Åström 1985b, 668; Åström 1986, 64) comparable to several from Troy (Blegen *et al.* 1953, fig. 386; Blegen *et al.* 1958, fig. 228), and smaller juglets. All the open vessels show typical Trojan incised decoration, but few of the closed shapes have any ornamentation. At Enkomi (Level IIIA) unpublished NW Anatolian Grey Ware kraters are represented by a vertical handle with incised wavy and straight lines (Fig. 15.7: d) and a horizontal loop handle (Fig. 15.7: c), comparable to an example from Troy (Blegen *et al.* 1953, fig. 387).[7]

Remaining material from later levels is quite fragmentary and one cannot be sure whether the sherd, even when it is found on a floor, represents period of use or just a postage stamp from an earlier era, as at Kition-*Bamboula*, where at least four fragmentary open and closed vessels came from a disturbed area, believed to result from looted tombs damaged during leveling operations for later houses around 1200 BC (Yon & Caubet 1985, 42). Of these, the most important consists of sherds from a distinguished large biconical krater with a fragmentary Cypro-Minoan inscription on the rim (Fig. 15.8: d; Yon and Caubet 1985, 156-157, no. 339, figs. 82, 85). String lines and the sheer size of the vessel show that, in addition to being wheelmade, the upper part must have been coil built, as were examples from Troy (Blegen *et al.* 1953, fig. 328: 37.1096).

In Cyprus, NW Anatolian Grey Ware is found with the standard Mycenaean *koine* cargo. Thus, it appears that Troy and other northwest Anatolian centers were part of the wide-ranging trading network of the koine. That only a handful of sherds of NW Anatolian Grey Ware kraters has been identified in central, southern, or western Greece, strongly indicates that the direction of movement lay toward Cyprus and the Levant. Moreover, the area of Cyprus which benefited from this contact

seems restricted to the immediate vicinities of Larnaca Bay and Enkomi. Perhaps the earliest vessels found their way to Cyprus and the Levant as part of a "trickle trade" of locals and Mycenaeans in the northeast Aegean during the thirteenth century or as personal possessions by traders and/or settlers.

The sheer rarity of NW Anatolian Grey Ware abroad might argue for its being a personal possession rather than a commodity for even the most casual trade. There is, however, evidence which might point to Trojans in Cyprus. For example, Trojan Tan Ware has been found for the first time outside Anatolia or Aeolia at the Cypriot site of Enkomi in a twelfth-century context. Yet the combined Trojan wares form an infintesimal fraction of the pottery excavated at Enkomi and other sites of this period.

Prior to this study few scientific analyses had been performed and results had been inconclusive due to the lack of a proper data base (Felts 1942; Jones 1986, 303-304). However, Liliane Courtois, by analyzing thin sections of similar NW Anatolian Grey Ware sherds from excavations in the Levant, characterized the fabric as imported, constituted of volcanic minerals from a rhyolithic massif, for which the closest candidate is on the western coast of Anatolia between Kolophon and Phokaia, near Smyrna (1971, 160). Moreover, I have recently demonstrated that kraters with incised or impressed decoration come almost exclusively from the Troad (Allen 1990). There appears to be no basis for doubting any connection between the finds in the Levant and Cyprus with Troy, but a definitive answer will come only with the results of more extensive petrographic and neutron activation analysis, currently being conducted for this project on a representative sample of sherds by the University of Manchester and the Fitch Laboratory of the British School at Athens.

Local variations of NW Anatolian Grey Ware may exist, but again, one must await results of physico-chemical analysis for a more definitive answer. Visible differences in fabric, manufacture or subtleties of surface treatment on sherds from Kition, Kouklia, Enkomi and Maa may represent imitations with local clay.

In the twelfth century, NW Anatolian Grey Ware continues to reach Cyprus,[8] as evidenced by the restorable finds from Hala Sultan Tekke—and fragmentary remains from Enkomi and Kition—in association with Mycenaean IIIC:1b, a ware frequently connected with

7. The only "Grey Minyan" published from Enkomi is, in fact, Tan Ware from Troy (Fig. 9; *Enkomi*, 258, pl. 68/21; Allen 1989). This material was found associated with Mycenaean, Pastoral Style kraters, and Handmade Burnished Ware (currently being studied by Despo Pilides).

8. Grey Ware also appears to reach Ras Shamra in the early twelfth century (Courtois & Courtois 1978, 364).

Aegean or Sea Peoples. In this period, sites around Larnaca Bay are increasingly fortified, reorganized and reoccupied by persons using Mycenaean IIIC:1b pottery.

In contrast, in Palestinian contexts, there is no reason to assume that NW Anatolian Grey Ware was still being imported after 1200 BC, for nowhere has it been found together with Mycenaean IIIC:1b Ware (Balensi 1980; Gitin & Dothan 1987). Although fragmentary examples occasionally appear in twelfth-century contexts, in Palestine, as in Cyprus, these may be post use.

The maritime association of NW Anatolian Grey Ware is clear from its presence on eastern Aegean islands and Cyprus, as well as its virtual absence in central and southern Anatolia (Allen 1990, 187-188). Perhaps "ships, compelled to bide their time in Beşik Bay, awaiting weather conditions favorable for [travel] through the Dardanelles," took on Trojan cargo, including jugs and jars of Grey Ware (Korfmann 1986, 17). The vases themselves could have been brought as containers (jars), or perhaps as status symbols like the Mycenaean Pictorial Style kraters, as fine items (drinking sets?) valued as booty or as heirlooms. Stemming from casual contacts along the coast of western Anatolia and various ports in the Levant in the thirteenth century, they continue in association with Mycenaean IIIC:1b only in Cyprus, possibly indicating a continuing link with the Aegean intruders, whether through Achaeans, Sea Peoples, or freelance "overseas agents, who are not necessarily Mycenaean Greeks, but who ape the manners of their overseas masters" (E.B. French 1986, 278), or homeless Trojan refugees. The nature of the transmission will become clear only with an emerging understanding of the relationship between the Aegean islands and coastal Anatolia.[9]

According to some recent interpretations, the twelfth-century destructions, abandonments and reorganizations in Cyprus took place slightly later than those in the Aegean, when Mycenae and Tiryns were wracked by earthquakes. The transitional period which followed at Tiryns is evidenced by further upheaval. Muhly characterizes the Cypriot destructions at this time as "a general period of confusion and disorder throughout the eastern Mediterranean [that is today seen as] the work of the Sea Peoples [known from Hittite and Ugaritic texts as well as Egyptian reliefs and inscriptions] but that to the ancient Greeks was seen as the background of the aftermath of the Trojan War and the Achaean colonization of Cyprus" (Muhly 1984, 52).

In the most recent assessment of Trojan chronology and the Trojan War, Bloedow re-examines crucial Mycenaean pottery from levels VIh and VIIa, concluding that Troy VIh was destroyed in the mid-thirteenth century and Troy VIIa in the mid- to late twelfth (Bloedow 1988, 34). He and others now see Troy VIh as the only possible Homeric Troy (Mellink 1986, 96-98; Korfmann 1986). It is during late Troy VI that Troy's contacts with the Mycenaean world were strongest, when its vessels might most likely have been included in Mycenaean cargo of the *koine*. The incised NW Anatolian gray ware appears to be the strongest material link between northwestern Anatolia and Cyprus at the traditional time of the Trojan War (Hankey 1984, 22).

In conclusion, there has been considerable confusion of identification and nomenclature of Late Bronze Age gray wares due to the misattribution of various foreign and local wares to the category of "Grey Minyan" or Anatolian Grey Ware, such as burnt Mycenaean, White Slip, and occasional Base Ring sherds as well as Trojan Tan Ware (Fig. 15.9: a-d; *Enkomi*, 258, pl.68/21: 2892/8), Pseudo-Minyan and *Buckelkeramik* (Fig. 15.9: e; *Kition* V Pt.2, pl. CLVIII: 2350; Allen 1989). However, true NW Anatolian Grey Ware is, for the most part, quite homogeneous, consisting of large ceremonial kraters with combed decoration coming almost exclusively from the Troad, and undecorated jugs. A visual examination of shapes, fabric, technology and decoration suggests that much of the gray ware in thirteenth- and twelfth-century strata from Cyprus has exact comparanda in the Troad and nearby Aeolian islands. Therefore, I suggest that the term *Anatolian Grey Ware* be adopted for this pottery. This new nomenclature should assist in the clarification of northwest Anatolian finds in the eastern Mediterranean and their chronological place in historical reconstructions for the thirteenth and twelfth centuries BC.

Production centers of Northwest Anatolian Grey Ware may have been in Lesbos and the region between Phokaia and Kolophon as well as the Troad (Allen 1990), but confirmation of this must await the results of scientific analysis. The question of trade and/or migration cannot yet be answered, but we have come closer to an understanding of the ware and its place in the interactions of northwest Anatolia in the eastern Mediterranean during the Late Bronze Age.

9. One anticipates new information from M. Korfmann's ongoing excavations at Troy (Latacz 1986, 97-127).

Acknowledgments

The field work would not have been possible without generous support from several sources: a Fulbright predoctoral fellowship for 1988-1989, the Harriet Pomerance Travelling Fellowship (AIA) for 1989-1990, the George S. Barton Fellowship (ASOR) 1988-1989, a travel grant from the Center for Old World Archaeology and Art of Brown University, and a Joukowsky Fellowship for the summer of 1988. I was privileged to be able to carry on my research at the Cyprus American Archaeological Research Institute (CAARI) in Nicosia; the Albright Institute of Archaeological Research (AIAR) and Institute of Archaeology, Hebrew University, Jerusalem; the American Research Institute in Turkey (ARIT), Istanbul; the British Institute of Archaeology at Ankara (BIAA); the American School of Classical Studies at Athens (ASCSA) and the British School at Athens (BSA). I wish to extend special thanks to Dr. Vassos Karageorghis, who as Director of Antiquities of Cyprus supported my work and also to Mr. Michael Loulloupis, Curator of the Cyprus Museum; Dr. Joseph Zias of the Rockefeller Museum; Dr. Yiannis Tzedakis, Minister of Antiquities, Greece; Dr. Alpay Pasinli, Director of the Istanbul Archaeological Museum; and Dr. Adnan Bounni, National Museum, Damascus. To these persons and institutions as well as the excavators who generously permitted me to study and sample their pottery and to the Radiochemistry Laboratory of the University of Manchester and the Fitch Laboratory of the British School at Athens, I owe a debt of gratitude.

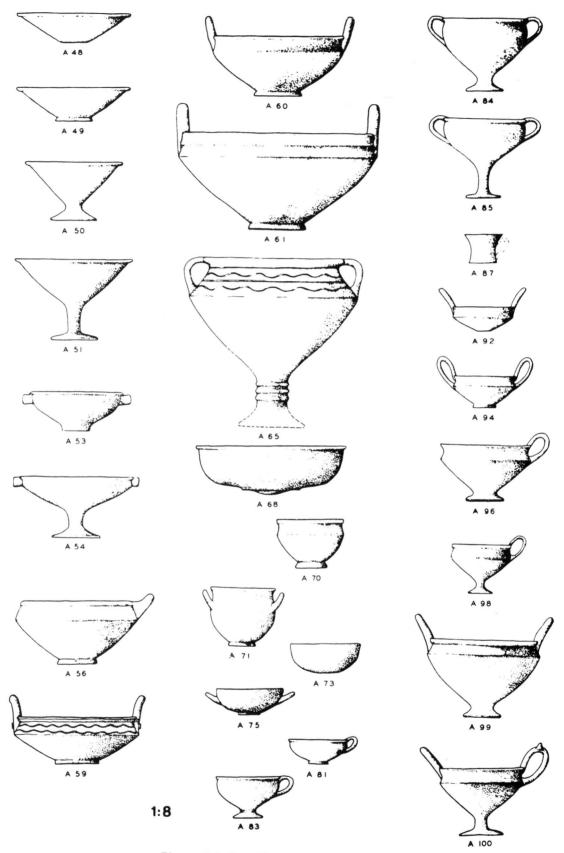

Figure 15.1. Grey Ware from Troy VI Late.

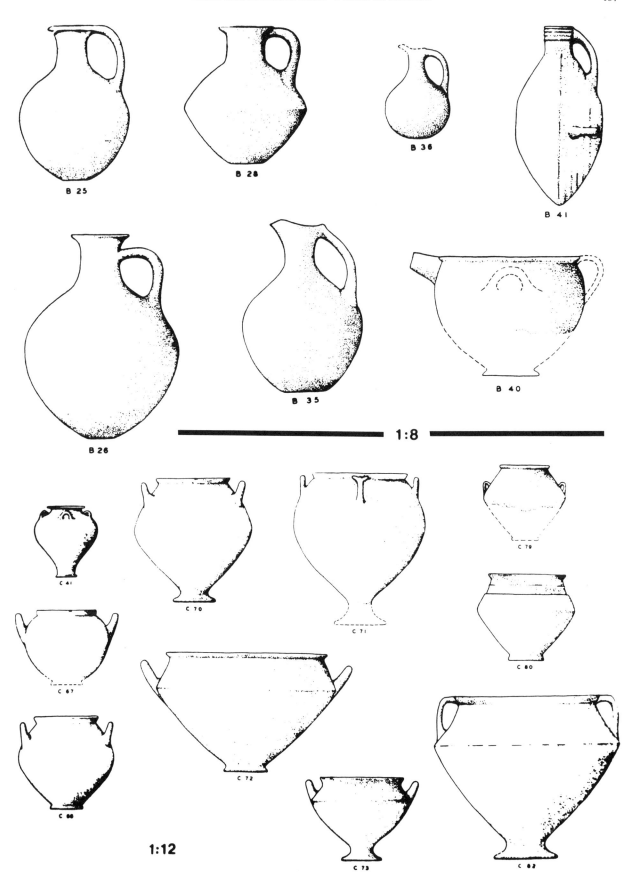

Figure 15.2. Grey Ware from Troy VI Late.

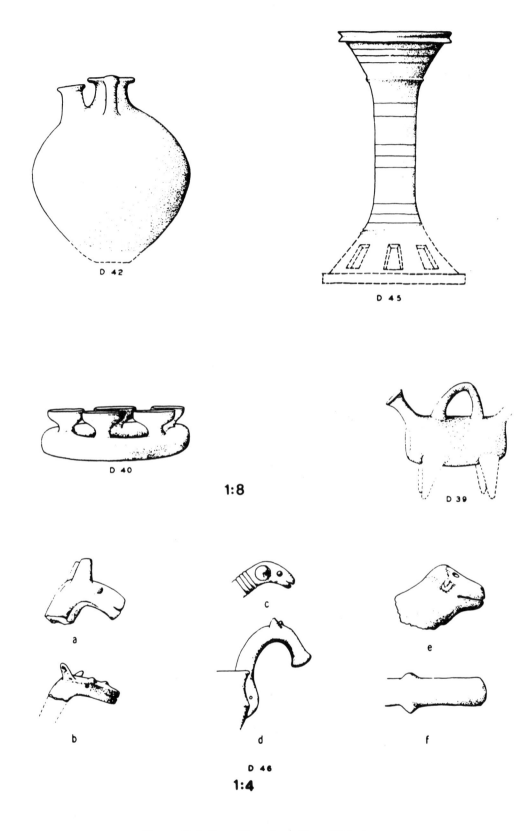

Figure 15.3. Grey Ware from Troy VI Late

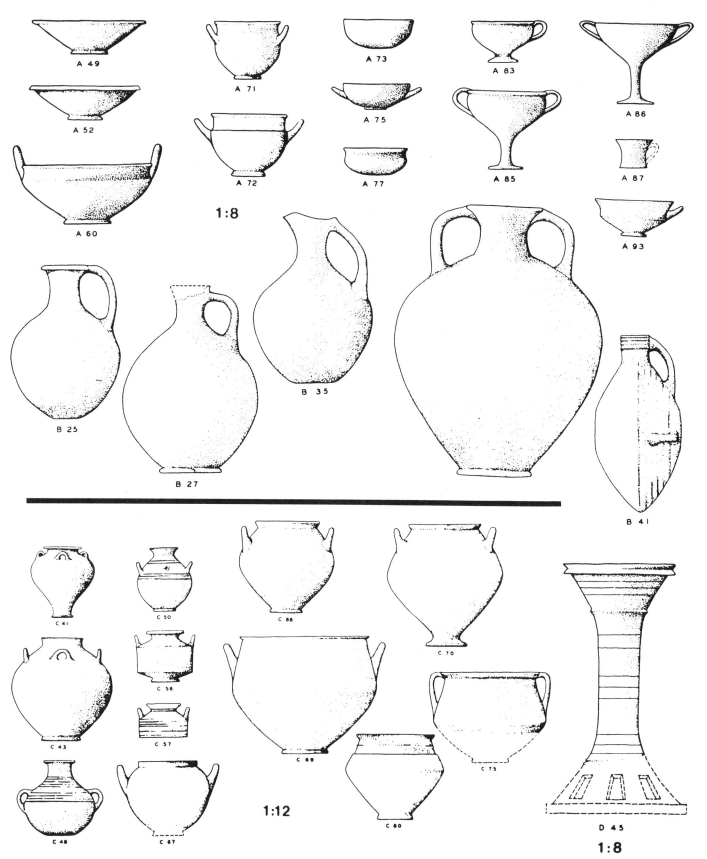

Figure 15.4. Grey Ware from Troy VIIa.

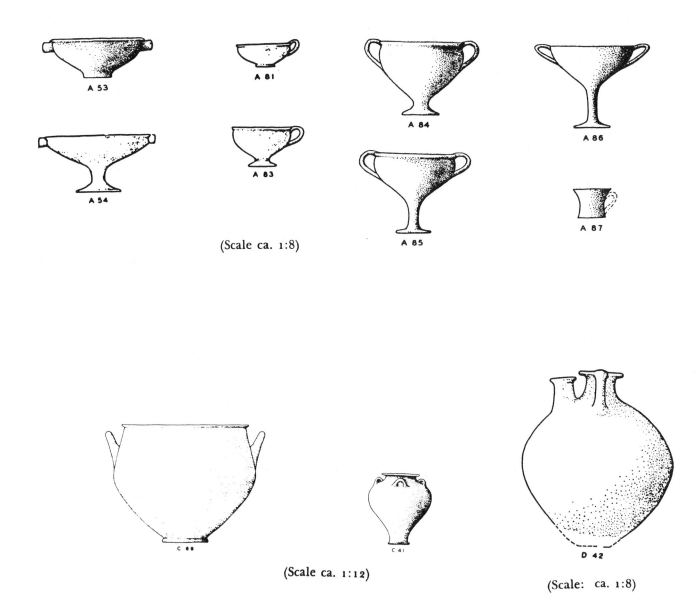

(Scale ca. 1:8)

(Scale ca. 1:12)

(Scale: ca. 1:8)

Figure 15.5. Mycenaean Shapes in Grey Ware.

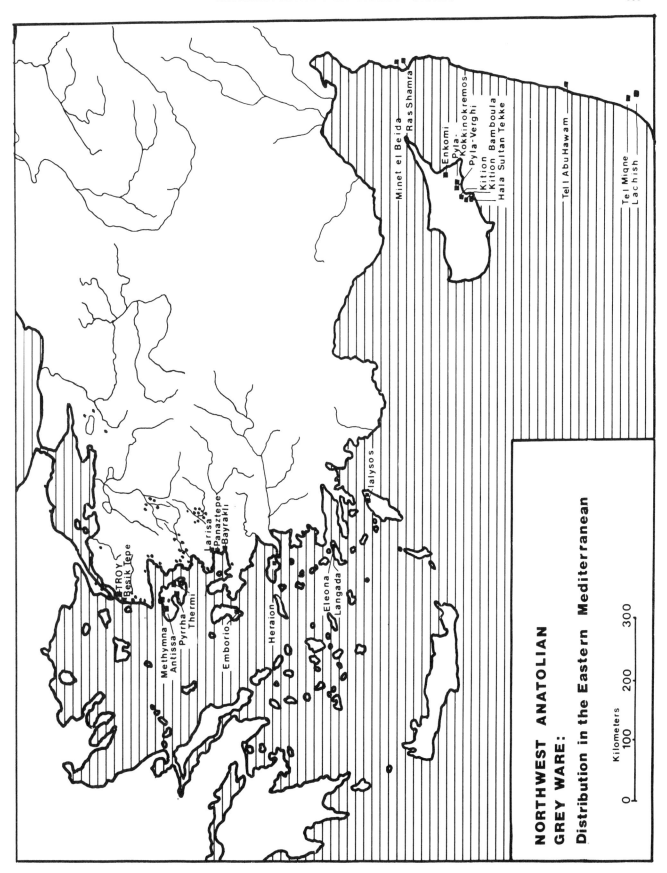

NORTHWEST ANATOLIAN
GREY WARE:
Distribution in the Eastern Mediterranean

Kilometers
0 100 200 300

Figure 15.6. Map showing distribution of Anatolian Grey Ware.

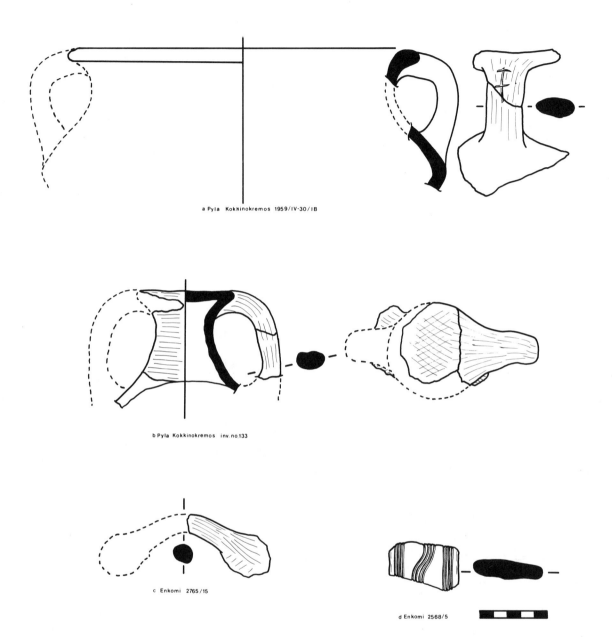

a Pyla Kokkinokremos 1959/IV-30/IB

b Pyla Kokkinokremos inv.no.133

c Enkomi 2765/15

d Enkomi 2568/5

Figure 15.7. Northwest Anatolian Grey Ware in Cyprus.

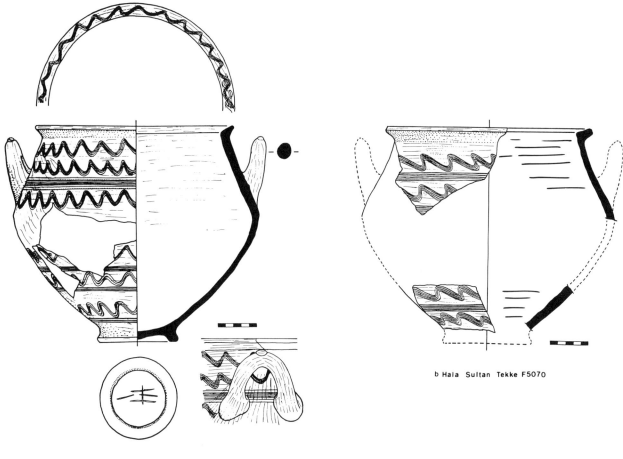

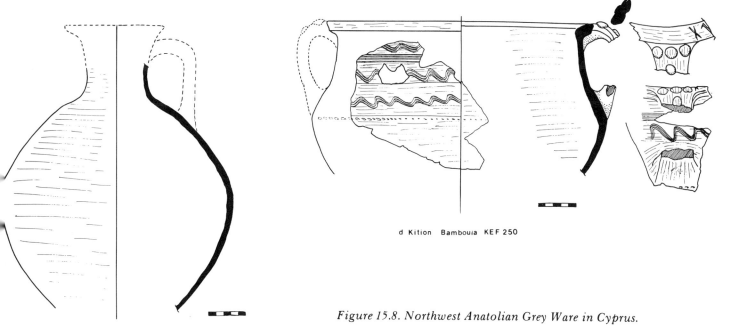

b Hala Sultan Tekke F5070

a Pyla Verghi T.1:53

d Kition Bambouia KEF 250

Figure 15.8. Northwest Anatolian Grey Ware in Cyprus.

c Hala Sultan Tekke HST 83. Bldg. 35

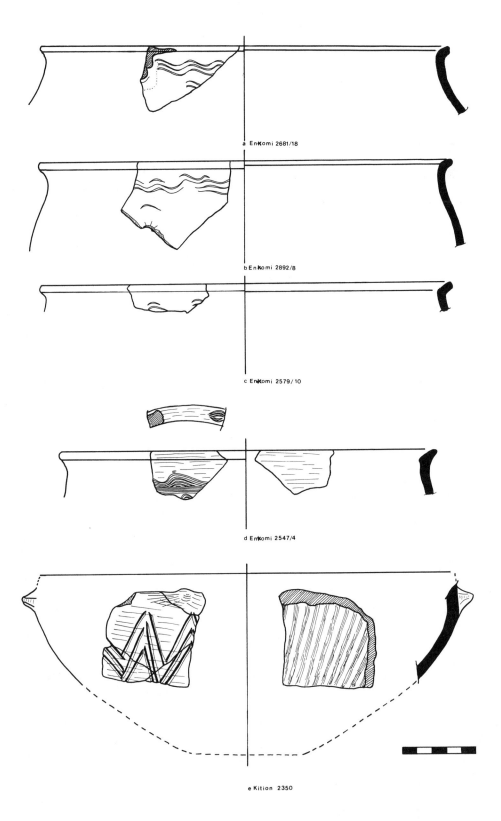

Figure 15.9. *Trojan Ware and* Buckelkeramik *in Cyprus.*

REFERENCES

Akurgal, Ekrem
1950 *Bayrakli: Erster vorläufiger Bericht über die Ausgrabungen in Alt-Smyrna.* Dil Tarih Cografya Fakültesi Dergisi VIII, 2-97.

Allen, Susan Heuck
1989 Rare Trojan Wares in Cyprus. *RDAC*, 83-87.
1990 Northwest Anatolian Grey Wares in the Late Bronze Age: Analysis and Distribution in the Eastern Mediterranean. Ph.D. dissertation, Classics Department, Brown University. Providence, Rhode Island.

Åström, Paul
1980 Cyprus and Troy. *OpAth* XIII.3, 23-28.
1985a Hala Sultan Tekke. In *The Archaeology of Cyprus 1960-85*, edited by Vassos Karageorghis, pp. 173-181. Nicosia.
1985b Review of *Chypre et la Méditerranée orientale au Bronze Récent* by Claude Baurain. *Gnomon* 43, 666-668.
1986 Hala Sultan Tekke and its Foreign Relations. In *Acts 1986*, 64-68.

Balensi, Jacqueline
1980 Les Fouilles de R.W. Hamilton à Tell Abou Hawan. Niveaux IV et V. Ph.D. dissertation, University of Strasbourg.

Bayne, Nicholas P.
1963 The Grey Wares of North-west Anatolia in the Middle and Late Bronze Age and their Relation to the Early Greek Settlement. Ph.D. dissertation, Oxford University.

Bittel, Kurt
1950 Zur ältesten Besiedlungsgeschichte der unteren Kaikos-Ebene. *Kleinasien und Byzanz. Ist Forsch* 17, 10-29.

Blegen, Carl W., John L. Caskey & Marion Rawson
1953 *Troy: The Sixth Settlement.* Vol. III: 1, 2. Princeton.

Blegen, Carl W., John L. Caskey, M. Rawson & Cedric Boulter
1958 *Troy: Settlements VIIA, VIIB, and VIII.* Vol. IV: 1, 2. Princeton.

Bloedow, Edmund F.
1988 The Trojan War and LH IIIC. *PZ* #65, 23-52.

Boehlau Johannes & Karl Schefold
1942 *Larisa am Hermos: Die Ergebnisse der Ausgrabungen 1902-1934.* Band III: Die Kleinfunde. Berlin.

Buchholz, Hans-Gunther
1974 Grey Trojan Ware in Cyprus and North Syria. In *Bronze Age Migrations in the Aegean: Archaeological and Linguistical Problems in Greek Prehistory*, edited by R.A. Crossland & A. Birchall, pp. 179-185. Sheffield.

Catling, Hector W.
1963 Patterns of Settlement in Bronze Age Cyprus. *OpAth* IV, 129-169.
1986 Discussion. In *Acts 1986*, 64-68.

Courtois, Jacques-Claude
1973 Sur divers groupes de vases mycéniens en Méditerranée orientale 1250-1150 avant J.-C. In *Acts 1973*, 137-165.

Courtois, Jacques-Claude & Liliane Courtois
1978 Corpus céramique de Ras Shamra-Ugarit, Niveau historique. Deuxième partie. In *Ugaritica VII*, pp. 191-370. Paris.

Courtois, Liliane
1971 Description physico-chimique de la céramique ancienne: La Céramique de Chypre au Bronze Récent. Ph.D. dissertation, University of Clermont.

Dikaios, Porphyrios
1952 Pyla, Cyprus. Excavations and Discoveries. *FA* 7, 1572.

Döhl, Heinrich
1986 Schliemann the Archaeologist. In *Myth, Scandal, and History*, edited by W.M. Calder III & D. A. Traill, pp. 95-109. Detroit.

Dörpfeld, Wilhelm
1902 *Troja und Ilion.* Athens.

Driehaus, Jürgen
1957 Prähistorische Siedlungsfunde in der unteren Kaikosebene und an dem Golfe von Candarli. *IstMitt* 7, 76-101.

Felts, Wayne
1942 A Petrographic Examination of Potsherds from Ancient Troy. *AJA* 43, 237-244.

Forsdyke, Edgar J.
1914 The Pottery Called Minyan Ware. *JHS* 34, 126-156.

French, David H.
1969 Prehistoric Sites in Northwest Anatolia II. The Balikesir and Akhisar/Manisa Areas. *AnatSt* XIX, 41-98.

French, Elizabeth B.
1985 The Mycenaean Spectrum. *Papers in Italian Archaeology* IV.3, 295-303.
1986 Mycenaean Greece and the Mediterranean in LH III. In *Traffici Micenei nel Mediterraneo: Problemi storici e documentazione ar-*

cheologica. Atti del convegno di Palermo, edited by M. Marazzi, S. Tusa & Lucia Vagnetti, pp. 277-282. Palermo.

Gitin, Seymour & Trude Dothan
1987 The Rise and Fall of Ekron of the Philistines: Recent Excavations at an Urban Border Site. *BA* 12, 197-222.

Hankey, Vronwy
1984 Archaeological Comments on The Trojan War: Its Historicity and Context by A.R. Millard. In *The Trojan War: Its History and Context*, edited by L. Foxhall & J.K. Davis, pp. 17-22. Papers of the First Greenbank Colloquium. Bristol.

Hood, M. Sinclair F.
1981 *Excavations in Chios 1938-1955: Prehistoric Emporio and Ayio Gala* I. BSA Supplement 15. Oxford.

1982 *Excavations in Chios 1938-1955: Prehistoric Emporio and Ayio Gala* II. BSA Supplement 16. Oxford.

Jones, Richard E.
1986 *Greek and Cypriot Pottery: a Review of Scientific Studies.* BSA Occasional Paper 1. Oxford.

Karageorghis, Vassos
1984 New Light on the Late Bronze Age of Cyprus. In *Cyprus at the Close of the Late Bronze Age*, edited by Vassos Karageorghis & J.D. Muhly, pp. 19-22. Nicosia.

Karageorghis, Vassos & Martha Demas
1981 Excavations at Pyla-*Kokkinokremos*, 1981. *RDAC*, 135-141.

1984 *Pyla-Kokkinokremos. A Late 13th Century B.C. Fortified Settlement in Cyprus.* Nicosia.

Kilian, Klaus
1988a Ausgrabungen in Tiryns 1982/1983. *AA*, 105-151.

1988b Mycenaeans Up to Date, Trends and Changes in Recent Research. In *Problems in Greek Prehistory*. Papers presented at the Centenary Conference of the British School at Athens, edited by Elizabeth B. French & K.A. Wardle, pp. 115-152. Manchester.

Korfmann, Manfred
1986 Beşik Tepe: New Evidence for the Trojan Sixth and Seventh Settlements. In *Troy and the Trojan War*, edited by Machteld Mellink, pp. 17-28. Bryn Mawr, Pennsylvania.

1988 Ausgrabungen an der Bucht vor Troia. *Tübinger Blätter*, 47-52.

Korfmann, M., J. Boessneck, V. Dresely & J. Neumann
1986 Vorbericht über die Ausgrabungen von 1984. *AA*, 303-363.

Korfmann, M., G. Hübner, V. Peschlow, A. von den Driesch, J. Boessneck & J. Wahl
1984 Vorbericht über die Ergebnisse der Grabungen von 1982. *AA*, 165-195.

Lamb, Winifred
1930- Antissa. *BSA* 31, 167-178.
1931

1932a Grey Wares from Lesbos. *JHS* 52, 1-12.

1932b Schliemann's Prehistoric Sites in the Troad. *PZ*, 111-131.

1936 *Excavations at Thermi on Lesbos.* Cambridge.

Maiuri, Amedeo
1923- Jalisos. Scavi della Missione Archaeologica
1924 Italiana a Rodi. *ASAtene* VI-VII, 83-341.

Matthäus, H.
1980 *Die Bronzegefässe der kretisch-mykenischen Kultur.* Munich.

Mee, Christopher B.
1984 The Mycenaeans at Troy. In *The Trojan War: Its History and Context*, edited by L. Foxhall & J.K. Davis, pp. 45-56. Papers of the First Greenbank Colloquium. Bristol.

Mellaart, James
1955 Some Prehistoric Sites in North-west Anatolia. *IstMitt* 6, 55-88.

1968 Anatolian Trade with Europe and Anatolian Geography and Cultural Provinces in the Late Bronze Age. *AnatSt* 18, 187-202.

Mellink, Machteld
1986 Postscript. In *Troy and the Trojan War*, edited by Machteld Mellink, pp. 93-101. Bryn Mawr, Pennsylvania.

Morricone, Luigi
1965-66
 Eleona e Langada. Sepolcreti della tarda età del bronzo à Coo. *ASAtene* XLIII-XLIV, 5-312.

Muhly, J.D.
1985 The Late Bronze Age in Cyprus: A Twenty-five Year Retrospect. In *The Archaeology of Cyprus 1960-85*, edited by Vassos Karageorghis, pp. 20-45. Nicosia.

1984 The Role of the Sea Peoples in Cyprus during the Late Cypriot III Period. In *Cyprus at the Close of the Late Bronze Age*, edited by J.D. Muhly & Vassos Karageorghis, pp. 39-56. Nicosia.

Pålsson-Hallager, Birgitta
1985 Crete and Italy in the LBIII Period. *AJA* 89, 293-305.

Schliemann, Heinrich
1881 *Ilios: The City and Country of the Trojans.* Berlin.

1958 *Briefwechsel aus dem Nachlass in Auswahl herausgegeben: Band 1876-1890*, edited by E. Meyer. Berlin.

Schmidt, Hubert
1902 *Heinrich Schliemann's Sammlung Troianischer Altertümer*. Berlin.

Vaughan, Sarah J.
1990 Preliminary Petrographic Analysis of Grey Ware from Troy. In Northwest Anatolian Grey Wares in the Late Bronze Age: Analysis and Distribution in the Eastern Mediterranean, by Susan Heuck Allen, pp. 207-208. Ph.D. dissertation, Classics Department, Brown University. Providence, Rhode Island.

Wace, A.J.B. & Carl W. Blegen
1939 Pottery as Evidence for Trade and Colonization in the Aegean Bronze Age. *Klio* 32, 131-147.

Wace, A.J.B. & M.S. Thompson
1912 *Prehistoric Thessaly*. Cambridge.

Yon, Marguerite & Annie Caubet
1985 Le Sondage L-N 13. Bronze Récent et Géometrique I. *Kition-Bamboula III*. Mémoire 56. Paris.

Cypriot Bronze Age Pottery and the Aegean

Gerald Cadogan

Aegean Bronze Age pottery seems to have had very little influence on Cypriot pottery production until Late Cypriot IIC:2 in the middle of the thirteenth century BC.[1] In LC IIC:2 it is the appearance of locally made Mycenaean-style shallow bowls and Pastoral—or Rude—Style pots, mostly kraters, that marks the changes. In LC IIIA the deep bowl joined the local Mycenaean-style production, and Cypriot table settings began to look different. (For discussion of the complicated problems in this sequence see most recently Karageorghis & Demas 1988, 255-266; Kling 1989a; 1989b; Cadogan forthcoming.) Any evidence for Aegean influences on Cypriot production before LC IIC:2, or lack of them, could help to clarify our understanding both of the Aegean trade with Cyprus and of how the Hellenizing of Cyprus happened. However, the evidence for influence before *ca.* 1250 BC is exiguous. It may be summarized quickly.

EARLY CYPRIOT-LATE CYPRIOT IIC:1

The four duck vases in Red Polished and Black Polished wares from Lapithos-*Vrysi tou Barba* and Nicosia-*Ayia Paraskevi* and, possibly, Dhenia are an odd group but nevertheless a definite link with the Early Bronze III Aegean (Merrillees 1979). Rutter (1985) discusses the type fully and, in view of the duck vases exported to western Anatolia, suggests that the Cypriot connection was from that direction rather than straight from the Cyclades (Rutter 1985, 38, fig. 3). The Cypriot potters must have seen imported duck vases, whatever their origin, to have copied the shape. In their customary way they gave the versions they made round bottoms rather than the canonical flat bases. The mouths also are different (Rutter 1985, 16, 21, n. 4, 22, n. 6).

In Middle Cypriot and earliest Late Cypriot it is impossible at present to find any certain Cretan or other Aegean influences in Cypriot pottery, although the kinship of the earliest Cypro-Minoan script to Linear A points to closer links than the scanty number of Cretan imports suggests (Cadogan 1979, 65). It is tempting to see the hemispherical bowls with accentuated or everted rims in Monochrome (as we find at Maroni), White Painted V, Red Slip, Proto Base Ring and Red Polished IV (such as Karageorghis 1965, 24, fig. 7: 71, 7: 76, 35, 37; *SCE* IV Pt.1B, 66-68, fig. XVI: 1-8, 79, fig. XIX: 8, 85, fig. XXI: 6; *SCE* IV Pt.1C, 133, fig. 36), as having been influenced by the Minoan hemispherical cups (such as Betancourt 1985, 74, fig. 48, 92, fig. 65, 106, fig. 77), but handle and base on the Cypriot bowls are quite un-Minoan. This suggests nothing more than a general similarity of shape and, presumably, function.

In Late Cypriot the story is the same, despite the steady increase in imports of Aegean pottery. These imports stand out as such (including virtually all the so-called Cypro-Mycenaean or Levanto-Helladic repertoire), and in general had no effect on the manufacture of Base Ring, White Slip and other Cypriot wares. The Cypriot potters stayed steadfast to their own inherited tradition, except for a few instances whose main characteristic is their rarity. These are:

(1) Piriform (or pithoid or three-handled) jars. Several of these in Cyprus have a quasi-Mycenaean fabric and finish, which suggests that they are not imports from the Aegean, and certainly not from the Argolid. It may be that they come from an Aegean source or sources that are still to be identified but, as there are also a few examples in Base Ring and White Painted VI wares (*SCE* IV Pt.1C, 55, 142, fig. LI: 4, 180, fig. LIII: 8-9; Åström 1989, 18-19, 59, figs. 25, 188, 189) it is more likely that they were made in Cyprus (*SCE* IV Pt. 1D, 772-773) as cheaper versions of the more valuable imports for poorer people (Åström

1. Or perhaps a little later in the century, following French and Åström (1980) whose synchronisms take the end of LC IIC into LH IIIC; Warren and Hankey (1989, 169) give no separate absolute dates for LH IIIB:2, with which LC IIC:2 is generally thought to be contemporary on the basis that this phase saw the appearance, and the peak in popularity, of decorated Mycenaean shallow bowls (discussions: Verdelis 1965; Mountjoy 1986, 132-133, fig. 164), although there are examples from LH IIIB1 destruction deposits at Mycenae, discussed by French (1967, 156-157), as Dr. Sherratt has kindly pointed out to me.

1989, 59). A traveling potter from the Aegean making quasi-Mycenaean examples in Cyprus is a possibility (Åström 1973, 126-127), but unlikely in view of the examples of the shape in traditional local fabrics.

The Cypriot examples cluster as equivalents of LH IIIA. Both the imported piriform jars and the probable local group come from tombs, and the imitations seem to have begun soon after the imports started to arrive around 1400 BC. This suggests that the new shape had a considerable impact in Cyprus, which is probably to be related to the pots' functions (what they held).

(2) Straight-sided (or square) alabastra are a similar story. A few examples dating from around 1400 are known in Base Ring (SCE IV Pt.1C, 142-143, fig. LI: 5, 181; Karageorghis 1965, 114-115, fig. 32: 19, 120) and White Slip II (and/or White Painted VI) (SCE IV Pt.1C, 55 [White Painted] 471, fig. LXXXVI.1 [White Slip]). (3) Similarly, Karageorghis suggested (1965, 115-116, fig. 32:31, 32:36, 120) that Base Ring juglets from Akhera imitate the LH III (B) shape.

(4) The amphoroid krater was adopted into the Cypriot repertoire in Plain White Wheelmade in LC IIB (Kling 1989b, 167).

(5) Some Mycenaean motifs such as joining semicircles (FM 42[2]) and the rosette (FM 27) were used by the White Slip potters (SCE IV Pt.1C, 434, fig. 46g: 6; Benson 1972, pl. 41: 2 [reference kindly supplied by Dr. Sherratt]), but it is not certain that they used these motifs before LC IIC:2, the joining semicircles also appearing on a Mycenaean-style shallow bowl at Toumba tou Skourou (Vermeule 1974, fig. 26) and the rosette, though known earlier, being a feature of one group of deep bowls in Greece in LH IIIB:2 (Mountjoy 1986, 131, fig. 162).

(6) I should mention also a small number of pots that have been described as Cypro-Mycenaean, with the implication that they were made in Cyprus, on grounds only of fabric and finish, and not because of their having a shape rare in Greece. Examples are a cup and juglet from Katydhata (Åström 1989, 59).

This list of influences, some of which perhaps belong anyway to the period after LC IIC:1, is paltry. It looks all the more paltry when we contrast it with the enormous amount of Cypriot pottery that does not show Aegean influence, and also with the large numbers of LH IIIA and IIIB pots in a wide range of shapes that were imported into Cyprus. We may conclude that the influence of the Aegean on Cypriot pottery production in the period EC I-LC IIC:1 was minuscule. Likewise, the influence of Cyprus on Aegean production was similarly limited. Mycenaean potters may have copied the Base Ring bowl shape (Karageorghis 1965, 204-207, fig. 48: 1-2, pls. XV: 3-6, XVI: 5-6; SCE IV Pt.1C, 363; SCE IV Pt.1D, 772) if, that is, they were not reproducing a Mycenaean bronze shape in clay, as Catling suggests (1986, 599). There is little more, probably nothing at all.

LATE CYPRIOT IIC:2-III

The appearance of Mycenaean-style shallow bowls that had been made in Cyprus at the same time as their imported LH IIIB:2 counterparts (FS 295/296), and the simultaneous appearance of the local version of the Mycenaean Pictorial Style, the Pastoral (or Rude) Style whose shapes include the deep bowl krater (FS 281), known in Greece from LH IIIB:1 (Mountjoy 1986, 115-116, fig. 142) and appearing in the Cypriot Mycenaean-style repertoire before the deep bowl itself, mark the start of a great change in Cypriot pottery production and use. A remarkable group of these bowls, both imported and local, with other pots (including Base Ring and White Slip bowls, but not any Mycenaean-style deep bowls) in Area 173 in Kalavasos-Ayios Dhimitrios Building X (South 1988) is an important deposit to compare with the West Wall deposit of Tiryns (Verdelis 1965).

Another Mycenaean shape to appear in LC II:C is the pedestalled shallow bowl (FS 310). It is rare. There is an example in White Slip, from Yeroskipos (Karageorghis 1973, 618-619, fig. 34; Maier & Karageorghis 1984, 104, 107, fig. 94); and it occurs in Plain White Wheelmade in Akhera Tomb 3 (Karageorghis 1965, 122, 127, fig. 36: 6, 134, 138 [assigning the tomb to the beginning of LC IIC]) and at Ras Shamra (Schaeffer 1949, 268-269, fig. 115: 15).

Its appearance in Plain White Wheelmade raises the question of whether the Mycenaean shallow bowl shape might not have, in part or in whole, a Cypriot or Syrian or Cypro-Syrian origin. The reason for suggesting this is that the Mycenaean shallow bowl, especially in its angular variety, may easily be related to the Plain White Wheelmade shallow bowl that had been in use for some time (Kling 1989b, 162-164, fig. 20: 1.b; SCE IV Pt.1C, 232-237, figs. LIX-LXII [and 252-253, fig. LXX]), and that in turn to the Base Ring bowl, suggesting that the Plain White Wheelmade and/or the Base Ring shapes may have led to the Mycenaean. As Dr. Kling points out, Stubbings was the first to make this suggestion (1951, 40, n. 2). The main differences are the change from a single horizontal lug-handle at the rim to a pair of horizontal handles and, of course, the painted decoration. But it is difficult to prove this origin, and there is a danger of chicken-and-egg arguing. What is reasonable is to as-

2. FM and FS numbers refer to Furumark motif and shape numbers respectively (Furumark 1941).

sume that when the Mycenaean shallow bowl reached Cyprus, and potters began to make it in Cyprus, the concept of such a bowl was already known in Cyprus. That it was not known in Greece before LH IIIB:1 (and hardly then) is a reason for allowing for an initial external source such as Cyprus and/or Syria.

If the Mycenaean shallow bowl did originate in the Plain White Wheelmade tradition, that would underscore the fundamental unity in fabric and shape of the painted Mycenaean-style shallow bowls with the Plain White shallow bowls. It is a help to see them as painted and plain versions of shapes that are closely similar, if not identical, as Dr. Kling and Dr. Sherratt point out in this volume. Dr. Karageorghis's suggestions of Painted Wheelmade for shapes such as these bowls sums up this position neatly (Karageorghis & Demas 1988, 216).

CONCLUSIONS

Such a little influence from the Aegean until the last phase of LC II is valuable evidence for the history of Cyprus. When nowadays we stress the continuity from LC IIC into LC IIIA, as more and cultural traits that used to be thought of LC IIIA date are found appearing already in LC IIC, the history of Mycenaean influence fits the new pattern well. The Mycenaean element in Cypriot pottery production, which had barely existed except for the (rare) copies of two LH IIIA shapes, grew fast from LC IIC:2 and continued growing in LC IIIA (notably with the appearance of the deep bowl), while the traditional Cypriot element started to decline and continued to do so in LC IIIA.

This means that from LC IIC:2, probably, and from LC IIIA, definitely, the Mycenaean element was something unmistakably new in the culture of Cyprus, and quite different from the pattern of the previous 150-200

years. We cannot tell who the potters in the Mycenaean style were in LC IIC:2 and LC IIIA: Mycenaean potters may have come from Greece in either period, or both, or they may have been Cypriot potters adapting to new demands. We can say, however, that this is the sort of evidence that is used in other periods in the Mediterranean to show the arrival of at least a few newcomers bringing their own customary needs and demands with them. In short, this is excellent—and at present the only—evidence that some Mycenaeans came to settle at least from LC IIIA, and probably from LC IIC. Their number may even have included a few potters who on reaching Cyprus set about meeting the demands for familiar Mycenaean pottery.

We may compare Thera and other Aegean islands in Late Cycladic I, when there would seem to have been a definite intent to produce Minoan-style pottery (and household utensils) that would be reasonably familiar to Minoan settlers (of rank and number unknown). Another parallel would be the Euboean colony on Ischia (Pithekoussai), where the clear aim of the newcomers was to have pottery made for them that was indistinguishable from the pottery brought or sent from home in Euboea. The Ischian potters were so successful at producing Euboean Geometric that today clay analysis is necessary to separate their Ischian Euboean Geometric from Euboean Geometric (Jones 1986, 673-680). That is precisely the result they intended. The same holds in Cyprus, and is worth remembering if we are downcast when trying to sort a table of shallow bowl sherds into those we think made in Greece and those made in Cyprus. The transition from virtually no influence from the Aegean on Cypriot pottery making to such a strong—and growing—influence is a watershed in the history of the island. It is when Cyprus began to become Greek.

REFERENCES

Åström, Paul
 1973 Comments on the Corpus of Mycenaean Pottery in Cyprus. In *Acts* 1973, 122-127.

 1989 *Katydhata. A Bronze Age Site in Cyprus.* SIMA LXXXVI. Göteborg.

Benson, Jack L.
 1972 *Bamboula at Kourion. The Necropolis and the Finds.* Philadelphia.

Betancourt, Philip P.
 1985 *The History of Minoan Pottery.* Princeton.

Cadogan, Gerald
 1979 Cyprus and Crete c. 2000-1400 B.C. In *Acts* 1979, 63-68.

 forthcoming
 Cyprus, Mycenaean Pottery, Trade and Colonisation. In *Wace and Blegen: Pottery as Evidence for Trade in the Aegean Bronze Age: 1939-1989*, edited by Carol W. Zerner. *Hesperia*.

Catling, Hector W.
 1986 Archaeological Comment. In *Greek and Cypriot Pottery. A Review of Scientific Studies*, by Richard E. Jones, pp. 574-613. Athens.

French, Elizabeth
 1967 Pottery from Late Helladic IIIB 1 Destruction Contexts at Mycenae. *BSA* 62, 149-193.

French, Elizabeth & Paul Åström
 1980 A Colloquium on Late Cypriote III Sites. *RDAC*, 267-269.

Furumark, Arne
 1941 *The Mycenaean Pottery. Analysis and Classification.* Stockholm.

Jones, Richard E.
 1986 *Greek and Cypriot Pottery. A Review of Scientific Studies.* Athens.

Karageorghis, Vassos
 1965 *Nouveaux documents pour l'étude du Bronze Récent à Chypre.* Paris.

 1973 Chronique des fouilles à Chypre en 1972. *BCH* 97, 601-689.

Karageorghis, Vassos & Martha Demas
 1988 *Excavations at Maa-*Palaeokastro *1979-1986.* Nicosia.

Kling, Barbara
 1989a *Mycenaean IIIC:1b and Related Pottery in Cyprus.* SIMA LXXXVII. Göteborg.

 1989b Local Cypriot Features in the Ceramics of the Late Cypriot IIIA period. In *Early Society in Cyprus*, edited by Edgar J. Peltenburg, pp. 160-170. Edinburgh.

Maier, Franz-Georg & Vassos Karageorghis
 1984 *Paphos. History and Archaeology.* Nicosia.

Merrillees, Robert S.
 1979 Cyprus, the Cyclades and Crete in the Early to Middle Bronze Ages. In *Acts* 1979, 8-55.

Mountjoy, Penelope Anne
 1986 *Mycenaean Decorated Pottery: A Guide to Identification. SIMA* LXXIII. Göteborg.

Rutter, Jeremy B.
 1985 An Exercise in Form vs. Function: The Significance of the Duck Vase. In *Temple University Aegean Symposium* 10, edited by Philip P. Betancourt, pp. 16-41. Philadelphia.

Schaeffer, Claude F.A.
 1949 *Ugaritica* II. Paris.

South, Alison K.
 1988 Kalavasos-*Ayios Dhimitrios* 1987: An Important Ceramic Group from Building X. *RDAC*, 223-228.

Stubbings, Frank H.
 1951 *Mycenaean Pottery from the Levant.* Cambridge.

Verdelis, Nikolaos
 1965 Tiryns. Mykinaïki epichosis exothen tou dytikou teichous tis akropoleos. *ArchDelt* 20.1, 137-153.

Vermeule, Emily T.
 1974 *Toumba tou Skourou. The Mound of Darkness.* Boston.

Warren, Peter & Vronwy Hankey
 1989 *Aegean Bronze Age Chronology.* Bristol.

LC IIC to LC IIIA without Intruders: The Case of Alassa-*Pano Mandilaris*

Sophocles Hadjisavvas

A first preliminary report on the excavations at Alassa-*Pano Mandilaris* appeared in 1986 (Hadjisavvas 1986), and some religious and socio-economic aspects of this Late Bronze Age community were discussed last year in Edinburgh (Hadjisavvas 1989). In this paper, I will touch upon the problem of chronology and the critical transition from LC IIC to LC IIIA.

This long-standing problem has been discussed many times in relation to major excavation projects, as well as in connection with historical sources or literary traditions (Karageorghis & Demas 1984, 66-75). Surveys on this subject have recently seen the light of publication (e.g., Kling 1987). It is not my intention to survey this problem again, nor is it my intention to solve it. However, I hope that a presentation of material from Alassa and a recognition of the peculiarities of the site will contribute to a better understanding of this transition in general.

Contrary to other contemporary settlements, Alassa preserves no traces of violent destruction, abandonment or reoccupation. The site was continuously inhabited from LC IB to LC IIIA. Although there is evidence for repair and expansion of the buildings, all floors belong to the final phase of occupation. Evidence for the earlier habitation of the site derives from closed deposits sealed under the floors as well as from the excavation of tombs situated within the settlement.

On the basis of the quantitative analysis used by the Swedish Cyprus Expedition (*SCE* IV Pt.1C, 700-701 table) of material excavated both in tombs and in the settlement, a long chronological sequence has been established at the site (Table 17.1). The earliest evidence is from Tomb 5, which yielded Base Ring I and White Slip I along with imported Red Lustrous Wheelmade ware. The tomb is roughly circular in plan with a beehive section and without the characteristic trench sunk in the middle. The latter is a feature of all the remaining tombs at Alassa. The finds and the architecture indicate a date not later than LC IB.

Tomb 4 could not be dated later than the LC IIB period, given the presence of two Red Lustrous Wheelmade bottles along with White Slip II and Base Ring II vessels.

Tomb 7 produced Base Ring II, a White Painted Wheelmade III imitation of a Mycenaean pyxis in bichrome technique, and a Plain White Wheelmade stemmed bowl; all justify a LC IIC date.

Tomb 8 could also be dated to LC IIC, as Base Ring II material was found along with sherds of White Painted Wheelmade III ware.

Tomb 6 yielded two Mycenaean stirrup jars and the best example of a White Painted Wheelmade III thelastron, or spouted jug, ever found on the Island (Hadjisavvas 1986, pl. XVIII.7). The three remaining vessels are jugs of Handmade Bucchero ware. One of the stirrup jars is Mycenaean IIIB, while the second could be classified as Mycenaean IIIC. The spouted jug appears to be an exceptional piece, its fabric being comparable to Mycenaean. This tomb can be dated to the latter part of the LC IIC period.

Tomb 3 was the richest of all, with 93 grave goods, including gold jewelry, bronzes and a hematite cylinder seal, along with a considerable number of stone objects. For present purposes, only the pottery will be discussed. Thirty-two of the fifty-seven vessels found in Tomb 3, representing more than 50% of the pottery, are White Painted Wheelmade III. Seven are Plain White Wheelmade II; eleven are Handmade and Wheelmade Bucchero; four are Coarse ware; one is Mycenaean IIIC Monochrome; and one is Red Slip. A single Base Ring II bowl was found at the bottom of the tomb within the oblong rectangular basin sunk into the middle of the chamber with some bones which represent an earlier burial. A strainer-jug decorated with running spirals on the shoulder is without parallel (Figs. 17.1, 2). As was the case with the spouted jug of Tomb 6, the fabric of this jug is of exceptionally good quality and does not conform to the standard fabric of White Painted Wheelmade

	DATE	TOTAL	Miscellaneous	Gold	Bronze	Stone	Bone	Coarse Ware	Mycenaean IIIC Monochrome	Mycenaean III C	Mycenaean III B	Red Slip	Black Slip	Plain White Wheelmade II	White Painted Wheelmade III	Bucchero	Plain White I	Monochrome	Red Lustrous Wheelmade	White Slip II	White Slip I	Base Ring II	Base Ring I
Tomb 1	LCIII A	32	2		1	10	1							1	17								
Tomb 2	LCIII A	18		1	1	4					1			4	5	2							
Tomb 3	LCIII A Early	93	3	5	9	14	3	4	1			1	1	7	32	11		1				1	
Tomb 4	LCII B	8															2		2	2	1	2	
Tomb 5	LCI B	4			1														1				1
Tomb 6	LCII C Late	6								1	1				1	3							
Tomb 7	LCII C	6			1			1						1	1							2	
Tomb 8	LCII C	17					1 (15)								sherds							2	

Table 17.1. Table showing ceramic distribution of tomb pottery at Alassa-Pano Mandilaris.

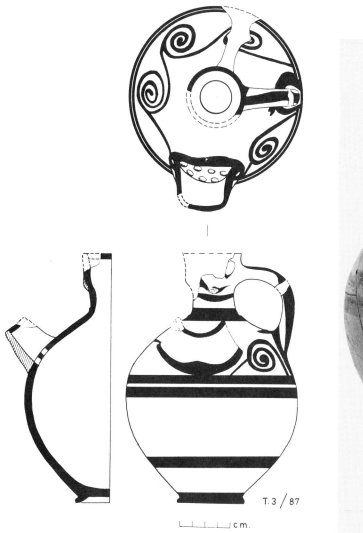

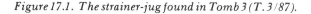

Figure 17.1. The strainer-jug found in Tomb 3 (T.3/87).

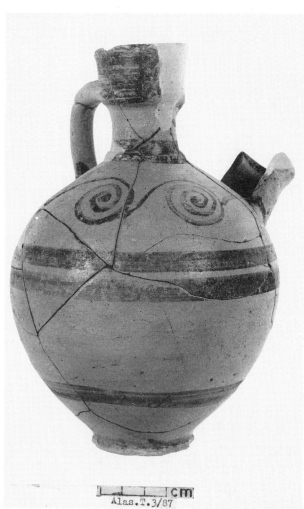

Figure 17.2. The strainer-jug found in Tomb 3 (T.3/87).

III ware. On the basis of quantitative analysis, we can date this tomb to LC IIIA.

Tomb 2, with its unique architecture (Hadjisavvas 1986, pl. XVIII.1), produced eighteen items. The pottery represents two-thirds of the finds. Five of the twelve ceramic vessels are White Painted Wheelmade III; four are Plain White Wheelmade II; two are Wheelmade Bucchero; and one is Mycenaean IIIB. The fabric of two of the White Painted bowls is similar to that of the strainer jug from Tomb 3 and the spouted jug from Tomb 6. The remaining bowls are of the standard soft, gritty fabric. The presence of Wheelmade Bucchero ware justifies a

LC IIIA date. A large proportion of the finds (more than 20%) are of stone.

Finally, Tomb 1 was furnished with 32 grave goods. Seventeen of eighteen pottery items are White Painted Wheelmade III ware, all of the standard type. The remaining one is an imitation of a Base Ring bowl in Plain White ware. One of the bowls, T.1/30, has a potmark on its base. Stone items represent 33% of the offerings. Tomb 1 dates to the LC IIIA period.

The earliest evidence from the habitation area comes from Locus 004, an irregular opening in the rock to the west of Room P (Fig. 17.3, grid reference B-9). This

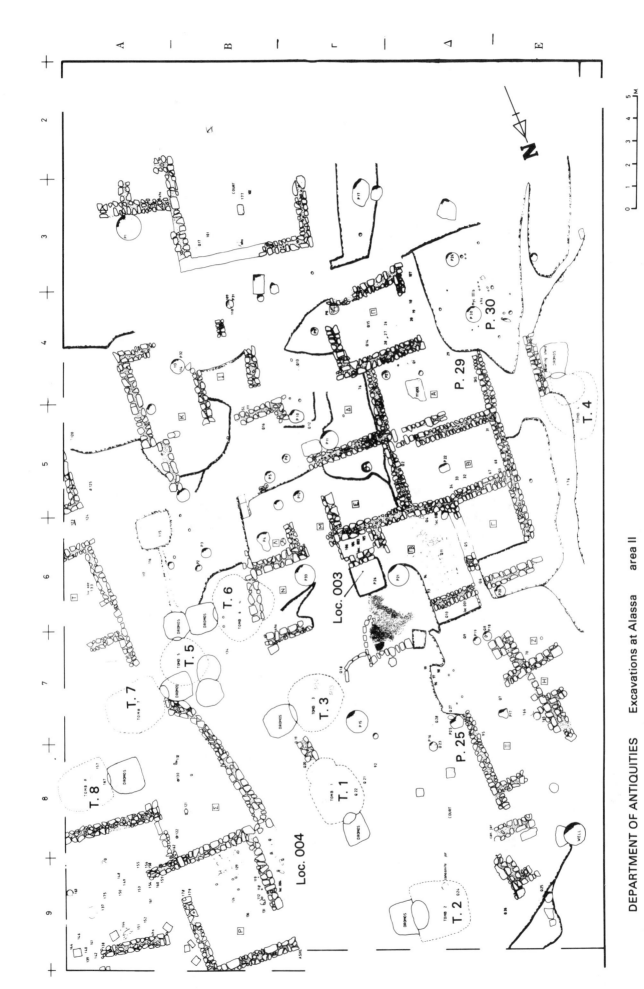

DEPARTMENT OF ANTIQUITIES Excavations at Alassa area II

Figure 17.3. Plan of the excavated remains at Alassa-Pano Mandilaris.

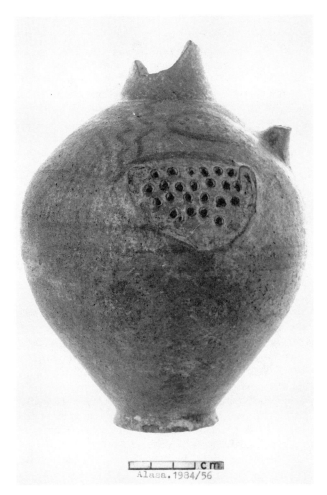

Figure 17.4. The strainer-jug (no. 56) found in the semi-apsidal structure at Alassa-Pano Mandilaris.

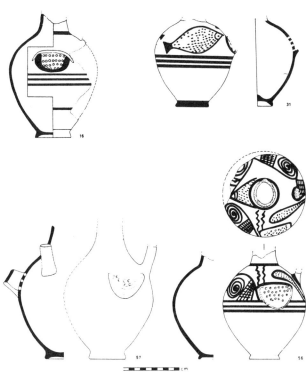

Figure 17.5. Strainer-jugs found on floors at Alassa-Pano Mandilaris: no. 16 (upper left), no. 31 (upper right), no. 57 (lower left), no. 56 (lower right).

deposit, which was interpreted as a rubbish pit, was sealed under the surface of a small square surrounded by several buildings and a street to the south. Many Base Ring and White Slip sherds have been uncovered in this pit along with animal bones. This suggests that the pottery derives from the nearby rooms, although we cannot exclude the possibility that some pottery may also have come from nearby tombs which were cleared to create room for new interments.

Locus 003 (Fig. 17.3, grid reference Γ-6) is a rectangular space enclosed by walls on three sides and resembles the holy of holies of the Kition temples. On the floor, which is located at a greater depth than the foundations of the existing walls and no doubt is earlier, we found two bull figurines in Base Ring fabric similar to the ones found at Bamboula which were dated by Benson to LCI-LCII (Benson 1972, 72, pl. 17). A White Shaved juglet was found in Pit 25 of Square 7Δ to the north of Locus 003.

In two other cases, pottery predating LC IIIA has been recovered in pits sealed under the floors. In Pit 29 of Room A we found a few sherds of White Slip ware, while in Pit 30—dug in an open space—we found sherds of a Mycenaean IIIB deep open vessel.

All remaining material found on the floors dates to the LC IIIA period. In Room B, which forms an inner space of a house and has suffered less from the cultivation of the site, we found a number of ceramic items which are important for the correlation between the floors and the tomb groups. The finds include a strainer jug, White Painted Wheelmade III bowls, a Coarse ware jug, Plain White Wheelmade vessels, and pithoi. Another strainer jug was found in Room Δ (Fig. 17.3) along with an imitation in Plain White ware of a Base Ring bowl; a Plain White jug; and an incense burner in White Painted Wheelmade III ware. Two more strainer jugs, nos. 56 and 57 (Figs. 17.4, 5: lower right; Fig. 17.5: lower left), were found with Plain White pottery in Square 7Γ around a curious semi-apsidal structure. On a sherd floor, ad-

jacent to this structure and incorporated into the same building with Locus 003, rested a bull figurine and a Plain White juglet. The figurine (Hadjisavvas 1989, fig. 3.6) illustrates the continuity of the use of this structure and suggests its use as a cult place. More than 30 similar bull figurines have been found at Alassa (Hadjisavvas 1986, pl. XVIII.2, 4).

The strainer jugs represent one of the most interesting groups of pottery found in the settlement and no doubt date to its final phase of occupation. All are similar in shape, with ovoid body, tapering neck and ring base. The upper part of the neck is missing in all cases. The handle, when preserved, is rectangular in section and probably extended from shoulder to rim. The cut-away strainer spout rests on the shoulder at right angles to the handle. Although they have stylistic affinities with Furumark's Type G (Furumark 1944, 235) and Benson's Type 3 (Benson 1972, 87, pls. 22, 56), our specimens have their own peculiarities both in terms of shape and decoration, indicating a localized style.

Of the three strainer jugs retaining their original decoration, one is very well preserved (no. 56: Figs. 17.4, 5: lower right). The paint is applied directly to the un-slipped surface of the vessels. The fabric of the three decorated specimens is a gritty buff-brown, while that of the fourth, undecorated example (no. 57: Fig. 17.5: lower left) is creamy-white. A common characteristic of the three decorated jugs is a group of three horizontal bands around the body just below the handle. Jug no. 16 (Fig. 17.5: upper left) also has a band around the neck and another outlining the spout. No. 31 (Fig. 17.5: upper

right) is decorated in the zone between bands and neck-line, with two fish antithetically arranged (cf. Furumark 1941, fig. 48.20, 21). The head of the fish is indicated with the help of two curved lines while the eye is represented by a dot. The body is decorated with dotted filler motifs and the tail is emphasized with massively applied paint. This jug has stylistic affinities with a strainer jug from Enkomi (Karageorghis 1962, 395, fig. 91). The example from Enkomi, however, is slightly larger and the fish are filled in with wavy bands.

Jug 56 (Figs. 17.4, 5: lower right) is richly ornamented in the zone between the group of bands and the neckline. Here, three stemmed spirals alternate with a net pattern. A loop with dotted filler ornament is placed between the strainer spout and the handle. The front half of a fish occupies the space opposite the handle, while two wavy bands vertically arranged divide the loop from one of the stemmed spirals. A comparison of the fabrics of the strainer jugs from the habitation areas (Fig. 17.3) and a similar example from Tomb 3 (T. 3/87, Figs. 17.2, 3) clearly shows that the latter has a much finer fabric and that its glossy slipped surface gives the impression of a Mycenaean import.

The possible relationship between Cypriot strainer jugs and those found in Philistia has been discussed in detail by Trude Dothan (1982, 191-218), and I hope that the new material from Alassa will help in searching for the origin of this vessel.

The characteristic skyphos with antithetical spirals, regarded at other sites as diagnostic LC IIIA, is absent at Alassa. Our use of quantitative analysis for dating avoids

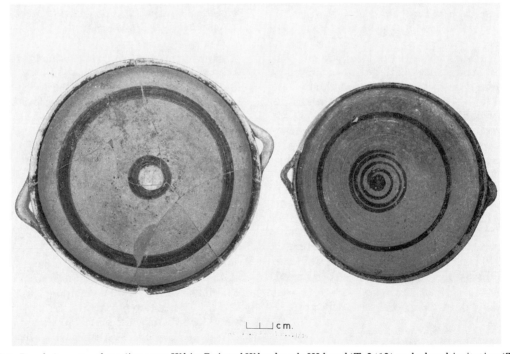

Figure 17.6. Bowls from tombs: a fine ware White Painted Wheelmade III bowl (T. 2/13) and a local imitation (T. 1/16).

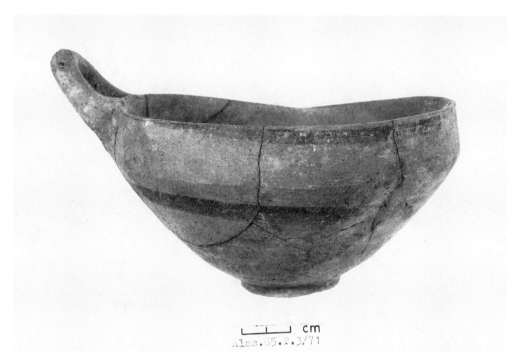

Figure 17.7. A misfired bowl of White Painted Wheelmade III ware found in Tomb 3 (T. 3/71).

historical implications and heeds Muhly's advice that "archaeological evidence must be interpreted on its own terms before it can be related to historical sources or literary traditions in any meaningful way" (Muhly 1984, 54).

If, however, we wish to speculate upon the historical information relating to Alassa, we may suggest that the absence of the Mycenaean IIIC:1b skyphos at this site indicates that the Achaeans, or whoever introduced this pottery type into Cyprus, never reached Alassa. This might also account for the continuous occupation of the site into LC IIIA.

Returning to our subject and speculating further on the ceramic evidence, we may suggest that the fine specimens of White Painted Wheelmade III ware were the products of traditional Cypriot ceramic centers which were copying well-known Aegean types. The fine specimens could be considered popular merchandise around the island which were in turn copied by local potters (e.g., see bowls, Fig. 17.6). Judging from the different fabrics at several sites and the presence of deformed vessels, we may suggest that the soft matte-painted pottery was produced locally. This certainly seems to be the case at Alassa-*Pano Mandilaris*, where very few examples of fine ware vessels have been found, and where a misfired bowl imitating a typical Mycenaean shape was placed in a tomb (Fig. 17.7).

This, in short, is the evidence derived from the study of the ceramic material from Alassa and its relation to the LC IIC-LC IIIA transition. The final excavation report is currently in preparation and a more detailed analysis and discussion will appear there.

REFERENCES

Benson, Jack L.
 1972 *Bamboula at Kourion: The Necropolis and Finds.* Philadelphia.

Dothan, Trude
 1982 *The Philistines and their Material Culture.* Jerusalem.

Furumark, Arne
 1941 *Mycenaean Pottery: Analysis and Classification.* Stockholm.
 1944 Mycenaean IIIC Pottery and its Relation to Cypriote Fabrics. *OpArch* III, 194-265.

Hadjisavvas, Sophocles
 1986 Alassa: A New Late Cypriote Site. *RDAC*, 62-67.
 1989 A Late Cypriote Community at Alassa. In *Early Society in Cyprus*, edited by E.J. Peltenburg, pp. 32-42. Edinburgh.

Karageorghis, Vassos
 1962 Chronique des fouilles et découvertes archéologiques à Chypre en 1962. *BCH* 86, 395.

Karageorghis, Vassos & Martha Demas
 1984 *Pyla*-Kokkinokremos. Nicosia.

Kling, Barbara
 1987 Pottery Classification and Relative Chronology of the LC IIC-IIIA Periods. In *Western Cyprus: Connections*, edited by David Rupp, pp. 97-113. SIMA LXXVII. Göteborg.

Muhly, J.D.
 1984 The Role of the Sea Peoples in Cyprus during the LCIII Period. In *Cyprus at the Close of the Late Bronze Age*, edited by Vassos Karageorghis & J.D. Muhly, pp. 39-55. Nicosia.

A Terminology for the Matte-Painted, Wheelmade Pottery of Late Cypriot IIC-IIIA

Barbara Kling

Problems of pottery classification and terminology surfaced at the very start of my study of the so-called Mycenaean IIIC:1b pottery of Cyprus for my doctoral dissertation several years ago and I have discussed them in several other places previously (Kling 1984, 1987, 1989a, 1989b). In the context of this symposium dedicated to such concerns, this paper summarizes the origin and nature of the problems; argues for the adoption of a single term for material previously classified into several different categories; and discusses some implications of such a change in classification.

Very simply, the problem is this: at most Cypriot sites that have been dated to the LC IIC and LC IIIA periods, there exists ceramic material that is wheelmade, decorated in a dark matte paint on a light-colored surface, and, on the basis of a limited amount of chemical analysis, seems to be for the most part produced in Cyprus, probably at several different locations (Kling 1989a, 91-94 with references). Several different terms have been applied to pottery that fits these criteria in different contexts. There is matte-painted Levanto-Helladic ware; Rude or Pastoral Style; Late Mycenaean IIIB and Mycenaean IIIB:2; Mycenaean IIIC, or IIIC:1, or IIIC:1b; and Submycenaean or Debased Levanto-Helladic, later renamed Decorated Late Cypriot III ware (for previous summaries, Kling 1984, 1987, 1989a).

Until very recently, discussion of these types of pottery has emphasized their differences, and they have generally been regarded as chronologically as well as culturally and historically distinct. Mycenaean IIIC pottery has been considered as an essentially Aegean ceramic style which arrived in Cyprus together with newcomers from that area at the beginning of LC IIIA and virtually wiped out the forms of pottery used in LC IIC, following a widespread catastrophe that coincided with a major disruption in the Aegean at the end of the Late Helladic IIIB period (e.g., *Enkomi*, 512-520; Furumark 1965, 103, 115-116). Decorated Late Cypriot III, although initially described by Gjerstad as a "local, indigenous fabric,

composed of and assimilating Mycenaean and old-Cypriote elements," with an emphasis on the Mycenaean (Gjerstad 1926, 220-228), has more recently come to be regarded as an essentially local style, the product of the surviving local Cypriot population; and the predominance of this ware at the sites of Kourion and Idalion, where Mycenaean IIIC was said to be absent, was cited as evidence that these sites were bypassed by the newcomers (*SCE* II, 618-624; Daniel 1942, 291-292; Benson 1972; Catling 1975, 211-212). Levanto-Helladic and Late Mycenaean IIIB or Mycenaean IIIB:2 of LC IIC have been seen as a limited local production in use alongside a variety of other local wares, such as White Slip and Base Ring, in the period before the disasters, drawing inspiration largely from Mycenaean pottery imported to the island from the Aegean (Karageorghis 1965, 157-181).

The existence of these different terms, and the significant differences in the interpretation of the pottery designated by them, implies that the pottery to which they are applied is readily distinguishable into separate groups; but, in fact, that is far from the case, and many scholars before me have also encountered difficulties in making such distinctions.

For example, as has been noted by many people, Levanto-Helladic or Late Mycenaean IIIB shallow bowls are indistinguishable from most varieties of bowls called Decorated Late Cypriot III (e.g., Catling 1955, 21-36; Sherratt 1980, 197; Maier 1985). Similarly, several of the shapes included in the Mycenaean IIIC category also appear in Decorated Late Cypriot III ware—such as the amphoroid krater, jug with strainer spout, and the skyphos (Furumark 1944, 232-240; Kling 1984). This overlap has created the situation in which one man's Decorated Late Cypriot III is another man's Mycenaean IIIC. At the excavations at Idalion in the 1930s, for example, no Mycenaean IIIC pottery was reported by the Swedish excavators, but a recent reassessment of the material by P. Ålin revealed types identical to those called Mycenaean IIIC in more recent years by others

(Ålin 1978). And, finally, the distinction between material that has been classified as Late Mycenaean IIIB and dated LC IIC and that called Mycenaean IIIC of LC IIIA is often not at all clear (e.g., Kling 1987, fig. 2).

The difficulties are bad enough with whole pots; the problem is even more acute when dealing with sherds, as I discovered when I had the opportunity to examine large numbers of sherds from several sites in Cyprus. Small ring bases from open vessels, for example, could belong equally well to a Mycenaean IIIB:2 or IIIC skyphos or any number of bowl shapes of the types called Late Mycenaean IIIB or Decorated Late Cypriot III (cf., e.g., Kition V, pl. CXVI, Courtyard C/12 and Courtyard C/13, called Late Mycenaean IIIB bowls [Kition V, Part II, 129]; pl. CXXVII, Temple 2/18, called Mycenaean IIIC:1 [Kition V, Part II, 139]).

I have argued previously that the explanation for this use of different terminologies for pottery that is in many cases indistinguishable seems to be the interpretation of the historical events at the end of the LC IIC period that was current for many years. Because LC IIC was regarded as contemporary with LH IIIB in the Aegean, Mycenaean style pottery found in Cyprus in LC IIC contexts was classified as Mycenaean IIIB. Mycenaean style pottery of the subsequent period, thought to represent a dramatically different culture contemporary with the subsequent period in the Aegean, was classified as Mycenaean IIIC. Perhaps the most significant impact of all was that once assigned on the basis of these historical interpretations, the pottery classifications then served to confirm them (Kling 1987).

Recently, however, this conception of the LC IIC/IIIA transition has started to change. Closer links for some features of the LC IIIA period have now been observed in the Levant than the Aegean and the earlier presence in Cyprus itself of some features has been increasingly appreciated (e.g., Catling 1980; Hult 1983 [ashlar masonry]). The cultural and historical distinctions between LC IIC and LC IIIA have become somewhat blurred. As I discussed in a recent paper, developments in the study of pottery are now also illuminating elements of continuity rather than change (Kling 1989b).

For example, although the emphasis in discussion of LC IIIA ceramics has been on pottery of Mycenaean style, other wares present in this period throughout the island— wheelmade Bucchero and Plain White Wheelmade II— were convincingly shown by Sjöqvist to have developed from earlier local ceramics (Sjöqvist 1940, 50-51, 59, 84). In addition, it may be noted that Base Ring and White Slip wares, the LC II pottery types par excellence, are also present in virtually all settlement contexts that have been dated LC IIIA (Kling 1989b, 167 for references). The recent trend has been to regard them in these contexts as intrusive survivals of an earlier phase of occupation,

particularly at sites, like Enkomi, where a long history of occupation is well documented (SCE IV Pt.1D, 700-701). This interpretation does not seem valid, however, at other sites, such as Idalion, for example, where the earliest occupation level contained Base Ring and White Slip wares as well as typical LC IIIA material, which could not be distinguished stratigraphically (SCE II, 618-624). At the very least, this would seem to suggest that no sharp break separated the use of these different kinds of pottery. It might also indicate that the use and manufacture of these wares overlapped, at least for a short period.

Similar observations may be made of the wheelmade, matte-painted pottery of this transition period. First of all, we may note the recognition of the continuity of some features from LC IIC into LC IIIA, which seems indicated by the near identity of certain types, particularly bowls, that occur in both periods; these similarities, in fact, are so striking that they have created problems in distinguishing the periods ceramically and raised questions about the established dates of some sites (Sherratt 1980, 197; Maier 1985; Podzuweit 1987; Kling 1984, 1987, 1989a, 1989b).

Secondly, we see the renewed appreciation of and interest in the fact that some features of this material were present in the island from much earlier phases of the Late Bronze Age, as Furumark pointed out long ago. In particular, several bowl shapes that, when decorated, have been referred to as Late Mycenaean IIIB and compared to Aegean pottery, are in fact quite comparable to shapes that were current in Plain White Wheelmade ware from the earliest phases of the Late Bronze Age in Cyprus itself (Furumark 1944; Kling 1989b). In addition, as recently observed by Susan Sherratt and Joost Crouwel, some shapes that came into the island from abroad apparently did so at different times, sometimes earlier than the LC IIC/IIIA transition as defined at certain sites. The bell krater, for example, which is popular in LC IIIA contexts, was already locally produced in LC IIC for the Rude Style; and the amphoroid krater appeared in local Plain White Wheelmade ware during LC IIB (Sherratt & Crouwel 1987; Kling 1989a, 130, 170-173; see also Sherratt, this volume).

There has also been an increased appreciation of the existence in the painted pottery of LC IIIA of stylistic hybrids that combine local, Aegean and Near Eastern elements. Sometimes these take the form of shapes with earlier history in Cyprus which are decorated in new ways that show some foreign influence. This phenomenon was noted, for instance, on an elaborately decorated amphoroid krater from Kition (Karageorghis 1977) and is pronounced on bell kraters from Enkomi that are decorated with motifs deriving from the Levant, the Aegean, and the earlier pottery of Cyprus itself (Enkomi, 852; Kling 1989a, 124-125). Sometimes we see

new shapes decorated with a combination of new and local motifs, such as appear on a strainer jug from Kouklia decorated with LH IIIC style birds and local Cypriot Rude Style bulls (Kling 1988b).

These observations of the overlapping, continuity and hybridization that exist in the painted pottery of LC IIC-IIIA demonstrate that it is not only difficult to separate this material into separate categories; it is also inappropriate to try to do so. What is clearly preferable in the present state of research is a flexible, inclusive term that recognizes this overlapping. Such a term is already in use by some scholars; this is White Painted Wheelmade III, which was introduced in 1972 by Paul Åström, initially to replace the term *Decorated Late Cypriot III* (*SCE* IV Pt.1C, 276), and gradually expanded to include all the classes of pottery that share these technical features (*HST* 3, 92; Kling 1984, 1989a). As presently defined and used, White Painted Wheelmade III spans the LC IIC and IIIA periods and includes all the matte-painted, wheelmade pottery in use in Cyprus at this time. This term has been adopted by a growing number of scholars in the past few years (e.g., Russell 1983, 109-111; Hadjisavvas this volume; Sherratt this volume).[1] Its general use could significantly reduce the difficulties in sorting and classifying sherd material from sites dating to these late phases of the Late Bronze Age that were presented by the range of terminologies in use previously, and reduce the confusion caused by the inconsistent use of these different terms by different scholars. More importantly, however, removing rigid chronological and cultural or historical distinctions would provide a change in the conceptual framework for the pottery that reflects our current understanding of the cultural and historical developments that took place in this period, and encourage thinking along these new lines. As has been stressed by many contributors to this volume, and as I hope to have shown as well, the manner of classifying pottery into categories, the choice of term applied to those categories, and the implicit meaning that term conveys, have a profound influence on the interpretation of the pottery and the contexts in which it is found. For the matte-painted, wheelmade pottery of LC IIC-IIIA, the abandonment of terms that carry chronological and historical meaning opens the door to a variety of new interpretations that will have significant impact on our understanding of the period in general (Kling 1989a, 174-175; Sherratt, this volume).

ADDENDUM

In the discussion period following the presentation of this and other papers dealing with Mycenaean style pottery in Cyprus, the question was raised, "Why White Painted Wheelmade *III?*" and the point made that this term, also, implies chronology, i.e., that the Roman numeral III suffix implies that the pottery belongs to the LC III period (Dr. V. Karageorghis). Professor P. Åström commented that the term originated as part of a series, following White Painted Wheelmade I and II which precede it in earlier phases of the Late Cypriot Bronze Age (see also *SCE* IV Pt.1C, 276). It should also be noted, however, that, as far as I am aware, *no* scholars who have adopted this term thus far have used it to denote material confined to the LC III period; and it is this specific fact, i.e., that the term has come to be used for material belonging to contexts that are dated to both LC IIC and LC IIIA, that makes it so useful to us now that the distinction of these periods has become blurred. It may be that as research progresses, scholars studying Cypriot pottery will decide that the Roman numeral suffixes for various classifications of pottery should be removed and replaced by other descriptive titles (see Vaughan, this volume and summary of discussion in the workshop sessions of the conference presented in the Introduction, this volume). If future scholars come to regard the "III" of White Painted Wheelmade III as implying a date for the material in the LC III period, it will, indeed, be necessary to change the term. For the present, however, the fact that White Painted Wheelmade III is well-defined, consistent with the material itself, and flexible argues for its usefulness.

1. The term White Painted Wheelmade was used by Karageorghis and Demas in their recent publication of material from Maa-*Palaeokastro* for material from that site previously designated as Late Mycenaean IIIB. They have, however, retained the term Mycenaean IIIC:1 for a portion of the pottery which they argue is readily distinguished from it (Karageorghis & Demas 1988, 216). The discussion presented here argues against segregating this material (cf. Kling 1988a, 317, note 2).

REFERENCES

Ålin, Per
 1978 Idalion Pottery from the Excavations of the
 Swedish Cyprus Expedition. *OpAth* XII, 91-
 109.

Benson, Jack L.
 1972 *Bamboula at Kourion. The Necropolis and the
 Finds.* Philadelphia.

Catling, Hector W.
 1955 A Bronze Greave from a 13th Century B.C.
 Tomb at Enkomi. *OpAth* II, 21-36.
 1975 Cyprus in the Late Bronze Age. *CAH*. Third
 edition. Vol. II, Part 2. Chap. XXII(b), 188-216.
 Cambridge.
 1980 *Cyprus and the West 1600-1050 B.C.* Ian
 Sanders Memorial Lecture. Sheffield.

Daniel, John F.
 1942 Review of *Problems of the Late Cypriot Bronze
 Age* by Erik Sjöqvist. *AJA* 46, 285-293.

Furumark, Arne
 1944 The Mycenaean IIIC Pottery and Its Relations
 to Cypriot Fabrics. *OpArch* III, 232-265.
 1965 The Excavations at Sinda. Some Historical
 Results. *OpAth* VI, 99-116.

Gjerstad, Einar
 1926 *Studies on Prehistoric Cyprus.* Uppsala.

Hult, Gunnel
 1983 *Bronze Age Ashlar Masonry in the Eastern
 Mediterreanean. Cyprus, Ugarit, and Neigh-
 bouring Regions.* SIMA LXVI. Göteborg.

Karageorghis, Vassos
 1965 *Nouveaux documents pour l'étude du Bronze
 Récent à Chypre.* Paris.
 1977 A Cypro-Mycenaean IIIC:1 Amphora from Ki-
 tion. In *Greece and the Eastern Mediterranean
 in Ancient History and Prehistory. Studies
 Presented to F. Schachermeyr*, edited by K.
 Kinzl, pp. 192-198. Berlin.

Karageorghis, Vassos & Martha Demas
 1988 *Excavations at Maa-Palaeokastro 1979-1986.*
 Nicosia.

Kling, Barbara
 1984 Mycenaean IIIC:1b Pottery in Cyprus: Prin-
 cipal Characteristics and Historical Context.
 In *Cyprus at the Close of the Late Bronze Age*,
 edited by Vassos Karageorghis & J.D. Muhly,
 pp. 29-38. Nicosia.
 1987 Pottery Classification and Relative Chronol-
 ogy of the LC IIC-LC IIIA Periods. In *Western
 Cyprus: Connections*, edited by D.W. Rupp,
 pp. 97-113. SIMA LXXVII. Göteborg.
 1988a Some Stylistic Remarks on the Pottery of
 Mycenaean IIIC:1 Style from *Maa-
 Palaeokastro*. In *Excavations at Maa-
 Palaeokastro 1979-1986*, by Vassos
 Karageorghis & Martha Demas, pp. 317-339.
 Nicosia.
 1988b The Strainer Jug from Kouklia Tomb KA I: A
 Stylistic Hybrid. *RDAC*, 271-274.
 1989a *Mycenaean IIIC:1b and Related Pottery in
 Cyprus.* SIMA LXXXVII. Göteborg.
 1989b Local Cypriot Features in the Ceramics of Late
 Cypriot IIIA. In *Early Society in Cyprus*, edited
 by Edgar J. Peltenburg, pp. 160-170. Edin-
 burgh.

Maier, Franz-Georg
 1985 A Note on Shallow Bowls. *RDAC*, 122-125.

Podzuweit, Christian
 1987 Zypern am Übergang von Spätzyprisch IIC zu
 IIIA. In *Ägäis- Kolloquium. Schriften des
 deutschen Archäologen-Verbandes IX. Kollo-
 quium zur Ägäischen Vorgeschichte*, edited by
 W. Schiering, pp. 185-192. Mannheim.

Russell, Pamela
 1983 Ceramics. In Kalavassos-*Ayios Dhimitrios* by
 A. South. *RDAC*, 104-113.

Sherratt, E. Susan
 1980 Regional Variations in the Pottery of Late Hel-
 ladic IIIB. *BSA* 75, 175-202.

Sherratt, E. Susan & J. Crouwel
 1987 Mycenaean Pottery from Cilicia in Oxford.
 OJA 6, 325-352.

Sjöqvist, Erik
 1940 *Problems of the Late Cypriot Bronze Age.*
 Stockholm.

Cypriot Pottery of Aegean Type in LC II-III: Problems of Classification, Chronology and Interpretation

E. Susan Sherratt

INTRODUCTION: HISTORY OF CURRENT CLASSIFICATORY AND CHRONOLOGICAL PROBLEMS

A classic dilemma posed from time to time by prehistoric pottery-dependent chronologies is the question of whether major period definitions should be based purely on ceramic distinctions or on distinctions in other aspects of the archaeological record—for instance, changes in other manifestations of material culture, in settlement patterns, or even perhaps a break in the stratigraphy of some key site. For much of prehistory in most parts of the world this type of dilemma, though present at the level of terminological debate, poses no serious problems, since the chronological parameters are uncertain enough, and the brushstrokes of various forms of general interpretation broad enough, to render precise chronological correlation between ceramic change and more long term changes in societies as a whole less of a burning issue. In areas like the Aegean and Cyprus, however, where proximity to the civilizations of the Near East and Egypt provides a much more refined relative and absolute chronology than is available elsewhere, and where, in later prehistory at least, interpretation of the archaeological record has traditionally been concerned above all with the detection of "historical" events, a dilemma of this sort has the ability to generate some extremely lively debate. In Cyprus, just such a debate has arisen recently between those who want to establish a

purely ceramic definition for distinguishing Late Cypriot IIC from Late Cypriot IIIA, and those who prefer to distinguish between these two periods on other grounds, particularly those of general cultural discontinuity and a clearly defined break in the history of the island which can be attributed to an event or series of events of historical significance.[1]

In 1958, the year that Dikaios completed his excavations in the settlement at Enkomi, no such dilemma was in sight, and the general picture seemed quite clear (*Enkomi*). The results of his excavations showed that at Enkomi at least the beginning of a new period of the Late Cypriot Bronze Age (Late Cypriot IIIA) was represented by a new phase of urban construction which followed a destruction at the end of Late Cypriot II. It was marked by the appearance of ashlar masonry, new forms of religious architecture and a new category of pottery, "Mycenaean IIIC:1," which had some evident similarities to Furumark's Mycenaean (or Late Helladic) IIIC:1 class and which was characterized above all by the skyphos or deep bowl—a shape not generally represented in what was so far known of Late Cypriot II contexts. Evidence from what little was known of other settlement sites, such as Sinda (Furumark 1965) and Pyla-*Kokkinokremos* (*Enkomi*, 895-907), seemed to confirm the

1. For recent discussions of this problem, see Kling 1987a; (and most recently of all) 1989b; Maier 1986. See also Muhly 1984; Karageorghis & Demas 1984, 66-75; *Kition* V Pt.1, 267-280; Karageorghis & Demas 1988, 255-266; Sherratt 1990a. Much of the ground covered in the present paper owes a great deal, in particular,

to ideas exchanged over the past few years with Dr B. Kling and Professor F.-G. Maier; and I am also grateful to Dr. V. Karageorghis for detailed comment and advice. None of these, naturally, can be held responsible for any errors of fact or judgement contained in the paper.

Enkomi picture in suggesting a major episode of disruption followed by cultural change throughout the island. The fact that few if any traditional Late Cypriot tombs containing Mycenaean IIIC:1 pottery could be found indicated a further element of discontinuity, suggesting that the watershed between Late Cypriot II and Late Cypriot III marked a major turning point in Cypriot history.

Cracks began to appear in this picture with the publication by Karageorghis (1965, 157-184) of material from the Palaepaphos-(Kouklia-)*Mantissa* tombs—to all intents and purposes traditional Late Cypriot II tombs which contained large numbers of the so-called Late Mycenaean IIIB bowls already known from other Late Cypriot II contexts, but which also included a skyphos (Karageorghis 1965, 161, fig. 39). Tomb 1 at Hala Sultan Tekke also contained a skyphos as well as some other Aegean shapes which seemed to have been locally made; and in this case the tomb had quite clearly been in continuous or continual use since early on in Late Cypriot II (*HST* I, 71-89). Kition Tomb 9 presented a similar picture (*Kition* I, 42-94); and Floor IV at Kition, which preceded a period of abandonment, also produced a few fragments of apparently locally made skyphoi (Kling 1985, 360-361). At Pyla-*Kokkinokremos*, where further excavations were carried out in 1981-82, the presence of apparently imported Late Helladic and Late Minoan IIIB pottery led to the revised conclusion that its abandonment, rather than its foundation (as Dikaios had thought), should be brought into line with the break in continuity associated with the end of Late Cypriot II (Karageorghis & Demas 1984, 68-69). However, it too had produced a couple of skyphoi (Karageorghis & Demas 1984, pls. XIX, XXXV).

PROBLEMS OF CULTURAL CONTINUITY

Thus, from the mid 1960s, it was already beginning to seem clear that the neat correlation which it had once been possible to draw between a break in settlement continuity and tomb use on the one hand, and the introduction of a new category of pottery on the other, was no longer going to work quite so well. At the same time, however, the notion of a clear cultural break between Late Cypriot IIC and Late Cypriot IIIA in aspects of the archaeological record other than the pottery has itself suffered some erosion. Ashlar masonry, for instance, is

now recognized as a well-established feature of Late Cypriot IIC architecture at sites such as Maroni-*Vournes* and Kalavasos-*Ayios Dhimitrios* (cf. e.g., Cadogan 1984; 1986; South 1983; 1984), while the site plans of Kition reveal a considerable element of architectural continuity—in layout and the presence and design of religious buildings, etc.—across the break which separates Floor IV from Floor III (*Kition* V, pls. 5, 9, 11, plans III-V; Karageorghis 1982, 98; cf. Negbi 1986, 106). A generally persuasive case for similar continuity at Enkomi, in layout and possibly even some of the more substantial buildings themselves, has recently been made by Negbi (1986, 101-105) and Courtois (Courtois *et al.* 1986, 7). If ashlar masonry, urban layout and the design and use of religious precincts and buildings can show such a strong element of continuity across the stratigraphical divides which separate Late Cypriot IIC from Late Cypriot IIIA at Enkomi and Kition, it seems reasonable to ask whether one might not also expect some continuity of tomb use over those same divides. At Kition at least, the way in which the layout of the Floor IIIA buildings in Area I continues to respect the presence of the tombs in the area suggests that this is a distinct possibility (*Kition* V, pls. 5, 9).

PROBLEMS OF CERAMIC FLUIDITY

In the ceramic field, too, distinctions which once seemed clear have come to appear considerably less so over the last decade or so, particularly with the realization that a number of different ceramic categories which were originally differentiated on the basis of shape range or decorative style are all best described as belonging to a single White Painted Wheelmade III ware, and that categories such as "Pastoral Style," "Late Mycenaean IIIB," "Mycenaean IIIC:1" and "Decorated Late Cypriot III" cannot easily be kept rigidly separate from one another either on classificatory or chronological grounds.[2] It seems clear, for instance, that the range of small bowls belonging to Dikaios' Late Mycenaean IIIB category (*Enkomi*, 841-843, 857-858) cannot be confined to a period which antedates his Mycenaean IIIC:1 class, but that it also coexists with it (cf. Kling 1987a, 101, 112 ill. 1; Maier 1985; Maier & von Wartburg 1986), and that its separation from the Mycenaean IIIC:1 category can best be seen as the result of a somewhat arbitrary distinction on grounds of shape rather than any fundamental difference of ware.[3] The Mycenaean IIIC:1 category itself

2. The practice of classifying all these varied categories under a single ware was first adopted, for good practical reasons, by the Swedish excavators of Hala Sultan Tekke (see *HST* 3, 92; and cf. Kling 1984a, 35) and has since been extended to some other sites (cf., e.g., Russell 1983, 104-113). Kling (this volume) makes an eloquent plea for its much more widespread use.

3. Dikaios' classification of these bowls as "Decorated Late Cypriot III" when found in Late Cypriot III contexts reflects his

determination to emphasize the overall ceramic distinctions between the Late Cypriot IIIA and Late Cypriot IIC periods as strongly as possible. Despite this, however, this chronological distinction (as defined by stratigraphical context) is not matched by any clear stylistic one, and the difference between Late Mycenaean IIIB shallow bowls and those of Decorated Late Cypriot III remains essentially one of (potentially confusing) terminology (cf. Kling 1987a, 101 and note 43).

comprises only those shapes thought to have been introduced from the Aegean at a particular point in Cypriot history (cf. Karageorghis *et al*. 1982, 105 n. 2; Kling 1984a), and as such reveals itself as a category which is based above all on an assumption of its cultural and historical origins (cf. Kling 1987a, 106). Thus, a particular version of carinated strap-handled bowl is included in this category because it is thought to be of LH IIIC origin, while other versions of carinated strap-handled bowls of similar size and presumably similar function, but which differ only in such small details as the height of the carination, are separated from it and put in quite different categories (cf. Kling 1985, 349; Sherratt 1990a, 158). Numerous other classificatory puzzles confront those attempting to distribute the great variety of Late Cypriot IIC-IIIA bowls among the various categories with their chronological and cultural overtones. How, for instance, should one regard two of the bowls from the upper burial level of Kition Tomb 9, which are skyphoi in all but their lack of handles (*Kition* I, pl. CLVII: 114, 122)? Are they skyphoi or not, and does the answer to this question affect one's view of their relative date and cultural origins?

In two recent papers Kling (1989a; this volume) has drawn attention to the fact that the typological boundaries both within and between the various categories into which Late Cypriot IIC and IIIA pottery has been divided are in reality extremely fluid. Not only—despite Karageorghis's gallant attempt to do so in the case of the bowls from Palaepaphos-*Mantissa* (Karageorghis 1965, 174-178)—does the wide range of bowl types generally assigned to the Late Mycenaean IIIB and Decorated LC III categories defy the imposition of clear typological taxonomies, but between the various Mycenaean and non-Mycenaean categories of White Painted Wheelmade III ware the boundaries are also far from clear. Patterns which are regarded as having an Aegean origin appear on shapes which have a long Cypriot tradition, while Aegean shapes include among their decoration motifs which seem traditionally more at home in Cyprus (Kling 1989a; Sherratt 1980, 197). Wares such as Base Ring and White Slip also interact with this generally fluid pattern, not only in the occasional appearance on White Slip II pottery of motifs such as the dot rosette found on White Painted Wheelmade III ware (cf., e.g., Benson 1972, pl. 17), but also in the form of such unclassifiable horrors as wheelmade Base Ring bowls or White Painted Wheelmade bowls with pure White Slip II decoration.[4]

AN HISTORICALLY BASED SOLUTION

Against this growing picture of cultural continuity and ceramic fluidity, it has become increasingly clear that the arrival at a generally acceptable scheme for dividing Late Cypriot IIC from Late Cypriot IIIA, which will at the same time take account of the apparent lack of correlation between significant ceramic change and a clear cultural break and/or a break in settlement continuity, is likely to prove a far from straightforward process. A solution which gets round some of the difficulties, however, has recently been put forward by Karageorghis & Demas (*Kition* V, Pt.1, 272, fig. 1; 1988, 259, fig. 1) who propose the creation of a new phase of Late Cypriot IIC (Late Cypriot IIC:2) which in effect acts as a transitional phase, linked to Late Cypriot IIC:1 (formerly Late Cypriot IIC) by a continuity of tomb use and, for the most part, settlement continuity, and linked to Late Cypriot IIIA by the presence of the skyphos (Fig. 19.1). At the same time, it is divided from Late Cypriot IIIA by a generalized horizon of destruction and rebuild-

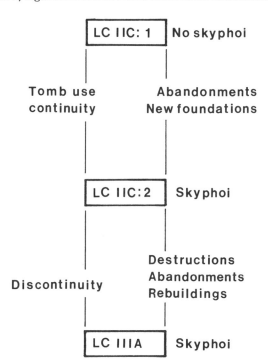

Figure 19.1. The conceptual framework of an LC IIC:2 chronological distinction (cf. Kition *V Pt.1, 269-274; Karageorghis & Demas 1988, 256-259).*

4. For wheelmade Base Ring bowls, see, e.g., Catling 1986, 595, note 148 with refs. Material from the Palaepaphos-*Evreti* wells includes an example of a Base Ring bowl shape in White Painted Wheelmade III fabric which has been covered with a matte wash, presumably to simulate a traditional Base Ring appearance (TE III 194). The same site has produced a fine example of a White Painted

Wheelmade hemispherical baseless bowl whose underside has been decorated with a White Slip II pattern of groups of parallel lines converging at the base (TE III 28; cf. for decoration, e.g., *Kition* I, pl. XI: 17, 49). I am grateful to Professor F.-G. Maier for showing me these and other pieces from his Palaepaphos-*Evreti* excavations, and for allowing me to mention them here.

Figure 19.2. Diagram showing ceramic associations of Late Cypriot IIC:1, Late Cypriot IIC:2 and Late Cypriot IIIA sites. (Dating according to Karageorghis & Demas 1988, fig. 1).

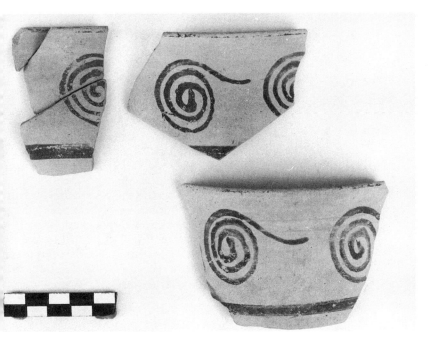
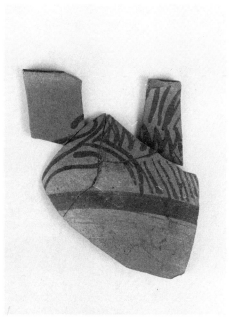

Figure 19.3. Sherds from Hala Sultan Tekke; illustrated courtesy of Professor Paul Åström.

ing or abandonment at sites such as Kition, Pyla-*Kok-kinokremos*, Sinda, Enkomi, Palaepaphos, Palaepaphos-*Eliomylia*, Palaepaphos-*Mantissa* and Hala Sultan Tekke, and from Late Cypriot IIC:1 by a smaller number of abandonments (as at Kalavasos-*Ayios Dhimitrios*, Maroni-*Vournes* and Toumba tou Skourou) and new foundations (as at Maa-*Palaeokastro* and Pyla-*Kokkinokremos*) which can continue to be interpreted, in historical terms, as a first wave of overseas settlers who preceded the main wave at the beginning of Late Cypriot III.

This solution is open to criticism on the ground that the main basis for the distinction of Late Cypriot IIC:2 from Late Cypriot IIIA lies in a chronological and causal alignment of events which is itself dependent on a particular historical interpretation: the falling out of use of

tombs of Late Cypriot II origin and tradition (Karageorghis & Demas 1988, 257), and the coincidence of this with a generalized horizon of destructions, abandonments and rebuildings. The distinction thus depends on an interpretative alignment with Dikaios' evidence from Enkomi of events at other sites which are assumed, but cannot be demonstrated, to be contemporary and causally related (cf. Maier 1986, 317), and for which the pottery tells a somewhat confusing story (Fig. 19.2). Can differences in the pottery (for example, the absence of imported LH IIIB pottery at Palaepaphos-*Mantissa* or in the upper burial level of Kition Tomb 9, or the absence of White Painted Wheelmade skyphoi in Enkomi Level IIB) be safely regarded as having no material chronological significance? Can one be sure that tombs—especially those containing skyphoi—do not continue to be used

and even perhaps constructed across the Late Cypriot IIC:2/Late Cypriot IIIA divide? (As Kling [1987a, 102] has pointed out, some of the skyphoi from tombs assigned to Late Cypriot IIC:2 look very much the same as ones from Late Cypriot IIIA contexts.) Or does one accept the premise of this solution that the break itself is the chronological anchor point to which any ceramic definition of the distinction between Late Cypriot IIC and Late Cypriot IIIA has to be seen as entirely secondary (cf. *Kition* V Pt.1, 269-270)?

POTTERY BASED SOLUTIONS

Rejection of this solution in favor of a purely ceramic definition of period distinction, however, also presents some serious difficulties, some of which are inherent in the whole concept of drawing up what are essentially (in terms of prehistory) extremely fine chronological distinctions on the basis of a material as complex and insensitive as pottery.[5] A number of possible criteria can and have been suggested, but singly and in combination none is without problems. One of the main ones centers on the relative proportions and general mix of different wares found in different assemblages (Kling 1987a, 104-105), but apart from the obvious difficulty that this depends on the availability of comprehensive statistics based on a generally agreed classification of different types of ware, there are indications that these proportions and mixes will vary not only regionally (cf. Hadjisavvas, this volume) but also according to functional and social context, between settlements, between tombs and settlements, and even within settlements themselves. The lower burial of Kition Tomb 9, for instance, already

shows a similarly small proportion of Base Ring and White Slip to wares of Aegean type as is found in Kition Level III, in contrast to Tombs 4 and 5 which, to judge by the Mycenaean pottery, cover a very similar time range (*Kition* I; cf. Sherratt 1990a, 162, n. 6); and the same seems to apply to the contents of the pit in Building X at Kalavasos-*Ayios Dhimitrios* (South 1988). Thus, while one could draw up ceramic *phases* consisting of assemblages which presented the same overall ceramic picture, there would be no guarantee that these represented distinct chronological entities and indeed some likelihood that they would not (cf. Kling 1987a, 105). While this method of classification might satisfy a deep-seated need to impose some order on what might otherwise seem to be ceramic chaos, its interpretation is likely to be far from straightforward,[6] and in particular the lack of useful chronological distinction would seem to deny much of the *raison d'être* of pottery classification as practiced now and in the past by Cypriot archaeologists.

Another possible marker—and one which since Dikaios' Enkomi excavations has been regarded as diagnostic *par excellence* of the Late Cypriot IIIA period—is the skyphos; and it is the continuing focus on this shape as a convenient criterion for distinguishing the beginning of Late Cypriot IIIA which, one suspects, at least partly underlies a recent suggestion that not only the upper burial of Tomb 9 at Kition but also the entire life of Kition Floor IV should be redated to Late Cypriot IIIA (Kling 1987b; 1989b, 82), a suggestion which does not seem to find firm foundation in the available evidence and which creates as many new problems as it solves.[7] Here it seems that there are serious dangers involved in

5. It is envisaged for example that Late Cypriot IIC:2 should span no more than about 10 years, between *ca.* 1200 B.C. and *ca.* 1190 B.C. (Karageorghis & Demas 1988, 259, fig. 1). It seems reasonable to ask just how realistic it is to suppose that this tiny amount of time should give rise to observable changes in the pottery record, even given that certain historical events may have led to the sudden imposition of new types and wares. In terms of effects on pottery even "sudden" is likely to mean rather more than ten years.

6. It cannot be assumed, for example, that differences between assemblages will simply represent different "cultural milieux" (cf. Kling 1987a, 105) except in a sense so general as to be virtually meaningless.

7. There are several difficulties with Kling's original arguments (Kling 1987b) which rest on an assumption that material from the fill above Floor IV in Area I (which is very similar to that associated with Floors IIIa and III) all belongs to destroyed Floor IV structures, and on an assumption that the lower burial of Tomb 9 was robbed at the time Floor IV was constructed by people other than the builders and users of Tombs 9, 4 and 5. Neither of these assumptions can necessarily be justified, and the relationship between the Floor IV architecture and the tombs in particular strongly suggests that the tombs were still in use (and were probably even constructed) during the life of Floor IV. What Kling has succeeded in demonstrating, however, is that Tomb 9 was not finally sealed until the construction of Floor III (i.e., the second Late Cypriot IIIA floor in the area); that the Tomb 9 lower burial was plundered at some

time between its deposition and the very end of Floor IV; and that some (though not necessarily all) of the pottery from the fill above Floor IV *may* belong to Floor IV structures. From this it is possible to conclude that the upper burial could have been deposited at any time between the plundering of the lower burial and the construction of Floor III, in a time span extending from Late Cypriot IIC (as represented by the lower burial) to Late Cypriot IIIA (as represented by Floor III); and that Floor IV has a possible maximum time span extending from Late Cypriot II (the time when Tombs 9, 4 and 5 were in use or even constructed) to Late Cypriot IIIA (if it can be assumed that some of the Late Cypriot IIIA pottery in the fill above Floor IV belongs to this floor). If nothing else, these conclusions have the effect of casting further doubt on the idea of a break in cultural and ceramic continuity between Late Cypriot II and Late Cypriot III at Kition.

Kling (1989a, 75-77) since appears to have modified her account somewhat to include room for the possibility that Floor IV, though constructed in Late Cypriot II, continued in use until a time when Late Cypriot IIIA pottery virtually indistinguishable from that associated with Floors IIIa and III was current, thus strengthening still further the arguments for cultural, ceramic and, indeed, stratigraphic continuity between what is conventionally regarded as Late Cypriot II and Late Cypriot III at Kition. I am extremely grateful to Dr Kling for sending me a copy of her book, and only regret that there has been insufficient time to fully appreciate the complexities of her latest arguments before completing this paper.

drawing up a whole new period definition on the basis of one shape alone, particularly since it is gradually becoming clear that this is not a shape which is confined in Cyprus to White Painted Wheelmade III pottery, but one which is also represented by imported LH IIIB examples and their Minoan counterparts, showing that the shape was already known and used on the island at a time when these imports were taking place.[8]

ALTERNATIVE INTERPRETATIVE FRAMEWORKS

At this point it seems pertinent to ask what the search for a definition of the ceramic distinction between Late Cypriot IIC and Late Cypriot IIIA is all in aid of. At one level, the obvious answer to this is a practical one: so that individual burial deposits, tombs, levels or other discrete contexts can conveniently and easily be assigned to one period or the other. At a more fundamental level, however, the question must concern itself with the reasons why it seems so imperative to draw a neat line, by one means or another, between these periods in the first place—and here the answer has to lie in the general interpretative framework within which much of the study of the later part of the Late Cypriot Bronze Age and its pottery has traditionally taken place: the division really matters only if it is believed that it hinges on some historical event or series of events which mark a major, and relatively abrupt, turning point in the general history of the island. Since many of the current problems associated with the classification and chronology of Late Cypriot IIC-IIIA pottery arise from the attempt to define a clear division, and thus ultimately from this particular historical form of interpretation, it might seem useful at this juncture to set aside, at least temporarily, the existing interpretative framework which has contributed to these problems and concentrate instead on exploring alternative models which might help explain the patterns of cultural continuity and fluid ceramic relationships which have begun to emerge during the last decade or so of research into the later part of the Cypriot Late Bronze Age.

For my own part, I become increasingly doubtful about both the practicability and advisability of any attempt to draw a neat line between Late Cypriot IIC and Late Cypriot IIIA either on ceramic grounds or on grounds of a break in general cultural continuity; and I believe that we may have to reconcile ourselves to seeing ceramic development on the one hand, and the checkered fortunes of individual sites on the other, as two quite separate continua whose relationship to one another is no more than incidental. As far as the pottery is concerned, while it is possible to see clear differences at either end of the continuum there is no single point in the middle where a clear overall division between two separate periods can be drawn. Rather, what we may be seeing in the emergence of a general class of White Painted Wheelmade III pottery in particular is the steady but gradual development, over a prolonged Late Cypriot IIC-IIIA time span, of a comprehensive painted wheelmade ware which was well suited for centralized industrial mass production, with a repertoire which covered all the broad functional categories once represented by a variety of imported and local wares (both wheelmade and handmade), and which drew right from the beginning on both Aegean and Cypriot ceramic models, and probably also on a range of intercultural metallic models for its shapes and decorations. It seems to me that it can be no coincidence that this development should have begun to take place at a time, in Late Cypriot IIC, when we are seeing increasing evidence of urbanization and administrative centralization on the island, a process which continues in Late Cypriot IIIA. These are the sort of conditions under which industrialized mass production of pottery might be expected to begin to take place; and, indeed, it was almost certainly under similar conditions (of centralized regional control under a palace system) that the mass-produced, highly standardized and widely exported LH IIIA and IIIB pottery of the Greek Mainland can be seen to have emerged.[9]

There can be little doubt that the LH and LM IIIA and IIIB pots which reached Cyprus during the fourteenth and thirteenth centuries were regarded by at least certain classes of Cypriot society as desirable objects in their own

8. For examples of imported LH IIIB skyphoi from Enkomi and Hala Sultan Tekke, see, e.g., Stubbings 1951, pl. IX: 1; *Enkomi*, pl. 87: 47; Karageorghis & Demas 1984, 47 note 6, fig. 5; *HST* 3, fig. 116; *HST* 8, fig. 402 top right; cf. Åström 1986, 64. For LM IIIB skyphoi from Kition see *Kition* I, pl. CXXIX; cf. Popham 1979, fig. 5.

9. Artzy (1985, 96-98) sees a similar process at work in the development of Base Ring II and White Slip II pottery, with the expansion of production indicated by signs of attempts to reduce the production cost of individual pots by the use of simpler and more hastily executed decoration, thinner slips which are easier to obtain and use, and the use of multi-tipped brushes etc. See also Keswani (this volume) for the increasingly wheelmade production of Plain White bowls, jugs and kraters at centers in eastern Cyprus during Late Cypriot II. In many ways this ware may be regarded as an undecorated equivalent of White Painted Wheelmade.

right whether or not they also acted as containers. The imported drinking sets consisting of decorated kraters, jugs, kylikes (or chalices) or mugs, small bowls or cups (cf., e.g., Vermeule & Karageorghis 1982, 21-22, III.21-2) may have been seen as exotica of status-enhancing value in themselves or possibly as acceptable substitutes for more costly precious metal sets,[10] but in any case it seems to have been elements of these drinking sets rather than the containers which were among the first vessels to be produced in Cyprus in a ware of Aegean type, possibly as supplements to, or more readily available substitutes for, the imported versions. The production of "Pastoral Style" mixing kraters has long been recognized as one of the first steps in this process, and this may have taken place relatively early on in Late Cypriot II, possibly at a time contemporary with the Amarna period to judge by some of the stylistic similarities between this style and some pieces of Egyptian polychrome painted pottery from Tell el-Amarna.[11] The production of a seemingly endless variety of small bowls, probably as drinking vessels and modeled on an assortment of Aegean, Cypriot and probably also metallic prototypes, also seems to have been quite an early part of this process, and functionally at least it is hard to separate these from the skyphoi, particularly the unusually small examples found for instance in Kition Tomb 9 or the Palaepaphos-*Eliomylia* tomb (cf. Sherratt 1990a). Other pieces of drinking equipment such as jugs, kylikes, chalices, mugs and possibly other shapes such as stirrup jars may also have entered the White Painted Wheelmade III

repertoire quite early on, to judge by the evidence of Kalavasos-*Ayios Dhimitrios*, Pyla-*Kokkinokremos* and the Kition tombs, and seem to have coexisted with imported Aegean pottery (cf. *Kition* I, 39, 59; Karageorghis & Demas 1984, pl. XXXV: 73; Russell 1983, 107-109, figs. 5: 3, 12, 6). Before the end of Late Cypriot IIIA other shapes such as strainer jugs, kalathoi and pyxides were added, some of the new additions appearing for instance at Enkomi in Level IIIA, others only in Level IIIB.[12]

By the time that, as in Enkomi Level III or Kition Floor III, White Painted Wheelmade pottery had increased in quantity to comprise almost half of the total associated pottery (*Enkomi*, 458; Kling 1985, tables 4-5), its total repertoire may be seen to cover all the broad functional categories once represented by a much wider variety of different local and imported wares. The wide range of bowls once produced mainly in handmade White Slip and Base Ring Wares was supplemented and gradually began to be replaced by the variety of wheelmade bowl types (including skyphoi) found in the "Late Mycenaean IIIB," "Decorated Late Cypriot III" and "Mycenaean IIIC:1" categories of White Painted Wheelmade III. The functions represented by imported drinking vessels were continued in the kraters, jugs, kylikes, chalices and possibly smaller skyphoi of the Pastoral Style and Mycenaean IIIC:1. The functions of Late Cypriot II plain domestic vessels in a variety of fabrics, Base Ring and White Shaved jugs and juglets and the like, were gradually subsumed in the varieties of similar sized and roughly similar shaped vessels found in Late

Artzy sees an additional explanation for this move toward increased mass production in White Slip II and Base Ring II pottery in the high level of demand for these wares in Levantine markets. It has been suggested elsewhere that the existence of a thriving re-export trade in Mycenaean pottery between Cyprus and the Levant may have been one of the factors which encouraged the initial development of a Cypriot production of pottery of Aegean type (Sherratt & Crouwel 1987, 344).

10. For metal versions of several of these apparently intercultural shapes from the Aegean and Cyprus, see Matthäus 1980; 1985.

11. The Ashmolean Museum, Oxford possesses fragments of two Egyptian polychrome pots from Tell el-Amarna with decoration which, stylistically and iconographically, bears a quite striking resemblance to that of some Cypriot Pastoral Style pottery. One (Ashmolean Museum 1924.165) consists of two large fragments of a large jar decorated in dark brown, red and blue paint with a scene of a piebald bull with long curving horns and lowered head in front of a papyrus-like bush (cf., e.g., Karageorghis 1965, pl. XXIII:5). The other (Ashmolean Museum 1931.436, from the "Mycenaean Merchant's House" [cf. Frankfort & Pendlebury 1933, 44-6]) is a fragment from a plate or shallow dish decorated on the inside with a fish design (cf., e.g., *Kition* I, pl. LXXIII: 90 where the design of at least one of the fish is not dissimilar). I am grateful to Dr. Helen Whitehouse for permission to mention these pieces which it is hoped will be the subject of a brief illustrated note before too long. The exact relationship between LH IIIA-B pictorial pottery, the Cypriot Pastoral Style and the figured scenes which appear on

Egyptian polychrome pottery in the Amarna period remains uncertain, but it seems worth noting that the Cypriot and Egyptian styles, in contrast to the LH pictorial, both clearly seem to owe something to artistic media other than pottery. In the case of the Egyptian versions, contemporary wall painting offers an obvious model, though a similar range of natural representations are also found on furniture, jewelry and textiles (cf. Bourriau 1981, 72). Ivory carving has been suggested as a model for the Pastoral Style (Karageorghis 1965, 234). The particularly close stylistic and thematic similarities between some of the Egyptian pieces and some of the early Pastoral Style (for the stylistic grouping of which cf. Karageorghis 1965, 231-259; Anson 1980; Vermeule & Karageorghis 1982) suggest that they may be particularly closely related both from the point of view of general inspiration and chronology, and that the beginning of the Cypriot Pastoral Style may therefore go back as far as the Amarna period in the fourteenth century. (See also Anson [1980, 14] for the suggestion that some of the earliest Pastoral Style from Cyprus is contemporary with late LH IIIA2 or early LH IIIB pottery.)

12. For strainer-jugs and kalathoi in Enkomi Level IIIa, see, e.g., Kling 1989b, 243, 261-262; cf. 394-395 (open shape no. 5, closed shape no. 2). For the high cylindrical pyxis, which first appears in Level IIIb at Enkomi, see Kling 1989b, 262; cf. 396 (shape no. 7c). Other shapes which first appear in Level IIIb at Enkomi include the neck-handled amphora and semiglobular cup (Kling 1989b, 241-242; cf. 394-395 [open shape no. 3k2, closed shape no. 1b]).

Cypriot III wheelmade ware, both painted and unpainted. That this process, which was already undoubtedly underway during Late Cypriot II, was a gradual one may be seen by the way in which certain traditional wares (particularly Base Ring) continued in production and use at Cypriot settlement sites into Late Cypriot III. That it was also in some sense a process of integration into a more or less single spectrum of wheelmade ware of what was originally a range of vastly differing types of ware, each of them often with a limited range of vessel types in what appear to be limited functional categories, may be shown by the way in which shapes or decorations originally characteristic of particular wares (e.g., White Slip, Base Ring or imported Aegean pottery) cross the boundaries between these wares and between the different categories of White Painted Wheelmade III pottery (cf. p. 187; Kling 1989a; Kling this volume). The final culmination of this process of integration can perhaps be seen most clearly in Proto-White Painted pottery, a wheelmade ware which may be regarded as functionally comprehensive and yet, perhaps for the first time, has a range of shapes and decorations which is well defined and standardized over the entire repertoire (cf. Iacovou 1988, 2, 84). By the end of Late Cypriot III, Cypriot pottery manufacture had arrived at the sort of island wide, standardized, wheelmade, mass-produced but quality controlled product which the Aegean had become accustomed to several centuries earlier, but which was conspicuously lacking on Cyprus before the later part of Late Cypriot II.

The specifically Aegean input into this long process was undoubtedly facilitated at the early end by the presence of imported Peloponnesian and Minoan pottery, much of which may itself have been specially produced for an export market (cf. Sherratt 1982). Later on, however, as political and economic conditions in both the East Mediterranean and Aegean changed toward the end of the thirteenth century, the nature and sources of this input appear, not surprisingly, to have altered, and from a time probably roughly equivalent to late LH or LM IIIB a selective range of influences from a number of different parts of the Aegean can be detected among the shapes and decorations of White Painted Wheelmade III pottery, above all perhaps from the Dodecanese and Crete, but also possibly from more distant regions such as the Cyclades and the Greek Mainland. Dodecanesian imports have been identified or suspected at sites such as Maa-*Palaeokastro*, Sinda, Enkomi, Hala Sultan Tekke, Kition and Pyla-*Kokkinokremos*,[13] and it may have been from this part of the world that shapes like the strainer jug and kalathos and certain forms of stemmed spiral motif entered the Cypriot Aegeanizing repertoire (Kling 1985, 356; Karageorghis & Demas 1984, 47-48). Cretan imports are known not only from the Kition tombs, but also from Pyla-*Kokkinokremos* (Karageorghis & Demas 1984, 50), Hala Sultan Tekke (Åström 1986, 64; cf. Karageorghis 1979) and Enkomi (*Enkomi*, pl. 80: 31), and it may well have been from Crete that the *FS* 176 class of stirrup jar, the high cylindrical pyxis, a type of kylix with carinated lip, and a whole range of skyphos motifs including isolated spirals, certain floral patterns (Fig. 19.3;[14] cf., e.g., Popham 1965, figs. 6-7, pls. 82d-83a) and isolated semicircles first reached Cyprus, together possibly with the occasional early use of a reserved line inside the rim (e.g., Maier 1972, pl. XVII: 5; cf., e.g., Popham 1965, figs. 4-8; Kanta 1980, 259). A few skyphoi from Maa-*Palaeokastro* (cf., e.g., Karageorghis & Demas 1988, pls. CLXX: 155A-B, CLXXXIII: Room 82/1, CXCII: 583, 430, CCX: 473) have a rather squat profile similar to those of a distinctive class of skyphos from Melos and Paros (Mountjoy 1984, 234-237, fig. 6; Mountjoy 1985, 151), while some carinated kylikes with areas of monochrome decoration from the same site also resemble ones found on those islands (Karageorghis & Demas 1988, pls. CLXXV: 580, CXCII: 303, 418, 505, 572; cf. Schilardi 1984, 193 fig. 6e; Koehl 1984, fig. 3: 8). Further afield, an occasional LH IIIC import from the Greek Mainland has been identified in Cyprus (Jones 1986, 557; Catling 1972), while the presence of one or two imported Argive LH IIIB:2 "Group B" skyphoi at Enkomi and Hala Sultan Tekke suggests that pottery imports from the Mainland, though probably seriously reduced, may not have ceased entirely towards the end of LH IIIB. There is also some indication of a knowledge in Cyprus of the Argive "Rosette Bowl" type, possibly in both its LH IIIB:2 and early LH IIIC forms (Sherratt 1990b, 113, 118).

As Catling (Catling 1986, 595) has pointed out, however, even the complete range of Aegean shapes found in White Painted Wheelmade III ware presents only a limited repertoire as compared with that of any single region of Greece and the Aegean, which suggests that we may be witnessing something other than the wholesale transference to Cyprus of the complete ceramic corpus of

13. Cf., e.g., Karageorghis & Demas 1988, 234, pl. CCIV: 48; Furumark 1965, pl. I; Jones 1986, 555; *Enkomi*, 271; *HST* 7, 39; Karageorghis & Demas 1984, 47-48 and pl. XXXV: 105 (cf., e.g., Morricone 1972-1973, fig. 370).

14. The skyphos sherds shown in Figure 19.3 come from Hala Sultan Tekke Area 8, well F1244 (4-5 m.) (cf. *HST* 8). I am extremely grateful to Professor Paul Åström for permission to illustrate them and for kindly allowing me to study and photograph material from his excavations at Hala Sultan Tekke.

KEY

—————— similarity coefficient of .75 - 1

— — — .50 - .74

- - - - - - .25 - .49

Figure 19.4. Inter-regional similarities in an early stage of LH IIIC, expressed in terms of similarity coefficients based on the distribution of selected pottery features (after Sherratt 1981, fig. 200).

a particular region or group of regions sometime in late LH/LM IIIB or early in LH/LM IIIC.[15] Rather, the eclectic nature of the Aegean element in White Painted Wheelmade III and the diversity of Aegean regions

which seem to have provided the main influences suggest that these influences may owe less to the imposition of the ethno-ceramic traditions of any coherent groups of Aegean immigrants than to Cyprus's participation in

15. Cf. Sherratt & Crouwel (1987, 343-344) for some of the Greek mainland features which appear to be missing or rare in Cypriot White Painted Wheelmade III pottery. Similarly, there is no sign of the stemmed bowls (*FS* 305-6) found in the Dodecanese and the Cyclades in LH IIIC, or of the stemmed kraters which seem to persist in LH IIIC in these regions. An obvious omission from the Cretan repertoire are the early forms of small octopus stirrup jar, known from LM IIIB and early LM IIIC, which eventually develop into more elaborate types. One of the main and possibly significant differences lies in the relative scarcity of Aegean container shapes in White Painted Wheelmade III ware—the amphoriskoi, straight-sided alabastra, piriform jars, collar-necked jars, etc. which in LH IIIC pottery represent the continuations of types widely exported to Cyprus from the Greek Mainland during LH IIIA-B probably primarily for their contents. Although it can be argued that these are more frequently found in tombs than in settlements in the Aegean, hopes that significant numbers of Late Cypriot IIIA tombs packed with White Painted Wheelmade III pottery with a typical repertoire of Aegean funerary shapes exist to be found one day are

fast beginning to fade. Those few tombs which do contain some Mycenaean IIIC:1 pottery, including some from the Kouklia area (Maier 1986, 313; cf. Kling 1987a, 105 note 76 with refs.) and possibly Kourion-*Bamboula* (Benson 1972, 20-21, pl. 32: B1062), mostly contain drinking set types such as skyphoi and kraters which are already well known from the settlements and which—significantly perhaps—in the LH IIIC Aegean are only rarely found in tombs. (Cf. however two isolated White Painted Wheelmade III alabastra from the Kourion-*Bamboula* tombs both usually regarded as Late Cypriot II in date [Benson 1972, pls. 22: B581, 45: B580]). The very fact that Late Cypriot IIIA tombs as a whole are so sparsely furnished with pottery of obvious Aegean shape and decoration tends to cast doubt on the idea that this pottery represents some sort of reliable evidence of ethnic identity (cf. Maier 1986, 313). It is above all perhaps in such a potentially sensitive cultural context as burial that one might expect to see evidence of a direct equation between pottery and ethnic or linguistic identity, if such an equation existed.

a new pattern of maritime trade which began to emerge with the collapse of the old political and economic imperial systems toward the end of the thirteenth century. This pattern seems to consist of a network of small scale maritime contacts of one sort or another between Cyprus and various parts of the Aegean which differs from the much more restricted pattern seen during LH IIIA and early LH IIIB when imported pottery found on the island can be seen to derive almost exclusively from the North East Peloponnese, or at most from the North East Peloponnese and Crete. That a (probably quite small scale and haphazard) trade or exchange of pottery in more than one direction was part of this maritime activity (which almost certainly included an element of individual mobility in various directions) may be seen not only from finds, in late LH IIIB or early LH IIIC contexts, of such things as Cretan pottery in the Dodecanese and the Cyclades, and of Cretan and Dodecanesian pottery in Eastern Attica and Euboea, but also from the distinct possibility that imports of Cypriot pottery (possibly including White Painted Wheelmade III pottery) may have reached various regions of the Aegean and beyond at this time. Cypriot ceramic imports in such contexts have been identified at Tiryns (Kilian 1988, 121, figs. 24-25), and may be suspected at Ialysos (Iacopi 1933, fig. 62), on Kos (Morricone 1972-1973, fig. 361b[16]), in Troy VIh (Blegen *et al.* 1953, fig. 417: 10;[17] cf. figs. 417: 19-26, 418: 17-21), in the Cyclades (Renfrew 1985, pl. 26(c); cf. Mountjoy 1985, fig. 5.22: 378) and much farther afield in Sardinia and Southern Italy (Vagnetti 1986; Vagnetti & Lo Schiavo 1989, 219-221); and there may well be more lying hitherto unidentified in other regions of Greece and the Aegean. A plot, not of imports, but of degrees of regional similarity based on the differential distribution of ceramic features shows, by an early stage of LH IIIC, a network linking Cyprus, the eastern fringes of the Aegean, Crete and the Cyclades quite closely together (Fig. 19.4)—probably in certain maritime activities which in turn linked in with an area very much farther to the west.[18] By mid-LH IIIC the pattern of contacts appears to increase in intensity and to take in a wider range of coastal and island regions of Greece and the Aegean within its general orbit (cf. Sherratt 1982, 188). Cyprus's evident participation in this network of maritime contacts (cf. Cadogan 1972), together with the probability that some Cypriot White Painted Wheelmade pottery reached at least some regions of the Aegean during late LH IIIB and LH IIIC raises the further possibility that ceramic influences, too, may have traveled westward from Cyprus, and that Cyprus itself may have made some contribution to certain aspects of LH IIIC stylistic development in some parts of the post-palatial Mycenaean world.

Finally, it ought to be stressed that the type of interpretative framework presented here need not necessarily be thought of as incompatible with the idea of people of Aegean origin living and operating in Cyprus throughout the Late Cypriot II and IIIA periods, or even with the idea of some relatively large scale immigration at some point within this timespan. What can be questioned, however, is the necessity for making any direct equation between pottery of Aegean type produced in Cyprus and the arrival of a discrete group or groups of people for whom pottery—and pottery alone—acted as some sort of conscious statement of ethnic identity which we can use to demonstrate the archaeological proof of their arrival. This seems to me to be unnecessary and currently, in view of the existing tangle in which problems of stylistic classification and chronology are inextricably intertwined with historical reconstruction, to be one of the main obstacles to a fuller understanding of the ceramic evidence. If we want to look for a controlling model, it ought to be a much more complex one which can encompass some discussion of economic and social factors as well as underlying political developments in Cyprus itself, of the nature (as opposed to the typology and stylistic details) of the pottery itself, of the advantages and attractions which a ware of White Painted Wheelmade III type may have offered and the manner in which its production may have been organized. Above all, it should be able to take account of the increasingly impressive picture of a highly sophisticated Late Cypriot II-III society which the work of excavators and scholars has built up in recent decades, and of the evidence for Cypriot involvement in a continuing but changing pattern of contact with the Aegean—two way rather than unidirectional—in which Cyprus did not remain a passive recipient but was well placed to become an increasingly important player, particularly in the changing game which rapidly emerged in the late thirteenth and early twelfth centuries as the old empires of east and west and their associated political and economic orders began to collapse around her.

16. This appears to be a fragment of a "bird skyphos" (probably with a single bird on the side of the pot) similar to the distinctive examples known from Kition, Kouklia and Tarsus (cf. Kling 1984b, 48), and now also from Maa-*Palaeokastro* (Karageorghis & Demas 1988, pl. CCXLIII: 250). The birds themselves are certainly highly comparable.

17. For examples of the same mug shape (*FS* 226 or 228) some of them also decorated with fish, cf. Karageorghis & Demas 1988, pls. CLXXV: 239, 352, 316, 581, CXCII: 354, CCVII: Room 25A/1). There is an example of the same shape decorated in Pastoral Style from Enkomi Tomb 18 (*SCE* I, pl. LXXXVIII: 1 top right).

18. For the features concerned and the method of calculating the similarity coefficients, see Sherratt 1981, 503-504, figs. 198-200.

Acknowledgments

I should like to thank the organizers of the Colloquium, Dr. J. Barlow, Dr. D. Bolger, Dr. B. Kling and Professor J.D. Muhly for inviting me to take part in the Colloquium's discussions and present a version of this paper. I should also like to express my gratitude to the A.G. Leventis Foundation and the Cyprus American Archaeological Research Institute for making it possible for me to spend some time in Cyprus thinking about some of the problems with which this paper is concerned, and particularly to Dr. Vassos Karageorghis for his very generous encouragement and hospitality and the stimulus of lively and enjoyable discussion.

REFERENCES

Åström, Paul
1986 Hala Sultan Tekke and its Foreign Relations.
 In *Acts* 1986, 63-66.

Anson, Dimitri
1980 The Rude Style Late Cypriot IIC-III Pottery.
 OpAth 13, 1-18.

Artzy, Michal
1985 Supply and Demand: A Study of Second Mil-
 lennium Cypriote Pottery in the Levant. In
 *Prehistoric Production and Exchange: The
 Aegean and Eastern Mediterranean*, edited by
 A. Bernard Knapp & Tamara Stech, pp. 93-99.
 Monograph 25. Institute of Archaeology,
 University of California, Los Angeles.

Benson, J.L.
1972 *Bamboula at Kourion, the Necropolis and the
 Finds*. Philadelphia.

Blegen, Carl W., John L. Caskey, & Marion Rawson
1953 *Troy III*. Princeton.

Bourriau, Janine
1981 *Umm El-Ga'ab. Pottery from the Nile Valley
 Before the Arab Conquest*. Catalogue of Ex-
 hibition, Fitzwilliam Museum Cambridge,
 Dec. 1981. Cambridge.

Cadogan, Gerald
1972 Cypriot Objects in the Bronze Age Aegean and
 their Importance. *Praktika tou protou dieth-
 nous Kyprologikou Synedriou* I, 5-13. Nicosia.
1984 Maroni and the Late Bronze Age of Cyprus. In
 Cyprus at the Close of the Late Bronze Age,
 edited by Vassos Karageorghis & J.D. Muhly,
 pp. 1-10. Nicosia.
1986 Maroni II. *RDAC*, 40-44.

Catling, Hector W.
1972 A Late Helladic IIIC Vase in Birmingham.
 BSA 67, 59-62.

Catling, Hector W. & Richard E. Jones
1986 Cyprus, 2500-500 B.C.: the Aegean and the
 Near East, 1500-1050 B.C. In *Greek and
 Cypriot Pottery*, by Richard E. Jones, pp. 523-
 625. Athens.

Courtois, Jacques-Claude, Jacques Lagarce, & Elisabeth
Lagarce
1986 *Enkomi et le Bronze Récent à Chypre*. Nicosia.

Frankfort, Henri & John D.S. Pendlebury
1933 *The City of Akhenaten Part II*. London.

Furumark, Arne
1965 The Excavations at Sinda. Some Historical
 Results. *OpAth* 6, 99-113.

Iacopi, Giulio
1933 Nuovi scavi nella necropoli micenea di Jalisso.
 ASAtene 13-14, 233-345.

Iacovou, Maria
1988 *The Pictorial Pottery of Eleventh Century B.C.
 Cyprus*. SIMA LXXVIII. Göteborg.

Jones, Richard E.
1986 *Greek and Cypriot Pottery. A Review of Scien-
 tific Studies*. Fitch Laboratory Occasional
 Paper 1. The British School at Athens, Athens.

Kanta, Athanasia
1980 *The Late Minoan III Period in Crete. A Survey
 of Sites, Pottery and their Distribution*. SIMA
 LVIII. Göteborg.

Karageorghis, Vassos
1965 *Nouveaux Documents pour l'Etude du Bronze
 Récent à Chypre*. Paris.
1979 Some Reflections on the Relations between
 Cyprus and Crete during the Late Minoan III
 period. In *Acts* 1979, 198-203.
1982 *Cyprus from the Stone Age to the Romans*.
 London.

Karageorghis, Vassos & Martha Demas
1984 *Pyla-Kokkinokremos*. Nicosia.
1988 *Excavations at Maa-Palaeokastro 1979-1986*.
 Nicosia.

Karageorghis, Vassos, Martha Demas & Barbara Kling
1982 Excavations at Maa-*Palaeokastro* 1979-1982. A
 Preliminary Report. *RDAC*, 86-108.

Kilian, Klaus
1988 Ausgrabungen in Tiryns 1982-3. *AA*, 105-151.

Kling, Barbara
1984a Mycenaean IIIC:1b Pottery in Cyprus: Prin-
 cipal Characteristics and Historical Context.
 In *Cyprus at the Close of the Late Bronze Age*,
 edited by Vassos Karageorghis & J.D. Muhly,
 pp. 29-38. Nicosia.
1984b The Bird Motif in the Mycenaean IIIC:1b Pot-
 tery of Cyprus. In *The Scope and Extent of the
 Mycenaean Empire*, pp. 46-57. Temple Univer-
 sity Aegean Symposium. Philadelphia.
1985 Comments on the Mycenaean IIIC:1b Pottery
 from Kition Areas I and II. In *Kition* V, 337-374.
1987a Pottery Classification and Relative Chronol-
 ogy of the LC IIC-LC IIIA Periods. In *Western
 Cyprus: Connections*, edited by David Rupp,
 pp. 97-113. SIMA LXXVII. Göteborg.
1987b Mycenaean IIIC:1b and Related Pottery in
 Cyprus. Ph.D. dissertation, Department of
 Classical Archaeology, University of Pennsyl-
 vania. Philadelphia.

1989a Local Cypriot Features in the Ceramics of LC IIIA. In *Early Society in Cyprus*, edited by Edgar J. Peltenburg, pp. 160-170. Edinburgh.

1989b *Mycenaean IIIC:1b and Related Pottery in Cyprus*. SIMA LXXXVII. Göteborg.

Koehl, Robert
1984 Observations on a Deposit of LC IIIC Pottery from the Koukounaries Acropolis on Paros. In *The Prehistoric Cyclades*, edited J.A. MacGillivray and Robin Barber, pp. 207-224. Edinburgh.

Maier, Franz-Georg
1972 Recent Discoveries at Kouklia (Old Paphos). *Praktika tou protou diethnous Kyprologikou Synedriou* I, 93-102. Nicosia.

1985 A Note on Shallow Bowls. *RDAC*, 122-125.

1986 Kinyras and Agapenor. In *Acts* 1986, 311-318.

Maier, Franz-Georg & Marie-Luise von Wartburg
1986 Ausgrabungen in Alt-Paphos. 13. Vorläufiger Bericht: Grabungskampagne 1983 und 1984. *AA*, 145-193.

Matthäus, Hartmut
1980 *Prähistorische Bronzefunde II. 1. Die Bronzegefässe der kretisch-mykenischen Kultur*. Munich.

1985 *Prähistorische Bronzefunde II.8. Metallgefässe und Gefässuntersätze der Bronzezeit, der geometrischen und archaischen Periode auf Cypern*. Munich.

Mountjoy, Penelope
1984 The Mycenaean IIIC Pottery from Phylakopi. In *The Prehistoric Cyclades*, edited by J.A. MacGillivray & Robin Barber, pp. 225-240. Edinburgh.

1985 The Pottery. In *The Archaeology of Cult. The Sanctuary at Phylakopi*, by A. Colin Renfrew, pp. 151-208. *BSA* Supplement 18. London.

Morricone, Luigi
1972-73 Coo-Scavi e Scoperte nel "Serraglio" e in località minori (1935-1943). *ASAtene* N.S. 34-35, 139-396.

Muhly, J.D.
1984 The Role of the Sea Peoples in Cyprus during the LC III Period. In *Cyprus at the Close of the Late Bronze Age*, edited by Vassos Karageorghis & J.D. Muhly, pp. 39-55. Nicosia.

Negbi, Ora
1986 The Climax of Urban Development in Bronze Age Cyprus. *RDAC*, 97-121.

Popham, Mervyn R.
1965 Some Late Minoan III Pottery from Crete. *BSA* 60, 316-342.

1979 Connections between Crete and Cyprus between 1300-1100 B.C. In *Acts* 1979, 178-191.

Renfrew, A. Colin
1985 *The Archaeology of Cult. The Sanctuary at Phylakopi*. *BSA* Supplement 18. London.

Russell, Pamela
1983 Ceramics. In Kalavasos-*Ayios Dhimitrios* 1982, by Alison South. *RDAC*, 104-113.

Schilardi, Demetrius U.
1984 The LH IIIC Period at the Koukounaries Acropolis, Paros. In *The Prehistoric Cyclades*, edited by J.A. MacGillivray & Robin Barber, pp. 184-206. Edinburgh.

Sherratt, E. Susan
1980 Regional Variation in the Pottery of Late Helladic IIIB. *BSA* 75, 175-202.

1981 The Pottery of Late Helladic IIIC and its Significance. Ph.D. dissertation, Somerville College, Oxford.

1982 Patterns of Contact: Manufacture and Distribution of Mycenaean Pottery, 1400-1100 B.C. In *Interaction and Acculturation in the Mediterranean*, edited by Jan G.P. Best & Nanny M.W. de Vries, pp. 179-195. Amsterdam.

1990a Note on Two Pots from Palaepaphos-*Eliomylia* Tomb 119. In *Tombs at Palaepaphos*, by Vassos Karageorghis, pp. 156-163. Nicosia.

1990b Palaepaphos-*Teratsoudhia* Tomb 105 Chamber B: 'Myc. IIIC:1b' Sherds. In *Tombs at Palaepaphos*, by Vassos Karageorghis, pp. 108-121. Nicosia.

Sherratt, E. Susan & J.H Crouwel
1987 Mycenaean Pottery from Cilicia in Oxford. *OJA* 6:3, 325-352.

South, Alison K.
1983 Kalavasos-*Ayios Dhimitrios* 1982. *RDAC*, 92-141.

1984 Kalavasos-*Ayios Dhimitrios* and the Late Bronze Age of Cyprus. In *Cyprus at the Close of the Late Bronze Age*, edited by Vassos Karageorghis & J.D. Muhly, pp. 11-17. Nicosia.

1988 Kalavasos-*Ayios Dhimitrios*, 1987. An Important Ceramic Group from Building X. *RDAC*, 223-228.

Stubbings, Frank H.
1951 *Mycenaean Pottery from the Levant*. Cambridge.

Vagnetti, Lucia
1986 Cypriot Elements beyond the Aegean in the Bronze Age. In *Acts* 1986, 201-214.

Vagnetti, Lucia & Fulvia Lo Schiavo
1989 Late Bronze Age Long Distance Trade in the Mediterranean: The Role of the Cypriots. In *Early Society in Cyprus*, edited by Edgar J. Peltenburg, pp. 217-243. Edinburgh.

Vermeule, Emily T. & Vassos Karageorghis
1982 *Mycenaean Pictorial Vase Painting*. Cambridge, Massachusetts.

Proto-White Painted Pottery: A Classification of the Ware

Maria Iacovou

HISTORICAL OUTLINE OF THE ARGUMENT

The subject of this paper is the classification of Proto-White Painted, the last of the Late Bronze Age painted Cypriot wares, which was produced on the island as late as the inception of the White Painted pottery of the Cypro-Geometric I period, and the definition of LC IIIB, the last phase of the Late Bronze Age.

As early as 1893, Proto-White Painted was identified among the finds in a tomb at Lapithos by Max Ohnefalsch-Richter, the vases from which he described as being of the "late Mykenaean class" (Ohnefalsch-Richter 1893, 296, 462). Soon afterward, John L. Myres identified six Proto-White Painted vases from Kouklia Tombs 6 and 12 and called them "Native Imitations" of the Mycenaean fabric (Myres 1899, 10, 50, 174). Thus, from the start, Proto-White Painted was recognized as an indigenous ware that bore a close relationship, in terms of its repertoire of shapes, to Late Mycenaean pottery.

Myres also dealt with the ware when he attempted to define the subtle changes of shapes from "the latest Mycenaean Age to the Early Iron Age" (Myres 1910, 107). Thus, Proto-White Painted acquired its relative chronological position and was properly assigned to the transition from the Bronze to the Iron Age. Amazingly, Myres dated this transition to *ca.* 1050 BC, which remains a conventional but unshakable absolute date for the end of the Cypriot Bronze Age (e.g., *SCE* IV Pt.2, 427; Pieridou 1973, 112).

For obvious reasons, namely its similarity to the latest Mycenaean pottery, Proto-White Painted was also called "Cypriote Submycenaean" by H.B. Walters (1912, xv-xvi) and even by Gjerstad in his early work on Cypriot prehistory (1926, 226). Erik Sjöqvist (1940, 125) had a great impact upon Gjerstad's division of LC III into two, not three, phases (e.g., Iacovou 1988, 5) and certainly prevented Gjerstad from upholding his original, tripartite division of LC III into A, B and C (*SCE* II, 624). On

the other hand, Sjöqvist dispersed the then limited amount of Proto-White Painted in his "late Levanto-Helladic class" (Sjöqvist 1940, 133). Fortunately, a year later, Furumark reinstated the individuality of Proto-White Painted but, since he defined it as earlier than the Cypro-Geometric I pottery, he called it "decorated early Cypro-Geometric pottery" (Furumark 1941, 122).

We now come to a significant point regarding the evolution of the argument over LC IIIB and the definition of Proto-White Painted. The first two volumes of the Swedish Cyprus Expedition, (*SCE* I; *SCE* II), had introduced vast groups of White Painted pottery, which helped define the upper limits of the Early Iron Age. Both Furumark (1944) and Gjerstad (1944) agreed that there were two distinct phases in LC III. The early phase, LC IIIA, was characterized by the circulation of a painted pottery which on Furumark's suggestion they called "Decorated Late Cypriote III" (Furumark 1944, 232). The late phase, LC IIIB, was defined by the production of a different painted pottery which Gjerstad called Proto-White Painted (Gjerstad 1944, 75). Thus the emphasis on this type of pottery shifted; by its very name it became the precursor of early White Painted and, to a less extent, the end product of Late Cypriot III.

At this stage the two scholars were in agreement concerning the main corpus of Proto-White Painted. They recognized as Proto-White Painted two rare belly-handled amphorae, one from Idalion (Furtwängler & Loeschcke 1886, pl. XXII: 160), the other from the Cesnola collection (Myres 1914, 53, no. 460), Ohnefalsch-Richter's Lapithos tomb group (1893, pl. 98), and also Lapithos Tomb 503A (Gjerstad 1944, 76, 84; Furumark 1944, 241-242). At the time, the vases from the LC IIIB burial stratum of Lapithos Tomb 503A were described as the best, but not the earliest, Proto-White Painted pottery (Gjerstad 1944, 103).

As for Kourion-*Kaloriziki* Tombs 25 and 26—which J.F. Daniel first (1937, 56-84) and J.L. Benson later (1973, 19, 34, 36) introduced as LC IIIB groups—Sjöqvist (1940,

132), Furumark (1944, 241-242) and Gjerstad (1944, 80, 82, 88), each in turn, pointed out that they were among the chronologically safe and satisfactory tombs of Cypro-Geometric IA and, as such, they did include some Proto-White Painted survivals. This is a significant point which was subsequently underlined by Angeliki Pieridou and Vassos Karageorghis, who have published nearly all the Proto-White Painted pottery that has appeared since the 1960s. Pieridou (1965) in her publication of Cypro-Geometric Tomb 74 from Lapithos stressed that since the tomb was originally used in the early Cypro-Geometric I period it was only natural that the assemblage included some Proto-White Painted vases. But how did Pieridou distinguish these few Proto-White Painted vases from White Painted I shapes which differed so little? "Proto-White Painted" she wrote "are identified by the distinct matt orange or orange-brown colour of their painted decoration" (Pieridou 1965, 105-106).

THE FABRIC

Because of the natural variations of the local clay beds and the circumstances of firing, the fabric of Proto-White Painted appears to the naked eye as either "greenish" or "brownish," certainly not different from the clay of the White Painted ware of the Cypriot Iron Age. Sometimes, the clay used to make Proto-White Painted is well sifted; however, more often than not, Proto-White Painted has small inclusions, red, black, or lime-white, and can even be very gritty. Also Proto-White Painted is not slipped but often has a distinct coating made of diluted clay, that is smoothed over the surface of the vase and provides a light matte background suited for decoration in a dark color.

Thus far, none of these factors distinguishes Proto-White Painted from White Painted. Furthermore, both wares are decorated in monochrome with a dark matte pigment. However, here lies the quality that separates Proto-White Painted from White Painted, even though the shapes are identical: it is the peculiar "behavior" of this originally matte dark washy substance which on Proto-White Painted shapes has fired, but not uniformly on any vase, into shades from light orange to brown (Iacovou 1988, 1-2). Marguerite Yon has suggested, and it is not an unreasonable speculation by any means, that this distinct color quality *may* have been the result of an intentional effort to imitate the fabric and color scheme of Mycenaean pottery (Yon 1971, 85-87). Personally, I no longer doubt that this is the case. In view of a future publication and through the kind invitation of Professor F.G. Maier, I was recently able to study various unpublished, modest groups of Proto-White Painted pottery from Palaepaphos. In addition to the usual tomb groups, there is a substantial deposit of fragmentary, settlement material from a bothros in the locality of *Asproyi*. Here, LC IIIA wares are found together with LC IIIB and Cypro-Geometric pottery, making it possible to compare locally produced Mycenaean IIIC skyphoi (Fig. 20.1; KD 171) or cups (Fig. 20.2; KD 172) with their Proto-White Painted counterparts (KD 53/32.1; KD 53/32.11). Having examined the material, I am thoroughly convinced that the potters who fabricated Proto-White Painted shapes tried, rather unsuccessfully, to achieve the fine, orange, light-color effect of local Mycenaean IIIC pottery. Their effort was relatively short-lived, like Proto-White Painted itself. The White Painted ware of Cypro-Geometric I has a uniform dull, matte black washy decoration, already apparent on vases of the late Proto-White Painted groups, such as *Xerolimni* Tomb 9 (Karageorghis 1967, 23).

REPERTOIRE OF SHAPES

Besides the quality of fabric and paint, the presence or the absence of certain shapes remains a vital criterion for differentiating LC IIIA, LC IIIB, and Cypro-Geometric I deposits. The belly-handled amphora (cf. Pieridou 1973, pl. 19) is totally absent in LC IIIA. The shape originated in the Mycenaean IIIC repertoire (e.g., Mountjoy 1986, 161) but in Cyprus it appeared first in Proto-White Painted and became the trademark of LC IIIB deposits (Iacovou 1988, 31, 41). Belly-handled amphorae remain an equally frequent shape in the White Painted and Bichrome wares of Cypro-Geometric I (e.g., Karageorghis 1983, 352).

As in the Mycenaean IIIC repertoire (Mountjoy 1986, 137-138, figs. 167-168, 161, fig. 203), the Proto-White Painted amphoriskos occurs simultaneously in various types; there is the collared-neck type, the *stamniskos* with a short and wide neck and the miniature version of the belly-handled amphora (e.g., Pieridou 1973, pls. 18, 20-21). With the exception of a rare specimen from Sinda, "probably of Rhodian manufacture" (Furumark 1965, 114, pl. I), the shape is hardly present in LC IIIA. Its *floruit* is in LC IIIB; it remains common in Cypro-Geometric I, almost exclusively in White Painted ware (Karageorghis 1983, 355) but practically disappears by the end of this period (Iacovou 1988, 34, 41).

Kylikes are certainly a common LC IIIA shape (cf. *Kition* IV, 9, pl. VII: 37), but the Proto-White Painted variety is distinct and unmistakable (cf. Pieridou 1973, pl. 5: 11-12; Karageorghis 1975, 54, pl. XXXIV). Both the kylix and the stirrup jar are Late Bronze Age shapes of Mycenaean origin that disappear by the end of LC IIIB; the large stirrup jar (Karageorghis 1975, pls. XXIV-XXV) becomes obsolete early in the course of LC IIIB (Iacovou 1988, 8). Only rare examples of the kylix and the small stirrup jar occur in early (transitional) Cypro-Geometric I tomb groups either as Proto-White Painted

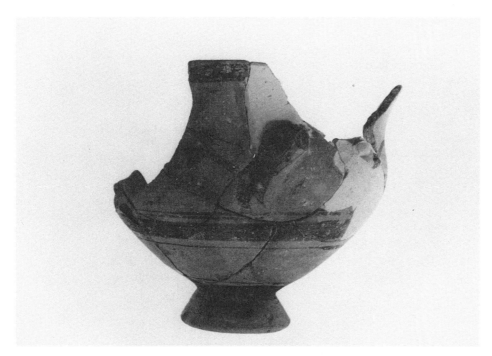

*Figure 20.1. KD 171: local Mycenaean IIIC skyphos from Palaepaphos-*Asproyi *Pit 6 (unpublished; illustrated by kind permission of Professor F.G. Maier).*

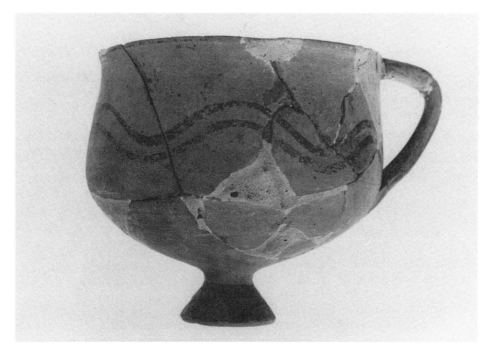

*Figure 20.2. KD 172: local Mycenaean IIIC cup from Palaepaphos-*Asproyi *Pit 6 (unpublished; illustrated by kind permission of Professor F.G. Maier).*

survivals or in White Painted ware. This is well attested in the extensive Iron Age cemetery of Palaepaphos-*Skales* (Karageorghis 1983, 356, 359). Also, neither shape occurs in the vast Cypro-Geometric assemblage of Salamis Tomb I (Yon 1971). In contrast, there are six Proto-White Painted kylikes in a small LC IIIB tomb group from Kition (Myres 1910, 107, pl. XXIX: 9-13, 16) and fragments of four Proto-White Painted stirrup jars in the LC IIIB burial stratum of Lapithos Tomb 503A (Pieridou 1972, pls. XLI: 1-3, XLIII: 43).

Kraters are not a LC IIIB shape; they become obsolete by the end of LC IIIA. However, a peculiar, large krater with pictorial decoration from the Sanctuary of the Ingot God is in Proto-White Painted (Courtois 1971, 269, fig. 106) and a smaller krater with wavy line decoration was found at Alaas (Karageorghis 1975, pl. II: 1).

No pictorial amphoroid krater is known from the Greek mainland in Mycenaean IIIC. In Cyprus, amphoroid kraters remained a pictorial shape as late as LC IIIA (e.g., *Kition* IV, pl. XIII). In LC IIIB the shape becomes rare and no specimen is known to have pictorial decoration. It occurs in Proto-White Painted (e.g., Courtois 1971, 167, fig. 16) but also in plain ware (e.g., McFadden 1954, pl. 23: 9). Its frequency remains the same in the early part of Cypro-Geometric I, but toward the end of this period amphoroid kraters in White-Painted and Bichrome ware increase in numbers and the shape begins to have a second *floruit* as a pictorial vase (e.g., Karageorghis 1983, pl. CCI); this time, however, the pictorial scene is on the neck, not on the shoulder as it had been on the Late Bronze Age shape (Iacovou 1988, 34-35, 41, figs. 27-30, 80-85).

It is also important to remember that unlike deep bowls and various types of shallow bowls (e.g., Pieridou 1973, pls. 1-4), the flat dish, namely the plate, is not found in Proto-White Painted; it did not exist in LC IIIB. It is a shape of local inspiration that appeared first in the White Painted, Bichrome and even Black Slip Painted wares of advanced Cypro-Geometric I groups (e.g., Karageorghis 1983, figs. XLVI-L). Its circulation is indeed limited to the Cypro-Geometric period (Iacovou 1988, 39).

Zoomorphic askoi and bird vases are plentiful in Proto-White Painted (e.g., Pieridou 1973, pls. 26-29), but terra cotta figurines are very rare in LC IIIB and are always associated with sanctuaries. There are, for instance, centaurs in Proto-White Painted from the Sanctuary of the Ingot God (Courtois 1971, figs. 121-127) and fragmentary animal figurines from the eleventh-century BC sanctuary at Salamis (Yon 1980, 76, fig. 3; for the complete range of Proto-White Painted shapes see Pieridou 1973 and *SCE* IV Pt.1C, 415-425).

PROTO-WHITE PAINTED BICHROME

Proto-White Painted is, as a rule, a monochrome ware and one should be careful not to misinterpret the variations of the dark paint as a second color (Iacovou 1988, 49, n. 47). However, a second, purple pigment has been observed, albeit rather rarely, on Proto-White Painted pottery. Personally, I do not believe in the use of the term *Proto-Bichrome* (*SCE* IV Pt.1C, 424; Karageorghis 1975, 46) on the analogy of Proto-White Painted because while Proto-White Painted does anticipate the White Painted ware, bichrome Proto-White Painted does not anticipate the development of the Cypro-Geometric Bichrome style. Pieridou pointed out the difference of the two techniques as early as 1966 and stated that the bichrome decoration characteristic of LC IIIB is wholly unconnected with the Bichrome style of Iron Age pottery (Pieridou 1966, 11-12).

On Proto-White Painted, the technique is as follows: matte black and purple red paints interchange symmetrically, or are combined in the drawing of every motif; it certainly looks as if the same brush was dipped into both pigments. Furthermore, the Proto-White Painted shapes on which the bichrome technique occurs are usually of Aegean origin: stirrup jars, pyxides, kalathoi, kylikes, belly-handled amphorae (Iacovou 1988, 50), or else they are affiliated with the Philistine ceramic repertoire: like the bird askoi and the ring vases (Dothan 1982, 220-227).

The Cypro-Geometric Bichrome style, on the other hand, uses the red color as secondary to the black with which it is not meant to overlap. The red is used sparingly to fill solid areas which have been carefully delineated and often outlined in black (Karageorghis 1975, 46).

It is my current belief that the Cypro-Geometric Bichrome technique was introduced to the Cypriot repertoire through the imported Near Eastern or Phoenician globular neck-ridged jug. Local imitations of this shape are numerous and are indeed a striking characteristic of the Cypro-Geometric ceramic repertoire (e.g., Karageorghis 1983, 358, 402; Bikai 1987, 58). The shape *does not* occur in Proto-White Painted deposits. The only imported shapes to be found in LC IIIB are the lentoid flasks (Karageorghis 1975, 66); and although these are sometimes decorated in two colors, they did not influence the decoration of their Cypriot Proto-White Painted counterparts which remained monochrome in LC IIIB (Iacovou 1988, 49-50). It is only later, in the Cypro-Geometric period, that we find locally produced lentoid flasks decorated in bichrome on the analogy of the imported globular and barrel-shaped jugs.

Interestingly enough, neither the Proto-White Painted pottery from the Sanctuary of the Ingot God at Enkomi (Courtois 1971), nor that from Idalion-*Ayios Georghios* Tomb 2 (Karageorghis 1965, 185-199) or *Kaloriziki* Tomb 40 (McFadden 1954, 136-137) includes

a bichrome vase. It appears that the LC IIIB bichrome technique was favored by workshops at the two opposite ends of the island. Thus, nearly half the Proto-White Painted vases from Alaas (Karageorghis 1975, 47), as well as a significant number from Palaepaphos (Karageorghis 1967, 15, no. 39, pl. I) are decorated in bichrome.

LC IIIB AND PROTO-WHITE PAINTED

We now turn to the upper limits of Proto-White Painted. The appearance of Proto-White Painted is associated with a most significant shift of settlement and cemetery sites that defines the transition from LC IIIA to LC IIIB (Iacovou 1989, 54). Proto-White Painted is not found at sites such as Pyla, Maa, Episkopi-*Bamboula*, Sinda or Hala Sultan Tekke, since these are settlements destroyed or abandoned in the course of LC IIIA. Also, Proto-White Painted is not found in earlier tombs—those constructed before LC IIIB. All the major Proto-White Painted deposits are tomb groups associated with the single use of a new tomb which is in most cases also a new type of tomb: the chamber with the long dromos (Karageorghis 1975, 25-26). Proto-White Painted is found throughout the island: at Lapithos, Salamis, *Kaloriziki*, Kourion, Idalion, Kition and Palaepaphos, namely at the sites of the historical city-kingdoms for which settlement evidence dating back to the eleventh century BC is meager but not absent (Iacovou 1989, 55-56).

There is certainly a transitional phase when all this site shifting takes place; thus, one finds at the LC II-III necropolis of Palaepaphos-*Kaminia* that just before its final abandonment at the end of LC IIIA, a few insignificant and impoverished burials took place in pits which contained only one or two vases, i.e., a Proto-White Painted stirrup jar or a juglet (Maier & Wartburg, 1985, 151). Otherwise, LC IIIB burials occur in new locations: at Palaepaphos-*Xerolimni* (Maier 1973, 77) and at *Lakkos tou Skarnou* (Maier 1970, 79).

Likewise at Enkomi, the Sanctuary of the Ingot God appears to have survived and functioned a while longer than the rest of the site, in a deserted city, the inhabitants of which had moved to Salamis where they promptly established a new sanctuary (Yon 1980, 76). As I have pointed out elsewhere, the Proto-White Painted material found in the Sanctuary of the Ingot God indicates a short early phase representative of the transition from LC IIIA to LC IIIB (Iacovou 1988, 8-9, 46).

At Kition, which is so far the only excavated settlement which was not abandoned in LC IIIA, Proto-White Painted begins to occur in Area II after the destruction of Floor III which dates to the later part of LC IIIA (*Kition* V, 266). However, neither a LC IIIB nor an early Cypro-Geometric burial was ever found to reuse earlier Bronze Age tombs at Kition. Proto-White Painted pottery

(Myres 1910) has been found in tombs located outside the city walls in Sotiros quarter (*Kition* I, 95) which became the established necropolis in early Cypro-Geometric I. Thus, we can conclude that like Palaepaphos, Kition established new burial grounds after LC IIIA.

THE "WAVY LINE" ISSUE

Now let us face the confusion caused by skyphoi and cups decorated with wavy lines. As mentioned above, in 1944 Gjerstad and Furumark agreed on the corpus of Proto-White Painted. In the 1960s, after Furumark had dug Sinda and Dikaios was working at Enkomi, Furumark noticed the presence of wavy line style pottery at Enkomi and its absence at Sinda. He proceeded to define this local Mycenaean IIIC pottery as the equivalent of early Proto-White Painted (Furumark 1965, 99-116). Besides the fact that by this he literally hand-picked these deep bowls from their proper context, which is Enkomi Level III (*Enkomi* I, 270-271), the profile and the overall shape of these skyphoi (Fig. 20.1) and cups (Fig. 20.2) is different from that of their Proto-White Painted counterparts, even if some of them begin to have a conical foot (Pieridou 1973, pl. 33, 1-4).

Furthermore, it is important to notice that Proto-White Painted deep bowls rarely carry wavy line decoration. They are instead decorated with simple wide bands, especially at Alaas (e.g., Karageorghis 1975, pl. XVIII). Certainly, however, the situation can be confusing when one deals with mere fragments of skyphoi and cups. A complete profile is necessary for the identification of a footed cup since it remains virtually the same from LC IIIA to the Cypro-Geometric I period and retains the wavy line decoration (e.g., Maier 1970, pl. X: 3; Karageorghis 1975, pl. XVI: 1).

What I wish to stress is that Enkomi Level III did not produce Proto-White Painted. The wavy line skyphoi and cups of Enkomi Level III are local Mycenaean IIIC style pottery. Dikaios, disagreeing with Furumark, regarded local Mycenaean IIIC pottery decorated with wavy lines and Proto-White Painted as two distinct ceramic entities. For this reason, he clearly stated that Proto-White Painted belonged to the stage which came immediately after Enkomi Level IIIC (*Enkomi* II, 495). Furthermore, he stressed that Level IIIC was a mere extension of Level III B (*Enkomi* II, 493-494) and that some wavy line pieces "foreshadowed Proto-White Painted types" (*Enkomi* II, 492). Therefore, the destructions and rebuildings within Enkomi Level III are totally irrelevant to the development of the pottery which is a mixture of Mycenaean IIIC and local types. Thus, Enkomi Level III represents a single cultural phase which is LC IIIA and no part of the level should be assigned to LC IIIB.

DEFINITION OF PROTO-WHITE PAINTED

Proto-White Painted as a repertoire of shapes is a very fine blend, an amalgamation of Aegean, local Cypriot and even Philistine (Mazar 1985) ceramic traditions. The polymorphy of the painted pottery of LC IIIA that tortures us in search of a common term (Iacovou 1988, 27, 80, 84) is put to rest once Proto-White Painted appears. Its appearance marks the coming together of all the earlier painted wares of LC IIIA. Proto-White Painted could not have been suddenly imported to Cyprus by newcomers (Jones 1986, 595); it was the result of a local amalgamation.

However, the range of shapes that form the basic Proto-White Painted repertoire suggests that Proto-White Painted was to a great extent a derivative of Mycenaean IIIC Middle and consequently a contemporary of Mycenaean IIIC Late, as these phases are now defined by the Aegean material (Mountjoy 1986, 155, 181). Thus, the relative date for the inception of Proto-White Painted depends to a great extent upon its correlation with the subdivisions of Mycenaean IIIC in the Aegean, making the Middle phase of Mycenaean IIIC a *terminus* following which Proto-White Painted began to be produced in Cyprus.

On the other hand, unlike the Greek mainland and the Aegean islands, Cyprus did not reach the Submycenaean stage stylistically or chronologically. According to currently available absolute dates (Mountjoy 1986, 8), around the middle of the eleventh century BC, Submycenaean superseded Mycenaean IIIC Late. At that point in Cyprus, LC IIIB ends and Proto-White Painted is gradually replaced by the White Painted ware of Cypro-Geometric I with which it shares at first many similar shapes.

REFERENCES

Benson, Jack L.
1973 *The Necropolis of Kaloriziki*. SIMA XXXVI. Göteborg.

Bikai, Patricia
1987 *The Phoenician Pottery of Cyprus*. Nicosia.

Courtois, Jacques-Claude
1971 Le Sanctuaire du Dieu au l'Ingot d'Enkomi-Alasia. In *Alasia I*, by C.F.A. Schaeffer, pp. 151-325. Paris.

Daniel, John F.
1937 Two Late Cypriote Tombs from Kourion. *AJA* 41, 56-84.

Dothan, Trude
1982 *The Philistines and their Material Culture*. New Haven, Connecticut.

Furtwängler, Adolph & G. Loeschcke
1886 *Mykenische Vasen*.

Furumark, Arne
1941 *Chronology of Mycenaean Pottery*. Stockholm.

1944 The Mycenaean Pottery and its Relation to Cypriote Fabrics. *OpArch* III, 194-265.

1965 The Excavations at Sinda: Some Historical Results. *OpAth* 6, 99-116.

Gjerstad, Einar
1926 *Studies on Prehistoric Cyprus*. Uppsala.

1944 The Initial Date of the Cypriote Iron Age. *OpArch* III, 73-106.

Iacovou, Maria
1988 *The Pictorial Pottery of Eleventh Century B.C. Cyprus*. SIMA LXXIX. Göteborg.

1989 Society and Settlements in Late Cypriote III. In *Early Society in Cyprus*, edited by E. Peltenburg, pp. 52-59. Edinburgh.

Jones, Richard E.
1986 *Greek and Cypriot Pottery: a Review of Scientific Studies*. Fitch Laboratory Occasional Paper I. BSA. Athens.

Karageorghis, Vassos
1965 Idalion-*Ayios Georghios*, Tombe 2. In *Nouveaux documents pour l'étude du Bronze Récent à Chypre*, pp. 185-199. Paris.

1967 An Early XIth Century B.C. Tomb from Palaepaphos. *RDAC*, 2-24.

1975 *Alaas. A Protogeometric Necropolis in Cyprus*. Nicosia.

1983 *Palaepaphos*-Skales. *An Iron Age Cemetery in Cyprus*. Nicosia.

Maier, Franz-Georg
1970 Excavations at Kouklia (Palaepaphos). *RDAC*, 75-80.

1973 Evidence for Mycenaean Settlement at Old Paphos. In *Acts* 1973, 68-78.

Maier, Franz-Georg and Marie-Luise von Wartburg
1985 Reconstructing History from the Earth, c. 2800 B.C.-1600 A.D. Excavating at Palaepaphos, 1966-1984. In *Archaeology in Cyprus 1960-1985*, edited by Vassos Karageorghis, pp. 142-172. Nicosia.

Mazar, Amihai
1985 The Emergence of the Philistine Material Culture. *IEJ* 35, 95-107.

McFadden, George H.
1954 A Late Cypriote III Tomb from Kourion-*Kaloriziki* no. 40. *AJA* 58, 131-142.

Mountjoy, Penelope Anne
1986 *Mycenaean Decorated Pottery: A Guide to Identification*. SIMA LXXIII. Göteborg.

Myres, John L.
1899 *A Catalogue of the Cyprus Museum*. Oxford.

1910 A Tomb of the Early Iron Age, from Kition in Cyprus. *AnnLiv* 3, 107-117.

1914 *Handbook of the Cesnola Collection of Antiquities from Cyprus*. Metropolitan Museum of Art, New York.

Ohnefalsch-Richter, Max
1893 *Kypros, die Bibel und Homer*. Berlin.

Pieridou, Angeliki
1965 An Early Cypro-Geometric Tomb at Lapithos. *RDAC*, 74-111.

1966 A Tomb Group from Lapithos Ayia Anastasia. *RDAC*, 1-12.

1972 Τάφος υπ'αρ. 503 εκ Λαπήθου Αγία Αναστασία, *RDAC* 237-250.

1973 Ο ΠΡΩΤΟΓΕΩΜΕΤΡΙΚΟΣ ΡΥΘΜΟΣ ΕΝ ΚΥΠΡΩ. Athens.

Sjöqvist, Erik
1940 *Problems of the Late Cypriote Bronze Age*. Stockholm.

Yon, Marguerite
1971 *Salamine de Chypre II. La tombe T.I du XIe s. av. J.-C*. Paris.

1980 La fondation de Salamine. In *Colloques Internationaux du CNRS Salamine de Chypre: Histoire et Archeologie*, pp. 71-80. Paris.

Walters, H. B.
1912 *Catalogue of the Greek and Etruscan Vases in the British Museum I, Part II*. London.

XXI

Regional Classification of Cypriot Terra Cottas

Annie Caubet and Marguerite Yon

Like many archaeological museums, the Louvre houses an important collection of Cypriot terra cotta figurines from the Chalcolithic through the Roman era. The collections are old;[1] some pieces were brought from Cyprus in a "pre-scientific" epoch, and others came by way of the marketplace, as gifts and the like. It is difficult to organize and classify such abundant amounts of material, because at the Louvre as at most large museums, these types of objects often lack information about their provenience and date.

The Louvre is currently in the process of publishing the figurines.[2] In order to facilitate this project, we have adopted the methods used for ceramic classifications, of which coroplasty is but one practical aspect. As in the case of vases, various criteria are used to order and classify the figurines:

1. Provenience
2. Date of context
3. Manufacturing technique
4. Material (paste, paint, etc.)
5. Iconography
6. Style

The first rough division of categories is based, in a somewhat subjective manner, on a general impression which implicitly takes account of all the criteria, especially the iconography and style. Thus, the figurines in the Louvre have been divided into accepted categories such as, for example, Archaic or Hellenistic. Thanks to recent Chalcolithic discoveries in Cyprus, we have been able to identify a figurine that actually belongs to the Chalcolithic period among a group of Roman terra cottas (Caubet 1974, 35-37). This first division is, of course, not precise enough, and a truly scientific approach must be applied in order to further subdivide these large assemblages.

Very often, provenience and date elude us. There are, however, some exceptions which are of primary importance in the classification process because they enable us to attribute a particular group to a specific region.

The physical description of the material remains partially subjective, except when expensive physico-chemical analyses are used. Regardless of price, however, it is not always possible to conduct such analyses on figurines because it is difficult to sample museum objects, especially those which are often small. Archaeometric procedures will eventually be carried out, but they can be done only after the classification has been sufficiently developed to allow the selection of representative samples.

Iconography can provide a convenient criterion when examples of a motif are limited, such as figurines with "ram's horns" characteristic of "Baal-Hammon Cypro-Archaic." On the other hand, certain series are abundantly represented, such as the innumerable "women with child"—a motif that appears extensively throughout three millennia (see Karageorghis 1977). In this case, although there are a large number of objects with an identical theme, they vary in style, and thus do not permit ready classification.

Within large groups defined mainly by period, we have chosen to attempt regroupings based on manufacturing techniques and procedures. Stylistic or archaeometric criteria were used to refine the classifications, and confirm the regional regroupings which become apparent for Cypriot sites. One such group is obvious for the Iron Age, the period which is best documented. Examples of this group are presented here to illustrate actual ongoing work from the Archaic series. These have already permitted attributions to certain regions of the island.

1. Acquired essentially in the last years of the nineteenth century.

2. By the authors of the present work, in collaboration with F. Vandenabeele, A. Hermary and A. Queyrel.

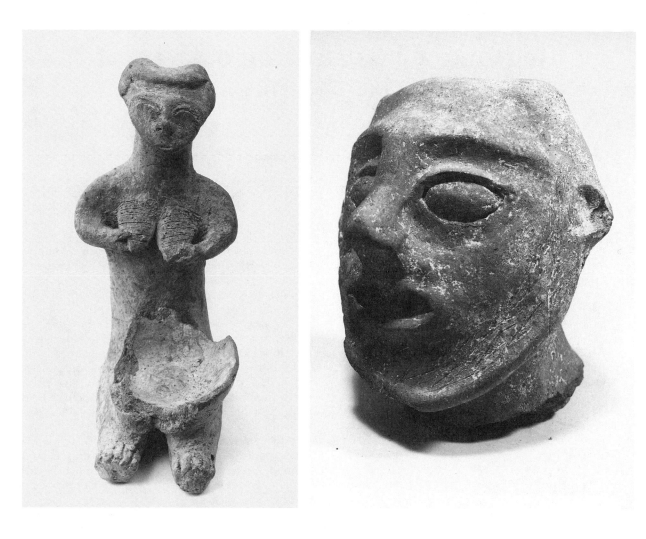

Figure 21.1. Chalcolithic terra cottas (Louvre Museum): a) AM 1176; b) AM 1144.

A similar approach would clarify the less understood assemblages from earlier periods, such as the Chalcolithic and Bronze Age, and allow them to be attributed to specific regions of the island. Already, the comparison of the Louvre's Chalcolithic terra cottas (Fig. 21.1), reputed to have come from the region of Alaminos in the southeast (Caubet 1974; Vagnetti 1974), with recent discoveries from Kissonerga in the southwest (Peltenburg 1988, figs. 61-62) shows evidence of great differences. These differences may be due, in part, to slight differences in date, but also, and more especially to regional variations. In the same way, it will be proven that the products which appear at Enkomi at the end of the Bronze Age, *ca.* 1100 BC (see Courtois 1971, 280-308 for centaurs, 326-356 for small idols), are totally unrelated to the traditional figurines of the late Bronze Age known

from other sites and tied to the Base-Ring technique. This is also true for female figures, as seen in the comparison of the small, black-painted idols and goddesses with flat heads, and for quadrupeds such as bulls (e.g., Kazaphani) contrasted with the two-headed centaurs of Enkomi (Fig. 21.2). Here again, the difference is partially explained by chronology, but also by the individual features of a workshop, with the same difference discernible between hand modelled techniques (Base Ring) and those which are wheelmade (painted ware).

It is our purpose, in the framework of this conference, to present a methodological approach so that its application to a series from the Iron Age (much more abundant, in the Louvre as elsewhere, than more ancient groupings) will allow a better understanding of the terra cottas of the Bronze Age.

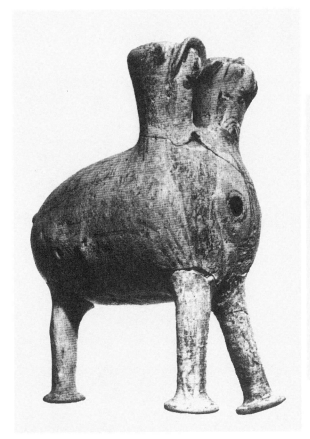
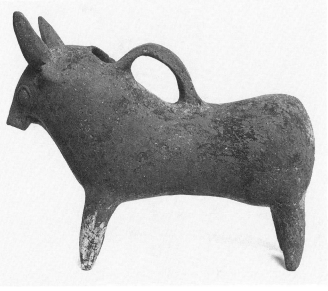

Figure 21.2. a) Painted terra cotta centaur from the Late Bronze Age (Courtois 1971, fig. 127); b) Terra cotta bull (Base-Ring) from the Late Bronze Age (Louvre Museum MNB 105).

CYPRIOT COROPLASTIC STUDIES: STATE OF THE QUESTION

In Volume II of the *Swedish Cyprus Expedition*, Gjerstad studied terra cotta statues of the Iron Age, along with other sculptures, in their iconographic and stylistic aspects, with special attention to large scale figures. He did not consider them for what they were, that is, as products specially tied to a particular material, in this case terra cotta. Thus, he avoided the technical criteria and the special constraints of the basic medium. Moreover, he also set aside the small figurines, which however, constitute the vast majority of the output.

Nevertheless, his pioneering work defined two principal areas of sculptural activity for the Iron Age: one region comprised the north and west of the island, marked by Egyptian and Syrian influence. The other region comprised the east and south, encompassing a large share of the sites from the center of the island, such as Idalion and Tamassos, which are characterized by Ionian influences.

More recently, G. Schmidt (1968, 127, pl. 14) analyzed the Cypriot terra cottas found at Samos, basing his work on manufacturing techniques and dates determined by excavational context. He clearly posed the question of the precise origin of these figurines. Reconsidering Gjerstad's proposed partition of the island into two zones, Schmidt enumerated the objects with known contexts. For the first group (north and west), he included objects from Ayia Irini, Vouni, Mersinaki, Palaepaphos, and Kourion. He also noted the resemblances between certain statues from Ayia Irini and from Samos.

For the second group (east and south), it is with Achna, Salamis, Idalion and especially Arsos that the most numerous comparisons can be established between

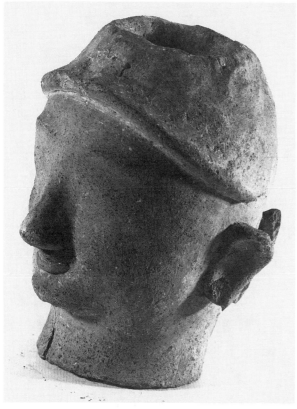

Figure 21.3. Terra cotta head from Kythrea (Louvre Museum AM 3678, di Cesnola 1894, Vol. I, pl. XVIII, 132).

Cyprus and the finds from Samos. A parallel can also be drawn for an example from Aradhippou near Kition (Cesnola 1894, pls. 29, 235).

According to Schmidt, the transition between the two zones would have been at Amathus, where one acknowledges that the Eteocypriot traditions persisted for the longest time.

The question of Cypriot terra cottas has evolved thanks to monographs devoted to the finds from systematically excavated sites. The first was the publication of the terra cottas from Kourion (Young & Young 1955) followed by the monograph on the small, hand modeled terra cottas from Salamis (Monloup 1984), which provided a background for the consideration of large scale terra cotta sculptures; until then, they were the only ones known from Salamis (Tatton-Brown 1980). Recently, the terra cottas from Amathus have been studied and published by Vassos Karageorghis (1987). But these groups seem, without exception, to be the individualized and sharply defined local products of workshops

with characteristics which are stronger than their affiliation with the larger groups as proposed by Gjerstad.

Following on these works, we have undertaken the study of the abundant material housed in the Louvre Museum, for which the provenience and context are frequently unknown. We have already attributed a certain number of pieces to specific workshops, and, by elimination, identified and localized other groups with the help of scanty indications of origin or by comparing them with series in other museums. Thus, workshops of Cypro-Archaic II have been recognized at Lapithos (Yon & Caubet 1988), others at Kition (Yon & Caubet 1989), and finally a Nordic group specifically at Kythrea (Caubet 1991). In the last case, the question was, first, to identify a small local workshop, second, to link it to a broader ensemble. This leads to a reconsideration of the partition of the island into two large zones formerly proposed by E. Gjerstad.

AN EXAMPLE OF A WORKSHOP IN THE NORTH AND WEST ZONE

The Louvre houses three large heads from the Cesnola collection, which have been identified as being from Kythrea, a site on the southern slope of Pentadaktylos (Cesnola 1894, pl. 18). They are beardless masculine heads, wearing a tight cap or helmet (Fig. 21.3). They are characterized by their rather soft rose-beige clay, and by their method of manufacture: they are coiled so as to form a sort of cylinder onto which lumps of clay were affixed to indicate details of the hair, nose and ears; additional facial features are hand modeled. Traces of slip indicate that the surface must once have been painted.

The style of these heads is characterized in a striking fashion by the absence of a genuine plastic treatment of the eyes and eyebrows. A simple swelling marks the placement of the eyes, while the outline and pupil are indicated by paint, as is the arch of the eyebrow (see Yon 1991). A comparable example from the Louvre, without provenience, still has the paint on the eyes.[3] In contrast, the mouth and nostrils were carefully cut into the surface with a sharp instrument, leaving acute angles. The contrast between the features which are merely painted and those which are sculpted is characteristic of this group.

When looking for parallels for the sculptures found in the north of Cyprus, one first turns to the various groups of large terra cotta statues known from the north and east regions: Salamis, Tamassos, Idalion, etc. There is, however, no resemblance that allows them to be integrated into that group. On the contrary, if one looks to

3. Inventory AM 812, donated by Jones Ponty to the Louvre in 1899.

the Bay of Morphou in the northwest, one will find in the Ayia Irini assemblage (*SCE* II, 642-824), alongside some dissimilarities (a shorter and wider nose at Ayia Irini, for example), a number of features in common with our group from Kythrea: the same types of votaries wearing a tight helmet (iconographic criterion), the same globular eyes without delineation of plastic detail, the same cut-away lips and nostrils (technical criteria).

The site of Limniti, also located in the northwest, furnishes obvious parallels with the examples from Kythrea (Tubbs 1890, fig. 11), exhibiting the same type of images—men's heads with tight caps and also the contrast between gently hand-modeled globular eyes, with the mouth and nostrils cut away at sharp angles.

The occurrence of relations between Kythrea and the sites of the Bay of Morphou is not surprising since communications were easy across the Ovgos Plain. Parallels between this group and the southwest region of the island, because of the obstacle posed by the Troodos Mountains, are more surprising. However, some of the statues recently discovered at Maa (Karageorghis 1988, 852, fig. 95) also show clear resemblance with our Kythrea group.

These stylistic comparisons between Maa on the one hand and Ayia Irini and Limniti (and Kythrea) on the other, lead us to consider the diffusion of styles and the modes of representation in the western part of the island. We must content ourselves here with merely raising the problem (the Maa collection will be published soon by the excavator). One might expect, however, that when these pieces are available, they may show close links which unite this group with that of Ayia Irini: the range of offering types is identical, as is the diversity of formats, with the noteworthy presence of large scale statues. It seems, therefore, from the point of view of coroplasty that there exists a true unity in the western part of the island, from Paphos to the Bay of Morphou. But the frontier is not well delimited, and the little group noted at Kythrea may be considered an eastern extension of that assemblage.

THE EASTERN GROUP

For the large scale terra cotta sculptures, there is a striking difference between the characteristics of the western group, which we have just defined, and those of the Idalion series (Fig. 21.4), as seen, for instance, in the examples now in the Louvre or those in Nicosia, Copenhagen, London and Berlin (e.g., De Ridder 1908, 142-147, nos. 125-127, pls 23-24; Walters 1903, 40, A 231). These are characterized by the abundance of decorative detail of the hair, eyebrows carefully delineated and drawn like raised plant leaves or feathers, enormous eyes emphasized by a thick swelling, and the strong nose. These same characteristics also appear at Salamis in the

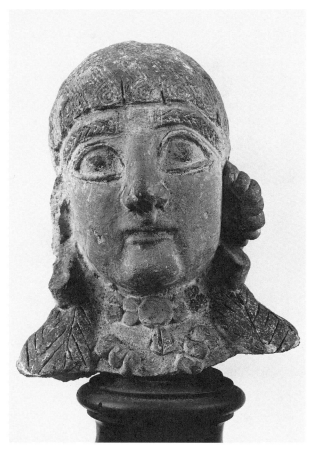

Figure 21.4. Terra cotta head from Idalion (Louvre Museum AO 22233; De Ridder 1908, pl. XXIII, 125).

collection from the sanctuary outside the walls known as "Toumba," (Tatton-Brown 1980, 63-64, figs. 2-7) and also at Tamassos-*Phrangissa* which, however, is located at the center of the island.

The small figurines, more numerous and popular, are less easily classified. However, the work of T. Monloup (1984) has recently shown that local production, exemplified by the piece at Salamis, clearly stands apart from other products.

WORKSHOPS NOT ASSIGNABLE TO EITHER GROUP OR ZONE

In his stylistic and regional classification, Gjerstad considered Amathus an exception because, according to him, it did not fall into either of the major stylistic zones of the island. He attributed the unique character of this site to the permanent Eteocypriot elements to which the texts bear witness. On the other hand, for reasons of technique and manufacture, we were led to recognize also a group at Kition (in the south of the island), and another from Lapithos (in the north). It is at Kition, for example, that the use of a mold with a double valve first

occurs and where the only evidence of the mixed technique consisting of a molded head placed on a wheel-made body was observed.

It seems impossible, however, to assign Lapithos, much less Kition, to one of the two stylistic zones previously proposed. Kition does not belong to the eastern group of Idalion/Salamis; the products from Lapithos are very different from those at Ayia Irini situated a short distance away. This originality may be due to the fact that Kition had a very strong Phoenician presence as early as the end of the ninth century; Phoenician influence is, as far as terra cotta technique is concerned, perceptible with the appearance in the sixth century of new uses of the mold as well as in iconographic choices. Lapithos is also a site with a Phoenician presence. It is certain that a large part of the specific character of these two sites can be attributed to the Syro-Palestinian influence.

Thus, the examples at Amathus, Kition and Lapithos demonstrate that the concept of a simple stylistic division of the island into two zones does not make allowances for the diversity of workshops. Nuances and variations must be taken into account.

CONCLUSION

Regional classification according to techniques, etc., has given convincing results for the examples which we have considered, permitting us to define evidence of the specific characteristics and origins of workshops and groups of workshops. This type of inquiry shows, at the same time, the importance of nonceramic data in the interpretation of production workshops. The extension of the method to earlier coroplastic assemblages for periods less well known from historic documents (e.g., the Bronze Age) would allow classifications to be refined, but above all it calls for great care and precision in the interpretation of the facts.

REFERENCES

Caubet, Annie

1974 Uneterre cuite chalcolithique au Louvre. *RDAC*, 35-37.

1991 Recherche sur les ateliers de terre cuite de la partie occidentale. In *Cypriote Terracottas. Proceedings of the First International Conference of Cypriote Studies, Bruxelles 1989*, edited by F. Vandenabeele, pp. 109-114. Brussels.

Cesnola, L.P. di

1885-1903

A Descriptive Atlas of the Cesnola Collection of Cypriote Antiquities in the Metropolitan Museum of Art, New York. New York.

Courtois, Jacques-Claude

1971 Le sanctuaire du dieu au l'ingot. In *Alasia* I, by Claude Schaeffer, pp. 151-362. Paris.

de Ridder, A.

1908 *Collection de Clercq, V. Les Antiquités chypriotes*. Paris.

Karageorghis, Jacqueline

1977 *La Grande Déesse de Chypre et son culte*. Lyon.

Karageorghis, Vassos

1987 The Terracottas. In *La nécropole d'Amathonte III*, edited by Vassos Karageorghis, O. Picard, and C. Tytgat, pp. 1-52. Nicosia.

1988 Distrait de Paphos. In Chronique des fouilles, by Vassos Karageorghis. *BCH* 112, 849-855.

Monloup, T.

1984 *Salamine de Chypre XII. Les figurines de terre cuite de tradition archaïque*. Paris.

Peltenburg, Edgar J.

1988 Kissonerga-*Mosphilia*. In Chronique des fouilles, by Vassos Karageorghis. *BCH* 112, 819-823.

Schmidt, G.

1968 *Kyprische Bildwerke aus dem Heraion von Samos*. Samos VII. Bonn.

Tatton-Brown, Veronica

1980 The Tubbs-Munro Excavations. *Actes du Colloque Salamine de Chypre, Lyon 1978*. Paris.

Tubbs, H.A.

1890 Excavations at Limniti. *JHS* 11, 82-99.

Vagnetti, Lucia

1974 Preliminary Remarks on Cypriot Chalcolithic Figurines. *RDAC*, 24-34.

Walters, A.H.

1903 *British Museum Catalogue, Terracottas*. London.

Yon, Marguerite

1991 Techniques de décor dans la coroplastie. In *Cypriote Terracottas. Proceedings of the First International Conference of Cypriote Studies, Bruxelles 1989*, edited by F. Vandenabeele, pp. 241-246. Brussels.

Yon, Marguerite & Annie Caubet

1988 Un culte populaire de la Grande Déesse à Lapithos. *RDAC*, 1-16.

1989 Ateliers de figurines à Kition. In *Acts of the Classical Colloquium Cyprus and the East Mediterranean, London 1988*, edited by Veronica Tatton-Brown, pp. 29-43. London.

Young, J.H. & S.H. Young

1955 *Terracotta Figurines from Kourion in Cyprus*. Philadelphia.

XXII

Techniques of Village Pottery Production

Lucy MacLaurin Hemsley

"Shall the thing formed say to him
that formed it
'Why hast thou made me thus?'
Has not the potter power over the
clay?''

(Romans 9: 20-21)

In Cyprus the reverse of the above quotation is also true. Many foreign potters coming to work on the island find the local clay impossible to use and so import it from abroad. The contrast between this position and the remarkable achievements of the ancient potters using the same clay is striking. Therefore, a study of how the present day Cypriot potter uses the clays of the island should add to our understanding of how potters of the past were able to use the clays to such effect.

The clays of Cyprus require considerable preparation before use and the actual firing of the finished product needs much care. Many Cypriot clays are marls, gray to brown in color and are calcareous. In the case of large grains or granules of lime, this can lead to lime blowing in firing, but often the carbonate appears to be finely dispersed. Calcite decomposes at about 900° C; at higher temperatures there may be a rapid body collapse, especially when montmorillonite is present.

Another major clay type in Cyprus is *terra rossa* which contains substantial amounts of secondary iron oxides and little carbonate. It is often found on the island already mixed with soil, for example, at Stavrovouni and Phini.

There is a third clay group containing kaolinite, which is the chief constituent of most high grade clays. It is only occasionally found in Cyprus (Bear 1963, 155), but where it does occur it is still very rich in montmorillonite.

With few exceptions all the Cypriot clays contain quantities of montmorillonite, a constituent of bentonite (Shepard 1971, 8). This provides the plasticity needed for such intricate work as the forming of tiny ceramic figures and is a great asset for the potter with imagination. Furthermore, it enhances the dry strength of the prefired ware, thus allowing such preparation as the scraping of the vessel walls at the leather hard stage to make them finer, thereby speeding up the rate of water loss. Owing to its distinctive plate-like structure,

montmorillonite absorbs water between its molecular layers, which accounts for its excessive swelling when wet. However, and this is of supreme importance to the Cypriot potter, the plates also absorb water soluble salts from the soil which modify the properties of the mineral.

When the vessel is fired, steam builds up between the plates causing them to crack, warp or explode. However, the addition of nonplastic materials such as soil, temper and mica enables the water to be lost over a long period at a low temperature and the shrinkage of the vessel is thereby lessened. Furthermore, the water between the plates evaporates, allowing the firing to be completed quickly. Successful blending is the result of experimentation and experience. Therefore, a study of the problems facing those who work with Cypriot clays now, together with their solutions to these difficulties, should add to our knowledge of the ways in which ancient potters coped with the same media to produce their pastes and vessels.

In the late 1970s, with the help of Judith and Andreas Stylianou, I interviewed a number of Cypriots working with island clays. These comprised three groups of potters: those working for the tourist trade, which included both refugees from the north and established potters; village potters who worked with the tradition of generations behind them; as well as brick makers who fired coarse clay in vast quantities. I did not interview the tile makers nor did I manage to interview all the potters working on the island at the time. Those interviewed worked in three areas: the central plain area situated around Nicosia, the Limassol area, and the Paphos area. Because this research was conducted in the late 1970s, many had recent experience working the clays from the Kyrenia area.

There was a great deal of experimenting on the part of the refugee potters from the north who wished to continue working for the tourist trade. After 1974, in order to start his new pottery, Moeses of Yerassa obtained

his clay from sites already used by local potters and brick makers. He used a very pale gray clay from Yerassa village, which he considered very like that which he had formerly used from Vasilia on the northern flank of the Kyrenia range; a white clay from Kalohorio; and a clay from just to the north of Limassol. These he mixed: one part of the first, to eight parts of the second, to four parts of the third. The clay from Yerassa was well known and was used by other potters and the Limassol Brick and Tile Company. A Knossos potter, Costas Mastraphas, mixed five parts of white clay from Tala village in Paphos, to one part of gray clay from Yerassa to one part of red soil from west Limassol. The Yerassa clay has a soapy feel, possibly the result of seams of serpentine forming a soft talc-like rock in the clay. Moeses fired his clay up to 850° C. and, although the same clay bed was used by different potters, each followed his own recipe by mixing this clay with clay and soil from other sources according to his or her individual requirements and taste.

The Kornos pottery workshop, which has become well known among tourists, is situated near Limassol and does not use the Yerassa clay at all. The potters specialize in producing a coarse red pottery used for everyday items such as water jugs. They also use this clay for modeling. It is as rare to find this coarse type of clay and unrefined soil used in the manufacture of present day finer wares as it was in those of the past. The paste when excavated is already a mixture of soil and clay and contains montmorillonite. This moist *homa* is allowed to stand overnight or for several days to allow an even moisture content. The firing range is from 600° C to a maximum of 1080° C; at the higher temperatures the ware in most cases shows distortion and slumping.

Skopolitres pottery in Ypsonas village mixes two clays on a 50:50 basis, one from Tseri near Nicosia and one from Kalohorio, a village in the foothills of the Troodos north of Limassol. Skopolitres was the only potter in the area whom I interviewed whose trade was not tourist oriented. Just as most of the potters in Limassol were working for the tourist trade, the potters I interviewed in Nicosia were more interested in producing pots for neighbors, that is, for daily use.

Peter's Pottery at Dhali also uses the clay from Stavrovouni. Although the potter claims this is not from the same bed as that used by the Kornos pottery, he recognizes the material as a mixture of clay and soil. He mixes one part of this to seven parts of local clay from the Yialias River in the village of Nisos, which he sifts with water. I spoke to Peter quite soon after the invasion and at the time he was mixing all this with three parts of clay from Panagra and one-half part of "ball" clay, i.e., black clay from Karmi. Both these sites are in the foothills of the Kyrenia range. The clay from Panagra fires red at a low temperature and whiter as the temperature mounts.

Ball clay, Peter told me, is black and becomes red on firing. It is very plastic and not good for firing. It is found above Karmi in the Kyrenia range and at Karmi and is often used for roofing there. Peter mixes these four different clays in a concrete mixer and after the clay is wedged it is ready for throwing.

A number of the potters working in and around Nicosia used clay from Karmi. Kyrillos' pottery uses white clay, which he claims is the best in the city, from opposite the Secretariat Building in Nicosia. He mixes this in a ratio of three to one with sieved red soil. He gets red clay for slip from Kornos or Phini, which he soaks before pouring away the surface mud. He formerly obtained his slip from Ayios Dhimetrianos (east of Kythrea) which, like the clay at Kornos, has soil mixed with it. White slip came from the gray soil in the Kyrenia range above Karmi.

Nicos Georgiou Kalchas, who works on the old Larnaca Road near Eylenja, uses a mixture of four parts of *homa* to six parts of clay. The clay that he once used from Vasilia in the north was gray and fired to red. Now he gets his clay from as deep beneath Nicosia as he can, usually obtaining it from the bottom of foundation holes dug for blocks of flats. The deeper he goes, he claims, the purer it is. The clay on the surface in Nicosia is too hard and does not dissolve easily in water. The *homa* comes from Tseri, about six miles south of Nicosia, a source which is used by brickmakers as well as by potters.

Panayiotis Barbas, who also works in Eylenja, uses a light gray clay which has hardened to a stone-like state and contains fossils; it has white patches which he calls "asbestos" and yellow patches which he calls "ferric oxide." This he mixes 50:50 with soil which he digs from as deep beneath Nicosia as he can; it is silty, has no stones and very little clay. He prepares the clay by crushing the rock with a wooden hammer and mixing it with the silty soil and water, before leaving it all night. The next morning he puts it into a sausage machine which pressurizes it and presents the clay ready for use.

Both of Panayiotis' slip clays are red. The first he finds near Mari in Limassol; he refers to it as "black clay" (*mavros konos*) and says it is very like Karmi clay. It becomes very thin when mixed with water. The second slip clay is white and is found near Yerassa in Limassol; this he mixes with water-sieved red soil to produce a red slip.

Panayiotis' kiln burns wood charcoal. He fires between six a.m. and nine p.m., so that it is dark by the time the final hour comes and he is able to see the color of the fire at the top of the dome. At the beginning, he uses very little fire and builds up the temperature slowly to 350° C over a period of about twelve hours; the pots are black at this point. He then raises the temperature to 1050° C within one hour and the pots become red. To obtain the

required heat he shovels burning charcoal into the oven and opens the door and the holes (*fanos*) near the top of the oven dome to create a draft. He keeps the holes glowing red and, after approximately one hour, the fire visible in the holes becomes silver-red, an indication that the pottery is ready. He then stops adding charcoal and lets the oven cool for twenty-four hours before removing the vessels.

Panayiotis Eleia from Kakopetria gets his white clay, which has sand in it, from Eylenja. He adds soil to the clay and colors it at the same time by putting red soil in a sieve and pouring water through it.

The last of the three regions is the Paphos area. In the late 1970s there were two potters working in Phini. The first got his clay from Ayios Nikolaos tis Paphos, locality *Mandres*. He mixed the clay about 50:50, according to the texture, with clayey soil he dug in Phini near the school. He then sieved this and added water. Although he normally prepared the clay, it was his wife who made it into fairly coarse pots. They also used to produce pithoi and roof tiles, but had not done so for quite some time.

The second potter from Phini, Sofronia, fired more regularly. She did not mix anything with her terra rossa from Ayios Nikolaos-*Mandres*, and maintained that her secret lay in the method of her firing. First she smoked the vessels outside at a very low temperature for four or five hours before putting them in the oven with a large quantity of wood. The firing went slowly at first but ultimately reached a high temperature. Initially the pots turned black from the smoke, but when higher temperatures were reached the blackness disappeared. When the pots turned red she let the fire die out. Her son said that she used to get her clay, which was red and appeared to be a mixture of clay and soil, from Phini-*Bines*; she used the clay as she dug it, after adding water.

In Kaminaria, Militiades Constantinou and his wife—in their spare time and only between June and October—make vessels, such as kleftiko pots for use in the village. He gets his clay from between Phini and Kaminaria, next to the Elea bridge. He takes red clay/soil and more sandy red soil from the same place and mixes them together equally; he says the red clay cracks when fired without additive. He then beats the clay, sieves it, mixes it with scrapings from other pots to make "more of the mixture;" then he adds water until he obtains the required consistency. Although he does sieve the soil and clay, he says it does not need washing. He makes both large and small pots from the same texture of clay. He fires the pots at a very low temperature so that they are smoking only from six a.m. until eight-thirty p.m. After this, he fills the kiln twice between eight-thirty and ten p.m. with burning charcoal, thus increasing the heat. At first the vessels are black from the smoke; when they become red they are ready.

The potter from Agios Dimitrios acquires his clay from just outside the village. Most of his red clay comes from the lower slopes just beside the road, while his white and some other red clay is obtained farther up the hill. However, he prefers to mix the white and red clay from the two separate localities in a 50:50 ratio.

Andreas Paniyi Krokos from Agios Dimitrios tis Marathasos makes vessels only from May until October. He obtains his clay from Petsounas and from Moni. (The latter clay, he says, is much "stronger"). He mixes these two clays respectively in a ratio of 5:1. In Mesoyi village, Phenis Alkithides mixes three clays: 60% from Yiolou village, 30% from Kannaviou and 10% from Mammonia village.

Brickmakers also mix clays, although on a much larger scale. Sayias Brickworks in Timi village in the Paphos district mixes 50% clay from Kouklia, 20% from Anatolikou, 30% from Kannaviou; or sometimes 50% from Kannaviou and 50% from Polemi. It can be seen from these figures that the mixtures vary.

Closer to Nicosia at Kotonis Brickworks, George Matsis gets his clay from south of Tseri village seven miles south of Nicosia. He does not mix the clay but says that it is important to leave it for about six months before it is used; if he uses it straightaway he gets 20-30% breakage. He then adds straw to the clay and fires it to between 800 and 900° C. He fires from above using electric burners. The clay changes color as it is fired: black to 400° C, red to 600-700° C, white to 900-1000° C, green to 1000-1200° C. The melting point is approximately 1200° C.

United Brickworks gets its terra rossa from Lythrodonda, and its white clay from Tseri, as does Pyramis Brickworks. Both establishments mix 30% terra rossa clay/soil with 70% white clay. The bricks are dried at 60° C and are then fired up to 900° C. At Mosphiloti Brickworks on the Limassol Road, Loukas Panayotou mixes clay and soil from Tseri in a 50:50 ratio. Without exception all those I interviewed either blended their clays with other clays and soil or used a clay and soil that was already mixed when excavated. When Savvas, now working in Yeroskipos, first moved south, he experimented by soaking the clays over periods of up to a year, constantly changing the water in the hope of removing the salts and so facilitating the firing of the vessels and reaching higher temperatures. He does not seem to have had much success for he is now importing his clays, as are a number of other potters who are working for the tourist trade. There is a tradition on the island of washing or soaking the clay for a short period and thus sifting or filtering out the finer particles. The potters who are importing their clay are all using electrically fired kilns and so reaching high temperatures relatively quickly.

The techniques of blending and firing are therefore of supreme importance in using Cypriot clays, as there are few which can be successfully fired without blending.

These are almost all terra rossa clays in which soil and clay are excavated already mixed. According to the refugee potters, there are gray clays in the Kyrenia area that do not need mixing. One example is a claybed two miles west of Kyrenia, near Karavas, once used by Saavas of Yeroskipos. The clay from a second bed near Mia Milea fires to 1030° C intact, although this clay does need about 10% sand added to it. The clay used by John Sabry, another refugee, came from beneath the sandstone (and so was probably already mixed with sand) in the bay east of Kyrenia Castle near the quarries. Sir George Hill mentions a pottery industry near the spring of Kephalo-vryso in Lapithos (Hill 1940, Vol. I, 268) which he claims has been there since ancient times. Undoubtedly the refugee potters found the clay from the north easier to use; for example, most had difficulty in making flat wares such as plates after they moved south.

Potters working in the same area rarely use the same recipe; each has his own favored beds of clay and *homa* and, even where they use the same clay beds, the percentages of the mixes differ. Some of the village potters have in the past used a variety of different mixes according to the nature of the ceramic that they wished to produce. These different mixes fire to varying degrees of color. Basically the marls which are gray to brown in color fire to a pale color or yellow; the terra rossa fires to a deep red or reddish brown color. Some clays alter color when they are fired. For example, the black clay from Karmi and from Mari in Limassol fires to red; the red Panagra clay becomes lighter in color on firing; the gray clay from Vasilia fires red; and the gray clay from above Karmi fires white and was used as a white slip. It is clear that potters need to know not only the different clays and their firing potentials but also the various colors that the clays produce.

The potter in antiquity must have faced the same difficulties of cracking and warping of vessels at high temperatures as the present day potter, yet his enjoyment of the plasticity of the Cypriot clays can be seen in many of the vessels he produced. His solutions to the problems are apparent in the variety of pastes he formed by blend-ing, as has been shown by Barlow and Idziak (1989). "The two varieties of clay are used not simply for two different wares but in varying combinations both for some shapes and for fabrics within certain ware categories" (Barlow & Idziak 1989, 66). As they state in their concluding paragraph: "The unusual geology of Cyprus, where rock and soil formation are exposed in rings around the central Troodos mountains, results in access to both calcareous and non-calcareous soils in most parts of the island" (Barlow & Idziak 1989, 75).

This of course does not include the area north of the Kyrenia Range; however, it would appear from the reports of the refugee potters that they mixed their clays there in much the same way as they were attempting to do in the south. Jones, citing Pierdou, observes that the eighteenth- and nineteenth-century potters working in Kephalovryso in Lapithos used no fewer than three clays, only one of them in any sense local, and blended a fourth clay from the neighboring hills for the thin walled jars (Jones 1986, 871). In other words, they moved their clay to their pottery production center. As we have seen from modern practice, some clay beds are preferred to others and, in the same way that clay was transported in the eighteenth and nineteenth centuries, it was probably similarly moved in earlier times.

Therefore I suggest that in the case of Cyprus, instead of two different ceramic technologies, one using calcareous and the other using non-calcareous clays as proposed in the context of the Aegean (Maniatis & Tite 1978, 490-492), there was one technology incorporating the use of both clay types to produce a wide variety of pastes for vessels of different functions. As Jones (1986, 343) notes with reference to the working methods of the ancient Cypriot potters:

> The analytical data strongly support the contention based on the petrological composition, as well as the visual appearance of the fabrics that the potters at a given centre exploited several clay sources and employed them individually or as a mix according to the vessel type or ware they were making.

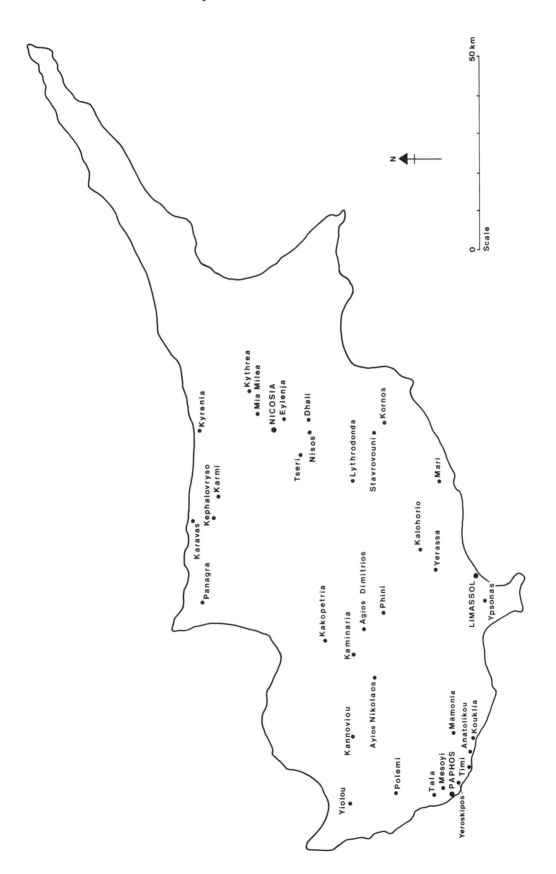

Figure 22.1. Map of locations of modern village potters.

REFERENCES

Barlow, Jane A. & Phillip Idziak
 1989 Selective Use of Clays at a Middle Bronze Age
 Site in Cyprus. *Archaeometry* 31, 66-76.

Bear L.M.
 1963 *The Mineral Resources and Mining Industry of
 Cyprus.* Ministry of Commerce and Industry
 Geological Survey Department, Bulletin 1.
 Nicosia.

Hill, George
 1940 *A History of Cyprus.* Cambridge.

Jones, Richard E.
 1986 *Greek and Cypriote Pottery: A Review of Scien-
 tific Studies.* Fitch Laboratory Occasional
 Paper 1. The British School of Archaeology,
 Athens.

Maniatis, Yannis & M.S. Tite
 1978 Ceramic Technology in the Aegean World
 during the Bronze Age. In *Thera and the
 Aegean World.* Vol. 1, edited by C. Doumas,
 pp. 483-492. London.

Shepard, Anna O.
 1971 *Ceramics for the Archaeologist.* Washington.

Ethnoarchaeological Evidence of Variation in Cypriot Ceramics and Its Implications for the Taxonomy of Ancient Pottery

Gloria Anne London

> So I came to hate ceramics because the archeologist decides to do typology on ceramics, and we have the most complicated hierarchy of ceramics—red on white, white on black, inside green and blue, and God knows what! The color and form in this is terrific—and you get very scientific sounding classifications. In reality, they don't mean a thing and you can classify almost anything anywhere.
>
> Paul Fejos, quoted by Matson (1984, 33)

INTRODUCTION

The impetus for a symposium on ceramics held thirty years ago originated with ceramic technologist, Frederick R. Matson, and Paul Fejos, the President and Director of the Wenner-Gren Foundation for Anthropological Research. One goal of the conference and the resulting publication, *Ceramics and Man* (Matson 1965), was to examine pottery for the purpose of better understanding the people who made and used it. To Paul Fejos, pottery typologies had become a cult within archaeology. To counteract this tendency, the conference was dedicated to analyzing what pottery has done for people and what people have done with pottery.

All pottery typologies are created to address certain explicit or implicit questions. If chronological information is required, the classification system reflects this need. Once the classification is formulated to address chronological issues, all pottery, with few exceptions, is seen as earlier or later than all other pottery. This is the goal of ceramic chronologies. The exceptions are imported wares, which are recognized as roughly contem-poraneous with "local" wares, and funerary wares which can coexist with a specific repertoire of domestic or "normal" pottery types.

Pottery typologies can also be designed to address nonchronological questions. For example, ceramic chronologies often fail to consider the contemporaneity of "local" pottery types. Regional ceramic developments, i.e., the simultaneous production of different pottery types in diverse parts of the country, require a typology or classification based on criteria such as clay type, manufacturing technique, and surface finish, which are not critical for ceramic chronologies, but are necessary to address social and behavioral issues. Ceramic chronologies were not designed to deal with contemporaneous wares. Archaeologists interested in determining when a pot was made, who made it, how, and why a pot looks as it does, face the challenge of eliciting both chronological and nonchronological information from the same pottery classification.

CERAMIC CHRONOLOGIES VERSUS CERAMIC TECHNOLOGIES

One hundred years age, Petrie (1891) demonstrated that variation in vessel forms and surface treatment bear chronological significance. Ceramic chronologies provide a powerful dating system especially in the absence of alternative methods to establish a time framework, but more can be learned from pottery.

After establishing *when* a pot was made, the next question traditionally asked was *where* it was made. Imported versus local were sufficient answers along with some suggestion regarding the region or country of origin for the imported ware. "Local" pottery referred to wares made at, near, or not far from wherever the pot was deposited. The issue of how local is local, although rarely considered, can and should be addressed by observing nuances in the manufacturing technique and surface markings. To document local trade and interaction across local boundaries or to understand the organization of the ceramics industry, an assessment of the normal local repertoire is essential. To understand *how* the pot was made and *why* it looks as it does requires the assistance of a potter or ceramic technologist to assess the scratches, drops of clay, imperfections, and the other traces of the potters' craft.

Ceramic technology is a multifaceted study involving the technique of manufacturing pottery and the organization of the ceramics industry. The method of manufacture can be divided into: 1) characterization of the clay with its inclusions and the treatment of the clay prior to fabrication; and 2) details of the construction technique. Each of these areas of study involves its own approaches and laboratory procedures. Together they determine the overall character of the industry.

ORGANIZATION OF THE ANCIENT CERAMICS INDUSTRY

For Cypriot ceramics, the question of pottery production initially concerned the big picture, or the organization of the industry while by-passing characterizations of the raw materials and studies of pottery manufacture. In part, the early strategy emerged in the absence of sophisticated chemical and mineralogical testing which have only recently become available for analysis of the clays and their inclusions. Spectrographic studies of pottery were, however, programmed already in the 1920s by Starkey for material excavated at Lachish in Israel, including wares of "local" manufacture as well as pottery imported from Cyprus (Tufnell *et al.* 1940, 85-88). Although clay analyses were beginning, it would be decades before the procedures were adapted to the needs of archaeologists.

From the start, researchers working with Bronze Age material from Cyprus speculated on whether or not the potters were craft specialists or domestic producers (Frankel 1988, 27-29), rather than where or how the potters worked. That approach carried with it implications for understanding the structure of society as a whole. Given the widespread distribution of the painted Cypriot trade wares, both within the island and abroad, the ceramics industry was described as "too large to have been delegated to the women of the household and it is legitimate to visualize potters' shops" (*SCE* IV Pt.1A, 291-292). In contrast, Frankel (1988, 31) characterized Early Bronze Age wares as the work of local domestic production and emphasized the inappropriateness of generalizing about the organization of the industry for the entire Bronze Age or for the island as a whole. Whatever its organization, the workings of the ceramics industry have implications for the manner in which archaeologists understand ancient Cypriot society. It is also evident that the economic role of women in antiquity has been minimized. There is every reason to conclude that women contributed significantly to the economy.

If the ancient industry resembled traditional potteries around the world today, complexity within the ceramic industry, rather than homogeneity was the norm. Ethnoarchaeological studies reveal the coexistence of potters working on different levels of production in India (Sinopoli 1988), the Philippines (Scheans 1977), Sardinia (Annis 1988, 47) and in Cyprus (London 1987a, 319; London 1989a; London *et al.* 1990). Men and women, working on all production levels, from domestic potters to full-time specialists, can be inferred for ancient Cyprus from the wide variety of manufacturing techniques, clays, shapes, and surface treatments, known for every archaeological period. The emergence of a new method of pottery manufacture would not cause all former techniques to disappear. Potters who specialize in large vessels might use a clay and fabrication technique distinct from that used by potters of the same era who made small and medium sized vessels requiring specific fabrics. Surface treatments are more likely to change or be copied than are the techniques of fabrication. Given the stability of the latter, it can be a powerful tool for reconstructing the organization of a ceramics industry.

To define the ancient industry, it is useful first to study the clay and manufacturing techniques rather than to start with the overall organization of the industry. The initial goal concerning the clay is to determine where the pottery was made within Cyprus. When examining the clays and their inclusions, the purpose is

not necessarily to determine the precise pottery production location, but to learn whether or not a particular ware was made in one place or in multiple locations. The coexistence of more than one center of production for any type of pottery presents a different reconstruction of the ceramics industry than a single production site.

A second aspect of the technology vital to define the organization of the pottery industry concerns the precise method of manufacture. The Lagarces (1972) have described the manufacturing technique for Late Cypriot Base Ring vessels excavated at Enkomi. In presenting his observations, especially concerning the tilt of the vessel toward the handle and the presence of strips of clay on the neck and down the front of the body, Merrillees (1982, 157) noted that some Base Ring jugs have incised lines on the neck instead of raised bands, and others lack any treatment on the neck. What is the significance of these differences? Might they represent the products of particular workshops or potters? If it can be demonstrated that jugs with a specific neck and body treatment coincide with one clay matrix, we are in a better position to reconstruct the ancient ceramics industry.

CERAMIC COMMUNICATIONS: HOW LOCAL IS LOCAL?

Recognition of contemporaneous fabrics and wares made in any given region enables a discussion of trade and interaction on a localized scale as well as the identification of boundaries. Ceramic typologies designed to differentiate local contemporaneous pottery provide the information to assess trade, not between countries, but within a single country or geographic region. Instead of long-distance commerce between foreign city centers or capitals, the focus shifts to trade among cities, towns and villages within one region. To document the relationships between settlements of all types and sizes within any single well-defined geographic area requires data on the subtle differences in pottery made in separate but coexisting centers of production.

Along with information of chronological and economic importance, ceramics can be considered as a form of communication. The surface treatment and overall vessel form serve as a silent language among those who made and used the pots. Surface treatment is not accidental but represents people, places, and belonging—or not belonging. Groups of people can be defined by their relationship to a particular artifact. Based on her ethnoarchaeological research in Mexico, Hardin (1984, 592) has interpreted variation in pottery as the result of

physical, social and cultural boundaries. Pottery is anonymous only to outsiders. Encoded in the designs or "decoration" is information which means different things to different people depending on the background of the individual and the context in which the artifact is found. For example, a Cypriot jug found in a tomb in the Levant might be recognized as a desirable, valuable imported artifact from Cyprus. The same pot type buried in a Cypriot tomb might be understood as a mass-produced, rather ordinary pot brought from the next village and/or made by a family relative. The same pot conveys different meanings to different people. Patrik (1985) has emphasized the difficulties in comprehending the meanings encoded in artifacts given the incompleteness of our knowledge of the historical and social contexts in which they were used.

To understand ancient pottery as a means of communication requires an assessment of ceramic variation within any single time period. Toward this goal, ethnoarchaeological studies of traditional potters prove useful, especially since the one can observe pots used in their original contexts. In Cyprus, village potters use local clays to produce a utilitarian repertoire, including jugs, jars, cooking pots, incense burners and flower pots, sold to the indigenous population. Most rural potters are women. Male potters today tend to be located in or near urban centers where they use local and imported clays to manufacture glazed and plain wares for local use and for the tourist market (Yon 1985, 103; Hemsley, this volume). The wheel-thrown and press-molded wares with glazed, brown and white surfaces contrast sharply with the incised, stamped and rouletted patterns on the coiled wares of the rural potters.

In 1986, I lived in two Cypriot villages for five months to record the traditional industry. Pottery production is limited to the dry season which extends from April to October. All aspects from clay procurement to the sale and distribution of the final products were recorded in conjunction with quantitative research strategies devised to measure annual output per potter, vessel dimensions, rate of loss due to firing, clay recipes, costs and sale value of the wares. Interviews with potters and nonpotters in numerous villages provided information otherwise unavailable. The study was also designed to test hypotheses derived from my previous ethnoarchaeological research of craft specialists who use local clays to coil build utilitarian vessels sold to the Filipino population of southeastern Luzon Island (London 1991).

TRADITIONAL CYPRIOT POTTERS

Red handmade pottery is produced in four villages in southern Cyprus, of which two were selected for study

(Fig. 23.1). In Kornos, thirteen potters are members of the Kornos Pottery Cooperative (Cp) and three potters work

privately (Pp). At Agios Dimitrios, a smaller remote village in the Troodos Mountains, are five potters, all women, two of whom are assisted by their husbands who have recently learned to make pottery. Also in the Troodos Mountains, not far from Agios Dimitrios, are Kaminaria where one potter makes traditional pots, and Phini where two women, aided by a son and husband, make tourist-oriented objects. Phini and Kaminaria were once prominent centers of pottery production according to informants. Hampe and Winter (1962, 62-72) described the Phini potters 25 years ago when more men were involved with the industry than at present. Today all traditional potters are over the age of fifty and no young people are learning the craft although in the cities young potters work in small factories and studios where electrical equipment and imported raw materials are the norm.

In each village, potters coil build their wares with the aid of a small turntable rotated by foot or hand and fire them in wood burning kilns (London *et al.* 1990, 52-68).

Figure 23.1. Traditional potters using local clays to produce red firing wares live in: Kornos (1), Kaminaria (2), Agios Dimitrios (3), and Phini (4). Potters using electric equipment and mainly imported clays and glazes work in: Nicosia (5), Larnaca (6), and Limassol (7) as well as other towns and cities.

Designs on the surface are incised, rouletted and stamped into the wet clay.

The traditional Cypriot potters are craft specialists in that they comprise a small percentage of the rural population, they are not involved in subsistence work on a regular basis, and they supply a large non-pottery producing clientele. A small percentage of the wares from each village reach the tourist markets; Cypriot pottery has been an item of trade for millennia. The potters sell their wares to shopkeepers, traveling merchants, or to individuals who come to the villages. Patterns of sales and distributions within Cyprus have been briefly described elsewhere (London 1989b).

CONTEMPORANEOUS CERAMIC TRADITIONS IN RURAL CYPRUS

One goal of the research was to determine whether or not contemporaneous pottery made in separate villages can be differentiated. Under the current circumstances, this involves an investigation of two individual but related issues: intravillage homogeneity and intervillage heterogeneity. A third concern is consistency in the work of each potter throughout her lifetime. To investigate the nature of variation in traditional Cypriot pottery, the wares made in each village were assessed in terms of the manufacture, especially the nuances of technique, form and finish. Analysis of these features enables one to differentiate among pots which superficially look alike. Questions concerning chronology were nonexistent since all pots included in the ethnoarchaeological study were made in 1986 during the field study. Older pieces, the few to have survived the past several decades, form a separate unit of the research project.

The degree of variation in the work of professional potters has been debated in the literature with the result that standardization has been equated with craft specialization (Adams 1979, 729; Balfet 1965, 170; Frankel 1988, 34-35; Johnson 1973; Nicholson & Patterson 1985, 57; Rathje 1975, 430; Rice 1981, 222). The archaeological literature suggests that variation in the wares of craft specialists is an oxymoron, yet rigorous testing to measure variation or the lack of it, has been limited except for the studies by Longacre, Kvamme, and Kobayashi (1988) and London (1985, 187-215; 1991). To assess the degree of uniformity in pottery made by craft specialists, the three aspects to investigate include: 1) variation in the work of each potter through time; 2) variation within the work of all craft specialists in each center of pottery production; and 3) variation between ceramics made in different villages.

VARIATION IN THE WORK OF INDIVIDUAL POTTERS THROUGH TIME

Variation in the work of each craft specialist throughout the lifetime of a potter can be studied only by long term field work as initiated by Longacre (1981, 63). Consistency in the work of each potter or each village over the years in Cyprus was difficult to assess. No systematic collections of traditional pottery were available for comparison, but an assemblage is now held in the Cyprus Museum for future research. Most potters do not keep examples of their older work. Pottery made by their parents was broken, reused, and replaced long ago.

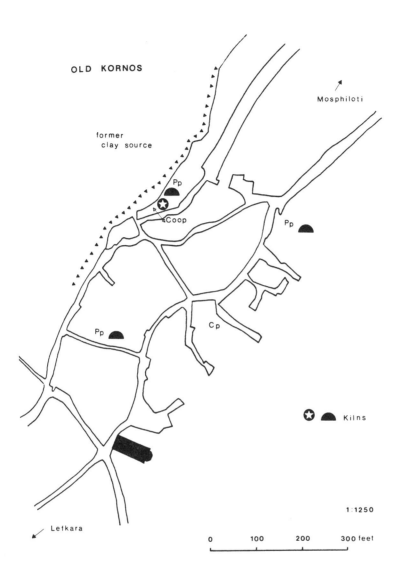

Figure 23.2. A plan of the older residential section of Kornos village shows the location of the private potters (Pp) and their kilns. They are a few minutes walk from the kiln and workspace of the members of the Kornos Pottery Cooperative (Cp) situated on the edge of the village adjacent to a ditch. One member of the Cooperative works in the lower level of her home in the residential area. Beyond the ditch is a former clay bed no longer in use. At present, heavy equipment owned by a builder in Kornos excavates clay from a deposit some 30 minutes drive from Kornos.

Members of the Kornos Pottery Cooperative work primarily in special buildings in an area belonging to the group where the communally owned kiln stands (Fig. 23.2). Pots that break as a result of the firing process remain in the area near the kiln. Few potters carry home cracked or unsalable pieces. There is no stockpiling of pottery from year to year. Pre-1986 pots in the building numbered fewer than five. These same potters have few clay vessels at home: plastic containers predominate in addition to clay flower pots.

In contrast, the three private potters work and fire pottery in the courtyards of their homes. Unmarketable pieces remain in the courtyard and provide the only collection of older pots available for study which can be attributed to a specific potter. The decorations were recorded for every pot in the courtyards to determine how

much variation there was in the work of each potter over the years.

In the courtyard of one private potter were 34 pots in use, mostly as planters, although not all were flower pots. The potter acknowledged making all the pots, some of which were said to be decades old. Of the collection, 27% (n=9) were types never decorated (beehives, casseroles, etc.); 3% (n=2) have a non-rouletted pattern; but the majority, 70% (n=23) have a rouletted pattern. Of the 25 decorated pots, rouletted patterns characterize 92% or all but two pieces. In 1986, this private potter continued to use the rouletted designs despite the overwhelming predominance of combed, incised, and stamped patterns characterizing wares of the other Kornos potters. This same potter, early in the 1986 pottery-making season, decorated her vessels with combed patterns, but only until her husband repaired the damaged rouletting tool. For this craft specialist, the ceramics found in the courtyard demonstrate strong continuity and consistency in the surface treatment over the decades.

In the courtyard of another private potter, 27 pots were present, including six forms (22% of the total) which are never decorated. As for the decorated pots (78% of the total), 25.9% (n=7) show an incised solid zigzag pattern; 40% (n=11) have a zigzag or straight line of incised dots; 7.4% (n=2) have a combed and stippled pattern; and the sole jug bears a rouletted pattern. Of the decorated pots (n=21), 85.7% (n=18) have zigzag patterns—the same design found on the 1986 pots of the woman made during the study period. The presence of rouletting on one pot found in the courtyard might reflect the potter's age. The two private potters discussed thus far are the senior working potters in Kornos. Pots in the their courtyards preserve rouletted patterns which are a tradition associated with the oldest generation of potters. Women of the next generation, some twenty years younger, favor stamped and incised patterns.

For the third and youngest private potter in Kornos, the two old misshapen unsalable pots in her courtyard do not provide an adequate data base for analysis. Perhaps if the loss rate were greater, and sherds were not reused, more pottery would be available at the source, but with a mean rate of 2% loss, the prospect of finding pots of the previous generations diminishes.

Although the analysis of variation in the work of individual craft specialists over the years is based on the wares of only two senior potters in one village, it suggests that consistency rather than variation prevails. Rigorous testing requires a return to the villages to observe the work of other potters over the years. The preliminary findings imply that the surface treatment used by craft specialists can remain almost constant for decades in Cyprus, where the potter decorates her own wares. However, if the surface treatment were rendered by a family member, especially a nonpotter, variation in the decoration can result, as is the situation among Filipino craft specialists (London 1986, 1991).

As for consistency in the work of these and the other potters during the 1986 season, the youngest of the private potters devoted much of her time to creating pieces for a gallery and sought to demonstrate as much imagination and variation as possible, especially for the fanciful composite pieces. For the other potters, it was easy to record tens of pots of each category with the identical designs yet the products of every potter are distinct.

VARIATION IN POTS MADE IN THREE CONTEMPORANEOUS PRODUCTION LOCATIONS: MORPHOLOGICAL DIFFERENCES IN COOKING POTS AND JUGS

Inter- and intra-village variation among craft specialists involves both vessel morphology and the surface treatment. Measurements were taken for hundreds of pots first in Kornos and later in Agios Dimitrios. In Kornos, cooking pots, jugs, jars, and ovens were measured with the assumption that similar pieces would be measured in Agios Dimitrios. Unfortunately, the repertoires for each village, differ in the percentages of vessel types made. In Agios Dimitrios, to meet the needs of a rural clientele, jars constitute almost half of the output, whereas in Kornos they represent less than 2%. Nor were casseroles manufactured in Agios Dimitrios in sufficient quantities for comparison with Kornos wares (see London 1989b, 47 for the percentages of each vessel type produced). Nevertheless, cooking pots and jugs (Fig. 23.3) can be evaluated in terms of whether or not a specific vessel morphology characterizes each potter and each community. A small number of pots from Kaminaria are included. These data are preliminary and part of a larger quantitative study currently in progress.

To assess vessel morphology for each potter and village, 58 round-bodied cooking pots of standard size made by thirteen potters from Kornos (n=8), Agios Dimitrios (n=4), and Kaminaria (n=1) were measured. By plotting rim thickness and maximum vessel circumference, two unrelated features of a pot, several observations can be made (Fig. 23.4). 1) On the individual level, the pots of each woman tend to cluster closely together revealing individual consistency and uniformity. 2) On the communal level, pots from each village cluster into two groups and allow one to differentiate distinct units. 3) In Kornos, the wares of the private potters resemble (but are not identical to) those of the members of the Cooperative. Each private potter works separately in her own courtyard while the members of the Cooperative work together. The similarity in the work of these two

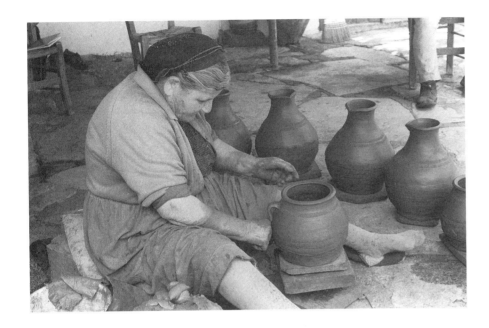

Figure 23.3. A Kornos potter adds a handle to a decorated cooking pot. On the floor around her stand unfinished jugs. The rouletted decoration has been applied, but the walls are too wet to support the weight of the loop handle. The flat bases will be trimmed into round bottomed jugs and cooking pots of the types included in the quantitative studies.

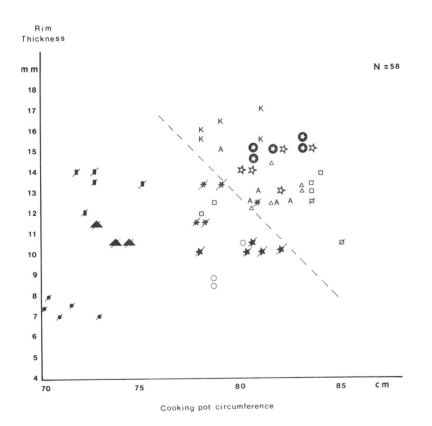

Figure 23.4. Cooking pots made in each village tend to group on different sides of the graph when rim thickness and maximum circumference are compared. Each symbol represents the work of a different potter. Solid marks designate Agios Dimitrios and Kaminaria (solid triangle). Open marks represent the Kornos potters, including the two private potters (K and A). There is some overlap between the two groups which is clarified by recording the order of handle and decoration application. An oblique slash (/) designates handle application prior to the decoration. This mark coincides with pots from Agios Dimitrios and Kaminaria. By combining the two vessel dimensions with order of the work, the cooking pots made in each tradition can be differentiated.

groups within Kornos suggests the existence of a specific village style common to potters who work under slightly different conditions.

Two issues warrant further discussion. There exists some overlap in the distribution of the cooking pots of the two villages. While plotting rim and circumference measurements is instructive, these measurements represent a small part of overall vessel morphology. More data are required to differentiate the wares made in each village, but not necessarily more measurements. No classification of ceramics can be based entirely on two measurements of vessel shape. Nuances in rendering the decoration allow one to associate each pot with one group or the other. In Agios Dimitrios, potters systematically apply the decoration after the handle. In Kornos, the opposite occurs: handle application follows the decoration and interferes, erases and smears the incised pattern. This distinction alone allows one to differentiate wares made in each village.

The second consideration concerns the three cooking pots made by the lone potter in Kaminaria. This small

sample is included to demonstrate its proximity to the wares from Agios Dimitrios rather than those of Kornos. It is imprudent to compare a small collection of three pots made by one potter with 55 pots made by twelve potters. It is noteworthy, however, that the Kaminaria pots clearly resemble those of Agios Dimitrios rather than Kornos pottery. Additional evidence suggests that in recent history, the southern part of the island has known two pottery traditions: one in the mountains (at Agios Dimitrios, Kaminaria and Phini), and a second in the foothills and lowlands (Kornos and Klirou). As discussed below, other differences in the pottery correspond to this regional division of the ceramics industry (London 1987b).

Jugs of varying sizes and shapes are made in the three villages. The most common round bottomed jug, with a pinched (Agios Dimitrios and Kaminaria) or trefoil-like (Kornos) spout and handle extending from rim to shoulder, was included in the quantitative analysis (Fig. 23.5). By plotting rim diameter and maximum vessel height for 44 jugs, two clusters form which correspond

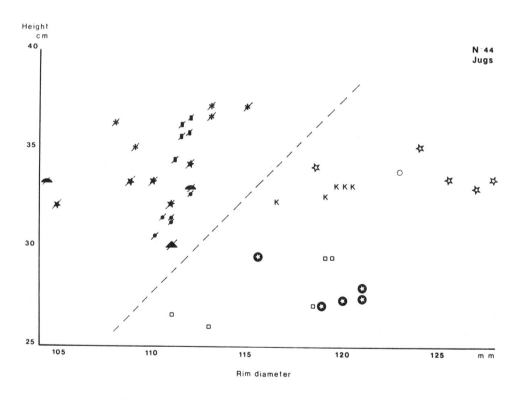

Figure 23.5. Jugs made in Agios Dimitrios (solid symbols) and Kaminaria (solid triangle) cluster on one side of the graph away from those made in Kornos (open marks, including one private potter K). An oblique slash (/) designates handle application prior to the decoration. The mark coincides consistently with the pots from Agios Dimitrios and Kaminaria.

to the villages of Agios Dimitrios and Kornos. The single Kaminaria jug falls near the group from Agios Dimitrios. Jugs made by each potter tend to cluster together revealing consistency in the work of individuals as well as the maintenance of a village-wide tradition as suggested by the cooking pot data.

These studies demonstrate unity within each community and diversity between the village traditions. The differences in contemporaneous wares are subtle, but discernible.

VARIATION IN POTS MADE IN THREE CONTEMPORANEOUS PRODUCTION LOCATIONS: THE SURFACE TREATMENT

If ceramics serve as boundaries among different communities, the marks incised on the pottery made in each Cypriot village should vary. To test this, marks on the shoulders of cooking pots, jugs and jars were recorded for all potters in three villages. As with the vessel morphology, there is a degree of overlap, but certain motifs and arrangements of the marks characterize each village. One difficulty emerged when the potters intentionally incised each pot with a different pattern in response to my interest in the marks. One potter in particular tried to differ each pattern, but once she realized that her pots were no longer measured and included in the study, she lost interest. In general, the goal of the research was to record and measure a minimum of five examples of each vessel type made by each potter. Given that the pots were removed from the kiln and sold while still hot, it was sometimes difficult to measure even five examples.

Combing patterns decorate pots in all three villages, but there are differences (Fig. 23.6). The Kaminaria pottery is easily separated from the others by the abundance of combing and the complexity of the patterns found on the body of the vessels, the handles and the lids of cooking pots. No potter in the other villages decorates cooking pot lids, although handles are sometimes incised. In Agios Dimitrios, pots have single or multiple and combed wavy bands. Potters in Kornos use combing primarily to render horizontal lines in conjunction with a variety of staccato-like marks, incised in a short quick movement, including oblique combed stipples.

In Kornos, where the largest number of potters work, one finds the largest variety of marks. Rouletted patterns and stamped rosettes are used today in this village alone. Until the recent past, a potter in Klirou village also used the rosette motif (Hampe & Winter 1962, figs. 48: 5, 49: 6). Originally from Kornos, the Klirou potter brought the Kornos tradition to her new home where she and her husband worked. In contrast to the Kaminaria potter, sparsity of the combing characterizes the Kornos tradition. Potters restrict the decorated area and the number of bands. When multiple bands occur, they are tightly spaced.

In Agios Dimitrios, single multiple wavy lines predominate. The long wavy lines are made with a single pointed tool, or a comb which is either dragged along the surface or used to create stipple marks. The objective is to cover a large area of the shoulder in contrast to the Kornos tradition. The use of long continuous lines diverges from the tendency in Kornos for short strokes quickly rendered. One example of a cooking pot made by a potter of the previous generation (Fig. 23.6: 6), i.e. the mother of a retired potter, confirms that broad wavy bands have been in use for decades in Agios Dimitrios.

Each potter normally uses the same or similar designs for different vessel types. For the Kaminaria potter, differences in the patterns for cooking pots and jugs exist, yet the multiple bands of combed stipples distinguish her work from all others. It should also be noted that I did not observe her at work and the possibility exists that she might not have decorated the vessels herself.

A further difference between the surface treatment in each village concerns the time of its application. In Kornos, the potters incise the patterns before the handle is added. In Kaminaria as in Agios Dimitrios, potters first apply the handles and then place the incised marks carefully between them. There is no interference of the marks by the handles. Consequently, a typology sensitive to nuances in the manufacture, morphology and surface markings, all of which are interrelated, allows one to differentiate among contemporaneous wares made by craft specialists in different centers of pottery production.

To return to the issue of variation in the work of craft specialists, the Cypriot traditional potters demonstrate consistency within the work of individual potters, but not complete standardization. The vessels made by each potter tend to cluster together although some variations occur. The surface treatment and vessel morphology of cooking pots and jugs differ for the two villages, as do other features, such as the order of the work. Differences in form and finish are less obvious *within* each village than *between* villages. In Kornos this applies to the private potters and members of the Kornos Pottery Cooperative. Variation in the pottery from each village communicates village boundaries rather than chronological distinctions.

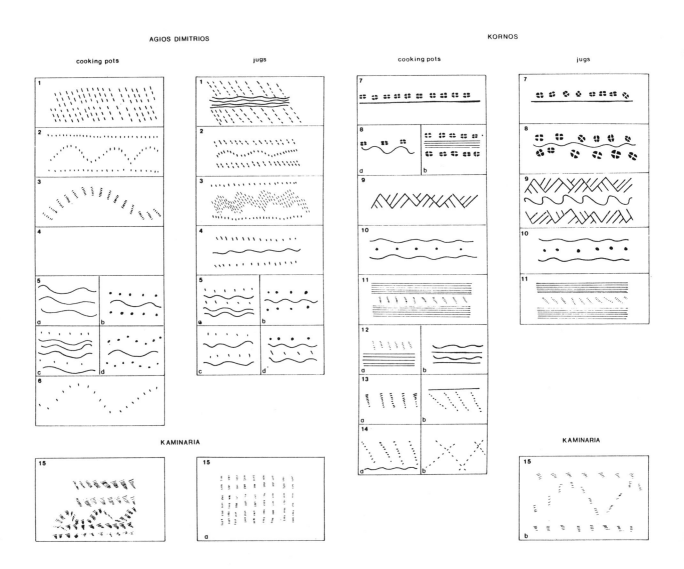

Figure 23.6. Decoration on cooking pots and jugs from Agios Dimitrios (1-6), Kornos (7-14), and Kaminaria (15). Each number represents a different potter. For some women, more than one design was recorded. In Agios Dimitrios, combing and wavy lines rendered with a comb or a single pointed tool predominate. One potter (4) chose not to decorate a series of jugs, but it cannot be determined if this was usual. A cooking pot made by a member of the previous generation also has a wavy band (6). In Kornos, stamped rosettes (7 and 8), rouletting (9) and tight bands of combing and staccato combed patterns prevail. A complex combed pattern typifies the Kaminaria cooking pots and jugs.

IMPLICATIONS FOR THE CONSTRUCTION OF TYPOLOGIES FOR ARCHAEOLOGICAL CERAMICS

Ceramic technology provides archaeologists with a method to classify pottery while not avoiding the concern for chronology or contemporaneity. Pottery typologies based on manufacturing techniques can address chronological developments whereas ceramic chronologies often neglect ceramic technology. To understand how the pot was made requires an assessment of every aspect of its manufacture and every change through time in that tradition using methods such as those advocated by Franken and Kalsbeek (1975).

To demonstrate the versatility of the technological approach a visit to the emporium at Mosphiloti, near Kornos, provides an example. Consider the Mosphiloti collection of new and used pottery the remains of a single level in an excavation rather than a store selling traditional artifacts. How would one classify it based on an assessment of the ceramic technology? The goal is not to simply create a typology, but to learn how the pottery was made, by whom, when and where.

A division of pots according to size and therefore function (Yon 1985) to describe the current Cypriot pottery would be the first objective. This is convenient and practical since ethnographic studies demonstrate that different manufacturing techniques are required to build the largest versus smallest pots. One would initially separate the large oversize jars (*pitharia*) and basins (*dani*) from the normal repertoire of jugs, jars, cooking pots, pita plates and goat-milking pots (*galeftiria*). A third category would consist of the smallest pieces, especially glazed wares. The coiling technique immediately unites the oversize containers with the normal repertoire. Cypriot *pitharia* and *dani* were often made by a special group of potters (*pitharades*) in the Troodos Mountains and foothills (London 1989a, 69-71; 1989c, 221). Like the traditional rural potters, the *pitharades* used the coiling technique, but to build walls three fingers thick, they worked with much larger coils than the full repertoire potters. The similarity between the coiling manufacturing technique used for the oversize containers and the normal repertoire indicates cultural and chronological connections between the two pottery groups. Both the oversize vessels and the normal repertoire at times were made in the same village by the same potter (male or female), however the *pitharia* and *dani* were often made by the *pitharades*, who were the husbands of women who produced the full repertoire.

For the normal or medium sized group, the next division would involve manufacturing technique, surface treatment and clay type. The three are closely related for most pottery. The method of fabrication and prepara-

tion of the clay determine and limit the surface finish. Coiled wares, often made of clays with relatively large quantities of nonplastics in the form of rocks and minerals, are problematic to burnish unless first coated with a slip to cover the inclusions. If this precaution is not taken, the burnish tool will drag the nonplastics across the surface creating disagreeable drag marks and scratches. With or without a slip layer, paint is an ideal method to cover the surface of a pot made from an unrefined clay. Painted patterns, especially elaborate designs, disguise low quality clays and poor work. As a consequence, surface finish, clay type and manufacture technique are three variables one should study together.

Surface treatment on twentieth-century pottery made in Cyprus is closely related to the manufacturing technique. Glazed surfaces and painted patterns are coincident with wheel-thrown and mold-impressed pottery made of imported materials by potters in small factories in or near urban centers. Incised, rouletted and stamped pots lacking glaze and paint coincide with the coiling technique characteristic of the rural potters who work with local clays. Following classification according to manufacturing technique, chemical and mineralogical analyses should test the division by identifying local versus imported raw materials. Another ceramic group, glazed pottery imported from Europe and the Far East, would be further differentiated from the locally produced glazed wares based on analyses of the clays, shapes and decorative motifs.

Within the repertoire of coiled pottery, a study of the manufacturing technique and surface treatment would allow one to recognize both a homogeneous method of pottery fabrication and subtle differences in overall vessel morphology, design motifs and order of the work. By observing the correlation between placement of the decoration and the handle, one could associate rouletted, stamped and staccato combing patterns with one tradition. The second tradition demonstrates a preference for covering large areas of the surface with wavy bands and/or complex combed patterns. The latter characterizes wares of the Troodos Mountain area. Wheel thrown undecorated cooking pots are urban copies of a traditional form. The technique of manufacture and lack of incised markings sever them from the traditional repertoire of the rural potters who employ the incised patterns to indicate their community and themselves. An overlap of decorative motifs on the group of largest vessels (*pitharia* and *dani*) and the normal-sized coil built repertoire would link the two categories as would analysis of the clays.

A hypothetical classification of the pottery at the Mosphiloti shop illustrates the potential of a typology based on ceramic technology. Whole pots and even sherds offer a multiplicity of information which would be inappropriate to neglect if the goal of ceramic analysis is to learn what pottery has done for people and what people have done with it. Ceramic technology allows archaeologists to classify pottery without making value judgements. Rather than considering the value of the marks, decoration and symbols as well made or aesthetically pleasing to a twentieth-century sense of design, the relevant questions concern the potters and their clients who were the intended audience for the information contained in the surface treatment. No single interpretation of that information suffices. The context and the audience determine the meanings. Locally made pottery can designate local boundaries of village, workshop, or family. The same pottery exported to a foreign country designates an exotic trade ware.

This system of classification accommodates contemporaneous pottery of all shapes, sizes and types, made by diverse techniques of manufacture with different surface treatments in various parts of Cyprus. It incorporates all facets of the ceramics industry which, rather than a monolithic organization, involves some complexity.

Whole pots from the ethnoarchaeological study provide the information to classify the Mosphiloti assemblage. Could one also classify a collection of sherds from a residential area of an excavation or the whole pots of a burial deposit? Sherd material should be amenable for such a study since many of the vessel attributes used to categorize the whole pots are features archaeologists regularly record for ancient pots and sherds, such as rim and base diameters and thicknesses, surface treatment, presence or absence of handles and, less often, the clay type. The current study advocates quantitative means to examine and record the surface markings and the manufacturing technique. An emphasis on precise pottery production techniques provides information

beyond the usual "fast wheel" or "hand made" categories which are of little value. A goal of the present study is to identify the wares of specific contemporaneous communities. The emphasis shifts from when to whom.

Archaeologists can approach ancient pottery from the perspective of ceramic technology thanks to a century of research devoted to defining ceramic chronologies. These can be further refined by examining how and where pots were made. For example, to return to the discussion of the Late Bronze Age Base Ring ware, are there variations in the techniques of manufacture which might correspond to differences in the clays and surface treatment noted above (see Vaughan, this volume)? Among other contemporaneous Late Cypriot pottery, Monochrome, Red-on-Black, Black Slip, and White Painted, what are the differences or similarities of their manufacture? Were all jugs of a certain size and shape made in precisely the same manner? Were all handles applied in the identical fashion? Rather than consider such differences evidence of chronological distinctions, ceramic technology can evaluate the relationship between such wares to understand developments and changes in the ceramics industry throughout the Late Cypriot Bronze Age and the societies that came before and after.

Another example concerns the Philistine pottery of the twelfth century BCE found along the coast of Israel, Lebanon, and elsewhere in the Mediterranean area. The results of my unpublished study of bowls bearing the characteristic Philistine painted motifs, as well as the assumed local red slipped bowls, suggest that despite superficial differences, the technique of their manufacture was identical. This preliminary finding on bowls excavated in Israel has broad implications for the organization of the pottery industry and for the origin and character of the society who made and used the painted and red slipped pottery.

CONCLUSION

To project the present organization of the pottery industry into the past is not the purpose of ethnoarchaeological studies. One advantage of studying pots made by traditional potters today is the ability to observe the pottery in use within its own context. Archaeologists can therefore learn the social and behavioral sources of variation in contemporaneous wares. In Cyprus, variation in the pottery reflects the organization of the industry. Glazed and plain table or tourist wares are made

by potters located mainly in urban centers, where they use electric tools and imported raw materials. Low fired incised wares made from local clays are hand built by rural potters for use by the indigenous population. The incised patterns and the nuances in the manufacturing technique allow one to differentiate among the pots of a specific community. Differences in the decoration impart both chronological and social information understood by specific people within and beyond the pottery

producing communities. Subtle variations in the manufacturing technique and surface markings that serve as sources of communication among contemporaries, although not always suitable chronological markers for archaeologists, can provide information about the organization of the ancient ceramics industry, trade and the social landscape.

Acknowledgments

My thanks are extended to Jane Barlow, Diane Bolger, Barbara Kling, and James Muhly for organizing this colloquium. The material presented here benefits from the stimulating conversations during the colloquium and from the other presentations.

The 1986 field work among the village potters of Cyprus was funded by a Fulbright-Hays Research Award for which I thank the late Mr. Renos Kamenos and the current Fulbright Commissioner in Nicosia, Mr. Daniel Hadjitoffi. The support and encouragement of Dr. Vassos Karageorghis, Director of the Department of Antiquities, and Dr. Stuart Swiny, Director of the Cyprus American Archaeological Research Institute are gratefully acknowledged as is the work of Mrs. Lydie Shufro and all the CAARI Trustees. My thanks also to the potters, their families, and those Cypriots who assisted with my research.

REFERENCES

Adams, William Y.

1979 On the Argument from Ceramics to History: A Challenge Based on Evidence from Medieval Nubia. *Current Anthropology* 20, 727-744.

Annis, M. Beatrice

1988 Modes of Production and the Use of Space in Potters' Workshops in Sardinia: a Changing Picture. *Newsletter of the Department of Pottery Technology* 6, 47-77.

Balfet, Hélène

1965 Ethnoarchaeological Observations in North Africa and Archaeological Interpretations: The Pottery of the Maghreb. In *Ceramics and Man*, edited by Frederick R. Matson, pp. 161-177. Viking Publications in Anthropology Vol. 41. New York.

Frankel, David

1988 Pottery Production in Prehistoric Bronze Age Cyprus: Assessing the Problem. *Journal of Mediterranean Archaeology* 1/2, 27-55.

Franken, Henk J. & Jan Kalsbeek

1975 *Potters of a Medieval Village in the Jordon Valley. Excavations at Tell Abu Gourdan, Jordan.* Amsterdam.

Hampe, Roland & Adam Winter

1962 *Bei Töpfern und Töferinnen in Kreta, Messenien, und Zypern*, reprinted 1976. Mainz.

Hardin, Margaret

1984 Models of Decoration. In *The Many Dimensions of Pottery*, edited by Sander E. van der Leeuw & Alison C. Pritchard, pp. 573-607. Amsterdam.

Johnson, Gary A.

1973 *Local Exchange and Early State Development in Southwestern Iran.* The University of Michigan Museum of Anthropology, Anthropological Papers 51, Ann Arbor.

Lagarce, J. & E. Lagarce

1972 Notes sur quelques procédés de fabrication des céramiques chypriotes au Bronze Récent. *RDAC*, 134-142.

London, Gloria A.

1986 Response to Melissa Hagstrum, "Measuring Prehistoric Ceramic Craft Specialization: a Test Case in the American Southwest. *JFA* 13, 510-511.

1987a Cypriote Potters: Past and Present. *RDAC*, 319-322.

1987b Regionalism in Traditional Cypriote Ceramics. *A Knapsack Full of Pottery.* Ar-
chaeo-Ceramological Miscellanea Dedicated to H.J. Franken. *Newsletter of the Department of Pottery Technology* 5, 125-136. Leiden.

1989a On Fig Leaves, Itinerant Potters, and Pottery Production Locations in Cyprus. In *Cross-craft and Cross-cultural Interactions in Ceramics*, edited by Patrick E. McGovern & Michael R. Notis, pp. 65-80. Ceramics and Civilization Vol. IV, edited by W. David Kingery. Columbus, Ohio.

1989b A Comparison of Two Contemporaneous Lifestyles of the Late Second Millennium B.C. *BASOR* 273, 37-55.

1989c Past Present: The Village Potters of Cyprus. *Biblical Archaeologist* 52.4, 219-229.

1991 Standardization and Variation in the Work of Craft Specialists. In *Ceramic Ethnoarchaeology*, edited by William A. Longacre, pp. 182-204. Tucson.

London, Gloria, Frosso Egoumenidou, & Vassos Karageorghis

1990 *Traditional Pottery in Cyprus.* Mainz.

Longacre, William A.

1981 Kalings Pottery: An Ethnoarchaeological Study. In *Pattern of the Past*, edited by Ian Hodder, Glynn Issac & Norman Hammond, pp. 49-66. Cambridge.

Longacre, William A., Kenneth L. Kvamme, & Masashi Kobayashi

1988 Southwestern Pottery Standardization: An Ethnoarchaeological View from the Philippines. *The Kiva* 53.2, 101-112.

Matson, Frederick R., ed.

1965 *Ceramics and Man.* Viking Foundation Publication in Anthropology No. 41. Chicago.

1984 Ceramics and Man Reconsidered with Some Thoughts for the Future. In *The Many Dimensions of Pottery*, edited by Sander E. van der Leeuw & Alison C. Pritchard, pp. 25-49. Amsterdam.

Merrillees, Robert S.

1982 Late Cypriote Pottery Making Techniques. In *Archéologie au Levant, Recueil R. Saidah. Collection de la Maison de l'Orient Méditerranéen No. 12. Série Archéolgique 9*, pp. 155-159.

Nicholson, Paul T. & Helen L. Patterson

1985 Ethnoarchaeology in Egypt: The Ballâs Pottery Project. *Archaeology* 38.3, 52-59.

Patrik, Linda E.
 1985 Is There an Archaeological Record? In *Advances in Archaeological Method and Theory*. Vol. 8, edited by Michael B. Schiffer, pp. 27-62. Orlando.

Petrie, W.M. Flinders
 1891 *Tell el-Hesy (Lachish)*. London.

Rathje, William L.
 1975 The Last Tango in Mayapan: A Tentative Trajectory of Production-Distribution Systems. In *Ancient Civilization and Trade*, edited by Jeremy A. Sabloff & C.C. Lamberg-Karlovsky, pp. 409-448. Albuquerque.

Rice, Prudence M.
 1981 Evolution of Specialized Pottery Production: A Trial Model. *Current Anthropology* 22.3, 219-240.

Scheans, Daniel J.
 1977 *Filipino Market Potteries*. National Museum Monograph No. 3. Manila.

Sinopoli, Carla M.
 1988 The Organization of Craft Production in Vijayanagare, South India. *American Anthropologist* 90.3, 580-597.

Tufnell, Olga, C.H. Inge, & G. Lankester Harding
 1940 *Lachish II: The Fosse Temple*. London.

Yon, Marguerite
 1985 Atéliers et traditions céramiques. In *Chypre: La vie quotidienne de l'antiquité à nos jours*, pp. 103-114. Actes du colloque Musée de l'Homme. Paris.

The Principles of Cypriot Bronze Age Pottery Classification

Robert Merrillees

It is characteristic of Cypriot archaeology that the analytical bases of our discipline have never been rationally argued or empirically tested. In his pioneering work of 1926, Einar Gjerstad stated he had retained the ceramic nomenclature established by Myres and Ohnefalsch-Richter "partly because these names are excellent in themselves, and partly because nothing is so meaningless and confusing as a continual changing of pottery-names, even if they do not give a clear representation of the pottery-types in question—especially since such a representation is in many cases impossible" (Gjerstad 1926, 88). As a result there has developed a tendency among scholars either uncritically to take the methodological frameworks, such as pottery classification and relative chronology, for granted, or no less unthinkingly, to reject them as being anachronistic or worse, unscientific. It is true that custom and convenience have most often been invoked to justify continued adherence to the systems currently in use, but since historiography, not to mention history, is anathema to most new archaeologists, appeals to precedent and the academic past of this subject are calculated only to excite rather than assuage controversy over the means available to us for making sense of the archaeological record.

Those of you who have read my *Introduction to the Bronze Age Archaeology of Cyprus* (Merrillees 1978) will understand how the terms used for classifying pottery and designating the relative chronology of prehistoric Cyprus came into existence. Even then, that survey of previous writings on the subject did not, and could not, determine the thought processes that went into individual contributions to the development of the nomenclature. Subsequent studies of a more general kind have not taken appreciation of this issue much further, though a useful service has been rendered by the *Dictionnaire illustré multilingue de la céramique du proche orient ancien*, in which Marguerite Yon and her collaborators (1981) set out to codify the ceramic ter-

minology employed in the literature and identify some of its underlying principles. More common, however, had been the kind of statement which sums up a century's research by a multiplicity of scholars through asserting that "in general...the current system of classification and chronology produces dating for the development of Cypriote civilization that are [*sic*] fundamentally in error" (Coleman 1985, 140).

The traditionalists and rejectionists have at least one thing in common. They both recognize that the present scheme of pottery classification for Bronze Age Cyprus is still far from perfect. Not only has it evolved over the years without any overall supervision or control except the judgment of one's archaeological peers, but there exists no mechanism to act as a clearing house or place of review for the modification of old terms and the introduction of new. Nearly all students of Cypriot prehistory who have had to examine and publish quantities of pottery remains have had to confront problems of identification and been tempted to devise refinements in the existing nomenclature so as to facilitate presentation of the material in an intelligible way to a wider public. The extent to which these changes have been accepted and used has depended to a large degree on chance, compatibility or coercion, and this in turn has allowed considerable scope for confusion and caution.

I would submit, however, that it is only by coming to understand why the ceramic terminology to which we are accustomed has continued in use and been sanctioned by the literature that it will be possible to disinter the reasons for its invention and determine the validity of its future application. There is no point and can be no justification for scrapping the old classification and replacing it with something new, or worse, with nothing at all, unless and until present practice is to be found totally unworkable. And since so little attempt has been made in recent years to establish on a firmer footing the principles which underpin the system enshrined in that bible of Cypriot archaeology, *The Swedish Cyprus Ex-*

pedition, it would say more about the erudition and standards of specialists of the present than of the past if we were to proceed from the assumption that the new generation of students had by their very advent made a *tabula rasa* of previous scholarship.

Accepting ware as the basic concept of pottery classification, it is necessary at the outset to recapitulate the guiding principles in applying the system to the ceramic remains of the Bronze Age. First and foremost it should be remembered that since we do not know the way in which the ancient potters themselves referred to their products, whether according to their shape, fabric or finish, or a combination of two or more of these dimensions, our modern day names for a category of containers with similar technical features are merely titles of academic convenience and are accordingly less important for what they literally say than for what they connote. Base Ring Ware, for example, is the generic term for a class of pottery of which the circular foot is a typical but by no means invariable element and is only one of a number of criteria that together make up the recognizable profile of the ware.

By this approach we seek, even if only subconsciously, to identify and designate the characteristics which the ancient potters gave to their products. It proceeds from the not unreasonable assumption that the chief criteria followed by the craftsmen were form and appearance, and that ware designations which reflect these features correspond most closely to their intentions. It is noteworthy that nearly all the generic terms currently in use, such as Red Polished, White Painted, Black Slip, Bichrome, Monochrome, White Slip, etc., draw on the surface finish and/or decoration of categories of vases, which, being the most visual aspect and capable of infinite variation within the technical parameters chosen, come closest to representing the deliberate expression of the potters responsible. Where this emphasis on surface treatment loses some of its force and makes classification complicated is in cases where shape assumes a primary role in the manufacturing concept, as happened early in Late Cypriot I, when experimentation produced a striking range of containers having much the same form but different wares.

It follows from this definition that ware titles should be based on visible features and, as a corollary, not incorporate nonintrinsic aspects, such as geographic or topographic terms. It was an unhappy day when Joan du Plat Taylor introduced the name "Apliki Ware" after the site she excavated in 1938 (Taylor 1952). She did, however, acknowledge that this ware was a coarse variant of the well-known Monochrome Ware (Taylor 1952, 159-160), and in *Swedish Cyprus Expedition* (IV Pt.1C), Paul Åström stated that "Since wares are not named after any particular site in the *Swed. Cyp. Exp.*, I prefer to call this fabric Coarse Monochrome Ware"

(*SCE* IV Pt.1C, 103). No less unfortunate was the appearance a decade ago of "Episkopi Ware," named after the site which James R. Carpenter excavated between 1975 and 1978. A variety of fine Red Polished Ware, often though not invariably decorated with incised and punctured motifs, Carpenter proposed, "on the basis of the diagnostic decorative style of some of its vessels,...to rename it 'Red Polished Punctured Ware,' a term offered initially by Swiny...in his unpublished doctoral dissertation" (Carpenter 1981, 64).

That leaves unresolved the issue of J. R. Stewart's Red Polished I (Philia) as well as other wares with this suffix, (*SCE* IV Pt.1A, 223-225), and Red Polished I (South Coast), which is specifically designated but nowhere described (*SCE* IV Pt.1A, 357, 359). In the case of the former, the addition of the term *Philia* can be justified on the grounds that this usage is intended to differentiate the ware names applicable to the Philia Culture from the same ones describing the pottery of the regular Early Cypriot sequence of the "Vounous Culture." In this context it would seem more appropriate to amend the suffix to read "Philia Culture." In any event Stewart's classification is less ambiguous than Dikaios' (*SCE* IV Pt.1A, 165-167) and should be employed in preference to the latter's, though Diane Bolger has preferred to refer to both concurrently without cultural suffix, at least in her catalogue and discussion of the material from Khrysiliou-*Ammos* and Nicosia-*Ayia Paraskevi* (Bolger 1983).

Red Polished I (South Coast) represents more of a problem. Because the Red Polished classification without geographic or cultural suffix was based on the pottery finds from the island's center and north coast, those series which belong to the same ceramic tradition and chronological horizon but have their own distinctive regional character required separate identification. While the assemblage from the northwest of Cyprus is typical of the Philia Culture, that from the south coast, though undoubtedly diagnostic of another "culture," was known from only a handful of examples without scientific provenances (Stewart 1988, 60), and could not be categorized as anything but Red Polished I (South Coast). The term has been retained and defined by Ellen Herscher (1981, 80) and Stuart Swiny (1981, 57), who, through their exemplary studies, have made a major contribution to our understanding of cultural developments in this part of Cyprus and shown the potential of the classification system for serving new needs and challenges. Noticeably, Stella Lubsen-Admiraal has not followed their lead in her catalogue of two vases of this ware in Amsterdam (1988, 127-128).

What these geographic and/or cultural suffixes have done is merely to give due recognition to the importance of regional diversity in the mainstream of a particular ceramic sequence. Just as Åström saw the scope for

elaborating the terminology of the White Painted series to allow for stylistic off-shoots with geographic associations (1966, 80-93), so Herscher and Swiny have not hesitated to expand the range of Red Polished Ware titles to take account of new regional variations and have added to the repertory terms such as Red Polished III Mottled, together with, of course, Red Polished Punctured. Herscher (1973) has independently identified a Red- and Black-Polished Ware from the western Karpas, which is abundantly represented in Desmond Morris' private collection (Morris 1985, 341-352), and Hennessy (1973, 10-22) has sought to attribute certain decorative styles in the Red Polished series to individual artists. These styles are, of course, once again nothing more than regional variations.

Perhaps the least satisfactory way of specifying subgroups within the broad classification sequences has been the incorporation of Roman numerals or letters of the alphabet into ceramic ware titles. Because, as has been pointed out so often, the Red Polished and White Painted series were originally based mostly on pottery from tombs and therefore on complete specimens, there was a temptation to pay less regard to the distinguishing technical features than to the chronological dimension. It is no coincidence that Red Polished I is typical of Early Cypriot I, Red Polished II of Early Cypriot II, and Red Polished III of Early Cypriot III, as well as, in this case, Middle Cypriot I-III, (SCE IV Pt.1A, 225-229), and it is significant that Stewart not only recognized that "each class of the Red Polished series in fact includes several different fabrics" but decided "to use shape and date as the main criteria....as I consider that the disadvantages of departing from a strict classification under wares are outweighed by the advantages of this system (arranging the Corpus under shapes)" (SCE IV Pt.1A, 223). The silliest result of this approach has been the classification of the ubiquitous hemispherical knob-lug bowl, which runs from Early Cypriot II to Middle Cypriot III, as Red Polished II, when technically the majority belong to Red Polished III and some are Red Polished IV (SCE IV Pt.1A, 333).

In classification terms what has happened in practice is that Red Polished I and II are considered north coast regional variants of the sequence, while Red Polished III and IV are encountered islandwide (Swiny 1981, 57-58). In sherd form, however, it is often extremely difficult to make these fine distinctions, and it is usually the cultural context that helps pinpoint the appropriate classification. The worst cases of the chronological distortion of the technical criteria are provided by the Black Slip series, in which Black Slip II and III are for the most part technically the same as Black Slip IV and V respectively, but are separately designated because Black Slip II and III can be assigned to Middle Cypriot deposits and Black Slip IV and V to Late Cypriot (SCE IV Pt.1C, 74-87)! There is, however, a category of Black Slip Ware with a soft greenish-buff fabric and thin, matte, friable black slip which is distinctive in its own right and typical of Late Cypriot I (Åström 1966, 61-62). It alone should be designated Black Slip IV.

The most curious of all categorizations, leaving aside the welter of names for the hybrid fabrics of Late Cypriot III, is White Slip II A. According to Mervyn Popham, who isolated the subgroup, "a distinctive regional variety, here called White Slip II A, seemingly centered in the south west of the island, was being made at the same time as White Slip II though its precise synchronisms with the more normal style elsewhere cannot yet be determined" (SCE IV Pt.1C, 432). If he had followed more conventional practice, he could have designated the class White Slip II Palm Tree Style or White Slip II South Coast (SCE IV Pt.1C, 445-447). Apart from Joan du Plat Taylor, who not only invented the term Apliki Ware but gave it A and B subdivisions, the only other scholar to have resorted to these alphabetical suffixes is Stewart, who used them to classify his White Painted (Philia) Wares (SCE IV Pt.1A, 224-225). They are not a helpful substitute for the more descriptive titles which specifically address the ceramic or cultural factors involved.

There can be no doubt that within the parameters defined above, as Åström, Herscher and Swiny have clearly demonstrated, the existing pottery classification system is capable of infinite adaptation and expansion, without consequent loss of intelligibility or credibility. Provided the ground rules are respected, every student should feel free to devise new terms, based on the analysis of a fresh body of material, whether recently excavated or assembled from among extant finds, and presented in such a way as to help others identify specimens of the same ware. But there should be a more co-ordinated approach to the vetting and launching of these terms, and I wonder if participants at this workshop might agree to circulate to each other in advance of publication a list of the new names they intend using, so that they can benefit from the knowledge and views of others in similar situations. This could be a very constructive outcome to these discussions, until, of course, we meet the next time.

REFERENCES

Åström, Paul
 1966 *Excavations at Kalopsidha and Ayios Iakovos in Cyprus.* SIMA II. Lund.

Bolger, Diane
 1983 Khrysiliou-*Ammos*, Nicosia-*Ayia Paraskevi* and the Philia Culture of Cyprus. *RDAC*, 60-73.

Carpenter, James R.
 1981 Excavations at Phaneromeni, 1975-1978. In *Studies in Cypriote Archaeology*, edited by J.C. Biers & David Soren, pp. 59-78. Institute of Archaeology Monograph XVIII. University of California, Los Angeles.

Coleman, John E.
 1985 Postscriptum: A Brief Reply to Dr. Merrillees. In *Archaeology in Cyprus 1960-1985*, edited by Vassos Karageorghis, pp. 138-140. Nicosia.

Gjerstad, Einar
 1926 *Studies on Prehistoric Cyprus.* Uppsala.

Hennessy, J. Basil
 1973 Cypriot Artists of the Early and Middle Bronze Age. *Australian Studies in Archaeology* 1, 10-22. Sydney.

Herscher, Ellen
 1973 Red-and-Black Polished Ware from the Western Karpas. *RDAC*, 62-71.

 1981 Southern Cyprus, the Disappearing Early Bronze Age and the Evidence from Phaneromeni. In *Studies in Cypriote Archaeology*, edited by J.C. Biers & David Soren, pp. 79-85. Institute of Archaeology Monograph XVIII. University of California, Los Angeles.

Lubsen-Admiraal, Stella
 1988 A Red Polished Sextet from Amsterdam. *RDAC*, part 1, 127-132.

Merrillees, Robert S.
 1978 *Introduction to the Bronze Age Archaeology of Cyprus.* SIMA Pocketbook IX. Göteborg.

Morris, Desmond
 1985 *The Art of Ancient Cyprus.* Oxford.

Stewart, James R.
 1988 *Corpus of Cypriot Artefacts of the Early Bronze Age.* SIMA III:1. Göteborg.

Swiny, Stuart
 1981 Bronze Age Settlement Patterns in Southwest Cyprus. *Levant* XIII, 51-87.

Taylor, Joan du Plat
 1952 A Late Bronze Age Settlement at Apliki, Cyprus. *AntJ* 32, 133-167.

Yon, Marguerite, ed.
 1981 *Dictionnaire illustré multilingue de la céramique du proche orient ancien.* Collection de la Maison de l'Orient Méditerranéen No. 10. Série archéologique 7. Lyon.

Ceramic Variability: Measurement and Meaning

David Frankel

PART 1: THEORETICAL BASIS

"We need more rather then fewer classifications, different classifications, always new classifications, to meet new needs" (Brew 1946, 65).

INTRODUCTION

As any discipline develops, new data, new techniques and new orientations force the reassessment of established procedures and practices. The archaeology of prehistoric Cyprus is no exception, and this conference is one symptom of a general feeling of dissatisfaction with some current analytical structures and typological systems. In responding to the pressure for change it is imperative to assess critically research aims in order to create systems which are appropriate to current demands and flexible enough to prove useful in the future, which will bring both additional data and new questions.

The perceived inadequacy of the established classification system is currently being reinforced by studies of newly excavated data (e.g., Coleman 1985; cf. Merrillees 1985). It is also implied in those specialized studies of particular aspects of ceramic variability concerned not with any overall typology, or universal schemes of classification, but with exploiting particular attributes for specific ends. This is not to say that the older systems have no value in modern archaeological research, but that it is necessary to recognize their initial aims, their structures and their limitations in order to use them appropriately, and to avoid that "fervent and unyielding commitment that archaeologists often feel toward particular typologies to which they have become habituated" (Adams 1988, 54).

Equally, in reassessing ceramic analysis, or developing new systems, it is crucial to recognize underlying issues and to avoid replacing current systems by others with similar implicit values or weaknesses. This can best be done by a clear explication of our current aims and concerns, and perceived directions, and also by a clearer understanding of fundamental factors affecting material culture.

The approach taken here differs markedly from the traditional all-encompassing typologies and the islandwide frame of reference championed by Merrillees who regards it as

> obvious that what is required for methodological purposes is a system whereby we can first designate a type fossil, either as a culturally homogenous and geographically discrete group of sites, called a "Culture", or a distinctive category of artefacts, such as a pottery Ware; secondly, determine the period of its existence according to a scheme of relative chronology that applies island-wide.... (Merrillees 1985, 14; cf. Merrillees 1977, 34; Merrillees 1979, 116)

Such an approach confuses the basic descriptive and comparative typologies with those needed for inference and analysis (cf. Adams 1988) and carries with it the simple assumption that we understand the nature of cultural process and how to derive meaning from the archaeological record. Equivalent ideas have, of course, been strongly condemned over many years by people such as Binford, some of whose trenchant remarks in one of his more recent critiques could well apply to much Cypriot archaeology (Binford 1989). The normative view of definable types and culture emphasizes internal homogeneity and external differences, imposing a model of discrete spatial and temporal entities, with clear boundaries. This might allow one to locate con-

structs in time and space, but does not lead to any real understanding of the meaning of these entities or the relationships between them or to explanations in terms of social organization, interconnections or change (cf. Stanley Price 1979). What I would prefer to do is to look outside this neat structure and to see the archaeological record, not as a neat set of entities, but rather as a *field*—a multidimensional field within which some attributes may group themselves together in some dimensions but not in others, with differing degrees of uniformity and variation, homogeneity and diversity, and with fuzzy, complex and overlapping boundaries.

Certainly we may need the simple structures—basic types and spatial/chronological entities—to give an initial insight into this complex field, but it is then important to leave them behind, and to address ourselves directly to the more difficult task of asking appropriate questions of appropriate data, and of learning to read the archaeological record in different ways.

This cannot, of course, be done all at once, but we may start with a more self-critical assessment of the nature of

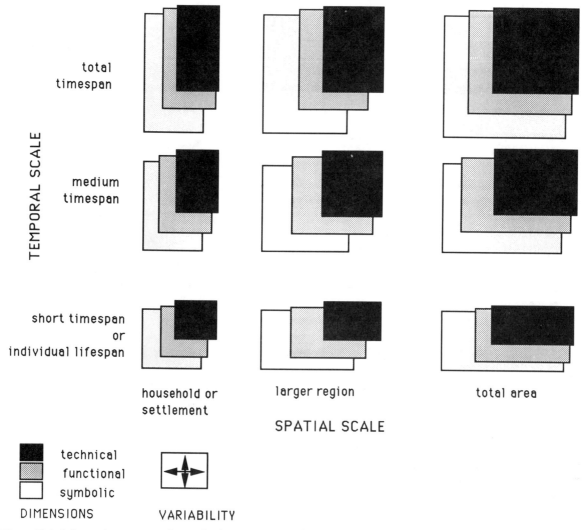

Figure 25.1. Schematic representation of the degrees of variability expected at different scales of time and space in symbolic, functional and technological dimensions of variation

archaeological reasoning and a careful assessment of typologies, with an awareness of their varied and limited utility in particular circumstances. One way to develop this further is to seek to isolate the separate cross-cutting and interleaved components which go to make up the archaeological record. An important issue is that of different dimensions and scales of variation. Analyses which are appropriate or useful for some purposes will not be useful for others. The attributes selected or the subtlety of distinctions identified in any analysis must be geared to the particular problem being addressed. In this paper I will discuss some aspects of this issue which raise questions concerning future directions in reading the ceramic record of prehistoric Cyprus.

VARIABILITY IN THE ARCHAEOLOGICAL RECORD

Figure 25.1 is an attempt to portray a summary of the nature and correlates of several major dimensions and scales of variation which affect archaeological material and its study. These fall into two main classes: *systemic* and *contextual*. The relative variability in some systemic factors affecting intrinsic attributes of artifacts is shown by the size of the squares, each representing an idealized situation at different scales along the two main contextual axes of time and space.

It is important at this stage to recognize that while systemic and contextual factors determine the degree of variability of the material, it is our choice and measurement of these variables which is of prime importance. We select the intrinsic attributes and define the extrinsic contexts to form our archaeological database. The archaeological record is not, therefore, an independent fixed phenomenon, but is created by archaeologists, and will vary not only by the accretion of newly discovered material, but also by the choices made in the field, laboratory or library over what to measure, how precise our measurements should be, and what to group into categories or place into assemblages for analytical purposes. The "facts" we refer to are contingent, not absolute. We need, therefore, to consider both the systemic source of variability in artifacts, and the impact of our observations upon our archaeological database.

CONTEXTUAL VARIABILITY

Contextual attributes are those of association and relationship not directly observable from artifacts but provided by the context of deposition, recovery and problem definition, or archaeological classification. Although Adams (1988, 49) separates these contextual variables from inferential variables, all extrinsic variables are also archaeological constructs, carrying inferential implications. In some circumstances the extrinsic or contextual associations of artifacts are clear—the simplest one being a tomb group from a single, definitive burial. Other excavated assemblages—particularly those from settlement sites—are artificial constructs defined in either the field or laboratory by the archaeologist on a variety of grounds (cf. Frankel 1988b). Other assemblages are created for analytical convenience. These associations are independent of the material itself and to varying degrees are the product of archaeological construction. So too are the analytical groupings created on the basis of intrinsic attributes which define spatial or temporal entities.

Traditional approaches see the time span and geographic range of an industry, style, tradition or culture as evident from "natural" boundaries; but the view taken here—that there are no truly "natural" boundaries but rather a complex multidimensional field of variation—emphasizes the artificiality of our constructs and places greater emphasis on understanding ranges or trends.

Simpler definitions of "cultures" with internal homogeneity and external diversity have, perforce, sharp, essentially unbridgeable boundaries: relationships between them are simple and their relationships not readily amenable to explanation. But boundaries are more complex, and take different forms. In spatial terms we *may* have entities clearly identified and separated by differences in material culture or we may have less sharp gradations, clinal variation indicating a different type of relationship between adjacent groups—a different context of interaction, perhaps a different symboling of social identification.

These differences are schematically illustrated in Figure 25.2, which shows three types of boundaries ranging from sharp (a) to very gradual (c). Each represents a different type of boundary effect, or an indication of different spatial scales of equivalent social interaction. A sharp fall-off in similarity indicates discrete spatial entities in a small scale of close social interaction, while a very gradual slope indicates more interaction at that geographic scale and fewer markers of local social identity, or a more widespread industry (cf. Hodder & Orton 1976, 195-197).

Similar boundaries divide entities in time. Change may take place rapidly or more slowly. Different processes

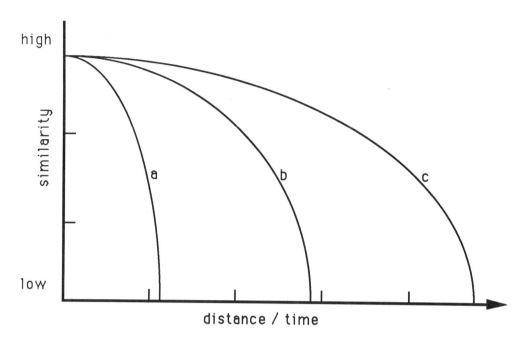

Figure 25.2. Fall-off in similarity over distance or through time: a) sharp fall-off indicating local groupings with sharp, clearly defined boundaries; b) intermediate fall-off; c) more even fall-off, indicating less sharp boundaries and less discrete entities in space or time

must be sought to explain these patterns, and we must seek ways of measuring this independently of the data themselves. This requires, in part, a recognition of the significance of different scales of archaeological time in terms of the degree of resolution that can be achieved, for even in stratigraphic sequences boundary effects are often simply the products of the archaeological construction of analytical units (Frankel 1988b). Suggestions of a "natural rhythm" of cultural development (Merrillees 1977, 40) preclude the possibility of identifying different rates of change and prevent us from understanding temporal variations in terms of different processes of innovation and change as seen in archaeological depositional contexts (cf. Millett 1987).

The approach espoused here—viewing the archaeological record as a multidimensional field—takes the emphasis away from formal types, cultures or other entities. The interest is on measuring different degrees of similarity or variability of different kinds, and placing these in time and space to look at linkages, rather than entities. To do this we need to consider carefully the scale at which we are examining the record as this will be crucial to understanding the significance of the degrees of similarity or variability that we perceive.

One axis in Figure 25.1 represents the scale of analysis in time, ranging from the finest levels achievable archaeologically to the total extent of the defined tradition being studied. Clearly, as the length of the time span increases, so too will the amount of variability within it. Classification which is appropriate for grouping material at a broad level—the entire life span of a defined style or tradition—is obviously not appropriate for investigating questions of finer-scale development or other cross-cutting dimensions.

Similarly, the horizontal axis in Figure 25.1 represents the spatial scale of analysis. Once again the basic concept is that the larger the scale, the greater the degree of variability within the archaeological record. At one end of this scale the products of one individual or household will have very limited variability in at least the two dimensions of technological and ideographic or symbolic variability compared with the far wider range of variability to be expected when the products of a broader region are considered. It is possible, however, that the variability in functional attributes would be as great within an individual's output as it would be in the products of all neighboring potters.

It should be clear therefore that what appear as significant differences between artifacts or assemblages at a finer level of analysis must be considered irrelevant noise at a more general scale.

SYSTEMIC VARIABILITY

Different intrinsic attributes of artifacts—those which can be observed directly on the artifacts themselves (Gardin 1980; Adams 1988) reflect different dimensions of variation. Some are determined by technological aspects of raw materials or manufacturing techniques; some are related to the primary function of the item; others are less conditioned by these factors and reflect culturally determined aspects—the ideographic or symbolic realm; all are influenced by the general social context in which the material is produced (Binford 1965; Frankel 1974; cf. Miller 1985).

As a simple example, the fabric and color of a vessel are primarily technological variation, the shape of a spout or handle may be functional, while the decoration basically reflects the symbolic or social factors. Of course many attributes are affected by all three of these major dimensions of variation, and some are interdependent. Nevertheless, it is still important and necessary to attempt to recognize which dimensions or factors are operating on which attributes in order to understand what it is we are observing, measuring or classifying.

In addition, these dimensions differ in their degree or range of variability. Although it is difficult to demonstrate this formally, it can be argued that, in general, technological variation is the most limited, as there are not only social or cultural constraints but fundamental design or technical reasons why particular processes must be followed. Functional variation is somewhat more flexible, as several forms may be equally capable of performing the same task, and in different situations different activities will require different functional forms. The most varied aspects are likely to be symbolic, where fewer underlying noncultural constraints apply. This difference in scale of variability is schematically indicated in Figure 25.1 by the relative sizes of the superimposed squares. Although for the sake of simplicity these ratios are portrayed as similar in all situations, there is no necessary reason why this should be so, and, indeed, comparison of these proportions at different scales of analysis, or in different contexts is itself of interest.

Beyond this simple characterization, further elements need to be considered. For example, particular technological factors will affect the relative variability observable in different shapes of vessels. Jugs are more complex vessels than bowls, and therefore have more potential to vary in some aspects (handles, necks, spouts), but may be less variable in body shape and proportion because of technical constraints imposed by the process of building the vessel (Frankel 1981, 92).

Ideographic variables may themselves vary at different scales so that analyses of design may consider *emblemic* or *assertive* styles reflecting aspects of group affiliation or individual identity (Weissner 1983, 257-258). These and other cultural factors cannot be measured in any way independently of the material being studied, and no simple, universal correlation of scale of problem definition and scale of variability can be expected.

One example of this is the relationship between variability of output and the context of production (Rice 1981; Frankel 1988a). It is often suggested that a more organized, more commercial, larger-scale ceramic industry will produce pots that are more uniform, that is, have a narrower range of variability than less formal household or personal production. This problem of defining the extent or degree of variability to be expected in a particular prehistoric industry is clearly a crucial one, and is complicated by the fact that it is, obviously, not independent of the data. The model of ceramic production favored is a product of analysis and cannot be used as an initial or external measure. Nevertheless, it must be borne in mind in constructing typological or other research tools, even where this issue is not the primary focus of attention.

Other factors affect our measures of internal variability. For example, simpler styles of decoration such as White Painted Ware Cross Line Style simply do not have the potential for variation of more complex decorative structures such as seen in central or northern Cypriot White Painted vessels. To what extent can these be measured and the degree of variability compared? Of course their relative complexity and associated variability may themselves be conditioned by economic forces affecting production or aesthetic ideals favoring or disapproving of variety, both of which need to be considered in assessing the meaning of the observed pattern.

It is especially important to consider the differences in the degree of variability for each of these dimensions of variation in attempting to compare the relative similarity or dissimilarity of artifacts or assemblages. What appears to be a general uniformity may reflect our concentration on technological or functional attributes and conversely an apparent diversity may be the product of a classification or measure based on symbolic or ideographic rather than more closely constrained sources of variation.

The recognition of the different meanings implicit in different attributes has other advantages. By allowing the separate measure of these different aspects it becomes possible to compare their variability, and to ask, for example, whether there is a common (relatively

uniform) technology in a ceramic industry, while there is a diversity in other aspects, and what this might mean for the type of relationships between different produc-tion centers (cf. Frankel 1981). This should provide a richer appreciation of potentials within the archaeologi-cal record.

CYPRIOT CERAMIC TYPOLOGY

As is well known, the normative ceramic analysis and classification of Cypriot Bronze Age pottery initially devised by J.L. Myres was subsequently revised and en-hanced by E. Gjerstad and his colleagues of the Swedish Cyprus Expedition, before being developed further by J.R.B. Stewart, P. Åström and others (Frankel 1974; Mer-rillees 1978). The initial, and primary, aim of these evolving typological systems was to order individual items and assemblages into temporal sequences. The adoption of the tripartite divisions of the Bronze Age, each characterized by a particular set of co-occurring types or wares gave a rigid structure to this chronology which from its inception has proved as much a hindrance as a help to understanding change (Myres 1926, 289; Frankel 1974, 2; cf. Graslund 1987).

The Swedish typological approach gave primary im-portance to the definition of *wares* (characterized by fabric, technique and surface treatment). Both in its original formulation, and in more developed form in the later volumes of the *Swedish Cyprus Expedition* (espe-cially *SCE* IV Pts.1A-1C) a hierarchical structure was used which did not clearly separate analysis of form from fabric, but included all types of intrinsic attributes in constructing the Corpus of Types. Where Åström intro-duced the concept of "Styles" (e.g., Pendent Line Style, Cross Line Style), this simply replaced ware as the basis of the hierarchical system, and again used a combination of many factors in higher levels of classification. Stewart's Corpus of Early Cypriot Pottery (see *SCE* IV Pt.1A, 212-213) was somewhat different in concept, with Ware and Type (or shape) clearly separated, so that the distribution of different forms across different tech-nological categories could be examined. However, his complex, seemingly idiosyncratic definitions of Types not only make application of the system difficult, but provide us with little ability to discern interrelationships and correlations within or between different types of attributes.

Chronologies built on these classifications initially used the defined ware series (for example Red Polished I, II, III, IV) which were understood by Gjerstad as rep-resenting convenient divisions within an evolving tradi-tion. This classificatory scheme implicitly recognized a model of continuous gradual change. The use of formal periods, however, implied clearer distinctions. It is therefore possible to see, from the earliest adoption of these two systems, a basic tension between the recogni-tion of gradual, multidimensional change in ceramics, and the formal chronological framework into which the material had to be fitted. This tension still remains with us, and is an underlying cause of the often expressed dissatisfaction with both typology and chronological divisions (cf. Stanley Price 1979).

The finer, more individualized classification scheme developed by Stewart allowed comparison of individual pots rather than comparison of proportions of different wares as the basis for dating assemblages, but also manifested this tension, and introduced others. Increas-ingly, as Cypriot archaeology developed, the simpler view of types as chronological markers was seen to be inadequate. This becomes evident in the debates con-cerning regional or chronological divisions of material (as for example with the status of the "Philia Culture"), due in part to alternative ideas of cultural systems and archaeological cultures, but also prompted by the in-creasing quantities of new data from more areas.

This creates the second tension between the fun-damental classification system and current data and problems: between a system developed with a model of a uniform development across the whole island and based on material from a restricted region, and the demands of material from many areas and the associated recognition of regional variation.

In looking for future approaches we also must recog-nize equivalent tensions: those between general systems that allow a primary identification and first level of comparison, and those which allow a recognition or measure of regional or intersite variation; between a need for a basic chronology and the avoidance of rigid models; between adequate description and inflexible typologies; between admitting complex multifactor variation and associated specific specialized study and the broader scale treatment of data. In other words we must combine common general approaches with spe-cialized analyses, in both problem definition and clas-sification.

If the concepts of variability noted above are legitimate, then they should help direct archaeological research toward a clearer definition of the aims of analysis and a recognition of the multifaceted nature of

enquiry. Some defined types may be useful at the broadest scale of primary documentation and general chronological ordering but will be of limited value when questions are asked at a different level. Finer-scale distinctions may be appropriate for intrasite or regional analysis, but will be irrelevant noise at a broader scale. It is therefore necessary to begin to construct models of the degree of variability to be expected at whatever scale of

analysis is preferred in order to select the appropriate level of precision for each dimension of variation, and each problem.

The problems and potentials inherent in this approach are perhaps now best considered in specific cases of definition and analysis of different dimensions of variation at different scales.

PART 2: ANALYTICAL EXAMPLES

VARIABILITY AT THE INDIVIDUAL SCALE

Consideration of the finest contextual level of analysis—that of the individual or very local scale—opens up key questions of how detailed our examination or analysis of material should be, and what level of variability we should regard as significant. Identifying material at the individual scale is, of course, common practice in Classical vase painting studies. It is less easily attempted with simpler technologies and styles. Several attempts have been made, however, to identify individual hands or workshops in Bronze Age Cyprus, both with later Mycenaean vessels and with earlier material (Hennessy 1973; Herscher 1972, 1973; cf. Frankel 1988a, 49-50).

Searching for the work of an individual potter rests upon an assumption that in some cases at least the individual will have a narrower range of variability than the local style, or that vessels grouped at this level of similarity have some clear meaning in terms of the context of production.

Apart from the groups proposed by Hennessy and Herscher, other individuals' work can also be identified where pots are extremely similar or display a particularly idiosyncratic touch. These cases are rare in prehistoric Bronze Age wares, and seldom can more than three or four vessels be grouped in this way. For example, one identifiable set of White Painted pots was probably manufactured at Politiko (Frankel 1974, 50; Frankel 1981, 95-96) while the common origin of three tripod juglets was noted by Åström (*SCE* IV Pt.1B, 39) to which I would add a fourth from Nicosia-*Ayia Paraskevi* (Tomb 8.15: Kromholz 1982, 155). Other pairs or small groups are also known. But these identical sets do not help with interpretations other than the possibility of demonstrating connections between sites or tomb groups. Until generalized beyond the identical (and therefore immediately suspect) they cannot contribute much to the understanding of the range of individual

production, or the relationships of personal, local and regional styles, which is basic to the question of variability. It is significant that so few of these identical sets can, in fact be established, implying considerable diversity in production even within each individual's output.

In order to illustrate this problem further I would like to consider a series of vessels from Lapithos that may all be the product of one workshop, or at least share aspects of a relatively unusual decorative style. These vessels do not always have much in common, but it is worth noting the relatively small distribution and low popularity of their motifs (particularly solid-filled and complex checkers) to appreciate the basis of this grouping (see Frankel 1974, appendix II). The approach taken here is a subjective one—a personal assessment of individual characteristics and their significance. Figure 25.3 presents a schematic picture of associations between thirty-seven vessels in this loose, polythetic set, some aspects of which may be explained in detail. This analysis is based on decoration and is concerned, therefore, with ideographic, rather than technical and functional variation, at the finest scale of resolution.

There can be no doubt as to the common origin of the two bottles (316.64, 2.36) and the amphora (316.4). All have the same use of alternate rows of crosshatched and solid-filled triangles, while the bottles both have horizontally hatched zigzag bands. One of the other features that bottle number 316.4 and the amphora (316.64) have in common is an axial divider in the form of a framed vertical wavy line. Two tankards from Lapithos Tomb 702 (144, 150) can be put together on the basis of the use of solid-filled elements and the general arrangement of the horizontal panels on the body. In addition they both have axial dividers in the form of crosshatched lozenges and both have double (parallel) zigzag lines on the rim. These two vessels may be linked to our primary group on the basis of the solid-filled motifs, while the crosshatched zigzags may be regarded as a large scale version of the hatched zigzag on the

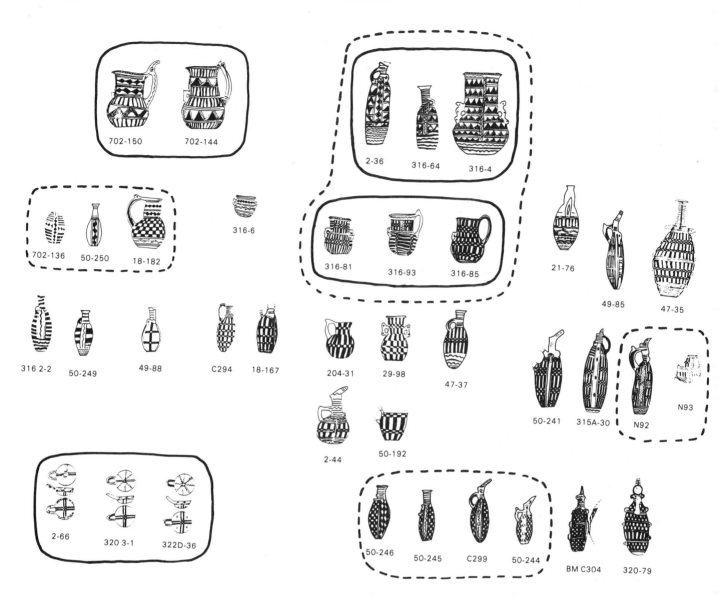

Figure 25.3. Schematic representation of the linkages between a series of vessels from Lapithos (drawings are sketches only, and not to scale)

bottles. Number 2.36 has similar axial dividers, and number 316.4 has the same motif on the rim as the two tankards and the wavy line inside the neck just below the rim is similar to that on number 702.144. We may also note the use of framed wavy lines as dividers on the necks of the tankards. Using similar observations it is possible to extend linkages beyond these vessels, and to consider more generally a range of others with solid bars and complex checker motifs (Fig. 25.3).

The fact that many of these motifs are relatively rare and the general style unusual (although not, of course, confined to these vessels or this region) may support the suggestion that these vessels were produced by a small

group of potters. When set against the total Lapithos production they appear distinctive, but are their internal similarities great enough for them to be considered as a valid group? And, if so, what sort of group—local style, products of one workshop, family or individual? In other words, does this reveal an individual's *assertive* rather than a group's *emblemic* style (cf. Weissner 1983). Can we proceed so far from the "identical" set even when considering vessels such as these, with their unusual or rare motifs?

Two related subgroups include vessels from Lapithos Tomb 316. These pots may be considered the work of one individual. Similarly the vessels from Tomb 702 may be

the work of one person. They are conventionally dated later than the material from Tomb 316, and therefore, if they are thought of as the work of the same potter, show a change in individual output in terms of shape and technique as well as style through time. Some other pairs or small groups of vessels (some of the flasks or the bowls) can also be regarded as the products of one potter, but the relationships between these sets and the other less readily grouped vessels remains an important problem. Not only does this raise the question of the development and range of output through one potter's productive life and the extent of borrowing or influences between potters, but this is clearly crucial to the measurement and understanding of variability in production. This is not, at least with the material considered here, amenable to formal analysis or any fixed scale of measurement, but must rely on more subjective judgments of what constitutes significant similarity. This must often consider relatively minor variation, beyond that needed for broader scale classification and analysis.

While it may be possible to suggest some such small groups on the basis of decorative style (ideographic variables) this cannot be so easily attempted in terms of shape or technique. In this case some vessels do have very similar surface appearance, but they are not so distinct as to be used as the hallmark of one potter, especially since individual potters did produce different wares (Herscher 1972). The range of shapes does give, however, some insight into the repertoire of finer wares but also indicates that functional variability cannot readily be used for this type of analysis.

The boundaries around one potter's work are therefore far from sharp, where they can be drawn at all, and few individuals can be identified in this way. Individual variability in shape and technique is perhaps close to that of the overall local industry, while in terms of decoration there was no requirement (obvious to us) for potters to differentiate themselves but rather a setting conducive to conformity with locally acceptable, general styles; in other words, we can perceive emblemic rather than assertive styles. Such an observation is not trivial, as it leads to a consideration of the context in which potters worked and vessels were produced. By examining the variability at this small scale, we may be able to develop models of the dynamics of production and the factors affecting potters in terms of individuality, innovation and conservatism.

VARIABILITY AT THE REGIONAL SCALE

Although it may prove impossible to isolate individuals within their local traditions, it is possible, at a broader scale of analysis, to compare and define regional relationships using more formal numerical methods to group artifacts or assemblages.

In my previous, broad-scale analyses of White Painted Ware decoration (Frankel 1974, 1978) I selected the intrinsic attribute of decoration on the grounds that as an indicator of symbolic variability it was most appropriate for measuring social relationships. The contextual definition of assemblages varied from the tomb to the cemetery or region depending on the quantity of material available. This variation in sample size may also, of course, affect the patterns observed, not only as larger samples have greater potential variability but also because they may derive from a longer time span or from a wider range of sources.

These analyses demonstrated that in terms of motif occurrence and motif preference there is strong evidence for regionalism, but that it is not appropriate to divide the island into sharply differentiated, discrete units. While there are clear local preferences, the boundaries around style zones display a gradual fall-off in similarity with distance (Fig. 25.4; Frankel 1974, 50; Frankel 1978, 158). Within this basic structure there is an interesting difference between the relative similarity of groups and regions based on the presence of motifs and that based on their proportional occurrence. There are, of course, technical problems of comparing similarity measured in different ways and based on different types of data. It is also important to remember that some of the variability in similarity may be due to chronological rather than spatial/cultural factors and that this type of diagram contains the implicit assumption of a symmetrical fall-off in similarity in all directions. Despite these problems, some common trends are evident in Figure 25.4. In each case, for closer sites, there is a lower level of similarity in terms of shared motifs than in terms of their proportional frequency of use. This initial greater similarity in proportional distribution of motifs is, however, offset by a steeper fall-off in relative similarity. This is not simply a reflection of the greater information content inherent in proportional counts, but rather indicates two distinct levels of meaning. We can envisage broader scale, less differentiated interaction at the level of motif interchange (little fall-off with distance) but smaller scale, more localized and internally homogeneous zones at the level of motif acceptability and use. Such difference must, once again, be significant in considering the social context in which potters adopted and employed symbols (cf. Frankel 1978). A general shared, common tradition can be seen at one level, with local symbolic markers segregating communities at another. Only by our separation of the different types of data, and a consideration of their different meanings, can such patterns be defined and understood.

Separate analyses of technical variation indicated a broad similarity (with some minor variations) across the

FRANKEL

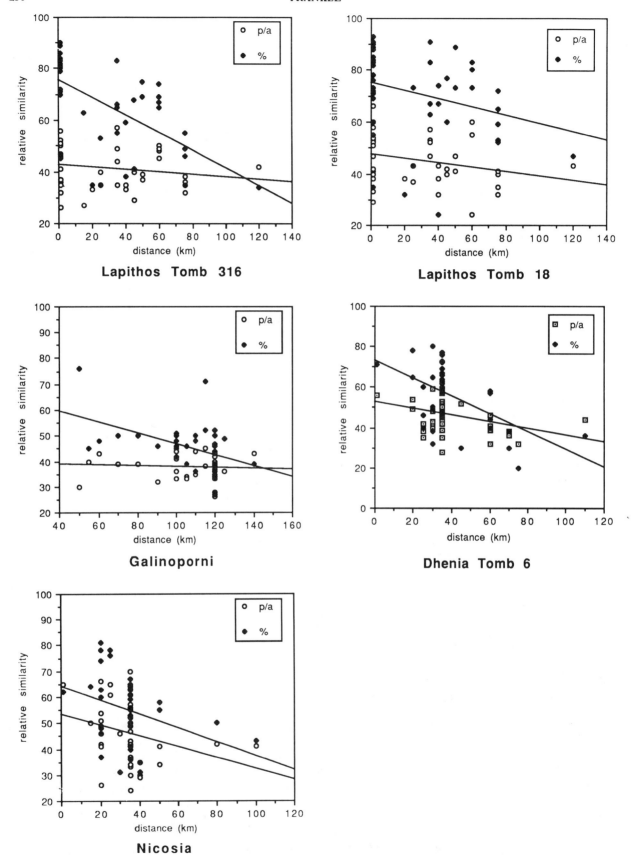

Lapithos Tomb 316

Lapithos Tomb 18

Galinoporni

Dhenia Tomb 6

Nicosia

*Figure 25.4. Relative similarity of pottery decoration plotted against distance for five White Painted Ware assemblages (for group definitions and data see Frankel 1974). a) Lapithos Tomb 316; b) Lapithos Tomb 18; c) Galinoporni; d) Dhenia Tomb 6; e) Nicosia-*Ayia Paraskevi. *Note: p/a = presence/absence.*

whole island in the surface colors of vessels, but some regional variation in vessel shape, although no internally homogeneous entities with strong, clear or sharp boundaries could be identified (Frankel 1981). A similar broad uniformity in technology has also been observed in the more detailed analyses by Barlow and Idziak (1988; Barlow this volume).

We have, then, measures of two dimensions of variation—symbolic and technological—which provide slightly different patterns of inter-regional relationships. Neither show very clear evidence of isolated groupings, but the technological similarities (selection and preparation of clays, forming and firing of vessels) appear less differentiated than those seen in motif preference. According to the model outlined above, one would expect some such greater (and certainly more easily measured) symbolic than technological variation. This perceived difference in the two types of variation may not be sufficiently great to justify an interpretation of greater interchange of technical than ideographic information. But, taking into account the difference between motif presence and motif acceptability, this difference may indeed be significant, reflecting a broader unity in fundamental aspects of the pottery tradition but more distinct local identification in the more complex use of symbols.

These examples serve to illustrate some of the varied scales and dimensions which we can isolate within the corpus of pottery from prehistoric Bronze Age Cyprus. The measurement of each gives a distinctive pattern, with a particular meaning. Monolithic typologies confuse this multiplicity of meanings. Varied, overlapping and specific analyses highlight particular issues; their later reintegration (and comparison with other types of material culture) can then proceed from a firmer foundation. Alongside the continued field research and laboratory analyses which contribute to our database and knowledge of sites, ceramics and society, we need also to assess critically how we create and explain observed patterning. In developing our ability to read the prehistoric record it is especially important to identify very clearly what questions we are interested in and how best to address them, and whether the attributes and techniques we use articulate appropriately with the available archaeological material.

Acknowledgments

I am grateful to Kym Thompson and Jenny Webb for their comments on drafts of this paper.

REFERENCES

Adams, William Y.
1988 Archaeological Classification: Theory and Practice. *Antiquity* 61, 40-56.

Barlow Jane A. & Phillip Idziak
1988 Selective Use of Clays at a Middle Bronze Age Site in Cyprus. *Archaeometry* 31, 66-76.

Binford, Lewis R.
1965 Archaeological Systematics and the Study of Culture Process. *American Antiquity* 31, 203-221.

1989 Styles of Styles. *Journal of Anthropological Archaeology* 8, 51-67.

Brew, John O.
1946 The Use and Abuse of Taxonomy. In *Archaeology of Alkali Ridge*, pp. 46-66. Papers of the Peabody Museum of Archaeology and Ethnography, Harvard University No. 24. Cambridge, Massachusetts.

Coleman, John E.
1985 Excavations at Alambra, 1974-84. In *Archaeology in Cyprus 1960-85*, edited by Vassos Karageorghis, pp. 125-141. Nicosia.

Frankel, David
1974 *Middle Cypriot White Painted Pottery: An Analytical Study of the Decoration*. SIMA XLII. Göteborg.

1978 Pottery Decoration as an Indicator of Social Relationships. In *Art in Society*, edited by M. Greenhalgh & J.V.S. Megaw, pp. 147-160. London.

1981 Uniformity and Variation in a Cypriot Ceramic Tradition: Shape and Colour. *Levant* XIII, 88-106.

1988a Ceramic Production in Prehistoric Bronze Age Cyprus: Assessing the Problem. *Journal of Mediterranean Archaeology*. 1/2, 27-55.

1988b Characterising Change in Prehistoric Sequences: A View from Australia. *Archaeology in Oceania* 23, 41-48.

Gardin, Jean-Claude
1980 *Archaeological Constructs: An Aspect of Theoretical Archaeology*. Cambridge.

Graslund, Bo
1987 *The Birth of Prehistoric Chronology: Dating Methods and Dating Systems in Nineteenth Century Scandinavian Archaeology*. Cambridge.

Hennessy, J. Basil
1973 Cypriot Artists of the Early and Middle Bronze Age. In *The Cypriot Bronze Age*, edited by J.M. Birmingham, pp. 10-22. Australian Studies in Archaeology 1. Sydney.

Herscher, Ellen
1972 A Potter's Error: Aspects of Middle Cypriote III. *RDAC*, 22-34.

1973 Red-on-Black Polished Ware from the Western Karpas. *RDAC*, 62-71.

Hodder, Ian & Clive Orton
1976 *Spatial Analysis in Archaeology*. Cambridge.

Kromholz, Susan
1982 *The Bronze Age Necropolis at Ayia Paraskevi (Nicosia): Unpublished Tombs in the Cyprus Museum*. SIMA Pocketbook XVII. Göteborg.

Merrillees, Robert S.
1977 The Absolute Chronology of the Bronze Age in Cyprus. *RDAC*, 33-50.

1978 *Introduction to the Bronze Age Archaeology of Cyprus*. SIMA Pocketbook IX. Göteborg.

1979 Pottery Trade in Bronze Age Cyprus. *RDAC*, 115-134.

1985 Twenty-five Years of Cypriot Archaeology: The Stone Age and Early and Middle Bronze Ages. In *Archaeology in Cyprus 1960-85*, edited by Vassos Karageorghis, pp. 11-19. Nicosia.

Miller, Daniel
1985 *Artefacts as Categories*. Cambridge.

Millett, Martin
1987 A Question of Time? Aspects of the Future of Pottery Studies. *Institute of Archaeology Bulletin* 24, 99-108.

Myres, John L.
1926 Review of *Studies on Prehistoric Cyprus* by Einar Gjerstad. *JHS* 46, 289-291.

Rice, Prudence M.
1981 Evolution of Specialized Pottery Production: A Trial Model. *Current Anthropology* 22.3, 219-240.

Stanley Price, Nicholas P.
1979 On Terminology and Models in Cypriote Prehistory. *RDAC*, 1-11.

Weissner, Polly
1983 Style and Information in Kalahari Projectile Points. *American Antiquity* 48, 253-276.

Index